Medieval
Clothing and Textiles

Volume 18

Medieval
Clothing and Textiles

ISSN 1744-5787

General Editor

Cordelia Warr — *University of Manchester, England*

Editorial Board

Eva Andersson Strand	*Centre for Textile Research, Copenhagen, Denmark*
Elizabeth Coatsworth	*Manchester, England*
Sarah-Grace Heller	*Ohio State University, USA*
Maren Clegg Hyer	*Snow College, Utah, USA*
Thomas M. Izbicki	*Rutgers University, New Jersey, USA*
Christine Meek	*Trinity College, Dublin, Ireland*
Lisa Monnas	*London, England*
Robin Netherton	*St. Louis, Missouri, USA*
Gale R. Owen-Crocker	*University of Manchester, England*
Lucia Sinisi	*University of Bari, Italy*
Monica L. Wright	*University of Louisiana at Lafayette, USA*

Book Reviews Editor

Robin Netherton — *St. Louis, Missouri, USA*

Founding Editors

Robin Netherton and Gale R. Owen-Crocker

Medieval
Clothing and Textiles

Volume 18

edited by

CORDELIA WARR

THE BOYDELL PRESS

© Contributors 2024

All Rights Reserved. Except as permitted under current legislation
no part of this work may be photocopied, stored in a retrieval system,
published, performed in public, adapted, broadcast,
transmitted, recorded or reproduced in any form or by any means,
without the prior permission of the copyright owner

First published 2024
The Boydell Press, Woodbridge

ISBN 978-1-83765-185-6

The Boydell Press is an imprint of Boydell & Brewer Ltd
PO Box 9, Woodbridge, Suffolk IP12 3DF, UK
and of Boydell & Brewer Inc.
668 Mt Hope Avenue, Rochester, NY 14620-2731, USA
website: www.boydellandbrewer.com

A CIP catalogue record for this book is available
from the British Library

The publisher has no responsibility for the continued existence or accuracy of URLs for
external or third-party internet websites referred to in this book, and does not guarantee that
any content on such websites is, or will remain, accurate or appropriate

Contents

Illustrations	vi
Tables	ix
Contributors	x
Preface	xiii

1 Linen Armour in the Frankish Countries: The Twelfth Century 1
Sean Manning

2 Serial Production and Individualisation in Late Medieval Silk
Weaving 41
Michael Peter

3 The Trousseau of Isabella Bruce, Queen of Norway (The National
Archives, Kew, DL 25/83) 73
Valeria Di Clemente

4 Make and Create: The Craftswomen in the Salone Frescoes of the
Palazzo della Ragione, Padua 99
Darrelyn Gunzburg

5 Combs, Mirrors, and Other Female Beauty Bling in the Later
Middle Ages 129
John Block Friedman

6 The Dividing Lines of Social Status in Sixteenth-Century Scottish
Fashion 165
Melanie Schuessler Bond

Recent Books of Interest 191

Author Index, Volumes 1–17 197

Illustrations

Linen Armour
Fig. 1.1 Map showing twelfth-century words for linen armour 35

Serial Production in Silk Weaving
Fig. 2.1 Altar hanging with Crucifixion scene, woven silk (Italy,
 1277–96), Domschatzkammer, Regensburg 42
Fig. 2.2 Line drawing of the Regensburg altar hanging 43
Fig. 2.3 Nicola Pisano, *Crucifixion of Christ* (detail), marble pulpit,
 ca. 1266–68, Cathedral, Siena 46
Fig. 2.4 Silk fragment with angels holding censers and instruments
 of the passion, lampas weave (Italy, ca. 1380), variant with
 metal thread pattern wefts, Abegg-Stiftung, Riggisberg 49
Fig. 2.5 Silk fragment with angels holding instruments of the passion,
 lampas weave (Italy, ca. 1380), variant with brocaded metal
 threads, Museum Catharijneconvent, Utrecht 50
Fig. 2.6 Silk fragment with angels holding censers, lampas weave (Italy,
 ca. 1380), variant with brocaded metal threads, Museum
 Catharijneconvent, Utrecht 50
Fig. 2.7 Panel of cloth-of-gold velvet with wavy-vine design (Italy, ca.
 1430–40), Abegg-Stiftung, Riggisberg 55
Fig. 2.8 Pattern reconstruction of the velvet panel in fig. 2.7 56
Fig. 2.9 Length of cloth-of-gold velvet with wavy-vine design (Italy,
 ca. 1470), Museum of Fine Arts, Boston 57
Fig. 2.10 Shoulder cape, brocaded velvet (Italy, ca. 1430–40), Bernisches
 Historisches Museum, Bern 58
Fig. 2.11 Pattern reconstruction of the velvet in fig. 2.10 59
Fig. 2.12 Cope of David of Burgundy, Bishop of Utrecht, front view,
 cloth-of-gold velvet with wavy-vine design (Italy, ca. 1470–80),
 Museum Catharijneconvent, Utrecht 60
Fig. 2.13 Cope of David of Burgundy, Bishop of Utrecht, back view,
 cloth-of-gold velvet with wavy-vine design (Italy, ca. 1470–80),
 Museum Catharijneconvent, Utrecht 61

Illustrations

Fig. 2.14	Altar frontal of Pope Sixtus IV, polychrome cloth-of-gold velvet woven to shape (Italy, ca. 1470–80), S. Francesco, Museo del Tesoro, Assisi	63
Fig. 2.15	Cope of King Henry VII of England, cloth-of-gold velvet woven to shape (Italy, 1498–1502), Stonyhurst College, Lancashire	64
Fig. 2.16	Panel of cloth-of-gold velvet with armorial design (Italy, ca. 1480–90), Metropolitan Museum of Art, New York	67
Fig. 2.17	Cope of David of Burgundy, Bishop of Utrecht, back view, cloth-of-gold velvet (Italy, ca. 1470–80), Museum Catharijneconvent, Utrecht	68
Fig. 2.18	Cope of David of Burgundy, Bishop of Utrecht, detail of fig. 2.17	69
Fig. 2.19	Dalmatic of David of Burgundy, Bishop of Utrecht, back view, cloth-of-gold velvet (Italy, ca. 1470–80), Museum Catharijneconvent, Utrecht	70
Fig. 2.20	Rood screen hanging of Albrecht of Brandenburg, detail, voided and brocaded velvet (Italy, ca. 1510–20), Cathedral Treasury, Halberstadt	72

Craftswomen in the Palazzo della Ragione Frescoes

Fig. 4.1	North facade of the Palazzo della Ragione and the Piazza dei Frutti, Padua	100
Fig. 4.2	Interior of the first-floor Salone of the Palazzo della Ragione, Padua	100
Fig. 4.3	Schematic (not to scale) of the Salone of the Palazzo della Ragione	112
Fig. 4.4	A woman sews a white *camicia*	114
Fig. 4.5	A woman sits on a bench sewing a white garment on her lap	118
Fig. 4.6	A woman holds a distaff and a drop spindle in the act of spinning	119
Fig. 4.7	A woman holds aloft the tools of spinning—a distaff and drop spindle	120
Fig. 4.8	A seated woman holds her arms wide	121
Fig. 4.9	A woman knits in the round	122
Fig. 4.10	A woman creates cord	124
Fig. 4.11	A hunter blows his horn while his two white dogs run alongside	125

Female Beauty Bling

Fig. 5.1	*Der Liebeszauber* ("The Love Spell"), anonymous Rhenish artist, ca. 1470, Museum der Bildenden Künste, Leipzig	136

Illustrations

Fig. 5.2	Woman at her toilette, anonymous Flemish artist, ca. 1480–90, Schiff Hours, folio 2r	137
Fig. 5.3	Parabolic mirror, from a public building, with town heraldic shields (German, ca. 1490), Musée Historique, Vevey, Switzerland	141
Fig. 5.4	Ivory mirror case showing lover's gift of a comb (Milan, Italy), Walters Art Museum, Baltimore	142
Fig. 5.5	Woman gazes into handheld mirror while being groomed, Vulgate *Lancelot du Lac*, 1470, Bibliothèque Nationale de France, Paris, MS fr. 112(1), folio 107	148
Fig. 5.6	Piero della Francesca, *Portrait of Battista Sforza*, showing ram's-horn hairstyle, 1465–66, Uffizi, Florence	159

Social Status in Scottish Fashion

Fig. 6.1	James V, 1591, Seton Armorial, National Library of Scotland, Edinburgh, MS Acc. 9309, detail of fol. 19r	168
Fig. 6.2	Men's gowns (price per ell in shillings)	170
Fig. 6.3	Men's non-mourning wool coats (price per ell in shillings)	171
Fig. 6.4	Men's non-mourning wool coats (price per ell from 6s to 22s)	173
Fig. 6.5	Men's wool coats vs. men's silk coats (price per ell in shillings)	174
Fig. 6.6	Men's mourning coats (price per ell in shillings)	175
Fig. 6.7	Men's wool mourning coats vs. men's wool non-mourning coats (price per ell in shillings)	176
Fig. 6.8	Wool fabrics (price per ell in shillings)	179
Fig. 6.9	Black wool fabrics (price per ell in shillings)	180
Fig. 6.10	Silk fabrics (price per ell in shillings)	180
Fig. 6.11	Taffeta fabrics (price per ell in shillings)	181
Fig. 6.12	Linen fabrics (price per ell in shillings)	183
Fig. 6.13	Comparison of silk and wool fabrics (price per ell in shillings)	184
Fig. 6.14	Comparison of black and taffeta fabrics (price per ell in shillings)	184
Fig. 6.15	Comparison of silk, wool, and linen fabrics (price per ell in shillings)	185
Fig. 6.16	Comparison of crimson and non-crimson fabrics (price per ell in shillings)	186

Full credit details are provided in the captions to the images in the text. The editors, contributors, and publishers are grateful to all the institutions and persons listed for permission to reproduce the materials in which they hold copyright. Every effort has been made to trace the copyright holders; apologies are offered for any omissions, and the publishers will be pleased to add any necessary acknowledgement in subsequent editions.

Tables

Linen Armour

Table 1.1	Words for quilted garments in twelfth-century Western Europe	4
Table 1.2	First attested use of terms for linen armour in a military context by language region	34
Table 1.3	Quilted garments worn alone and with iron armour in English and French sources	36

Contributors

CORDELIA WARR (Editor) is Professor of Medieval and Renaissance Art at the University of Manchester. Her research focuses on clothing, its representation, and its problematic relationship with the spiritual realm. She has published widely on the representation of religious dress. Her book *Dressing for Heaven: Physical and Spiritual Dress in Italian Art 1215–1545* (2010) investigates clothes as liminal objects, drawing on areas such as material culture, Renaissance models of consumption and devotion, and gender studies. Her recent publications include "*In persona Christi*: Liturgical Gloves and the Construction of Public Religious Identity" (*Bulletin of the John Rylands Library*, 2019), and a chapter on "Dress and Belief" for volume 3 of the *Bloomsbury Cultural History of Dress and Fashion* (2016).

ROBIN NETHERTON (Reviews Editor) is a costume historian specializing in Western European clothing of the Middle Ages and its interpretation by artists and historians. Since 1982, she has given lectures and workshops on practical aspects of medieval dress and on costume as an approach to social history, art history, and literature. Her published articles have addressed such topics as fourteenth-century sleeve embellishments, the cut of Norman tunics, and medieval Greenlanders' interpretations of European female fashion. A journalist by training, she also works as a professional editor. She co-founded and for fifteen years co-edited *Medieval Clothing and Textiles*.

MELANIE SCHUESSLER BOND is Professor of Costume Design at Eastern Michigan University. She focuses on clothing in sixteenth-century Western Europe with particular attention to material culture and the sociological implications of clothing. In addition to her book, *Dressing the Scottish Court, 1543–1553: Clothing in the Accounts of the Lord High Treasurer of Scotland*, she has published articles and chapters on various topics, including French hoods, children's clothing, and treason and clothing. She has also presented numerous papers on sixteenth-century clothing, including wedding attire, ladies-in-waiting, movie costumes, and Scottish clothing. Her current project is a book on the wardrobe of Mary, Queen of Scots.

VALERIA DI CLEMENTE is Associate Professor of Germanic philology at the University of Catania (Italy), Department of Humanities. Her research focuses on the medical-pharmaceutical literature in Medieval Germanic languages, anthroponymy, the presence of the Germanic linguistic and cultural element in medieval Scotland, women's studies (Western and Northern Europe in the Middle Ages), the reception of Germanic myths and literature in contemporary cultural production, Early Scots

and related literature, with special attention to cultural and linguistic exchanges. Her scientific and institutional profile can be found at http://www.disum.unict.it/docenti/valeria.diclemente.

JOHN BLOCK FRIEDMAN is Emeritus Professor of English and Medieval Studies at the University of Illinois at Urbana-Champaign and presently a Fellow of the Center for Medieval and Renaissance Studies at Ohio State University. He is the author of numerous books and articles, including *Monstrous Races in Medieval Art and Thought* (1981, reprinted 2000). His recent work includes *Book of Wonders of the World: Secrets of Natural History, Ms fr. 22971: Studies and Translation of the Facsimile Edition* (with Kathrin Giogoli and Kristen M. Figg, 2018); "Dogs of Lust, Loyalty, and Ingratitude in the Early Modern Manuscript Painting of Robinet Testard," *Reinardus* 34 (with Kristen M. Figg, 2022); and "Word into Image: Apocryphal Infancy Gospel Motifs on Antoni Gaudí's *Sagrada Família* Nativity Façade," *Digital Philology: A Journal of Medieval Cultures* (2023).

DARRELYN GUNZBURG holds a Ph.D. in History of Art (University of Bristol, 2014) and a B.A. (Hons.) in History of Art (Open University, 2006). She taught History of Art at the University of Bristol (2010–14) and since 2009 has taught on the M.A. distance-learning course run by the Sophia Centre for the Study of Cosmology in Culture at the University of Wales Trinity Saint David, where she contributes material on the art historical expression of the sky in culture. She has twice been guest editor for *The Journal of Religion, Nature and Culture*, most recently for issue 13.1 (2019), *Inside the World of Contemporary Astrology*. She is the editor of *The Imagined Sky: Cultural Perspectives* (2016), and co-editor of *Space, Place and Religious Landscapes: Living Mountains* (2021).

SEAN MANNING has studied History, Greek and Roman Studies (M.A. Calgary, 2013), and Ancient History and Ancient Near Eastern Studies (Ph.D. Innsbruck, 2018). His home on the Web is https://bookandsword.com, and he is affiliated with the Department of Greek and Roman Studies, University of Victoria, Canada. He is preparing to publish his second book, on the clothes worn with European armour from 1320 to 1620. His contribution to this volume is part of a project that began in January 2019: originally intended as preparation for making a *gambeson*, it has since taken up more of his sewing time than expected.

MICHAEL PETER is Curator of textiles and decorative arts pre-1200 at the Abegg-Stiftung in Riggisberg, Switzerland. A special focus of his research within the field of textile art lies in the development of weaving technology, loom construction, and pattern design under the conditions of medieval serial production. He has published on medieval goldsmiths' art and ivory sculpture as well as on the history of metal threads in textile art. In 2019, he published a two-volume collection catalogue of velvets before 1500 in the collection of the Abegg-Stiftung. He has contributed to exhibition catalogues for major exhibitions on Carolingian, Ottonian, and early Romanesque art as well as contributing to the advisory boards for these exhibitions.

Preface

This volume contains six essays arranged chronologically. As is often the case in volumes of *Medieval Clothing and Textiles*, a range of sources are discussed: literary and documentary material; clothing and material remains; frescoes, panel paintings, and images in manuscripts. Contents extend from the twelfth century to the sixteenth and geographically from southern Europe to Scotland and Norway.

The opening essay, by Sean Manning, investigates the use of quilted and linen armour. By the year 1160, warriors in Catholic Europe often wore quilted coats over, under, or instead of iron armour. Texts from the twelfth century onwards record this practice, but archaeological and iconographic evidence is very limited before the thirteenth century. In addition, texts provide information that paintings, sculptures, and surviving garments cannot, such as cost, the equipment of low-status soldiers, and what was hidden under visible outer layers. However, references to soldiers wearing quilted coats appear in a wide variety of texts in different languages with different vocabulary. This article, which is the first in a planned series, provides the most important references to these garments across Western Europe in both their original language and in translation. Looking at texts in Latin, the Romance languages, the Germanic languages, and Old Irish suggests that the different terms for quilted coats were more or less interchangeable in this period. By the late twelfth century, soldiers' quilted coats were part of a cultural package with items like *covertures* (trappers for horses), *cuiries* (leather defenses for the chest), and iron hats. The article also raises the question of why the earliest evidence comes from the British Isles and northern France, when the technology may have been imported from the cotton-growing regions around the Eastern Mediterranean and the Black Sea.

Michael Peter, in the second essay of the volume, moves from linen to silk and from literary to material sources, looking at serial production in late medieval silks. Medieval silk weaving was characterised by the different interests of producers and consumers. The buyers' needs for exclusivity and individual self-representation were contrasted on the side of the manufacturers by the mechanisms of the market and the rules of serial production, which aimed to economise and standardise the weaving processes as much as possible. Opportunities to modify patterns and motifs to fit individual preferences were extremely limited. The purchaser did not act as a patron with a free choice of form and design, but rather as a mere customer, whose options were constrained by the selection on offer. As a result, the tailor was given a new role. He inserted himself between the manufacturer and the buyer, giving his client back something of the latter's former role as patron. A series of technical innovations, as

Preface

well as changes in pattern design and loom construction, offered further opportunities to accommodate the individual requirements of the buyer within the framework of serial production.

Valeria Di Clemente presents a new edition of the inventory of Isabella Bruce's bridal goods. The Scottish noblewoman married Eiríkr II, King of Norway, in 1293; the only extant copy of the inventory was drawn up on 25 September 1293 in Bergen and is kept in the National Archives, Kew, under the shelfmark DL 25/83. Di Clemente's new critical reading aims to carefully render the original aspect of the text and is accompanied by an introduction on the historical context and a discussion of the items contained in Isabella's trousseau both from a material/cultural and a linguistic point of view.

The next essay moves to a focus on monumental fresco painting in Italy. Darrelyn Gunzburg explores the representation of craftswomen in the frescoes of the Salone of the Palazzo della Ragione in Padua, Italy. Completed between 1218 and 1220 and subsequently added to and repaired, the building was the geographical centre of Padua and its symbolic heart, the place where justice was administered. The complex imagery of the scheme includes representations of trades and skills, sky constellations, images of the zodiac signs and the planets, and a rich assembly of labours associated with each month, as well as theological and liturgical themes. Although many of the trades depicted are ones in which men were dominant, the frescoes include seven women busily engaged in crafts which are rarely depicted in medieval mural decorations—spinning, sewing, knitting, and making cord. In examining these seven women, Gunzburg raises the question as to whether their crafts and skills were being recognized by being painted onto the Salone walls, or whether, by omission, other areas of women's work were being suppressed.

The final two essays in this volume are both by authors whose long-term scholarly interests in clothing and textiles have resulted in publications in previous volumes of *Medieval Clothing and Textiles*, John Block Friedman and Melanie Schuessler Bond. Indeed, the authors collaborated on their most recent essay in this publication ("Fashion and Material Culture in the Tabletop of the Seven Deadly Sins Attributed to Hieronymus Bosch," in volume 16). Friedman's essay on female beauty bling describes specific components of female beauty in the Middle Ages by both visual and literary means, including manuscript miniatures and descriptions by medieval writers such as Boccaccio. The beautiful woman's chief utensils were the comb and the mirror, whose materials, manufacture, sale, and eventual symbolism have not hitherto received much detailed discussion. The essay also treats processes for cosmetically "improving" the skin and lips, and decorating and covering the hair. These beauty practices produced a variety of responses from medieval moralists ranging from poets to preachers. In addition to classical, medieval, and Renaissance written sources, such as recipe collections, treatises on gynecology and medicine, and preaching handbooks, late medieval manuscript miniatures and graphic media show women before mirrors grooming themselves by combing their hair, applying cosmetics to the face, and the like. All these witnesses give us much valuable information about medieval cosmetic

Preface

practices and the details of how to achieve an ideal beauty, as well as male clerical reactions to female beauty.

Melanie Schuessler Bond explores the Scottish royal treasurer's accounts of the mid-sixteenth century in order to decipher how certain types of clothing and fabric represented the dividing lines of social status. Particular garments and accessories, such as women's hoods and men's gowns, were markers of high status, as can be seen from the small number of people who received them. Similar patterns can be found in the types of fabrics granted to various groups of people. The quality of fabric was also graded to the recipient—the range of prices of wools, for example, was wide. The dye also made a significant difference. Bond's analysis of the patterns of distribution of garment and fabric types, dyes, trims, and other items reveals something of the social structure of sixteenth-century Scottish society and how it was expressed.

Volume 18 marks a return to the usual timetable for the publication of *Medieval Clothing and Textiles*. This is in no small measure due to the enormous help received from the board members and many other scholars who have generously devoted their time and expertise to review article submissions and consult with authors. The editor would particularly like to mention the founding editors, Gale R. Owen-Crocker and Robin Netherton, as well as the team at Boydell who continue to support the publication in myriad ways, and have been instrumental in ensuring that the series continues to prosper.

It is a great pleasure to announce that, from volume 19, we will be welcoming Melanie Schuessler Bond as co-editor. Professor Bond brings a wealth of experience as a professional costume designer, costume technician, and costume history scholar. As noted above, she is well acquainted with *Medieval Clothing and Textiles*, having published several articles in the journal, beginning with "'She Hath Over Grown All that Ever She Hath': Children's Clothing in the Lisle Letters, 1533–40," in volume 3.

We continue to consider for publication in this journal both independent submissions and papers read at sessions sponsored by DISTAFF (Discussion, Interpretation, and Study of Textiles Arts, Fabrics, and Fashion) at the international congresses held annually in Kalamazoo, Michigan, and Leeds, England. Proposals for potential conference speakers should be sent to robin@netherton.net (for Kalamazoo) or gale.owencrocker@ntl.world.com (for Leeds). Potential authors for *Medieval Clothing and Textiles* should send a 300-word synopsis to cordelia.warr@manchester.ac.uk.

Authors of larger studies interested in submitting a monograph or collaborative book manuscript for our subsidia series, Medieval and Renaissance Clothing and Textiles, should apply using the publication proposal form on the website of our publisher, Boydell and Brewer, at https://boydellandbrewer.com/boydell-brewer-prospective-authors. We encourage potential editors to discuss their ideas with the General Editors, Robin Netherton (robin@netherton.net) and Gale Owen-Crocker (gale.owencrocker@ntlworld.com), before making a formal proposal.

Linen Armour in the Frankish Countries:
The Twelfth Century

Sean Manning

While most kinds of armour appear in the archaeological record long before they can be identified with certainty in written evidence, the reverse is true for quilted armour in Western Europe. This appears in written sources from the twelfth century onwards, whereas the oldest surviving quilted garments[1] and depictions of soldiers in quilted garments[2] date to the thirteenth. Moreover, written sources give detailed lists

This is the first of a planned series of three articles on linen armour. Some of the research in this paper was supported by the Social Sciences and Humanities Research Council, Canada.

1 These include two examples in France: the quilted sleeve of Bussy-Saint-Martin and the *aketon* of Isabelle of France at Notre-Dame de Paris. On the sleeve of Bussy-Saint Martin, see Caroline Piel and Isabelle Bédat, "La manche de saint Martin à Bussy-Saint-Martin (Seine-et-Marne)," *Coré* 2 (March 1997): 38–43; Catherine Besson-Lagier, "The Sleeve from Bussy-Saint-Martin: A Rare Example of Medieval Quilted Armor," *Medieval Clothing and Textiles* 17 (2023): 28–66. On the *aketon* of Isabelle of France at Notre-Dame de Paris, see Tina Anderlini, "The Shirt Attributed to St. Louis," *Medieval Clothing and Textiles* 11 (2015): 49–78, at 67–72. The former was carbon dated to ca. 1160–1270; the latter is associated with the sister of Louis IX, who died in 1270. Excavations at Cornmarket and Bridge Street, Dublin, uncovered a large fragment of leather with parallel rows of stitching which has been exhibited as "remains of a c.1150–1190 quilted leather aketon" (National Museum of Ireland, Dublin, acc. no. 92E109:400:212 A–D). While it does not appear to have been formally published, the interpretation that this was part of a thick quilted armour seems to be based on texts and art from later periods. There is some information about the excavations in Alan Hayden, "West Side Story: Archaeological Excavations at Cornmarket and Bridge Street Upper, Dublin—A Summary Account," in *Medieval Dublin I: Proceedings of the Friends of Medieval Dublin Symposium 1999*, ed. Seán Duffy (Dublin: Four Courts Press, 2000), 84–116.
2 The Las Huelgas Apocalypse from Spain (New York, Morgan Library, MS M.429, 149v, painted ca. 1220) and a Massacre of the Innocents on a font in the Duomo, Verona (twelfth century?) are the earliest clear depictions of quilted armour in Western Europe of which I am aware. The way we interpret material culture in art is strongly influenced by our preconceptions, so our understanding that paintings and sculpture show quilted armour depends on the texts and the surviving garments. While this article was being edited, Stephen Bennett was working on a similar project that has since appeared and

of materials, information on construction techniques, prices, and other information that cannot be learned from art or the surviving artifacts. However, these texts are written in a wide variety of languages and call similar garments by a confusing variety of names. Medieval societies were multilingual, so it is necessary to study all languages spoken in a region to understand individual terms. Many terms could be used quite naturally in English, the Romance languages, and Latin. This project lays out the most important known sources from across Catholic Europe with translations, so that texts from the same country in different languages, and texts in the same language in different countries, can be studied side by side.

The sources discussed in this study are drawn from dictionaries (see Appendix 1.1 for a list), research on medieval armour, and reading by the author and fellow enthusiasts. Searchable digital corpora have been a very great help, but so have been the discussion forums and mailing lists of the 1998–2018 era where interested parties could pool their private lists of evidence.[3] When selecting sources for inclusion, I have tried to represent as many languages and regions as possible and preferred sources with technical information to sources which simply mention a *gambeson, pourpoint,* or *aketon*. Unless otherwise indicated, translations are my own.

TERMS DISCUSSED

In Western Europe before the Fourth Crusade (1202–4), five families of words can refer to a quilted coat. (For words for quilted garments, see table 1.1.) *Aketon, gambais/ gambeson*, and *pourpoint* are relatively easy to interpret, although *aketon* can also refer to cotton fibre or to cotton cloth (see sources ii.2, ii.9, ii.10, ii.13, below); the etymology of *gambeson* is disputed; and *pourpoint* can be anything which is quilted, such as a bedcover or horse cover. Words in the *jupe* family are more difficult to interpret. *Jupe* is borrowed from the Arabic word *jubbah*, a type of tunic. Romance speakers often added suffixes, making *jupels, jupeaus,* and *jupons*. By the fourteenth century,

contains photos of these early sculptures and paintings; we have seen drafts of each other's work. I agree that in English usage around the year 1300, an *aketon* was usually worn under the mail and a *gambeson* was usually worn over it, but I do not agree that this distinction is found outside of England or before 1250 (see table 1.3). Until the new close-fitting fashion appeared in the fourteenth century, people used many different names for the same quilted coats. Stephen Bennett, "Under or Over (or Both)? Textile Armour and the Warrior in the High Middle Ages," *Arms & Armour* 20, no. 1 (2023): 35–53.

3 Pavel Alekseychik, Stephen Curtin, Jonathan Dean, ergosum, Dan Howard, Håvard Kongsrud, Gregory Liebau, Leonard "Len" Parker, and Mart Shearer were especially active contributors. Jessica Finley, Evan Schultheis, and Monica L. Wright commented on translations. John Thompson's Armour Archive (http://armourarchive.org) and Nathan Robinson's MyArmoury (http://myarmoury.com) were especially useful places to find sources and coordinate the search.

Linen Armour

most *jupons* seem to be quilted.[4] In earlier periods, many *jupes* and *jupels* have costly embroidery or a fur lining and are not clearly quilted.[5] Because *jupe*s and *jupels* could be either luxurious "Saracen-style" coats or quilted coats, each use of these words needs to be carefully examined to interpret it correctly. Lastly, Old Norse texts such as the Norwegian *King's Mirror* make it clear that Old Norse *panzar* was a protective quilted coat.[6] In the fourteenth century, cognates of *panzar* can mean "coat of mail" (e.g., French *panchire*, Italian *panzerone*, German *Panzer*).[7] The two senses "quilted coat" and "mail coat" seem to be used in different regions.

4 By 1219 Venice had a guild of *zuparii* (*jupe*-makers) who worked with bowed cotton; Giovanni Monticolo, ed., *I capitolari delle arti veneziane: sottoposte alla giustizia e poi alla giustizia vecchia dalle origini al MCCCXXX* (Rome: Tipografo del Senato, 1896), 23–54. The Bonis brothers of Montauban in Languedoc sold their customers *coto mapus* (unspun cotton), fustian, and *tela* (linen cloth) to make *jupos* in the 1340s; Édouard Forestié, *Les Livres de comptes des frères Bonis, marchands montalbanais du XIVe siècle*, Archives Historiques de la Gascogne 20 (Paris: Honore Champion and Cocharaux Frères, 1890). *Jubon* in Iberia became synonymous with *doublet* in England. Rich *jupons* were made for Edward III of England of three fabrics and half a pound or one pound of silk per *jupon*; Sir Nicholas Harris Nicolas, "Observations on the Institution of the Most Noble Order of the Garter," *Archaeologia* 21 (1846): 34, 35. By 1388 the dukes of Burgundy were paying a *pourpointier* to make *jupons* of *toile* and fustian; Bernard Prost and Henri Prost, *Inventaires, mobiliers et extraits des comptes des ducs de Bourgogne de la maison de Valois, 1363–1477*, 2 vols. (Paris: Ernest Leroux Editeur, 1913), 2:438, 452, 480. In 1400 the tailors of Troyes specified that new *jupons* must not be stuffed with old cotton; Denis-François Secousse, ed., *Ordonnances des rois de France de la troisième race*, vol. 8 (Paris: Imprimerie Royale, 1750), 384–89. Cf. the picture of Chaucer's Knight in the Ellesmere Chaucer (San Marino, California, Huntington Library, MS EL 26 C 9) and the word *jupponerie* (not *jupperie*) below.

5 Eunice Rathbone Goddard, *Women's Costume in French Texts of the Eleventh and Twelfth Centuries* (Baltimore: Johns Hopkins University Press, 1927), s.v. *jupe*. Cf. source ii.14, where a *jupe* is worn over a *panzar* and a coat of mail.

6 A text of the *King's Mirror* is available in C. R. Unger, P. A. Munch, and Rudolph Keyser, eds., *Speculum regale. Konungs-skuggsjá. Konge-speilet* (Christiania [Oslo]: Trykt hos C. C. Werner & Comp., 1848), 86–88 (chaps. 37, 38); a flawed translation is printed in Laurence Marcellus Larson, ed., *The King's Mirror (Speculum regale—Konungs skuggsjá)* (New York: American-Scandinavian Foundation, 1917), 211–20. This text will be discussed in more detail in a subsequent article.

7 Jean le Bel mentions "les haubergons, que on appelle maintenant panchieres"; Jacques de Hemricourt mentions soldiers "armeis d'unne cotte de fier appelée panchire"; and an Italian version of Justin's *Epitoma Pompeii Troagi* translates *brevis lorica* as *corto panzerone*. See Jules Viard and Eugène Déprez, eds., *Chronique de Jean le Bel* (Paris: Librairie Renouard, 1904) 1:127; Baron C. de Borman, Alphonse Bayot, and Édouard Poncelet, eds., *Oeuvres de Jacques de Hemricourt* (Brussels: Maurice Lambertin, 1931), 3:40 (chap. 41); Salvatore Battaglia, *Grande Dizionario della Lingua Italiana*, 21 vols. (Turin: Unione Tipografico-Editrice Torinese, 1961–2002), s.v. *panzerone*. Illustrations of Justin's story show that the artists understood this expression to mean a shirt of mail (e.g., Paris, Bibliothèque Nationale de France, MS Nouv. Acq. Fr. 15939, 94v; Geneva, Bibliothèque de Genève, MS fr. 190/191, 104v). Francesco di Marco Datini (act. 1363–1410) lists *panceroni* among other mail in his inventories and orders from suppliers; Luciana Frangioni, ed., *Milano fine Trecento: Il carteggio milanese dell'Archivio Datini di Prato* (Florence:

Sean Manning

Table 1.1: Words for quilted garments in twelfth-century Western Europe.

Word	Etymology
aketon, auqueton, hoqueton	Arabic *al-qutun* ("cotton, garment made from cotton"); *FEW*, 19:102a, s.v. *qutun*
gambais, wambais, Wammes	Either Greek βάμβαξ ("cotton") or Germanic *wamba* ("belly, innards"); *DEAF*, G:106
gambeson, wambaison	Romance *gambais* ("quilted coat") + diminutive suffix *-on*
gamboisé (adj.)	Romance *gambais* + *é* ("made like a gambeson, quilted")
pourpoint (adj. and noun)	Latin *perpunctus* ("pierced through, stitched through"); see source iii.3
panzar (Old Norse only)	Romance *pansière* or *panzerone* ("shirt of mail") from Latin *pantex* ("belly"; i.e., "protection for the belly")
jupe, guppe, zuppa, giubba, çuppa	Arabic *jubbah* ("tunic"); *DEAF*, J:741–42, s.v. *juppe*
jupel, giuparello, etc.	Romance *jupe* + diminutive suffix *-l* ("little *jupe*")
jupon, zupone, etc.	Romance *jupe* + diminutive suffix *-on* ("little *jupe*")
jupeau, etc.	Romance *jupe* + diminutive suffix *-eau* ("little *jupe*")

Note: Etymologies after Kurt Baldinger et al., eds., *Dictionnaire étymologique de l'ancien français* (Quebec: Presses de l'Université Laval, 1971–; noted here as *DEAF*), and Walther von Wartburg et al., eds., *Französisches Etymologisches Wörterbuch*, 25 vols. (Leipzig: Teubner and Zbinden, 1928–2002; noted here as *FEW*).

The word doublet (Latin *diplois*) sometimes appears before the fourteenth century, but rarely with the meaning "a quilted garment worn by soldiers." Because this term is uncommon and hard to interpret before the fourteenth century, I have not focused on it. The Italian terms *farsetto* and *suprasegna/sopraensegna* and the Norse and German terms *Troie/Tröja* will be discussed in later articles in this series. The sense of jack as "a quilted coat" is not attested until 1358 so it will not be discussed in this series.[8] Terms for smaller protective fabric items, such as collar (throat pro-

Opus Libri, 1994), 2:8. Iron body defenses were divided into *Panzer* and either *Harnasch*, *Brustblech* (breastplate), or *currisia* (cuirass) in fourteenth- and early-fifteenth-century Switzerland; Regula Schmid, "The Armour of the Common Soldier in the Late Middle Ages: *Harnischrödel* as Sources for the History of Urban Martial Culture," *Acta Periodica Duellatorum* 5, no. 2 (2017): 14–17 (cf. Jost Amman's woodcut of a *Panzermacher* from 1568).

8 *Dictionnaire du Moyen Français (1330–1500)*, online ed. (Paris: Centre National de la Recherche Scientifique, 2007), http://www.atilf.fr/dmf, s.v. *jaque*. *Middle English Dictionary*, online ed. (Ann Arbor, MI: University of Michigan Press, 2001), http://quod.lib.umich.edu/m/med, s.v. *jakke* n.(2). The name seems to come from the French use of *Jacques Bonhomme* to mean "a foot soldier" like "Tommy Atkins" or "Ivan" in the twentieth century.

Linen Armour

tection), spaulder (shoulder protection, French *épaulier*), and cuisse (thigh armour), will be discussed under individual sources.

In thirteenth-century England, these garments were called linen armour, as contrasted with iron armour such as coats of mail or helms.[9] Among armour confiscated from the Anglo-Norman knight Falkes de Bréauté in 1224 were "linen armours [*de lineis armaturis*]: a *pourpoint* and a spaulder of black cendal, […] cuisse and collar and coif and arming coat and two pairs of *covertures*" (i.e., quilted trappers for horses; see source ii.11).[10] By the end of the century, the linen armourers were one of the Companies of London.[11] In France after the Black Death, these garments were classed as *jupponerie* or *pourpointerie*, but these terms included everything made with the same skills, including bedcovers and horse blankets.[12] The term "linen armour" seems a suitable alternative to modern expressions such as "quilted armour" or "textile defences," even though linen armour was not always literally of linen cloth and was not always intended to stop weapons on its own.

I. THE EARLIEST SOURCES

After a period of about 700 years when there is no clear evidence for fabric or leather armour in Western Europe, texts from the twelfth century begin to mention soldiers wearing quilted garments.[13] The earliest sources are ambiguous or difficult to date.

9 William Rothwell et al., eds., *Anglo-Norman Dictionary*, online (2nd) ed. (London: Modern Humanities Research Association in conjunction with the Anglo-Norman Text Society, 2006–), https://anglo-norman.net, s.v. *armure > linge armure*; R. E. Latham et al., eds., *Dictionary of Medieval Latin from British Sources*, 17 fascicules (Oxford: Oxford University Press, 1975–2013), s.v. *armatura* (c).

10 *Curia Regis Rolls*, vol. 11 (London: HMSO, 1955), no. 1913.

11 Matthew Davies and Ann Saunders, *The History of the Merchant Taylors' Company* (Leeds, UK: Maney, 2004), 11–13, 49–52.

12 Aside from *Dictionnaire du Moyen Français*, s.v., see the rule of the armourers, *coustepointiers*, and helmers of Paris from 1364, in René de Lespinasse and François Bonnardot, eds., *Les métiers et corporations de la ville de Paris: XIVe–XVIIIe siècles*, 3 vols. (Imprimerie Nationale: Paris, 1886–97), 2:319–22, and the rule of the *pourpointiers* of Paris from 1382, at 3:212–13 (chap. 19).

13 Chapter 15 of the anonymous treatise *De rebus bellicis* (fourth century AD?) recommends that soldiers wear a *thoracomachus* of woollen felt covered with a "Libyan hide" under their armour; text and discussion in E. A. Thompson, *A Roman Reformer and Inventor, Being a New Text of the Treatise* De rebus bellicis (Oxford: Clarendon Press, 1952). Vegetius' *Epitoma Rei Militaris* (383–450), Carolingian documents and literature, and the earliest surviving *chansons de geste* do not give similar advice. Many better-documented cultures had warriors with iron armour and helmets, and warriors in their hats and tunics, and no armour in between, so there is no basis for assuming that early medieval warriors must have used some form of linen or leather armour.

Sean Manning

Source i.1: Rashi's commentaries (France, before 1105)
Shlomo Yitzchaki of Troyes, better known as Rashi, was a learned rabbi who lived from 1040 to 1105. His commentaries on the Torah and the Talmud mention words like *porpojjnt* and *ganbais* in Hebrew letters, sometimes with clarifying notes in Latin letters by later scribes in the margins.[14] These are generally accepted as the first recorded uses of the words *pourpoint* and *gambais*, but the scholars who found them do not give the context.[15]

Source i.2: Codex Diplomaticus Cavensis
The archives of the abbey of the Santissima Trinità at Cava de' Tirreni near Salerno in Italy mention a *zippa* of silk in 990 and a *juppa* in a list of domestic goods from 1053.[16] These seem to be the first recorded uses of words in the *jupe* family in a European language, but not all *jupes* were quilted (a quilted *jupel* appears in source ii.13, and a soldier wears a *ioppus* in source ii.16, but both of these are masculine words derived from feminine *jupe*).

Source i.3: English charters
Three English documents dated 1119 (but in a copy from 1280), 1137, and ca. 1150 mention Herebertus Weambasarius (or *Womba-* or *Wambar-*), an H. Wambarsarius, and the land of Safredus Wambasarius (*terram Safredi Wambasarii*).[17] If the dates and the readings are correct, these men were named for the profession of "*gambeson*-maker" (French *gamboisier*).

14 Kurt Baldinger et al., eds., *Dictionnaire étymologique de l'ancien français* (Quebec: Presses de l'Université Laval, 1971–), s.v. *gambais, porpoint*. For the glosses, see Arsène Darmesteter, "Les gloses françaises de Raschi dans la Bible," *Revue des études juives* 53 (1907): 192, and 55 (1908): 74; and Arsène Darmesteter and David Simon Blondheim, eds., *Les gloses françaises dans les commentaires talmudiques de Raschi*, vol. 1 (Paris: Libraire Ancienne Honoré Champion, 1929), 18 no. 149A, 75 no. 536: "brosder (de) ganbais."

15 The words *banbacio* and *bambeth*, found in lists of clothing in Catalan from around 1080, also seem to be forms of the word *wambais/gambais*. Baldinger, *Dictionnaire étymologique*, s.v. *gambais*, citing "Corom 2,647"; probably some edition of J. Corominas, ed., *Diccionario crítico etimológico de la lengua castellana*, 4 vols. (Bern: Francke, 1954–57).

16 Vincenzo de Bartholomaeis, "Spoglio del 'Codex diplomaticus cavensis' (continuazione e fine)," *Archivio Glottologico Italiano* 15:346, 362.

17 Latham, *Medieval Latin from British Sources*, s.v. *wambesarius*. The University of Toronto's Documents of Early England Data Set (DEEDS) has a transcription of the first text at https://deeds.library.utoronto.ca/charters/05630008 and an automated dater which shows the legal language as typical of circa 1120 rather than 1280. (I thank Ariella Elema for the reference.)

Linen Armour

Source i.4: Gesta Herwardi Saxonis *(written in England ca. 1107–31, set in Frisia ca. 1063)*

Hereward was an English outlaw who became a folk hero for resisting the Normans when he returned from Flanders after the death of Harold Godwinson. A fanciful Latin account of his life claims to be based on a damaged English text and oral tradition.[18] In this passage, the people of Scaldemariland (Zeeland?) have learned that he ambushed another part of their army with 300 picked men. In the following I will note one important difference between the two major editions of the only manuscript (one edited by Thomas Duffus Hardy and Charles Trice Martin, the other by S. H. Miller).

> Pro quo enim cum ira magna et indignatione maxima suo more ad bellum praeparati procederent, nullo modo nec aliquem praeterire vivum conjurantes, his armis praecincti et muniti; cum feltreis togis pice et resina atque in thure intinctis, seu cum tunicis ex coria valde coctis [Miller: cortis], et in manibus hastilia clavata et torta ad pugendum vel ad retrahendum, seu ad percutiendum, et cum tribus jaculis quadratis aut quatuor ad jaciendum. Inter duos quippe sic munitos, unus semper cum gladio vel cum secure constituebatur, praeferens etiam scutum illorum duorum. Habuerunt enim nimis multam et magnam multitudinem, sed incompositam. Dux vero Flandrensis exercitus et Herewardus magister militum videntes illos in convalle descendere, super montana contra suum statuerunt exercitum.[19]

> [On account of which they proceeded prepared to war in their own fashion with great anger and the greatest indignation, swearing that no-one whatsoever would escape alive, girdled and furnished with these arms: with felt togas soaked with pitch and resin and incense,[20] or with well-boiled (Miller: very short) tunics, and with nailed and wrought darts in their hands for striking or for withdrawing, or for piercing, and with three or four darts with squared heads for hurling. Between two so furnished, one was always placed with sword or axe, carrying a shield for them both. For they had an exceedingly great and numerous but disorderly multitude. And indeed the leader of the Flemish army and Hereward the *magister militum* (a Late Roman office), seeing them descend into the valley, posted their own army atop a mountain opposite them.]

Our hero's army defeat their enemies. The story of Hereward's time in exile includes so many tropes from romances—sailing to distant lands, battling bears and foreigners,

18 The date is uncertain, but the author implies that Hereward lived some time before his own time. The only known manuscript was written in the thirteenth century. For the details, see Stephen Knight and Thomas Ohlgren, eds., *Robin Hood and Other Outlaw Tales* (Kalamazoo, MI: Medieval Institute Publications, 1997), and Elisabeth van Houts, "Hereward and Flanders," *Anglo-Saxon England* 28 (1999): 201–23.

19 Text from "Gesta Herwardi incliti exulis et militis," in *Lestoire des Engles solum la tranlacion maistre Geffrei Gaimar*, 2 vols., ed. Thomas Duffus Hardy and Charles Trice Martin (London: HMSO, 1888), 2:366, 367 (chap. 12). There is another edition with a full English translation: S. H. Miller, ed., *De Gestis Herwardi Saxonis: The Exploits of Hereward the Saxon*, trans. Rev. W. D. Sweeting (Peterborough, UK: Geo. C. Caster, 1895), 28–29.

20 Greek θύος and Latin *tus* or *thus*, which can refer to frankincense specifically. Frankincense is not soluble in water or alcohol so it would be hard to dip cloth into it. My thanks to Mark Clarke for his comments on medieval language for exotic gums and resins.

winning the hand of a beautiful and capable woman—that most readers suspect that the author of this text filled out his sources with details from other stories. But how should we interpret the description of Frisian armour?

The author of the *Gesta* avoided loan words from the vernacular, so if he knew words like *gambeson* he would not have used them. Felt is absent from later descriptions of this armour, but it might be the author's substitute for the newfangled word cotton/ *aketon*.[21] The Norwegian *King's Mirror* mentions a well-blackened linen *panzara* in the thirteenth century,[22] and John Mair's *Historia Maioris Brittaniae* (1521) says that "having his body covered in linen cloth sewed together in many layers and waxed or pitched and covered with stag's skins, the commons of the highland Scots charges into battle."[23] The fifteenth-century jacks in Lübeck are painted on their outer surface with a mix of carbon and linseed oil which may have been meant to waterproof areas exposed to rain.[24] A fifteenth-century English manuscript has a recipe for hardening fabric for jacks with alum, mastic, "gum resin," and wort (although not with black pigment).[25] It is probably safest to note this interesting text but not try to base an argument on it.

Source i.5: An Irish heroic attribute

The stories and poems which we call "Irish mythology" contain a number of descriptions of the armament of the heroes and villains and their armies. The *Táin Bó Cúailnge* (*Cattle Raid of Cooley*), one of the most famous stories in this tradition, describes the demigod and hero Cú Chulainn as follows:

21 Felt does appear in the eleventh-century *Casus Sancti Galli*, where Abbot Engilbert of St. Gall orders the brothers to make wicker shields, slings, darts, cudgels with points hardened in the fire, and felt armour (*piltris loricae fiunt*) before hiding from Magyar raiders. See George Henry Pertz, ed., *Monumenta Germaniae Historica: Scriptorum,* vol. 2 (Hanover, Germany: Hahn, 1829), 104. This and earlier references to felt garments worn by soldiers deserve a separate study.

22 Unger, Munch, and Keyser, *Speculum regale*, 86–88 (chaps. 37, 38). The Old Norse phrase for the blackening is *ok vel svörtuðum*.

23 John Mair, *Historia Maioris Britanniae, tam Angliae quam Scotiae [...]* (Paris: Jodocus Badius Ascensius, 1521) book 1, chap. 8, fol. 16: "Tempore belli loricam ex loris ferreis per totum corpus unduunt & in illa pugnant. In panno lineo multipliciter intersuto & caerato aut picato cum ceruine pellis coopertura vulgus syluestrium Scotorum corpus tectum habens in proelium prosilit." Another translation is available in John Major, *A History of Greater Britain, as Well England as Scotland,* trans. Archibald Constable (Edinburgh: Edinburgh University Press, 1892), 49. A facsimile of the 1521 *editio princeps* is available at https://archive.org/details/ita-bnc-mag-00001173-001 (accessed Aug. 20, 2023).

24 Jessica Finley, "The Lübeck Wappenröcke: Distinctive Style in Fifteenth-Century German Fabric Armor," *Medieval Clothing and Textiles* 13 (2017): 121–52, especially 138, 139.

25 John Shirley, in London, British Library, Add. MS 16165, fol. 1, as transcribed in Ian Eaves, "On the Remains of a Jack of Plate Excavated from Beeston Castle in Cheshire," *Journal of the Arms and Armour Society* 13, no. 2 (1989), 141 n. 40.

Linen Armour

Ba don chatheirred catha sin & comraic & comlaind ro gab-som imbi secht cneslénti fichet cíartha clárda comdlúta bítís ba thétaib & rothaib & refedaib i custul ri gelchnes dó arnacha ndechrad a chond nach a chiall ó dofíced a lúth láthair.[26]

[To that wardress of battle and fight and combat which he put about him belonged seven and twenty waxed, board-like, equally close skin-tunics (*cneslénti*, perhaps "tunics next to the skin" rather than "tunics of skin") which were girded by cords and swathings and ropes on his fair skin, to the end that his wit and reason might not become deranged when the violence of his nature came over him.][27]

This passage is found in a miscellaneous manuscript known as the *Book of the Dun Cow*, in a section written by a monk who was murdered by Vikings in 1106, so must be at least that old. Normally, a line from a poem which describes Cú Chulainn's warp spasms, scythed chariot pulled by armoured horses, and spell of invisibility for his horses and driver would be a matter for myth not history.[28] But a very similar phrase appears in another story, the *Chase of Sid na Mban Finn*:

7 is amlaid ro būi Finn 7 cotún clíabfairsing uimi ina rabatar secht ciarlēnti fichet ciartha clārtha comdlúta a n-imdítean a chuirp re congala ocus re comthógbāil chatha.

[And Finn was arrayed thus: he had a broad-chested cotún about him, in which were twenty-seven board-like, compact, waxed shirts (*ciarlēnti*) protecting his body against fights and the uprising of battle.][29]

This second story is harder to date; the editor guessed "thirteenth or fourteenth century."[30] It contains the Irish cognate of French *aketon*.

These two phrases are clearly related. Does the absence of the word *cotún* from the first imply that the word had not yet been borrowed into Irish in 1106, or does the second phrase help us understand the dreamlike language in the first? Cú Chulainn's oxhide battle-girdle to keep out spears also covers the same area as the iron breast-plate in the Norwegian *King's Mirror*, which I will discuss in a subsequent article. If the *Táin Bó Cúailnge* were written a hundred years later, it would be very tempting to say that Cú Chulainn's twenty-seven shirts and oxhide battle-girdle were inspired

26 Cecile O'Rahilly, ed., *Táin Bó Cúalnge from the Book of Leinster*, ed. (Dublin: Dublin Institute for Advanced Studies, 1967), 60, 61, digitized at https://celt.ucc.ie/published/ G301035 (accessed Aug. 20, 2023).

27 Translation from Joseph Dunn, *The Ancient Irish Epic Tale Táin Bó Cúalnge* (London: David Nutt, 1914), 188 (chap. 17b).

28 When enraged, Cú Chulainn undergoes a fearsome transformation called a warp spasm: his muscles and organs shift within his skin, one eye is withdrawn while the other bulges out, his hair stands up into fearsome spikes, and blood spurts from his forehead. In this state he kills everyone in sight. In recent times, heroes such as Goku and the Incredible Hulk also change their appearances and gain strange powers when enraged.

29 Text and translation from Kuno Meyer, *Fianaigecht: Being a Collection of Hitherto Inedited Irish Poems and Tales Relating to Finn and his Fiana* (Dublin: Hodges, Figgis, and Co., 1910; repr., London: Percy Lund Humphries and Co. Ltd., 1937), 72–73 (chap. 18).

30 Meyer, *Fianaigecht*, xxxi.

Sean Manning

by *aketons* stuffed with many layers of linen (sources iii.1–3) and *cuiries* (hardened leather defences for the chest).

Source i.6: The Caithréim Chellacháin Chaisil *(Ireland, 1127–34?)*
An Irish story records the deeds of King Chellacháin Chaisil of Munster (d. 954). Two passages describe armour. The first (from chapter 11) is about a battle between the hero and his men and an army of Norse (Lochlann).

> IS andsin ro eirghetar clanna Eogain gu crodha ciallmar curata ima caemri im Ceallachhan cum an chatha. Ocus do coraighhedh gu calma ag na curaduibh bro bhadhbha bithaluinn bhuanaicmheil bratac Ocus sonn sesmach sithremhar sleagh 7 tor tenn triathonchonta taisech 7 grinne gasda gadhamail gormlann 7 lonnbhuaile ladhach línanart uman laechraid. ár ni rabhutar gormait nait glanluirecha gu n-gasraid. acht mad inair cuanna coirtharblaithi 7 cotuin 7 muincedha maisecha mingresacha re diden corp 7 cnes 7 caeimcenn.

> [Then towards the battle arose the descendants of Eogan fiercely, prudently, bravely around their gentle king, around Cellachan. And there was arrayed bravely by the heroes an ever beautiful, very strong, fold (?) of battle, surrounded by standards, and a solid, very thick palisade of spears, and a strong, princely-ensigned tower of chiefs, and a skilful phalanx of blue blades, and a handsome (?), strong enclosure of linen cloth (*línanart*) around the heroes. For the heroes had neither blue helmets nor shining coats of mail (*glanluirecha* < Latin *loricae*), but only elegant tunics with smooth fringes, and *cotúns*, and beautiful, finely wrought collars to protect bodies, and necks, and gentle heads.][31]

Muince (pl. *muinceda*) are collars,[32] and *cotún* (pl. *cotúin*) seems to descend from the same Arabic word for "cotton" as French *aketon*.

In the second passage (from chapter 95), the army of some heroes of Munster confront armies from Leinster with its Norse minority rich in iron:

> Tancatar rompa iarsin gu cenn oirrtherach mhuighi na h Almhaine Orcus mar do bhadar annsin co bhfacadar na .V. catha coraighthi ar lar an muighi fo glere sciath 7 lann 7 luirech fo ghlere shleagh 7 chotun 7 cathbarr Orcus as e do bhi ann sin. Murchad mac Finn ri Laigen 7 a tri derbraithre .i. Donnchad 7 Find 7 Aedh […]

> [They proceeded forward to the eastern point of the plain of Almhuin. And as they were there, they saw five battalions drawn up in the middle of the plain with choice shields, and swords, and coats of mail (*luirech*), and with shining spears, and *cotúns* (*chotun*),

31 Text and translation from Alexander Bugge, *Caithreim Cellachain Caisil: The Victorious Career of Cellachan of Cashel* (Christiania [Oslo]: Gundersens Bogtrykkeri for Dot norske historiske kildeskriftfond, 1905), 6–7, 64 (chap. 11). Bugge followed a Latin-Irish gloss *cotún = parma* ("small shield") and translated it as "shield" or "target," but outside glossaries this word seems to mean "cotton" or "quilted coat."

32 eDIL 2019: Electronic Dictionary of the Irish Language, https://dil.ie, s.v. *muince* (accessed Aug. 18, 2023).

Linen Armour

and helmets. And he who was there was Murchadh, son of Finn, king of Leinster, and his three brothers, Donnchadh, Finn, and Aedh (… the list of kings and princes continues)][33]

This Irish work on the deeds of a tenth-century king of Munster may have been composed between 1127 and 1134, but the best manuscript was written around 1500 and had been aggressively edited by its scribes.[34] If the original contained these lines, it would be the first known text from the Frankish countries to use any form of the word *aketon*.[35] The detail about collars in chapter 11 does match descriptions and depictions of linen armour from the late twelfth and thirteenth century (e.g., source ii.1), but that does not mean that these lines date earlier than the late twelfth century.

Source i.7: John of Salisbury, Policraticus *(England, before 1159)*
The last early source does not describe quilted armour at all, but a different kind of non-metallic protection. John of Salisbury's treatise on statesmanship draws on classical literature, the Bible, and historical *exempla* from recent times. The following passage describes Harold Godwinson's war with the king of Gwynedd in 1062 and 1063.

> Anglorum recens narrat historia quod, cum Britones irruptione facta Angliam depopularentur, a piissimo rege Eadwardo ad eos expugnandos missus est dux Haroldus, uir quidem armis strenuus et laudibilium operum fulgens insignibus et qui tam suam quam suorum posset apud posteros gloriam dilatare nisi meritorum titulos, nequitiam patris imitans, perfide praesumpto regno decoloraret.

> Cum ergo gentis cognosceret leuitatem, quasi pari certamine militiam eligens expeditam, cum eis censuit congrediendum leuem exercens armaturam, peronatus incedens, fasciis pectus et praeduro tectus corio, missilibus eorum leua obiectans ancilia et in eos contorquens nunc spicula, nunc mucronem exerens, sic fugientium uestigiis inherebat ut premeretur "pede pes et cuspide cuspis" et umbo umbone repelleretur.[36]

> [The recent history of the English tells us that, when the Britons having invaded the country were ravaging England, the most pious King Edward (the Confessor) had sent Duke Harold to drive them out, a man truly active in arms and brilliant in signs of praiseworthy works, and who would have been able to extend the glory of himself and his followers among later generations, if only he had not stained his titles of merit, imitating the wickedness of his father, by seizing the kingdom by oathbreaking.

33 Text from Bugge, *Caithreim Cellachain Caisil*, 54, 114 (chap. 95). I have adapted his translation with reference to dictionaries and to Andrew J. Halpin, "Archery and Warfare in Medieval Ireland: A Historical and Archaeological Study" (Ph.D. diss., Trinity College Dublin, 1999), 40–42.

34 Bugge, *Caithreim Cellachain Caisil*, 57–60, argues for a date of composition between 1127 and 1134.

35 Walther von Wartburg et al., eds., *Französisches Etymologisches Wörterbuch*, 25 vols. (Leipzig: Teubner and Zbinden, 1928–2002), 19:100–102, s.v. *quṭun* just says "12. Jh." and I have not found any earlier examples of use.

36 Text from Clemens C. I. Webb, ed., *Ioannis Saresberiensis episcopi Carnotensis Policratici sive de nugis curialium et vestigiis philosophorum libri VIII*, 2 vols. (Oxford: Clarendon Press, 1909), 2:19 (book 6, chap. 6, par. 598c/d).

Sean Manning

When, therefore, he had come to know the instability of the nation, selecting a nimble part of the soldiery as if for an equal contest, with them he decided to train for a light-armed engagement, marching quickly in boots, and with the breast covered with bindings and hardened leather, opposing light shields to their missiles and at one time hurling darts at them, at another wielding the point of the sword, and sticking so close on the trail of the fugitives that "foot was pressed by foot and point by point"[37] and boss was beaten back with boss.]

"Bindings and hardened leather" which covered the breast were later known as a *cuirie* in French. Like the *Gesta Herwardi Saxonis* (source i.4), *Policraticus* puts this kind of armour in the eleventh century, a hundred years before vernacular texts mention it. John of Salisbury may have projected a practice from his time into the past, just as he drew classical and biblical texts into the present.

II. EPICS AND SAGAS, 1160–1200

Beginning around 1160, a range of Western European texts use words that definitely refer to quilted garments worn by soldiers.

Source ii.1: Wace's Roman de Rou *(Normandy, begun in 1160, abandoned ca. 1175)*
The *Roman de Rou* is an epic poem of the history of Normandy up to the Battle of Tinchebrai in 1106. In the following passage the Normans have readied themselves to fight the English at Hastings.

> Arme furent tuit le baron,
> Li cheualier a le gueldon. (7690)
> La gent a pie fu bien armee,
> Chascun porta arc e espee;
> Sor lor testes de fer chapels,
> A lor piez liez lor panels;
> Alquanz orent boenes coiriees,
> Qu'il ont a lor uentre liees;
> Plusors orent uestu gambais;
> Coiures orent ceinz et tarchais;
> Cheualiers ont haubers e branz,
> Chauces de fer, helmes luisanz, (7700)
> Escuz as cols, es meins lor lances,
> E tuit orent fair conoissances,
> Que Normant altre conuest,
> Qu'entrepresure n'i eust,
> Que Normant Normant n'oceist, (7705)
> Ne Normant altre ne ferist.

37 Webb (*Policratici*, 2:19) notes that here John of Salisbury borrowed a phrase from first-century Roman poet Statius (*Thebaid*, 8.399).

Linen Armour

[Armed was every baron,
The horseman had the guidon. (7690)
The folk on foot were well armed,
Everyone bore bow and sword;
On their heads iron *chapels* (caps),
On their feet lay their panels;
Some of them asked good *cuiries*,
Which were laid on their bellies;
More asked to wear a *gambais*;
Collars were donned and targes;
Horsemen had hauberks and brands,
Iron hose, brilliant helms (7700)
Shields at their necks, no less their lances
And all had made cognizances,
So that one Norman would know another,
So that there would not be strife between them,
So that Norman would not kill Norman, (7705)
Nor one Norman strike another.][38]

This short passage mentions *chapel de fer* (an iron headpiece like a broad-brimmed hat), *cuirie* (a leather defence for the chest), *gambeson* (*gambais*), and probably collar (if *coiures* > *cou* ["neck"] + -*ier* ["thing for the"] + -*es* [plural suffix]). It also associates the first three terms with the foot soldiers who used bow and sword while the horsemen wore iron mail and fought with sword and lance. Many sources (e.g., ii.6, ii.7, iii.3) present infantry as "early adopters" of this new armour and link *aketons*, *pourpoints*, and *gambesons* with *chapels de fer*. Texts from the fourteenth, fifteenth, and sixteenth centuries often mention soldiers wearing identifying marks called cognizances.[39] These could be as elaborate and individualistic as a coat with a heraldic device, or as simple and binary as a strip of coloured cloth.

Several other texts from the twelfth and thirteenth century distinguish between the *gambeson* and the collar (e.g., source i.6). Because most coats in this period were pulled on over the head and required relatively large neck openings, a separate collar may have been seen as the most practical way to protect the delicate, vulnerable neck. Opening the collar in the front would have created a weak spot over the fragile larynx.

38 Text from Hugo Andresen, ed., *Maistre Wace's Roman de Rou et des ducs de Normandie*, 3 parts in 2 vols. (Heilbronn: Verlag Gebr. Henninger, 1877–79), 2:334–35. There is a complete translation of the poem in Glyn S. Burgess, *The History of the Norman People: Wace's Roman de Rou* (Woodbridge, UK: Boydell, 2002), 177. While I refer the reader to other translations if I know them, the translation here is my own, as are all other translations from Greek, Latin, French, and High German in this article except for Ambroise (source iii.4).

39 *Middle English Dictionary*, s.v. *conissaunce* n.; *Dictionnaire du Moyen Français*, s.v. *connoissance*.

Sean Manning

Source ii.2: Aliscans *(France, 1165–90?)*
Aliscans, a *chanson de geste* in the Guillaume d'Orange cycle, survives in sixteen man-
uscripts. It describes a legendary battle between Christians and Saracens. In this scene,
Guillaume's relative Vivien has been merrily slaughtering heathens when Haucebiers
the Saracen becomes enraged:

> En sa main tint d'une lance un tronchon;
> Par tel aïr en jeta le baron, (375)
> Tot li desront son hauberc fremillon
> Et trespercha par mi son auketon, [variant: le gambison]
> Si ke par mi son vermeil ciglaton (377a)
> Li enbati el cors jusqu'au poumon.
> Viviëns chiet, ou il vausist ou non.[40]

> [In his hand he took the stump of a lance,
> With such spirit he thrust at the baron, (375)
> That it completely broke his glittering hauberk
> And pierced right through his *aketon* (variant: the *gambeson*)
> And through the middle of his vermillion *siglaton*
> It impaled the body up to the lung.
> Vivien fell, whether he deserved it or not.]

In another scene, a speaker describes how Guillaume was travelling in disguise:

> Uns haumes pent devant a son arćon,
> Derriere trosse son hauberc fremillon,
> Mais n'a entor forrel ne gambison.
> Blanc est la maille assés plus d'auketon
> Et s'en y a de rougue com carbon. (2340)
> Molt par sont grant andoi si esperon;
> Plus a la broce de .x. pans environ.
> Si a vestu un mauvais siglaton
> Et par deseur un hermin pelichon.
> Haut a le nes par deseur le gernon (2345)
> Et gros les bras, les poins quarrés en son,
> Ample viaire et ceveus a fuison;
> A grant mervelle resamble bien felon.[41]

> [A helm hung before at his saddle bow,
> Behind was bound his glittering hauberk,
> But around it was no case or *gambeson*.

40 Text from Erich Wienbeck, Wilhelm Hartnacke, and Paul Rasch, eds., *Aliscans: Kri-
tischer Text* (Halle, Germany: Max Niemeyer Verlag, 1903), 23 (laisse 13, lines 374–79).
There is a partial English translation in Joan Ferrante, trans., *Guillaume d'Orange: Four
Twelfth-Century Epics* (New York: Columbia University Press, 1974), and a complete Ger-
man translation in Fritz Peter Knapp, ed. and trans., *Aliscans: Das altfranzösische Helde-
nepos nach der venezianischen Fassung M* (Berlin: De Gruyter, 2013).
41 Wienbeck, Hartnacke, and Rasch, *Aliscans*, 139–40 (laisse 62, lines 2336–48).

Linen Armour

The mail was much more white than *aketon*
And there was also mail red like a garnet.[42] (2340)
Both of his spurs were very big,
The yoke was more than ten spans around (!).[43]
He had dressed in a bad *siglaton*
And above it a coat furred with ermine.
High was his nose above his moustache, (2345)
And thick were his arms, fists blocky at the end of them,
His hair was full and his locks were thick;
It was amazing what a ruffian he looked like.]

In the first passage, *aketon* and *siglaton* are garments made from cotton fabric and silk fabric. In the second, *aketon* is cotton fabric or fibre. Words often switch between the semantic spheres of "textiles" and "garments made from that textile" (e.g., denim, "type of cloth from Nîmes" > "type of trousers typically made from denim cloth").

Source ii.3: Benoit, Chronique des Ducs de Normandie *(Normandy, ca. 1172–76)*
Benoit's chronicle was an extremely ambitious vernacular work for its day: it fills three printed volumes. His verses are spotted with *aketons* and *cuiries* just as much as helms and hauberks. For the purposes of this article, I have selected a few useful passages.

Dunc vestirent les aucotuns
E les haubers desus, tresliz; (ii.3625)
Lacent les heaumes clers, burniz;
Ceignent les treschanz branz d'acer:
Hardi e coragus e fier,
En sunt venu al grant assaut.[44]

[And so they donned the *aketons*,
And the triple-woven hauberks on top, (ii.3625)
Laced the bright, burnished helms;
Girdled the cutting swords of steel:
Hardy and brave and fierce,
They have come to the great assault.]

Mult furent lié Costentineis;
Les haubers vestent demaneis
E lacent eaumes e quirées; (ii.11840)
Tost sunt lor gentz apareillées;

42 In this sentence, *carbon* seems to mean "gem bright as a hot coal" like English *carbuncle*.
43 Knapp, *Aliscans*, thinks that lines 2341 and 2342 in my text refer to the stirrups and the stirrup leathers, which would make more sense but does not match the text I am translating.
44 Text from Francisque Michel, ed., *Chronique des Ducs de Normandie par Benoit*, 3 vols. (Paris: Imprimerie Royale, 1836–44), 1:209 (book 2, lines 3624–29). This is equivalent to volume 1, page 170, of the edition by Carin Fahlin, *Chronique des Ducs de Normandie*, 4 vols. (Uppsala: Almqvist and Wiksells, 1951–79), based on a different manuscript and numbering the lines continuously across both books of the poem.

Sean Manning

E cum il i aient enor,
Del comandement lor seignor
Est desiros chascuns del faire;
Ne s'en voudra nul d'els retraire. (ii.11845)[45]

[The Cotentiners were very angry,
They immediately put on hauberks
And laced helms and *cuiries*. (ii.11840)
Soon their people were dressed,
And because they had good repute,
Each desired to do
The command of his lord,
Nor did anyone at all wish to retreat. (ii.11845)]

Del duc Richart qu'os pot l'on dire?
C'est des autres princes li sire
E des bons chevaliers la flor.
La nuit el grant palais autor, (ii.19185)
Quant sis osbers li fu ostez,
Qui en plusors leus ert fausez,
Remest en l'aucoton de seie
Qui en sanc e en suor glaceie;
Les mailes out el front enprientes. (ii.19190)[46]

[On Duke Richard what can you say?
He is the master of all the princes
And of good chevaliers the flower.
That night outside the great palace, (ii.19185)
When he was pulled out of his hauberk,
Which was broken in many places,
He remained in the *aketon* of silk.
Which was soaked in blood and sweat:
The rings were impressed on the front. (ii.19190)]

To my knowledge, Benoit does not use words in the *gambeson*, *pourpoint*, or *jupe* families and he does not describe the armour of infantry. This text clearly indicates that Richard's *aketon* was worn under his hauberk and that it prevented the rings of mail being driven into his flesh by powerful strikes. It also indicates that an *aketon* was not necessarily made of cotton cloth.

Source ii.4: Bertrand de Born, Lo coms m'a mandat e mogut *(Provence, ca. 1170–1200)*
Bertrand was one of the most famous Provençal troubadors, and his life is fairly well documented. One of his *sirventes* (songs in the voice of a current or would-be retainer) begins as follows:

45 *Chronique des Ducs*, ed. Michel, 1:491 (book 2, lines 11838–45) = ed. Fahlin, 1:405, 406.
46 *Chronique des Ducs*, ed. Michel, 2:131 (book 2, lines 19183–90) = ed. Fahlin, 1:614.

Linen Armour

> Lo coms m'a mandat e mogut
> Per n'Araimon Luc d'Esparo
> Q'ieu fassa per lui tal chansso
> On sion trencat mil escut,
> Elm et ausberc et alcoto,
> E perpoing falsat e romput.

> [The count has sent and moved me too,
> by Raymond-Luke of Esparron
> to write a song for him that can
> cut through a thousand shields for him,
> with helm, hauberk, and *aketon*,
> with *pourpoint* ripped and torn as well.][47]

This is a rare early mention of two types of quilted garment in the same sentence. Because it is a metaphor, we should be careful about assuming that the poet understood *aketons* and *pourpoints* as clearly distinct objects, or that the poet believed that warriors wore both at once.

Source ii.5: Thomas of Kent, Le Roman de Alexander / Le Roman de Toute Chevalerie *(England, ca. 1175–85)*
This verse romance about Alexander the Great was composed in the late twelfth century, but the five manuscripts contain additional material added as late as the early thirteenth century, and some have been "improved" by continental scribes who did not like Thomas' Anglo-Norman dialect. One couplet goes as follows:

> Il n'ad cely qui ne prenge son escu, (843)
> Son haubert e son gambeison e son espié molu[48]

> [There was nobody who had not taken up his shield, his hauberk and his *gambeson* and his milled sword (*molu* < Fr. *moudre* and Latin *molere*).]

This passage gives us a new spelling of *gambeson*, and implies that it is part of the standard equipment of an armoured soldier.

47 Text from William D. Padden, Jr., Tilde Sankovitch, and Patricia H. Stäblein, eds. and trans., *The Poems of the Troubadour Bertran de Born* (Los Angeles: University of California Press, 1986), 107. Translation adapted from James Donalson, *Poems of Bertrans de Born: A Virtual Book by Brindin Press*, https://web.archive.org/web/20110716171113/http://brindin.com/vb40cove.htm (accessed Aug. 11, 2023).

48 Brian Foster, ed. with the assistance of Ian Short, *The Anglo-Norman "Alexander": "Le Roman de toute Chevalerie" by Thomas of Kent*, 2 vols. (London: Anglo-Norman Text Society, 1976–77), 31 (lines 843, 844). For an affordable translation of Foster and Short's text into modern French, see Catherine Gaullier-Bougassas and Laurence Harf-Lancner, eds., *Le roman d'Alexandre, ou, Le roman de toute chevalerie* (Paris: Honoré Champion, 2003).

Sean Manning

Source ii.6: The Fuero *of Alfambra (Aragon, 1174–76)*
After being conquered by Aragon, the town of Alfambra in Iberia was granted market rights (*fuero* < Latin *forum*) including the following:

> Todo uezino de Alfamara que terna cauallo deue lo toner de .II. siellas en susso e deue tener armas escudo et lanza et capillo de fierro et perpunt et uala cauallo de .XXX. mazmodinas et con esto sea escusado de pecha.

> [All people living in the neighbourhood (*vezinos*) of Alfambra who hold horse ought *lo toner* of two saddles *en susso* and ought to hold arms: shield and lance and iron cap and *pourpoint* and the horse should be worth 30 *mazmodinas* (an Alamohad gold coin) and with this he shall be excused from scrounging a living.][49]

The *fuero* is in the name of count Rodrigo Gonzálvez, who took control of the town in 1174 and mentions its privileges in a document dated 3 September 1176.[50]

Source ii.7: Henry II's Assize of Arms (England, ca. 1181)
Roger of Howden (act. 1170–1201) preserved this law in his history of the reign of Henry II of England. It divides the free population into four categories, each with the duty to provide itself with certain arms and use them in his service. The clause dealing with the poorest category goes as follows:

> III. Item omnes burgenses et tota communa librorum hominum habeant wambais, et capellet ferri et lanceam.[51]

> [3rd: all burghers and the whole commons of free men shall have *gambais* and iron cap and lance.]

The annalist who preserved this law added that those with *gambeson* and iron cap should have "lance and sword, or bow and arrows" and that King Philip of France and Count Philip of Flanders heard of this law and proclaimed that their own subjects should do the same.[52]

49 Text from Manuel Albareda y Herrera and Juan Moneva y Puyol, eds., *Fuero de Alfambra* (Madrid: Rev. de Archivos, Bibliotecas y Museos, 1925), 36 (chap. 78). I have left untranslated some phrases which I do not understand.

50 Albareda y Herrera and Moneva y Puyol, *Fuero de Alfambra*, 10, 100, 101. This text is also discussed in Francho Nagore Lain, "Aspectos lingüísticos de la redacción romance de los fueros de Teruel y Albarracín en comparación con otros textos medievales en aragonés," in *Tiempo de Derecho foral en el sur aragonés: Los fueros del Teruel y Albarracín*, ed. J. A. Salas et al., 2 vols. (Zaragoza, Spain: Ediciones del Justicia de Aragón, 2007), 1:428–30.

51 Text after Nicholas Vincent, ed., "Assize of Arms (Ass Arms)," Early English Laws database, https://earlyenglishlaws.ac.uk/law/texts/ass-arms (accessed Aug. 13, 2023). The *editio princeps* was in William Stubbs, ed., *Select Charters and Other Illustrations of English Constitutional History* (Oxford: Clarendon Press, 1870).

52 William Stubbs, ed., *Gesta Regis Henrici Secundi Benedicti Abbatis: The Chronicle of the Reigns of Henry II and Richard I, A.D. 1169–1192*, 2 vols. (London: Longmans, Green, Reader, and Dyer, 1867), 1:270.

Linen Armour

The Assize of Arms and the *fuero* of Alfambra are very valuable, because they describe the equipment of ordinary foot soldiers in a period when artwork, romances, and chronicles focus on rich horsemen.[53]

Source ii.8: Chrétien de Troyes' Perceval *(France, ca. 1182–90)*
In this very influential romance, the Red Knight gets into a quarrel with a youth who kills him with one blow of a lance. The poet has great fun describing how the yokel does not know how to remove the knight's equipment, including:

> Une cote molt aesie, (1155)
> De drap de soie gambesie,
> Que desoz son hauberc vestoit
> Li chevaliers quant vis estoit.[54]
>
> [A very comfortable coat (1155)
> Of gamboised cloth of silk,
> Which under his hauberk
> The knight had put on while he still lived.][55]

Source ii.9: The First Continuation of Chrétien de Troyes' Perceval *(France, ca. 1190–1210)*
After Chrétien de Troyes died with a popular work incomplete, some of his admirers continued the story. The earliest continuation to his *Perceval* has several passages mentioning *gambesons* and *aketons*.

> Dessus l'un fist metre sa selle
> De ses armes fresche et novelle,
> Bons iert et toz noirs par nature;
> N'i mistrent autre coverture. (1020)
> Lors fist metre devant un lit
> Une grande coute de samit,
> Puis a ses armes demandees.
> Cil cui[i] il les ot conmandees (1024)
> Li aporterent maintenant.

53 We will meet infantry with just a *gambeson* and iron cap again in Joinville and Villehardouin in the second of my three planned articles on this subject.

54 Text from Alfons Hilka, ed., *Christian von Troyes: Der Percevalroman (Li Contes del Graal)* (Halle, Germany: Max Niermeyer Verlag, 1932).

55 This seems to be the oldest surviving use of an adjective derived from *gambais* (cf. source ii.10 and the profession in source i.3). By roughly 1180, French speakers thought of garments and textiles which had been made like *gambesons*. Sir Samuel Rush Meyrick created the English form "gamboised" in 1821 and it has been used in armour scholarship ever since. Samuel Rush Meyrick, "Observation on the Antient (sic) Military Garments Formerly Worn in England," *Archaeologia* 19 (1821): 215, 216; Claude Blair, *European Armour Circa 1066 to Circa 1700* (London: B. T. Batsford Ltd., 1958), 34, 35; Ralph Moffat, *Medieval Arms and Armour, a Sourcebook: Volume I: The Fourteenth Century* (Woodbridge, UK: Boydell & Brewer, 2022), 246.

Sean Manning

Dui vallez bel et avenant
Li lacerent ses genoillieres,
Chauces de fer forz et legieres (1028)
Li lacent cil a cercle d'or,
Uns esperons tranchanz a or
Li lacent par desus aprés,
Puis li font vestir un gambés (1032)
De soie et de coton porpoint.
Aprés ce n'i demore point,
Ainz li ont un haubert vestu
Si fort qu'il ne crient un festu (1036)
Cop d'espee ne cop de lance.
Et aprés ce sanz demorance
Li laça Tristenz la vantaille,
Li niés lou roi de Couruaille, (1040)
Icil qui por Yseut la blonde
Ot tant d'anui et tant de honte.
Un hiaume li metent anson
Qui fu de l'uevre Salemon. (1044)
Puis li ont une espee çainte
Qu'il n'a ou monde fame anceinte,
S'elle an fust sor le chief ferue
Dou plait de celle espee nue, (1048)
Que maintenant ne fust delivre,
Se respasser deüst ou vivre.

[He had one of them saddled
With a tidy new saddle from his arms,
It was good and all black in colour,
So it did not need any other *coverture*. (1020)
Then he had put before a bed
A great cover of samite,
Then called for his arms.
Those who he had commanded (1024)
Brought them immediately.
Two good valets came,
They laced his knee-pieces
Hose of iron strong and light (1028)
They laced, which had a circle of gold.
A pair of sharp spurs in gold
They laced on top afterwards,
Then he was dressed in a *gambais* (1032)
Of silk and of cotton quilted.
After that they did not stop,
But dressed him in a hauberk
So strong that he would fear no gap (1036)
From blow of sword nor blow of lance.
And after that without delay,

Linen Armour

Tristan laced his ventail,[56]
The nephew of the king of Cornwall, (1040)
The one who for Iseult the fair
Suffered such pain and such dishonour.
A helm they also put
Which was the work of Solomon.[57] (1044)
Then they girdled a sword
Such that in all the world there was no woman in labour,
Who when struck on the head
With the flat of that naked sword (1048)
Would not immediately give birth,
As she hung between death and life.][58]

His opponent Guiromelant stands "on a tidy new drapery of new vermillion quilted samite" ("Sor une cote fresche et cointe / de fres samit vermoil porpoi[n]te") while he is dressed in iron hose and spurs, then in "a *pourpoint* of *aketon*, which had been brought from Venice, with lion cubs all over it" ("Vesti un porpoin[t] d'auqueton / A lionciaus tot anviron; / Aportez li fu de Venice"), and finally a hauberk.[59]

In another incident, Gawain encounters a knight sitting under a pine tree wearing an *aketon* of purple (*un auqueton de porpre avoit*).[60] He refuses to speak, and is not wearing his sword. In a third scene, Gawain gets up, washes his face, feet, and hands, and dresses for a joust in "a rich *pourpoint* of cotton / banded with purple and with samite" ("Un riche porpoint de coton, / De porpre et de samit bandé").[61] He then puts on his arms, the sword Excalibur, and so on. In a fourth passage, King Arthur examines a mysterious corpse wearing "an *aketon* / of samite and of *siglaton* / *miparti* by the middle" (i.e., the left half was covered in one fabric and the right with the other) ("Qui ot vestu un auqueton / De samit et de siglaton / Parmi le mileu miparti") and iron hose with golden spurs.[62] Arthur makes a comment about how well the dead man's *gambesons* (*li ganbesons*) fit him.

56 The ventail (*vantaille*) is the part of a hood of mail which covered the cheeks and chin.

57 *Aliscans* mentions a saddle that was the work of Solomon; Wienbeck, Hartnacke, and Rasch, *Aliscans*, line 2335. Knapp, in his translation of *Aliscans* (127), suggests that this is a technical term for a way of decorating gold, ivory, and marble. Nigel Bryant prefers "fit for king Solomon"; Nigel Bryant, trans., *Chrétien de Troyes, The Complete Story of the Grail: Chrétien de Troyes' Perceval and its Continuations* (Cambridge: D. S. Brewer, 2015), 87.

58 Text after William Roach and Robert H. Ivy, Jr., eds., *The Continuations of the Old French Perceval of Chrétien de Troyes*, vol. 2, *The First Continuation: Redaction of MSS EMQU* (Philadelphia: University of Pennsylvania, 1950), 32–33, 485–86, 548–49. There are complete translations of the continuation in Ross G. Arthur, trans., *Three Arthurian Romances: Poems from Medieval France* (London: Dent, 1996), and Bryant, *Complete Story*; my translation is influenced by this one, especially in the last five lines.

59 Roach and Ivy, *Continuations*, 35, 36 (lines 1148, 1149, 1161–63).

60 Roach and Ivy, *Continuations*, 476 (line 15863); cf. Bryant, *Complete Story*, 203.

61 Roach and Ivy, *Continuations*, 485, 486 (lines 16168–70); cf. Bryant, *Complete Story*, 206.

62 Roach and Ivy, *Continuations*, 548 (lines 18465–67). For the context, see Bryant, *Complete Story*, 225.

Sean Manning

Because the First Continuation uses three families of words, we can see that the poet could describe the same garment as either *pourpoint* or *aketon* or *gambeson*. By themselves these words had other meanings: *pourpoint* meant "stitched-through," and *aketon* was a fabric associated with the Arab world (presumably one containing cotton). But all three words could describe a quilted garment worn over the shirt and under the hauberk, and King Arthur could call a garment a *gambeson* which the narrator called an *aketon*.

Source ii.10: Gui de Nanteuil *(unknown, ca. 1175–1225)*
This little-known *chanson de geste* mentions men dressed in *une coute pourpointe d'auqueton* (a quilted coat of *aketon*) and *une coute pourpointe*.[63] The men are not described as wearing iron protection. Similar phrases such as *cote gamboisée* show up in Chrètien de Troyes (source ii.8) and later French texts such as the rule of the armourers of Paris from 1311.[64]

Source ii.11: Herbort von Fritslar's Liet von Troye *(Hessia, ca. 1190–1200)*
Herbort von Fritslar wrote an epic about the Trojan War. In this scene, Achean and Trojan forces are locked in combat.

> Mit zorngeme mvte
> Reit agomennon (9015)
> Vnd tydeus son
> Diomedes der kvne
> Schilde rot grune
> Vō golde vō lasure
> Rosse kouerture (9020)
> Die halsberge wisse
> Hiwen sie mit fliss
> Durch den helm vnz an den loc
> Wambois wappē roc
> Man ros vn phert (9025)
> Die vinde wichē hinderwert
> Unz an den burck haugē […][65]
>
> [With wrathful might
> Rode Agamemnon (9015)
> And Tydeus' son
> Diomedes the keen;

63 Paul Meyer, ed., *Gui de Nanteuil, chanson de geste: Pub. pour la première fois d'après les deux manuscrits de Montpellier et Venise* (Paris: F. Vieweg, 1861), 17, lines 502–32, and 22, lines 660–91. There are newer editions by James R. McCormack (Geneva: Droz, 1970), and Nathalie Desgrugillers-Billard, 2 vols. (Clermont-Ferrand, France: Paleo, 2009).
64 Lespinasse and Bonnardot, *Les métiers*, 3:319, items 1, 4.
65 Text from Georg Karl Frommann, ed., *Herbort's von Fritslar liet von Troye* (Quedlinburg und Leipzig: Gottfried. Basse, 1837), 103–4.

Linen Armour

> Shields red green
> Of gold of lacquer,
> Horse *covertures*, (9020)
> The hauberks white
> They hewed vigorously
> Through the helm and on the hole
> *Gambeson*, coat of arms,
> Man horse and steed (9025)
> The enemy fall back,
> Until the castle fence (…)][66]

Both the Old Norwegian *King's Mirror*[67] and the rules of the Paris guilds from 1296 onwards[68] mention *covertures* for horses that were quilted like a *gambeson* or *aketon* (the *coopertoria* in the rules of the *jupe*-makers of Venice from 1219 could be for beds or for horses).[69] I will discuss these in subsequent articles. Similar horse armours were still used for parades in Sudan in the late twentieth century, and a few ended up in Europe after the battle of Omdurman in 1898. It is possible that Herbort meant the quilted kind of *coverture*.

Source ii.12: Ulrich von Zatzikhoven, Lanzelet *(Switzerland or Austria, sometime after 1193)*

Ulrich von Zatzikhoven wrote an Arthurian story inspired, he claimed, by "a welsh book [i.e., a romance] of Lancelot" ("daz welsche buoch von Lanzelete")[70] which belonged to a certain Hugh de Morville, who travelled to Austria to serve as hostage for Richard the Lionheart. (It is possible that this is the same man who stood guard at the murder of Thomas Becket.) In this scene, Lancelot pursues five knights who have been robbing and burning near the castle where he is a guest:

> fürbaz kundet uns das lied.
> ir geverte was ze roube guot:
> Schilt, banier, îsenhuot. (3810)
> cleiniu wambas, snelliu ros,
> daz si berc unde mos
> deste schiere möhten überkomen,
> diz moht in allez niht gevromen;
> er entworhtes alle gelîche. (3815)

66 My working hypothesis is that *vinde* is related to *Feind* ("enemy") or *vende* ("footman"), *wichen* is *weichen* ("to yield, move back"), and *haugen* is *hagen* ("hedge, stockade").

67 Unger, Munch, and Keyser, *Speculum regale*, 87 (chap. 38); translated as "shabrack" in Larson, *King's Mirror*, 218.

68 Lespinasse and Bonnardot, *Les métiers*, 3:318, item 10; 3:321, items 9, 10; 3:211, items 9, 12.

69 The Latin rule of the *jupe*-makers of Venice was printed in Monticolo, *I capitolari*, 23–54.

70 Ulrich von Zatzikhoven, *Lanzelet*, ed. W. Spiewok (Greifswald, Germany: Reineke-Verlag, 1997), line 9341. He is probably the same person as a lay priest who witnessed a document at St. Peterzell in Switzerland in March 1214.

Sean Manning

> [Furthermore, the poem tells us
> That they were armed as was good for robbing,
> Shield, banner, iron hat, (3810)
> little *gambeson*, fast horse,
> so that they could more quickly cross
> mountain and moor.
> These could not help them at all,
> He destroyed them all alike. (3815)][71]

By the end of the twelfth century, it seems that some wealthy warriors were choosing to wear an iron cap and a *gambeson* rather than heavier armour which restricted their sight, hearing, and breathing or was slower to put on and off. If they found themselves in intense close-ranged combat, lacking a full armour could be very dangerous. From this time until the early seventeenth century, well-equipped European warriors valued the ability to choose different balances of weight, protection, and freedom of sight and breathing by adding, removing, or substituting parts of their armour.

Source ii.13: Athis et Prophilias *(west France, ca. 1200)*
In this romance with a classical setting, one vassal was dressed:

> En un jupel cort d'auqueton, (18497)
> Porpoint et forré de coton,
> Remest sengles, bien fu tailiez.[72]

> [In a short *jupel* of *aketon*, (18497)
> Quilted and stuffed with cotton,
> Re-put once, well was it cut.]

Remettre ("to put back, put again, put twice") is a difficult word in this context, but quilted garments made twice (*faites à deux fois*) and made once (*faites à une fois*) also appear in the rules of the armourers of Paris from 1296 and the rule of the *pourpointiers* of Paris from 1382.[73] *Jupel* relates to *jupe* ("a type of garment for the upper body") as *chapel* relates to *chape* ("cap") and is the French cognate of Italian *zuparello/juparello/giuparello*. As discussed above, many *jupes* and *jupels* are said to be furred, made of

71 Text from Ulrich von Zatzikoven, *Lanzelet*. My translation of lines other than 3810 and 3811 is influenced by Ulrich von Zatzikhoven, *German Romance IV: Lanzelet*, ed. and trans. Kathleen J. Meyer (Cambridge: D. S. Brewer, 2011). There is another English translation of this charming poem in Ulrich von Zatzikhoven, *Lanzelet: A Romance of Lancelot*, trans. Kenneth G. T. Webster, ann. Roger Sherman Loomis (New York: Columbia University Press, 1951).

72 Text from Alfons Hilka, *Li Romanz d'Athis et Prophilias (L'histoire d'Athenes)*, 2 vols. (Dresden, Germany: Gesellschaft für romanische Literatur, 1916), 2:343.

73 These were printed in George Bernard Depping, ed., *Réglemens sur les arts et métiers de Paris rédigés au XIIIe siècle et connus sous le nom du Livre des métiers d'Etienne Boileau* (Paris: Crapelet, 1837), 370–73, and Lespinasse and Bonnardot, *Les métiers*, 3:210–13. Benoit (source ii.3) uses *remettre* in the sense of "to keep on, to put back on."

Linen Armour

fulled cloth, or have other features which would be unusual in a quilted garment (while *jupons* are usually quilted; see note 4, above). This is the oldest clear reference to a quilted *jupe*, *jupel*, or *jupon* which I have read, if the printed text is correct (some manuscripts say *corset* or *sorcot* instead of *jupel*; see also source ii.16).

Like *Aliscans* and *Gui de Nanteuil* (sources ii.2 and ii.10), *Athis et Prophilias* thinks of *aketon* as a type of fabric rather than a type of garment.

Another arming scene in this poem is worth quoting:

> Levez se fu Pirithöus,
> Mout sa hasta Cassidorus.
> Si se vestirent et chaucierent,
> Come les armes le requirent.
> Un gambés ot chascuns vestu (15085)
> d'un samit vert, porpoint menu.
> D'armes baillier s'aparellierent:
> Chauces de fers premiers lacierent
> Et puis les blans haubers vestirent,
> Dessus se ceinstrent et cousirent, (15090)
> Et riches cotes a armer
> D'un siclaton d'outre la mer
> A laz de soie tot entor;
> Ne senblent mie vavasor
> Qui sont mëu por corre a proie […] (15095)[74]

> [Pirithöus got up,
> Cassidorus quickened his movement.
> They dressed and hosed themselves,
> As the arms required.
> Each had put on a *gambais* (15085)
> of green samite, finely quilted.
> They had prepared themselves to bear arms:
> first they laced on hose of iron
> And then dressed in white hauberks,
> above they girdled and laced themselves, (15090)
> And rich arming coats,
> of a *siglaton* of outremer,
> With laces of silk all around;
> They did not look like mere vassals
> Who are moved to chase after game (…)] (15095)

Gambés seems to be one spelling of *gambais* rather than *jambes* ("legs, greaves"). Did the poet see the *gambais* as "arms" or clothing? Line 16338 of this poem also mentions *covertures* alongside rich armours, double hauberks, and shining helms. As in *Liet von Troye* (source ii.11), these could be quilted, but that is hard to prove.

74 Text from Alfons Hilka, *Li Romanz d'Athis et Prophilias (L'histoire d'Athenes)*, 2 vols. (Dresden, Germany: Gesellschaft für romanische Literatur, 1916), 2:221.

Source ii.14: King Sverri's Saga *(Norway, describes events up to 1202, finished slightly later)*
King Sverri Sigurdsson of Norway (r. 1177–1202) sponsored a King's Saga about his deeds. Towards the end of his life he was confronted by rebel farmers near Oslo, and the Saga describes him as follows:

> konungr sat a brúnum hesti hann hafði goða bryniu ok styrkan panzara vmb utan ok yzstan rauðan hiúp viða stalhufu sua sem Suðr menn hafa ok yndir brynkollu ok panzara hufu sverþ a hlið ok kesiu i hendí

> [The king sat on a brown horse. He had a good hauberk and a strong *panzar* above it and outmost a red *jupe* (*hiup*), a wide steel cap like the southern men (i.e., Germans) had, and beneath it a mail coif (*brynkollu*) and *panzar* coif (*panzara hufu*), sword at his side and *kesiu* (a type of spear) in his hands.][75]

The mid-thirteenth-century Norwegian *King's Mirror* makes it clear that in thirteenth-century Norway, a *panzari* was a kind of quilted garment, although cognates of this word can also mean "shirt of mail."[76]

As we saw with *Athis et Prophilias*, words in the *jupe* family are difficult to understand, and specialists in different languages and periods interpret them differently. It seems likely that King Sverri's *hiup* (feminine) was a "Saracen-style" surcoat rather than a quilted garment: in Old Norse, the usual words for quilted garments are *panzar* and *troya*.

Elsewhere in the king's saga, there is a battle at sea:

> Sa maðr var aptr a scipi Hallvarðar. er hafði stal-hufo oc panzara oc hvartveGia a garzcu. þesi maðr hafdi fengit slag af sceptiflettu snimma oRostunnar. sva at nefit var mioc sacat oc lamit. en er scipit var mioc hroðit var hann upp comiN a viðuna hia siglunni.

> [In the after part of Hallvard's ship there was a handsome man, who wore a steel cap and a *panzar*, both of Gautish make. Early in the fight he had been struck with a javelin that had sorely wounded and fractured his nose, and when the ship was well-nigh cleared he had gone on the high deck beside the mast.][77]

Broad-brimmed iron caps provided good vision and breathing, but they did not protect the face as well from rising blows as did other kinds of headpiece.

Source ii.15: The Roman de Waldef *(England, ca. 1190–1210)*
This French romance from England has a verse that lists hauberk, shield, *pourpoint*, and helm ("Ne fort halberc ne fort escu, / Ne purpuint ne nul healme agu / Ne vus purroit

75 Text from Finnur Jónsson, ed., *Eirspennill—Am 47 fol—Nóregs konunga sǫgur: Magnús góði—Hákon gamli* (Kristiania [Oslo]: Trykt i Julius Themtes Boktrykkeri, 1916), 419 (chap. 180). Translation by Håvard Kongsrud. There are substantial differences in text and numeration between different editions of this saga.

76 See "Terms discussed," page 2.

77 Text from Gustav Indrebø, ed., *Sverris saga etter Cod. AM 327 4°* (Kristiania [Oslo]: I hovedkommission hos J. Dybwad, 1920), 168–69 (chap. 121/159). Translation adapted from John Stepton, ed., *Sverrissaga: The Saga of King Sverri of Norway* (London: David Nutt, 1899), 202.

Linen Armour

certes valoir"). This confirms that the word *pourpoint* was used for a military garment in England by circa 1200. Sources at this date are difficult to divide into "Continental" and "British," but *Waldef* is about East Anglia before the Norman Conquest.[78]

Source ii.16: Annales Ianuenses *(year 1165, author was active until 1173)*
In 1165 relations between Genoa and Pisa were as unfriendly as ever. There were disputes about trade in pepper and cotton and other merchandise.[79] One day, a Pisan galley ambushed the galley of a certain Trepedecino outside Porto Venere in Liguria where the consuls of Pisa and Genoa were talking. As the Genoese chronicle tells us, Trepedecino called to the shore for help, and the Genoese consul complained to his Pisan counterpart:

> Quid vultis faciamus? Videtis galeam vestram, que venit manu armata contra meam. Ite, si placet, ad eam, et venite ad insulam vel ad discum sicut amici, et emat hic tamquam galea nostra. Et statim consul Pisanus ivit cum butio et ascendit galeam, et posuit in capite elmum et iuppum in dorso, veniens contra nostram.[80]

> ["What do you want us to do? You see your galley, which comes with an armed band against mine. Go, if you please, and come to an island or a *discus*[81] as friends, but whatever you do let this galley of ours pass." And right away the Pisan consul went with his hawk and boarded a galley, and placed a helm on his head and a *jupon* on his back, coming against our galley.]

The Genoese consul joined in and captured the Pisan galley with their consul and 32 of the better sort of Pisans. This was the beginning of decades of wars between Pisa and Genoa. This part of the *Genoese Annals* was written by chancellor Obertus who ceased writing in 1173 and disappears from the city records at about that time.[82] This *ioppus* (masculine) is probably a quilted coat like the later Italian *zuparelli*.

By the end of the twelfth century, linen armour called *aketon, gambais, gambeson, panzari, pourpoint*, and probably *jupel* is recorded in northern France and England. While sources from Northern France and England are plentiful, only single sources are known from Scandinavia (source ii.14), Italy (ii.16), Provence (ii.4), and Christian Spain (ii.6). The two sources from beyond the Rhine are both romances (sources ii.11, ii.12).

78 Anthony J. Holden, ed., *Le Roman de Waldef (Cod. Bodmer 168)* (Cologny-Geneva: Fondation Martin Bodmer, 1984), line 22274, as cited in Rothwell, *Anglo-Norman Dictionary*, s.v. *pourpoint*. A translation has been published as Ivana Djordjević, Nicole Clifton, and Judith Weiss, trans., *Waldef: A French Romance from Medieval England* (Leeds, UK: Arc Humanities Press, 2020).
79 George Henry Pertz, ed., *Monumenta Germaniae Historica: Scriptorum*, vol. 18 (Hanover, Germany: Hahn, 1863), 63, line 24: "Piper et bombacium aliasque merces."
80 Text from Pertz, *Scriptorum* 18:65, lines 8–11.
81 I am uncertain of the meaning of this word in this context.
82 Pertz, *Scriptorum* 18:3, 4; for a more recent discussion, see Michael McCormick, "Annales Ianuenses," in *The Oxford Dictionary of Byzantium*, ed. Alexander Kazhdan (Oxford: Oxford University Press, 1991).

Sean Manning

III. THE THIRD CRUSADE

The fall of the Latin Kingdom of Jerusalem in 1187 and the Third Crusade (1189–92) inspired many writers to compose detailed descriptions of the equipment of soldiers. In fact, we have descriptions of Frankish armour through East Roman and Muslim eyes as well as their own writers.

Source iii.1: Nicetas Choniates (a.k.a. Acominatus, after 1207)
Men from all over Europe flocked to the crusade, and one was Conrad of Montferrat who had been fighting for the emperor of Constantinople in 1187. A contemporary East Roman writer describes his deeds in that year as part of a larger history.

> Αὐτὸς μέντοι ἄνευ θυρεοῦ τηνικαῦτα διηγωίζε, ἐκ δὲ λίνου πεποιημένου οἴνῳ αὐστηρῷ ἱκανῶς ἡλισμένῳ διάβροχον πολλάκις περιπτυχθὲν δίκην θώρακος ἐνδύετο· ἐς τοσοῦτον δ'ἦν ἀντιτυπὲς ἁλσὶ καὶ οἴνῳ συμπιληθὲν ὡς καὶ βέλους εἶναι παντὸς στεγανώτερον· ἠριθμοῦντο δ'εἰς ὀκτωκαίδεκα καὶ πλείω τὰ τοῦ ὑφάσματος συμπτύγματα·

> [Conrad himself was fighting without a shield, but instead of body armour he was wearing a certain textile, made from linen, macerated in sour wine well salted, folded (or layered) many times, which after having been fulled with the salt and wine was so resistant to blows that it could not be penetrated by any weapon. There were eighteen or more layers (or folds) of this textile.][83]

Conrad's relationship with the emperor turned for the worse, and he headed east, helped to take Acre, was elected king of Jerusalem, and died at the hands of two Assassins while returning from a feast. The detail about salt and wine seems to be unique to this text, although it has inspired 400 years of speculation about the construction of ancient linen armour.[84]

Source iii.2: Radulfus Niger, De re militari et triplici via peregrinationis Ierosolimitane *(1187 or 1188)*
Radulfus Niger, a cleric who divided his life between England and France, looked on the preparations for an armed pilgrimage and was not sure that they would bring the expected spiritual or military rewards. His treatise began harmlessly enough with a discourse on the knight's equipment as an allegory, but as the argument developed he made it clear that crusaders would have to live a strictly disciplined life if they hoped to be rewarded by God. In his view, crusaders who brought along a mob of the wrong sort of people would fall into sin and be defeated by the Turks, and crusaders

83 Greek text from Sylvia Törnkvist, "Note on Linen Corselets," *Opusculata Romana* VII.6 (1969): 81, 82. My translation has previously appeared in Sean Manning, "A History of the Idea of Glued Linen Armour," *Mouseion* 17, no. 3 (2020): 492–514. There is a full translation of Choniates' annals in Harry J. Magoulias, trans., *O City of Byzantium: Annals of Niketas Choniates (1140–1213)* (Detroit, MI: Wayne State University Press, 1984).
84 Manning, "Glued Linen Armour."

Linen Armour

who made a bodily but not a spiritual voyage would never win spiritual rewards. His treatise was addressed to the chivalry and he seems to have tried hard to speak to current knightly fashions.

Liber I Capitulum XIX: De multiploi linea et corio cocto

Ad vitalium quoque custodiam multiplois linea varie consuta lorice superponitur et subinduitur aut corium excoctum. Per lineam predictam industria significatur, que multo labore perquirtur, sicut linum multo labore candidatur et conficitur. Per hanc industriam venialium evitatur contagio, per corium excoctum inveterata boni consuetudo intelligitur, que otia repellit et occasiones venialium.[85]

[Book 1, Chapter 19: On many-layered[86] linen and boiled leather

Also, for the protection of the vitals many-layered linen sewed together many times is put atop the hauberk and boiled leather is worn underneath. By the aforesaid linen industry is indicated, which is acquired[87] by much work, just as flax is whitened and put together with much work. By this work the infection of venial sins is avoided, by boiled leather the ingrained habit of good is understood, which drives away idleness and opportunities for venial sins.]

Liber I capitulum XXXV: De direptione multiplois [linee] et corii cocti et geniculariorum et corrigiarum[88]

Multiplois linea, que loricam defendit et missilia eludit, ab homine tollitur, quando morum custodia infatuatur. Corium etiam excoctum, quod vitalia protegit et custodit, rumpitur aut tollitur, quando boni consuetudo vetus in contrariam commutatur. Scinditur, cum vetus consuetudo boni interrumpitur et eius loco noxia vel turpis occupatio admittitur. Genicularia vero, quibus femora et ilia proteguntur, rumpuntur aut evelluntur, quando custodia castitatis et continentie irruente luxuria fedatur et spurcitie carnis homo mancipatur. Corrigie et laquei, quibus mores et virtutes sibi coherent, ab invicem laxantur, ut ad noxiam libertatem licentie secularis acephalus et ab omne lege solutus homo transvolaverit.[89]

[Book 1, Chapter 35: On the division of many-layered (linen) and boiled leather and *geniculariorum* and straps.

Many-layered linen, which defends the hauberk and defeats missiles, is worn by a man, whenever he is infatuated by protection of customs. Boiled leather, which protects and

85 Latin text from Radulfus Niger, *De re militari et Triplici Via Peregrinationis Ierosolimitane (1187/1188)*, ed. Ludwig Schmugge (Berlin: Walter de Gruyter, 1977), 107 (book 1, chap. 19).

86 I assume *multiplois* is equivalent to Classical Latin *multiplex* and Old French *multiplies*.

87 Charles du Fresne du Cange et al., eds., *Glossarium Mediae et Infimae Latinitas*, vol. 6 (Niort, France: Léopold Favre, 1883–87) lists *perquirere* as a synonym for *acquirere* in English legal Latin.

88 *Linee* is missing from both manuscripts of this text. *Direptione* may be a form of *diremptio* ("separation").

89 Niger, *De re militari*, 114 (book 1, chap. 35).

guards the vitals, is also worn, whenever the habit of goodness turns the old into its contrary. This can be seen when old custom of good is broken and in its place harm or base occupation is admitted. *Genicularia* also, by which the hips and thighs are protected, are broken or torn away whenever preservation of chastity and continence are spoiled by embrace of sensual pleasure (*luxuria*), and someone is given over to the filthiness (*spurcitie < spurcus*) of flesh. Straps and laces, by which habits and virtues stick together, are loosened by each other, so that leaderless (*acephalus*) the man released from all law flies to embrace the liberty of secular license, to his harm.]

Radulphus' *genicularia* seem to be cuisses (thigh protection), even though strictly speaking *genicularia* are pieces for the knee (French *genou*). Perhaps he had not studied this word as well as he learned other knightly vocabulary.

The custom of wearing hard armour under mail can be seen in the Maciejowski Bible (New York, Morgan Library, MS 638, fols. 3, 10, 11, etc.), where some knights have pushed back their mail coifs revealing an iron skullcap (French *cervellière*) underneath. Radulfus describes a *cuirie* worn in this way, while Guillaume le Breton describes a "plate of forged and tempered iron" worn on the breast under the hauberk in the third book of his *Philippidos*.[90] That story is set in the twelfth century, but written in the thirteenth, so it will be discussed in the second of my planned articles on this subject.

Source iii.3: Itinerarium Peregrinorum et Gesta Regis Ricardi *(set in 1191 but written a few years later)*
After the fall of Jerusalem in October 1187, fighting concentrated on the port of Acre, which the Franks besieged and Saladin's forces defended. The following account, almost certainly written by someone who had been present in the English camp, describes a crusader who approached the enemy too closely.

> Armatus quidem erat more peditum satis competenter, ferreo tegmine capite munito; lorica quoque, tunica etiam linea multiplici consuta, lineis interioribus difficile pene-trandis, acu operante artificialiter implicitis; unde et vulgo perpunctum nuncupatur.[91]

> [He was armed well enough for a footman, with his head fortified with an iron covering, a hauberk as well, and also a linen tunic sewn together in many folds, difficult to penetrate because of the linen interior, skilfully joined by needlework, whence it is called *pourpoint* (Latin *perpunctum*, "stitched-through") in the vernacular.]

A Turk shot him from the wall and penetrated all of his linen and iron defences, but not a scroll with the name of God which he wore about his neck.

A beloved folk etymology explains *pourpoint* as "for points (i.e. laces)" but both this source and Guillaume de Deguilevile's *Pèlerinage de la vie humaine* (1330–32) dis-

90 Henri-François Delaborde, ed., *Oeuvres de Rigord et de Guillaume le Breton, Historiens de Philippe-Auguste*, vol. 2 (Paris: Librairie Renouard for the Société de l'Histoire de France, 1885), 83, lines 496–98.

91 Latin text from William Stubbs, ed., *Chronicles and Memorials of the Reign of Richard I*, vol. 1, *Itinerarium Peregrinorum et Gesta Regis Ricardi* (London: Longman, 1864), 99 (book 1, chap. 48).

Linen Armour

agree.[92] Tasha Dandelion Kelly has worked to spread awareness of the true etymology in lectures and online discussions.[93]

Source iii.4: Ambroise, History of the Holy War *(set in 1191, written 1194–97)*
Ambroise was a Norman poet who strongly sympathized with Richard of England. He tells some of the same stories as the *Itinerarium Peregrinorum*, and it seems that either he had read the *Itinerarium* or the author of the *Itinerarium* knew his poem. One of these is the story about the Turk with the crossbow and the soldier with the name of God about his neck, whom he calls a sergeant (*serjant*, a soldier with status and equipment between an ordinary man's and a knight's):

> Armez de coife e de hauberc (3567)
> E de parpoint a meint bel merc.[94]
>
> [Armed with coif and with hauberk (3567)
> And with a *pourpoint* with a very beautiful mark.][95]

The Turk is said to use a windlass crossbow (*arbaleste a tur*) from an arrow loop (*archiere*: lines 3569–71).[96] In this case, the old-fashioned language of the *Itinerarium* and Ambroise's up-to-date military jargon complement one another.

Later in the siege, the crusaders have undermined the Cursed Tower in the city wall and caused part of it to collapse. The crusaders try to expand the breach while the defenders block it up and drive countermines. Even King Richard had himself carried

92 This is a difficult text to cite since there are multiple versions in French and medieval translations into other languages. The passage is around line 3920 of the French (e.g., J. J. Stürzinger, ed., *Le pelerinage de vie humaine de Guillaume de Deguileville* [London: Nichols and Sons for The Roxburghe Club, 1893], 122), but it is the translations which are explicit that "and riht as þe doublet is maad with poynynges (for whi it is cleped a purpoynt) riht so whoso hath it in, of prikkinges he bicometh armed. Bi prikkynges it is worth þat þat it is, and withoute prikkinges it is nothing woorth"; Henry Avril, ed., *The Pilgrimage of the Lyfe of the Manhode*, 2 vols., Early English Text Society, o.s. 288 and 292 (Oxford: Oxford University Press, 1985, 1988), 1:51, lines 2110–14. This English version is clearer that the stitches of the *pourpoint* and the pricks of suffering in human life make the *pourpoint* or the person more precious.

93 A version of one of her talks, "Martial Beauty: Padding and Quilting One's Way to a Masculine Ideal in 14th-Century France" (paper presentation, International Congress on Medieval Studies, Kalamazoo, MI, May 2013) is available at http://cottesimple.com/articles/martial-beauty (accessed Aug. 9, 2023).

94 Text from Gaston Paris, ed., *L'Estoire de la Guerre sainte* (Paris: n.p., 1897), 95–96. See also the edition and translation by Marianne Ailes and Malcolm Barber, *The History of the Holy War: Ambroise's "Estoire de la guerre sainte,"* 2 vols. (Woodbridge, UK: Boydell, 2002).

95 Item 12 of the rule of the *pourpointiers* of Paris from 1323 (Lespinasse and Bonnardot, *Les métiers*, 3:209) and the rule of the *pourpointiers* of Troyes from 1400 (Secousse, *Ordon-nances*, 8:388, item 13) state that certain types of work must have an *enseigne, exemplaire,* or *essanglaire* on the collar to show how they are made. Ailes and Barber, *History of the Holy War*, 2:82, translate this phrase as "very finely decorated pourpoint."

96 Paris, *L'Estoire de la Guerre sainte*, lines 3569–71.

Sean Manning

from his sickbed into the firing line where he shot with a crossbow and offered money to anyone who removed a stone from the tower.

> Uns Turs s'iert armez richement
> Des armes Auberi Climent,
> Qui le jor trop s'abandona;
> Mais li reis Richarz lui dona (4970)
> D'un fort quarel el gros del piz,
> Que cil chai morz sanz respiz.
> Lors veissiez Turs descovrir,
> Por le doel de celui covrir,
> E as quarels abandoner (4975)
> E traire e de granz cops doner.
> Ne furent ainc de tel defense:
> Merveilles ot qui s'en apense.
> La n'aveit mestier armeure,
> Tant fust tenanz, fort ne seure: (4980)
> Dobles parpoinz, dobles haubercs
> Ne tenouent ne c'uns drap pers
> Les quarels d'arbaleste a tur,
> Car trop erent de fort atur.
> E li Turc par dedenz foirent (4985)
> Tant que li nostre s'en fuirent
> E qu'il les covint remuer;
> Eth vos Sarazins a huer.

[One Turk had arrayed himself richly in the arms of Aubery Clément and that day he took too great a risk. King Richard struck him with a bolt square on the chest, which killed him instantly. There you would have seen Turks coming out of cover to assuage their sorrow for him; they laid themselves open to bolts and shot and struck great blows. Never was there such a defence. Everyone who considers it marvels at it. Armour, however good, strong or sure was no use there—double *pourpoints* and double hauberks—they were no more use than blue cloth (*drap pers*) against the windlass crossbows, for the bolts were such powerful types. Moreover, the Turks within countermined until our miners had to flee and withdraw. How the Saracens mocked.][97]

Source iii.5: Bahā᾿ al-Dīn, Life of Saladin *(describes events in 1191, written slightly later)*
Bahā᾿ al-Dīn ibn Shaddād wrote a laudatory life of the controversial Sultan Saladin of Egypt. One of the difficult events he had to deal with was the sultan's failure to stop the crusaders in their march south from Acre towards the port of Jaffa:

A second messenger came in to announce that the enemy had commenced their march, whereupon the Sultan (Saladin) ordered his drum to beat, and mounted at the head of his cavalry. He then set out, and I accompanied him close up to the army of the Franks,

97 Text from Paris, *L'Estoire de la Guerre sainte,* 133. Translation slightly adapted from Ailes and Barber, *History of the Holy War,* 2:100, 101.

Linen Armour

when he formed his troops in line round the enemy, and gave the signal for battle. The marksmen were posted in front, and the arrows shot by both sides fell thick as rain. The enemy had already formed in order of battle; the infantry, drawn up in front of the cavalry, stood firm as a wall, and every foot-soldier wore a vest of thick felt (*libd/labūd*) and a coat of mail (*sābighah*) so dense and strong that our arrows made no impression on them.[98] They shot at us with their great arbalests, wounding the Moslem horses and their riders. I saw some (of the Frank foot-soldiers) with from one to ten arrows sticking in them, and still advancing at their ordinary pace without leaving the ranks. [...] This was the disposition of their forces, according to my own observation, and to information given me by some of the Frank prisoners and the merchants who frequented their camp.[99]

At first glance, Bahā' al-Dīn confirms what Frankish observers on the Third Crusade say about their own infantry. But for those unable to read Arabic the situation is not so simple. The translation above, by Claude Reignier Conder, was published in 1897 and based on an earlier French translation, not the original Arabic text. Scholars in Conder's day often had an idiosyncratic understanding of words for material culture in medieval languages. For example, Conder translated *khazaghand* (a coat of mail covered and lined with fabric, French *jaseran*, English *jesseraunt*) as "wadded tunic."[100] He may have translated the first garment in the passage quoted above as a "vest of thick felt" because he believed Bahā' al-Dīn was referring to the *gambeson* or *pourpoint* in Frankish sources. The most recent translator of the same passage, who worked from newer editions and the oldest manuscript, has an important difference:

The enemy army was already in formation with the infantry surrounding it like a wall, wearing solid iron corslets and full-length well-made chain mail, so that arrows were falling on them with no effect. They were shooting with crossbows and wounding the Muslims' horses, their cavalry and infantry. I saw various individuals amongst the Franks with ten arrows fixed in their backs, pressing on in this fashion quite unconcerned.[101]

Did the infantry wear "a vest of thick felt" or "solid iron corslets"? Since I cannot read Arabic, I can only say that translators disagree.

98 The transliteration of the Arabic words for armour comes from David Nicolle, "The Military Technology of Classical Islam," 2 vols. (Ph.D. diss., University of Edinburgh, 1982), 1:180, 199. Nicolle used an edition of the Arabic from 1897.

99 Translation from Claude Reignier Conder, *The Life of Saladin* (London: Palestine Exploration Fund, 1897), 281–82. Note that this translation was based on a French translation, not the Arabic original text (xvi, xvii) and a contemporary reviewer was not impressed with the result. Duncan B. MacDonald, "Review: Behâ Ed-Dîn's The Life of Saladin," *The American Journal of Semitic Languages and Literatures* 15, no. 3 (1899): 182–84. I thank Håvard Kongsrud for the reference.

100 Conder, *Life of Saladin*, 367. Philip K. Hitti, *An Arab-Syrian Gentleman and Warrior in the Period of the Crusades: Memoirs of Usāmah Ibn-Munqidh* (New York: Columbia University Press, 1929), 129, makes the same mistake.

101 Translation from Bahā' al-Dīn Yūsuf ibn Rāfi' Ibn Shaddād, *The Rare and Excellent History of Saladin*, trans. Donald Sidney Richards (Aldershot, UK: Ashgate, 2001), 170.

Sean Manning

CONCLUSION

By around 1200 quilted garments called *aketons, gambais, gambesons, ioppi, jupels, pourpoints,* and *panzari* are recorded in most of the Frankish countries (but not in the Low German countries; see table 1.2). Many of these terms have distinct regional affiliations: for example, garments were often called *aketons* in Britain and France, but not in Germany or Italy (see fig. 1.1). Different writers use different words depending on their dialect or to create pleasant variation: there is very little evidence that any of these authors used several different words to describe several different quilted garments (source ii.9 and table 1.3).

Table 1.2: First attested use of terms for linen armour in a military context by language region.

Mediterranean language regions	
Iberia	*perpunt*, ca. 1175 (source ii.6)
Provence	*alcoto*, ca. 1170–1200 (source ii.4)
	perpoing, ca. 1170–1200 (source ii.4)
Italy	*ioppus*, 1165 (source ii.16)
Northern continental language regions	
France	*gambais*, ca. 1160–75 (source ii.1)
	gambison, ca. 1165–90 (source ii.2)
	gambisons, ca. 1190–1210 (source ii.9)
	auketon, ca. 1165–90 (source ii.2)
	aucotuns, ca. 1175 (source ii.3)
	pourpoint, ca. 1190–1210 (source ii.9)
	coute pourpointe, ca. 1175–1225 (source ii.10)
	jupel, ca. 1200 (source ii.13)
High Germany	*wambois*, ca. 1200 (source ii.11)
	wambas, after 1193 (source ii.12)
Low Germany	none attested
Atlantic island/peninsular language regions	
Scandinavia	*panzar*, ca. 1200 (source ii.14)
Britain	*gambeison*, ca. 1180 (source ii.5)
	gambais, ca. 1181 (source ii.7)
	perpunctum, ca. 1191 (source iii.3)
	purpuint, ca. 1190–1200 (source ii.15)
Ireland	*cotún*, ca. 1130? (source i.6)

Linen Armour

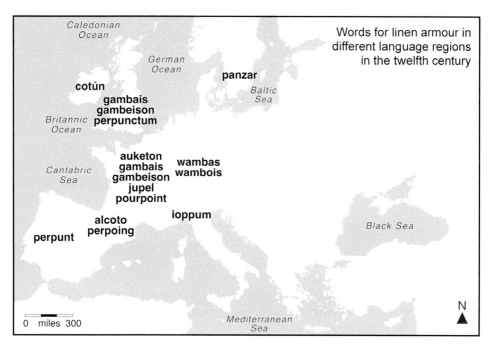

Fig. 1.1: Map showing twelfth-century words for linen armour according to linguistic region. Greek, Arabic, Hungarian, and the Slavic languages are not included. Map: Cath Dalton, based on a drawing by Sean Manning.

Many of these passages describe foot soldiers with wide-rimmed iron caps and quilted coats, or horsemen with high helms, white hauberks, and quilted coats. Sometimes rich men with horses arm in the first way (sources ii.12, ii.14, iii.1) and sometimes a foot soldier wears a hauberk over his quilted coat (sources iii.3, iii.5). *King Sverri's Saga* (ii.14) and Radulfus Niger's *De re militari* (iii.2) are the only texts where a soldier wears a quilted garment over a hauberk. From 1190 onwards, some of these texts mention an additional decorative garment worn on top: the texts in this chapter call it a *hjup* (*jupe*: source ii.14), *wappen rock* (ii.11), *cote á armer* (ii.13), or *gonele*,[102] rather than surcoat or coat of arms.

From 1160 onwards, it seems to have been very common to wear a quilted coat under a hauberk, but how common, and why these garments were worn, is less clear.

102 *Chronique des Ducs,* ed. Michel, 3:35 (book 2, lines 32785–86: "Vestent desus les aucotons, / Les blans osbers soz les goneles" = ed. Fahlin, 2:372.

The arming scenes do not mention a quilted layer under mail hose, so it is difficult to believe that mail was always worn over a padded garment.

Table 1.3: Quilted garments worn alone and with iron armour in English and French sources.

Term	Worn alone	Worn under hauberk
aketon	—	Sources ii.2, ii.3
gambais (and variants)	Source ii.1	Sources ii.8, ii.9, ii.13
jupe (and variants)	Sources ii.13, ii.16	—
pourpoint (and variants)	Source ii.10	Sources ii.9, iii.3, iii.4

In the expense accounts and guild rules which survive from the thirteenth century onwards, most of these garments are stuffed with raw cotton: guild rule after guild rule lists layers of linen cloth, unspun cotton, and *bourre de soie* (probably unspinnable silk waste) as the three proper stuffings, and on 7 January 1465, the *pourpointiers* of Amiens declared that due to the excessive price of cotton members of the art should be allowed "to layer the bodies of *pourpoints* with white wool, neat, washed and guarded, for the period of one year" (so wool was not seen as an acceptable substitute for cotton in ordinary circumstances).[103] While little cotton was grown in the Frankish countries, it was imported from Egypt, Syria, and the Black Sea in bulk, and by the twelfth century, workers in Italy had begun to spin and weave it.[104] Special thick garments to resist weapons or make iron armour more comfortable are also mentioned in East Roman military manuals long before they appear in Frankish sources.[105] We would therefore expect quilted armour to have appeared among the Romans or Arabs and spread to the Frankish countries with words like Arabic *quṭun* ("cotton") (< *cotún* and *aketon*), Greek *bambax* ("cotton") (one possible ancestor of *wambais* and *gambeson*), and Arabic *jubbah* ("upper garment for a man") (< *jupe, jupeau, jupel,* and *jupon*).

Yet it is a curious fact that so far, the earliest sources for soldiers in quilted garments come from northwestern Europe (Ireland, England, Normandy, Champagne, Norway) rather than the Mediterranean. To some extent this may reflect that some

103 Augustin Thierry, ed., *Recueil des monuments inédits de l'histoire du tiers état: première série, chartes, coutumes, actes municipaux, statuts des corporations d'arts et métiers des villes et communes de France, région du Nord,* 4 vols. (Paris: Imprimerie Impériale, 1853), 2:110 n. 2: "Une ordonnance du 7 janvier 1465 permit aux pourpointiers, attendu la cherté du coton, qui valait IIII s. VIII d. la livre, d'emplir 'les corps des pourpoints de laine blanche, nette, lavée et gardée pendant un an.'"

104 Maureen Fennell Mazzaoui, *The Italian Cotton Industry in the Later Middle Ages, 1100–1600* (Cambridge: Cambridge University Press, 1981), 7–27, 59–72.

105 For example, Eric McGreer, *Sowing the Dragon's Teeth: Byzantine Warfare in the Tenth Century* (Washington, DC: Dumbarton Oaks, 1995), 13, 89. For other examples and context, see Tim Dawson, "*Kresmata, Kabadion, Klibanion*: Some Aspects of Middle Byzantine Military Equipment Reconsidered," *Byzantine and Modern Greek Studies* 22 (1998): 38–42.

Linen Armour

regions began to produce long texts in the vernacular sooner than others, and some regions have left us more archives and manuscripts. It also reflects that the philological armour scholars from 1786 to 1958 preferred to cite English, French, and Latin texts. Yet it is peculiar that so few sources from Iberia, Occitania, or Italy have been identified. Our sources on the Third Crusade (iii.1–3) also emphasize many layers of linen, not cotton between linen, although we do not know what the bare word *aketon* or *gambais/wambais* implied to contemporary audiences. More research is needed to understand how this technology became present in Western Europe in the twelfth century, and how it related to technologies in the East Roman and Islamic worlds.

Appendix 1.1

DICTIONARIES AND CORPORA USED

Baldinger, Kurt, et al., eds., *Dictionnaire étymologique de l'ancien français* (Quebec: Presses de l'Université Laval, 1971–). Expanded digital version at https://deaf-server.adw.uni-heidelberg.de.

Battaglia, Salvatore, *Grande Dizionario della Lingua Italiana*, 21 vols. (Turin, Italy: Unione Tipografico-Editrice Torinese, 1961–2002).

Blair, Claude, *European Armour Circa 1066 to Circa 1700* (London: B. T. Batsford Ltd., 1958).

Bruhn de Hoffmeyer, Ada, *Arms and Armor in Spain*, 2 vols. (Madrid: Instituto de Estudios sobre Armas Antiguas, 1972 and 1981).

Dictionary of Old Norse Prose, University of Copenhagen, http://onp.ku.dk.

Dictionnaire du Moyen Français, version 2015, available at http://www.atilf.fr/dmf.

Diefenbach, Lorenz, *Glossarium Latino-Germanicum Mediae et Infimae Aetatis* (Frankfurt-am-Main: Joseph Baer Verlag, 1857).

Du Cange, Charles Du Fresne, et al., eds., *Glossarium Mediae et Infimae Latinitas*, 10 vols. (Niort, France: Léopold Favre, 1883–87).

eDIL 2019: Electronic Dictionary of the Irish Language, https://dil.ie.

Gärtner, Kurt, Klaus Grubmüller, and Karl Stackmann, eds., *Mittelhochdeutsches Wörterbuch*, 3 (of 5 to 6 planned) vols. (Stuttgart: S. Hirzel Verlag, 2013–). Digital version with additional resources at http://www.mhdwb-online.de/index.html.

Gay, Victor, *Glossaire Archéologique du Moyen Age et de la Renaissance*, 2 vols. (vol. 1, Paris: Libraire de la Société Bibliographique, 1887; vol. 2, Paris: Picard, 1928).

Grimm, Jakob, and Wilhelm Grimm, *Deutsches Wörterbuch*, 17 parts in 33 vols. (Leipzig: S. Hirzel, 1854–1971; repr., Munich: Deutscher Taschenbuch Verlag, 1984).

Köbler, Gerhard, *Mittelhochdeutsches Wörterbuch*, 3rd ed. (2014), https://www.koeblergerhard.de/mhdwbhin.html.

Latham, R. E., et al., eds., *Dictionary of Medieval Latin from British Sources*, 17 fascicules (Oxford: Oxford University Press, 1975–2013).

Lewis, Robert E., et al., eds., *Middle English Dictionary* (Ann Arbor, MI: University of Michigan Press, 1952–2001). Expanded online edition at http://quod.lib.umich.edu/m/med.

Lexer, Matthias, *Mittelhochdeutsches Handwörterbuch*, Version 01/23, Wörterbuchnetz des Trier Center for Digital Humanities, https://www.woerterbuchnetz.de/Lexer.

Lexis of Cloth and Clothing Project [database], University of Manchester (closely related to Owen-Crocker, Coatsworth, and Hayward, eds., below), http://lexissearch.arts.manchester.ac.uk.

Niermeyer, J. F., and C. van de Kieft, eds., *Mediae Latinitatis Lexicon Minus*, 2nd ed., 2 vols. (Darmstadt: Wissenschaftliches Buchgesellschaft, 2002).

Owen-Crocker, Gale R., Elizabeth Jane Coatsworth, and Maria Hayward, eds., *Encyclopedia of Dress and Textiles in the British Isles c. 450–1450* (Leiden: Brill, 2012).

Rothwell, William, et al., eds., *Anglo-Norman Dictionary*, online (2nd) ed., Aberystwyth University, https://anglo-norman.net.

Von Wartburg, Walther, et al., eds., *Französisches Etymologisches Wörterbuch*, 25 vols. (Leipzig: Teubner and Zbinden, 1928–2002). The print edition can be read at https://lecteur-few.atilf.fr. A revised, digital edition currently only covers words beginning with B.

A number of other dictionaries were consulted but did not provide significant information that was not available in the list above. I learned of two books too late to address them in this first article: Ralph Moffat, *Medieval Arms and Armour, a Sourcebook: Volume I: The Fourteenth Century* (Woodbridge, UK: Boydell, 2022) and Álvaro Soler del Campo, *La evolución del armamento medieval en el reino Castellano-leonés y Al-andalus (siglos XII–XIV)* (Madrid: Servicio de Publicaciones del E.M.E, 1993). The website Arlima: Archives de Littérature du Moyen Âge (https://www.arlima.net) is an excellent resource on editions, commentaries, and translations of high medieval literature. A list of sources discussed in this series, with links to online versions if they exist, can be found on the author's website at https://www.ageofdatini.info/bibliotheca/linen-armour.html.

Serial Production and Individualisation in Late Medieval Silk Weaving

Michael Peter

Whenever the conversation turns to single orders or special commissions in medieval silk weaving, sooner or later the altar hanging with a Crucifixion scene in Regensburg will be brought up as one of the most elaborate and exclusive commissions to have survived from the decorative arts of the Middle Ages (figs. 2.1 and 2.2).[1]

The basic type of pictorial fabric is well known from medieval textile art. Starting from the thirteenth century, fabrics with subjects containing human figures are mentioned in merchants' account books and church inventories.[2] They can also be found among the surviving silk weavings of the period, depicting the Crucifixion of Christ along with a variety of other religious images, including various saints, the enthroned Virgin Mary, the Nativity, the Adoration of the Magi, the Entombment, and the Resurrection.[3] Alongside these, secular scenes from courtly literature are also attested to as pictorial themes in woven silks.[4]

However, all these fabrics containing human figures depict small-scale scenes, scarcely more than a hand span wide. They were products of the extensive use of serial production, by means of which the centres of the Italian silk industry supplied the European market. Like the later woven orphrey bands with figurative designs of

1 Regensburg, Germany, Domschatz, inv. no. D 1974/87. Otto von Falke, *Kunstgeschichte der Seidenweberei*, 2 vols. (Berlin: Ernst Wasmuth, 1913), 2:40, fig. 303; *Sakrale Gewänder des Mittelalters*, exhibition catalogue, Munich, Bayerisches Nationalmuseum (Munich: Hirmer, 1955), 29, cat. no. 58 (Sigrid Müller-Christensen), figs. 66–67; Donald King, "Some Unrecognised Venetian Woven Fabrics," *Yearbook of the Victoria and Albert Museum* 1 (1969): 53–63, at 56, figs. 5–6; Achim Hubel, *Der Regensburger Domschatz* (Munich: Schnell & Steiner, 1976), 229–34, cat. no. 113, plate 16, figs. 156–57.
2 King, "Venetian Woven Fabrics," 53–59.
3 Von Falke, *Seidenweberei*, 2:41–42, figs. 304–6; King, "Venetian Woven Fabrics," 53–56, figs. 1, 4; Leonie von Wilckens, *Die textilen Künste: Von der Spätantike bis um 1500* (Munich: C. H. Beck, 1991), 136–43, figs. 148, 149.
4 Von Falke, *Seidenweberei*, 2:42, fig. 307; King, "Venetian Woven Fabrics," 55, figs. 2, 3.

Fig. 2.1: Altar hanging with Crucifixion scene, woven silk, Italy, 1277–96. Regensburg, Domschatzkammer, inv. no. D 1974/87. Photo: Domkapitel Regensburg (Josef Zink).

Fig. 2.2: Line drawing of the Regensburg altar hanging, from Otto von Falke, *Kunstgeschichte der Seidenweberei* (Berlin: Ernst Wasmuth, 1913), vol. 2, fig. 303.

the fifteenth and sixteenth centuries, they were manufactured as repeat patterns in countless repetitions, to be used as ornaments for secular or ecclesiastical clothing.[5]

The Regensburg altar hanging is, in contrast, a unique piece with respect to its content, form, technique, and design. It originally measured about 120 centimetres (about 1⅜ yards) in height and 300 centimetres (3¼ yards) in width,[6] and was commissioned by Heinrich von Rotteneck, the bishop of Regensburg from 1277 to 1296. The identity of the commissioner is made clear on the hanging, through both text and imagery. Kneeling in full pontificals, his hands raised in intercession, the bishop appears to the side of the Crucifixion scene, while a woven inscription gives his name and title. It may be assumed on this basis that Heinrich was both the commissioner and the recipient of the hanging. This type of full-figure donor portrait is unique in thirteenth-century silk weaving, representing the first occurrence in the history of European silk production. The original destination of the hanging is reflected in yet another detail of the depiction, namely the figure of St. Peter, whose prominent position between the image of the donor and the Crucifixion group is due to his liturgical significance for Regensburg Cathedral, of which he was the main patron saint.

Today, the hanging conveys only a faint impression of its original appearance and colouring.[7] The Crucifixion scene and the frame borders have been considerably trimmed and shortened. Of the figures standing to the right of the Crucifixion group, only a fragment of a holy bishop, who was positioned at the end of the row of figures, has survived. The damage to the fabric itself is similarly severe. The metal threads that once covered the entire background of the image have almost all lost their gilding. All that remains of them is the natural-coloured linen core and the transparent strips of animal gut that once carried the metal layer. In addition, the pattern weft has been lost in many places, with the result that the figures—whose colours were originally bright red, white, and violet—are mostly only visible through the effect of the reddish-brown binding warp.

The construction of the weave clearly shows that the crucifixion scene is not an extended or altered repetition of an existing pattern design, but rather a one-off production. The basic structure follows the type of a multicoloured samite: two warp and four different weft systems create the weave, with the main warp separating the weft systems from each other on the front and back, while the binding warp binds the pattern wefts in twill.[8]

When compared to a typical samite, however, the binding of the pattern weft reveals a number of significant peculiarities.[9] The binding warp does not work *par*

5 Ruth Grönwoldt, *Paramentenbesatz im Wandel der Zeit: Gewebte Borten der italienischen Renaissance* (Munich: Hirmer: Abegg-Stiftung, 2013), 13–26.

6 Hubel, *Regensburger Domschatz*, 226.

7 For the state of conservation, see Hubel, *Regensburger Domschatz*, 231.

8 Definitions and explanations of technical terms can be found on the website of CIETA (Centre Internationale d'Etude des Textiles Anciens): https://cieta.fr/cieta-vocabulaire.

9 For a weave diagram, see Hubel, *Regensburger Domschatz*, 230.

passée—i.e. in units, each of which comprises a complete sequence of wefts. Instead, it binds over each weft separately, and only when the weft appears on the front side of the fabric for pattern formation. At the same time, the displacement of the binding points reveals leaps and discontinuities that can only be explained in terms of manual intervention. The warp threads were not, therefore, moved and controlled by a figure harness (a mechanical pattern device) that had previously been set up, but were rather picked out in groups by hand during the weaving process, in order to lift the appropriate selection of warps for each pattern weft.[10]

Here it becomes clear that the Regensburg hanging is an exceptional case in thirteenth-century silk weaving—an anomaly that owes as much to the special wishes of its patron as to the outstanding craftsmanship of the weavers. Obviously, selecting the warp threads by hand was quicker and less expensive than setting up a complete figure harness for a weaving of this size, since it dispensed with the need for a drawing system. Only in the case of the serial production of a pattern could the time and cost involved in setting up a draw loom with figure harness for such a weaving be recovered.

There can be little doubt that the definition of the subject matter, the introduction of a donor's portrait, and the choice of saints all follow the patron's specifications. How precise these specifications were, however, is difficult to determine. The presence of the Italian form ENRICVS in the woven donor inscription indicates that the stipulations mainly took the form of general instructions concerning the pictorial programme and did not include a detailed painted or drawn model. Only later, in Regensburg, was the name filled out to HEINRICVS by embroidery.

Something similar can be said about the format of the hanging, whose dimensions probably reflect the standard dimensions and guild regulations of Italian weaving workshops rather than the client's own wishes. Its original size corresponded quite precisely to that of a normal woven *coupon*,[11] meaning that neither the warp length nor the loom width would have had to be altered to produce it.

Likewise, the representation itself is mainly derived from Italian models. According to written sources, it was primarily the workshops of Venice that wove fabrics with figural subjects in the thirteenth and early fourteenth centuries. In both the inventories of church treasures and the records of papal donations, such fabrics are repeatedly referred

10 Hubel, *Regensburger Domschatz*, 229.

11 On the width and length of woven silks, see Monique King and Donald King, "Silk Weaves of Lucca in 1376," in *Opera Textilia Variorum Temporum: To Honour Agnes Geijer on Her Ninetieth Birthday*, ed. Inger Estham and Margareta Nockert (Stockholm: Statens Historiska Museum, 1988), 67–76, at 67–69 and 74–76; von Wilckens, *Die textilen Künste*, 131; Regula Schorta, "Von Mustern und Webstühlen: Serialität in der mittelalterlichen Kunst," in *L'art multiplié: Production en masse, en série, pour le marché dans les arts entre Moyen Âge et Renaissance*, ed. Michele Tomasi (Rome: Viella, 2011), 25–42, at 36–37.

Michael Peter

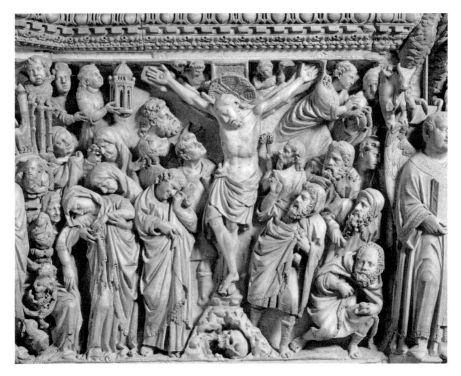

Fig. 2.3: Nicola Pisano, *Crucifixion of Christ* (detail), marble pulpit, ca. 1266–68. Siena, Cathedral. Photo: Bridgeman Images (Luisa Ricciarini).

to as Venetian works,[12] and it is therefore not without justification that textile historians have long argued that the Regensburg hanging was produced in Venice as well.[13]

The art-historical evidence does, however, allow for other attributions. The Crucifixion scene follows a type that is particularly familiar from Tuscan art of the thirteenth century, originating with Nicola Pisano's pulpit in Siena (fig. 2.3),[14] whose novel Crucifixion iconography with three nails and a suffering body posture soon found its way into other fields of Tuscan art, ranging from marble sculpture[15] to

12 King, "Venetian Woven Fabrics," 55–56.
13 See Hubel, *Regensburger Domschatz*, 233; Agnes Geijer, *A History of Textile Art* (London: Pasold Research Fund in association with Sotheby Parke Bernet, 1979), 59; von Wilckens, *Die textilen Künste*, 137.
14 Siena, Cathedral of S. Maria Assunta, dated 1266–68; see John Pope-Hennessy, *An Introduction to Italian Sculpture,* vol. 1, *Italian Gothic Sculpture* (London: Phaidon, 1955), 176–77, plate 6, fig. 47; Joachim Poeschke, *Die Skulptur des Mittelalters in Italien*, 2 vols. (Munich: Hirmer, 1998–2000), 2:71–75, plates 29–30.
15 Crucifixion panels of the pulpit in Pistoia, S. Giovanni Fuorcivitas, by Fra Guglielmo, ca. 1270, and the pulpit in Pistoia, S. Andrea, by Giovanni Pisano, dated 1301; see Pope-

Serial Production in Silk Weaving

frescoes,[16] panel painting,[17] and the goldsmiths' art of the late thirteenth century.[18] Moreover, stylistically speaking, the woven figures have their closest parallels in this artistic realm.[19] In Venice, by contrast, this type is documented only much later.[20] The artistic background of the hanging must therefore be re-examined. That said, it is clear that its style and iconography are not based on any models from the patron's own artistic sphere.

SERIAL PRODUCTION

The special position of the Regensburg hanging in medieval silk production is even more apparent when its individuality is compared with the usual parameters of the serial production of textiles. Opportunities to modify design to fit individual preferences were extremely limited. The result, as stated above, was that the purchaser did not act as a patron with a free choice of form and content, but rather as a mere customer, whose options were constrained by the selection on offer. This meant that the client's choice was essentially restricted by predetermined levels of quality and price.

The constraints resulting from the market orientation and production method of the medieval silk industry can be seen in the rather narrow range of variations to

Hennessy, *Italian Gothic Sculpture*, 180, fig. 49; Poeschke, *Skulptur des Mittelalters*, 2:82, 115–18, plates 47, 49, 113, 122.

16 Fresco cycle with the Passion of Christ in the Lower Church of Siena Cathedral, ca. 1270–80; see Alessandro Bagnoli, "Alle origini della pittura senese: Prime osservazioni sul ciclo dei dipinti murali," in *Sotto il duomo di Siena: Scoperte archeologiche, architettoniche e figurative*, ed. Roberto Guerrini (Milan: Silvana, 2003), 107–47, at 125–26, figs. 31, 43.

17 Crucifixion scenes by Duccio, Giotto, and their followers; see Evelyn Sandberg-Vavalà, *La croce dipinta italiana e l'iconografia della passione* (Verona, Italy: Apollo, 1929), 891–906; Edward B. Garrison, *Italian Romanesque Panel Painting: An Illustrated Index* (Florence: Leo S. Olschki, 1949), nos. 464, 465, 484, 490, 497; James H. Stubblebine, *Duccio di Buoninsegna and His School*, vol. 1, *Text*, vol. 2, *Plates* (Princeton, NJ: Princeton University Press, 1979), 60, 92–106, 130–37, 157–89, figs. 110, 210, 211, 214, 228, 237, 240, 313, 314, 315, 375, 391, 392, 429, 430, 434, 442, 449, 469; Marcello Gaeta, *Giotto und die Croci dipinte des Trecento: Studien zu Typus, Genese und Rezeption* (Münster, Germany: Rhema-Verlag, 2013), 88–90, 265–368, cat. nos. 1–214.

18 Silver altar of St. James in Pistoia, Cathedral of San Zeno, ca. 1275–1300; see Lucia Gai, *L'altare argento di San Iacopo nel duomo di Pistoia: Contributo alla storia dell'oreficeria gotica e rinascimentale italiana* (Turin, Italy: Umberto Allemandi, 1984), 81, fig. 72; Giuseppe Cantelli, *Storia dell'oreficeria e dell'arte tessile in Toscana dal Medioevo all'età moderna* (Florence: Banca Toscana, 1996), 12, fig. 2. The type can also be found in the work of Guccio di Mannaia and his circle; see Elisabetta Cioni, *Scultura e Smalto nell'Oreficeria Senese dei secoli XIII e XIV* (Florence: Studio per edizioni scelte, 1998), 58–150.

19 So, for example, in the aforementioned silver altar of St. James in Pistoia (note 18) or in the head reliquary of San Galgano in Siena, Museo dell'Opera del Duomo, ca. 1270. For the reliquiary of San Galgano, see Elisabetta Cioni, *Il Reliquario di San Galgano: Contributo a la storia dell'oreficeria e dell'iconografia* (Florence: Studio per edizioni scelte, 2005), 61–114, figs. 41 and 44–46.

20 See Gaeta, *Croci dipinte*, 216–20, figs. 295–304.

which a given design could give rise within serial production. One example is the use of alternating colour schemes, which can be found in the Middle Ages in silks[21] and in woven borders.[22] The same principle applied to the use of different materials for threads, the quality and quantity of which established a clear hierarchy in the rank and ambition of the works.

How limited the options were is best illustrated by a silk pattern design with angels holding censers and instruments of the Passion, whose numerous surviving fragments are preserved in various versions: in the form of an all-silk fabric upon which the figures appear in yellow against a dark-blue background, as well as in a more elaborate version, which, instead of pattern wefts made of yellow silk, uses metal threads of gilded animal gut with a linen core to depict the figures.[23]

One of the variants with metal threads is distinguished by the use of gold pattern wefts with a particularly thick and high-quality metal coating, which is otherwise very rarely found in fourteenth-century silk weaving (fig. 2.4).[24] In another, more modest variation, only the instruments of the Passion have been highlighted with gold, while much lower-quality brocading metal threads are used in place of metallic pattern wefts (figs. 2.5 and 2.6).[25]

21 See, for example, a silk design with birds and palmettes, Italy, ca. 1420–30, that has been preserved in two versions: one with metal thread pattern wefts in Prato, Italy, Museo del Tessuto, inv. no. 81.01.03, the other with silk pattern wefts and details with brocaded silk and metal threads in Vienna, Museum für angewandte Kunst, inv. no. T 878/1865. For the silk in Prato, see Rosalia Bonito Fanelli, *Five Centuries of Italian Textiles, 1300–1800: A Selection from the Museo del Tessuto Prato* (Prato, Italy: Museo del Tessuto, 1981), 27, fig. 3; Daniela Degl'Innocenti and Tatiana Lekhovich, eds., *Lo Stile dello Zar: Arte e Moda tra Italia e Russia dal XIV al XVIII secolo*, exhibition catalogue, Prato, Museo del Tessuto (Milan: Skira, 2009), 109, cat. no. 7. For the silk in Vienna, see Moriz Dreger, *Künstlerische Entwicklung der Weberei und Stickerei innerhalb des europäischen Kulturkreises von der spätantiken Zeit bis zum Beginne des 19. Jahrhunderts, mit Ausschluss der Volkskunst*, vol. 1, *Text*, vols. 2 and 3, *Plates* (Vienna: K. K. Hof- und Staatsdruckerei, 1904), 2, plate 106.
22 Examples include two woven borders, Italy, ca. 1500, depicting identical scenes of the Annunciation of the Virgin, with different colour schemes: Munich, Bayerisches Nationalmuseum, inv. no. 65/260; see Saskia Durian-Ress, *Meisterwerke mittelalterlicher Textilkunst aus dem Bayerischen Nationalmuseum: Auswahlkatalog* (Munich: Schnell & Steiner, 1986), 144, cat. no. 54a. Prato, Museo del Tessuto, inv. no. 75.01.524; see Daniela Degl'Innocenti, ed., *I tessuti della fede*, exhibition catalogue, Prato, Museo del Tessuto (Florence: Edizioni della Meridiana, 2000), 38 cat. no. 6 (Daniela Degl'Innocenti).
23 The numerous variations are compiled in Karel Otavský and Anne E. Wardwell, *Mittelalterliche Textilien*, vol. 2: *Zwischen Europa und China* (Riggisberg, Switzerland: Abegg-Stiftung, 2011), 307–10, cat. no. 121; Grönwoldt, *Paramentenbesatz*, 258–60, cat. no. A6.
24 Riggisberg, Switzerland, Abegg-Stiftung, inv. no. 2861a–b; see Otavský and Wardwell, *Zwischen Europa und China*, 307–10, cat. no. 121; Grönwoldt, *Paramentenbesatz*, 260, colour plate 1. For the metal threads, see Michael Peter, *Gewebtes Gold: Eine kleine Geschichte der Metallfadenweberei von der Antike bis um 1800* (Riggisberg, Switzerland: Abegg-Stiftung, 2022), 76, figs. 30a and b.
25 Utrecht, Netherlands, Museum Catharijneconvent, inv. nos. ABM st864a–b; see Micha Leeflang and Kees van Schooten, eds., *Middeleeuwse Borduurkunst uit de Nederlanden*,

Serial Production in Silk Weaving

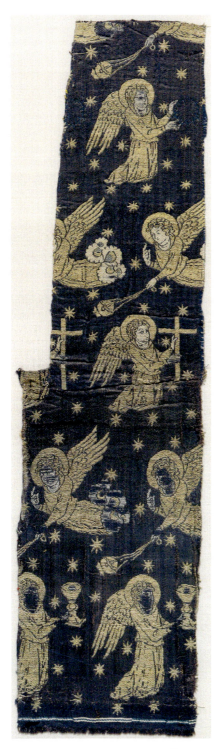

Fig. 2.4: Silk fragment with angels holding censers and instruments of the passion, lampas weave, Italy, ca. 1380. Variant with metal thread pattern wefts. Riggisberg, Abegg-Stiftung, inv. no. 2861. Photo: Abegg-Stiftung, Riggisberg, 1999 (Christoph von Viràg).

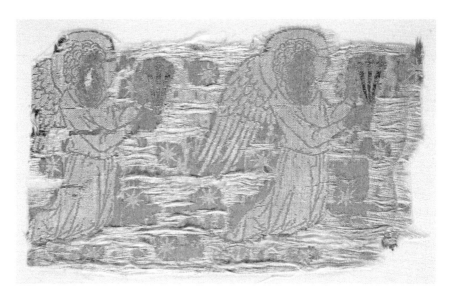

Fig. 2.5: Silk fragment with angels holding instruments of the passion, lampas weave, Italy, ca. 1380. Variant with brocaded metal threads. Utrecht, Museum Catharijneconvent, inv. no. ABM st864 a. Photo: Museum Catharijneconvent, Utrecht (Ruben de Heer).

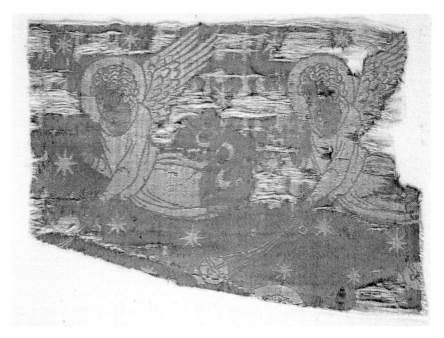

Fig. 2.6: Silk fragment with angels holding censers, lampas weave, Italy, ca. 1380. Variant with brocaded metal threads. Utrecht, Museum Catharijneconvent, inv. no. ABM st864 b. Photo: Museum Catharijneconvent, Utrecht (Ruben de Heer).

Serial Production in Silk Weaving

Other variations have also survived: besides fragments with different colour schemes, there are versions with different weaves,[26] and—in one case—with a different sequence of figures,[27] such that it is safe to assume that the variations were produced on various looms working in parallel.

The more elaborate of the two main versions—the one with metal threads—is also mentioned in the written sources of the fourteenth century, namely in a further variant in which the angels appeared in gold against a red background. Archival records and inventory entries of the time link it to a canopy donated for the main altar of Angers Cathedral between 1360 and 1382 by Mary of Blois, duchess of Anjou and later queen of Sicily and Naples.[28]

For the variant with golden figures against a blue background, Karel Otavský has suggested a probable origin in the treasury of Karlstein Castle near Prague.[29] The extant fragments apparently originate from a donation of vestments by Charles IV to the castle chapel that he built,[30] meaning that the choice of the unusually high-quality metal thread can be traced back to a high-status purchaser who intended it to be used for a very prestigious purpose.

The pattern itself—and thus also the corresponding setup of the loom—was not changed to accommodate higher-quality thread material with a stronger metal coating. Instead, the task of adapting to the customers' varying quality standards and representational demands was shifted from the weaving workshops to the supply industry, which produced silk and metal threads of different kinds and qualities.

VELVETS

The technical effort involved in adapting to individual requests in serial production increased even further when, towards the end of the fourteenth century, figured velvet was introduced into European silk weaving.[31] Both the setup of the loom and

 exhibition catalogue, Utrecht, Museum Catharijneconvent (Zwolle, Netherlands: Wbooks, 2015), 149–50, cat. no. 14 (Lieke Smits).

26 New York, Metropolitan Museum of Art, inv. no. 15.126.1, with the ground bound in twill instead of a satin weave.

27 Formerly Berlin, Kunstgewerbemuseum, inv. no. K 6138 (war loss); see Julius Lessing, *Die Gewebe-Sammlung des Königlichen Kunstgewerbe-Museums*, 11 vols., 2nd ed. (Berlin: Ernst Wasmuth, 1913), plate 183b; von Falke, *Seidenweberei*, 2:89, fig. 464.

28 See Ruth Grönwoldt, "Paramente und ihre Stifter: Italienische Paramente des Trecento in zwei französischen Kathedralen," in *Festschrift Ulrich Middeldorf*, ed. Antje Kosegarten and Peter Tigler (Berlin: Walter de Gruyter, 1968), 81–87, at 81–83, plate 42; Grönwoldt, *Paramentenbesatz*, 130, 260.

29 Otavský and Wardwell, *Zwischen Europa und China*, 309.

30 Otavský and Wardwell, *Zwischen Europa und China*, 310.

31 For the beginnings of figured velvet weaving in Europe, see Lisa Monnas, "Developments in Figured Velvet Weaving in Italy During the Fourteenth Century," *Bulletin de Liaison du Centre International d'Étude des Textiles Anciens (CIETA)* 63–64 (1986): 63–100; Michael Peter, "Velvets of the Fifteenth Century: Art, Technique, and Business," in *Velvets of the*

the weaving itself were complex and time-consuming. The pattern is formed not by the weft, but by an additional system of warp threads that are passed over thin metal rods inserted individually during weaving to create a pile over a foundation weave. The pile warp requires six times more thread than that used by the main warp of the foundation weave, so that velvets consumed far more silk than flat-woven textiles. Velvets correspondingly represented the most expensive of all silk fabrics and were much sought after at court and by the church for their ability to confer an aura of authority and wealth on those who wore or used them.

With weft-patterned silks, it was easy for the weaver to change the colour scheme of the pattern during the weaving process. All that was needed was to exchange the weft threads.[32] With velvets, by contrast, such a change could only be achieved with great effort. Their warp-patterned structure usually did not allow such changes to be made during the weaving process. Re-entering the complete warp for an on-demand colour change would have incurred enormous extra costs.

Nonetheless, the high costs and, consequently, high earning potential of the velvets made them the focus of new business opportunities. The manufacture of velvets became the main field of technical and economic innovation. Despite, or perhaps precisely because of, their high-cost production, it was particularly through the velvets that the Italian silk-weaving industry succeeded in achieving a new level of flexibility, market adaptation, and customer orientation. The solution was simple and mainly involved diversifying production. The range of products was enlarged, in order to serve as many different customer interests as possible and to reach an ever-broadening circle of clients.[33]

Production underwent a process of optimising costs and work efficiency leading to the execution of standardised pattern types that were woven in large quantities with numerous variations in colour and design. Production was divided among several looms that all wove different variants of a basic design at the same time. The serial production of a single pattern developed into the production of entire series of patterns. The variants in the series differed only in a few details that were modified or interchanged within a highly restricted repertoire of motifs. Furthermore, a single variant of a design was woven using varying thread count, both in the warp and in the weft. Starting from around 1470, a new quality of velvet was produced, in which the ratio of pile warp ends to main warp ends was doubled to create a denser and more durable pile. In order to compensate for the higher warp count, the warp-pattern step of the pile was also doubled, so that the same design could be woven in both lighter and

 Fifteenth Century, ed. Michael Peter (Riggisberg, Switzerland: Abegg-Stiftung, 2020), 9–20, at 11–14.

32 See Schorta, "Von Mustern und Webstühlen," 36.

33 Sergio Tognetti, *Un'industria di lusso al servizio del grande commercio: Il mercato dei drappi serici e della seta nella Firenze del Quattrocento* (Florence: Leo S. Olschki, 2002), 114–18. See also Lisa Monnas, *Merchants, Princes, and Painters: Silk Fabrics in Italian and Northern Paintings* (New Haven, CT: Yale University Press, 2008), 26; Peter, "Velvets of the Fifteenth Century," 17.

Serial Production in Silk Weaving

heavier qualities without changing the figure harness.[34] In this way, identical patterns were produced at different prices to appeal to a broader range of clients.

It is clear from this that such comprehensive series of pattern variations were not launched by individual weavers or workshops, but rather were financed, planned, and organised by an entrepreneur, who stipulated the design and spread the work to a group of contractors that could be expanded as soon as the design proved successful.[35] The lengthy preparatory work by the suppliers, as well as the time-consuming setting up of the looms, generated costs that could only be recovered much later, with the sale of the fabrics. They required advance financing through credit,[36] and it is telling that, alongside silk weaving, trade and banking also rose to become leading business sectors, providing the basis for the economic and political development of the Italian city-states.[37]

The need to rationalise and increase efficiency gradually affected all kinds of velvets. Even high-end production was affected, including costly cloth-of-gold velvets, in which not only large parts of the pattern but also the whole background of the design is brocaded with gold. From the 1470s, countless variations on only a few pattern types of cloth-of-gold velvets were put on the market.[38] These variants were available in clearly distinct grades of quality, distinguished by weaving material and weft proportion (i.e. by the amount of gold included) and by the more or less refined outline of the design.

34 This applies, for example, to a group of velvets that includes a chasuble back in Riggisberg, Abegg-Stiftung, inv. no. 4000, Italy, ca. 1470–80, all of which show the same pattern design, some of them with a proportion of 3 main warp ends to 1 pile warp end and a warp pattern step of 2 pile warp ends, the others with a proportion of 6 main warp ends to 1 pile warp end and a warp pattern step of 1 pile warp end. See Michael Peter, *Mittelalterliche Textilien,* vol. 4: *Samte vor 1500,* 2 vols. (Riggisberg, Switzerland: Abegg-Stiftung, 2019), 2:300–303, cat. no. 59, at 302. For further examples, see 1:225–26, 230, 257–58, and 2:299.

35 Raymond Adrien De Roover, *The Rise and Decline of the Medici Bank, 1397–1494* (New York: W. W. Norton, 1966), 167–93; Florence Edler de Roover, "Andrea Banchi, Florentine Silk Manufacturer and Merchant in the Fifteenth Century," *Studies in Medieval and Renaissance History* 3 (1966): 223–85, at 237–56; William Caferro, "The Silk Business of Tommaso Spinelli, Fifteenth-Century Florentine Merchant and Papal Banker," *Renaissance Studies* 10 (1996): 417–39, at 425–32.

36 See Edler de Roover, "Andrea Banchi," 227–28; Richard A. Goldthwaite, "Local Banking in Renaissance Florence," *Journal of European Economic History* 14, no. 1 (1985): 5–55, at 19–31; Tognetti, *Un'industria di lusso,* 43–60, 155–59; Richard A. Goldthwaite, *The Economy of Renaissance Florence* (Baltimore: Johns Hopkins University Press, 2009), 204–30, 451–52, 458–68.

37 See Goldthwaite, "Local Banking," 37–50; Reinhold Christopher Mueller, *The Venetian Money Market: Banks, Panics, and the Public Debt, 1200–1500* (Baltimore: Johns Hopkins University Press, 1997), 3–32, 81–120; Thomas Ertl, "Silkworms, Capital and Merchant Ships: European Silk Industry in the Medieval World Economy," *Medieval History Journal* 9 (2006): 243–70, at 255–56; Goldthwaite, *Economy of Renaissance Florence,* 13–20.

38 Peter, *Samte vor 1500,* 2:321–63, cat. nos. 65–69.

Michael Peter

The same pattern was woven with two, or with one, brocaded metal threads in a pass.[39] Variants with two yellow silk wefts instead of gold threads have also survived.[40] For less ambitious wares, thick and undyed silk of lower quality was introduced for the ground wefts,[41] using up to six picks with each lifting of the warp, in order to accelerate the pace of work. Thus, production output was raised, while labour and material costs were reduced.

THE ROLE OF THE TAILOR

It goes without saying that the growing standardisation of production and the expansion of the industry's clientele at the end of the fifteenth century took place primarily at the expense of exclusivity. However, along with economies of production, new forms of self-representation emerged. The warp-patterned structure of the velvets opened up new possibilities for fulfilling the customer's desire for luxury and individuality.

While the weft-patterned fabrics of the fourteenth century were distinguished by small motifs, densely packed compositions, and rapid repetitions of pattern units, the fifteenth century saw a fundamental change, as warp-patterned velvets became the leading genre in textile art. Here the ornament was aligned lengthwise instead of breadthwise, in warp direction instead of weft direction. The new pattern designs were characterised technically by the ever-greater height of the repeats and artistically by the increasing dynamism and monumentality of the forms.[42]

This change found its most significant expression in the cloth-of-gold velvets with large-scale wavy-vine design, as evidenced, for example, by a velvet panel in Riggisberg (figs. 2.7 and 2.8),[43] which has a repeat height of 180 centimetres (almost 2 yards), and a length of velvet in Boston (fig. 2.9),[44] which has a repeat height of about 260 centimetres (about 2⅞ yards). Both of these are surpassed by the famous shoulder cape

39 Lisa Monnas, *Merchants, Princes, and Painters*, 26, fig. 24. Further examples include a panel of cloth-of-gold velvet in Bern, Switzerland, Bernisches Historisches Museum, inv. no. 21, and a chasuble in Chiavenna, Italy, Collegiata di San Lorenzo, Museo del Tesoro, Italy, ca. 1470, showing an identical pattern design, the chasuble in Chiavenna with two, the panel in Bern with one gold pattern weft in the pass; see Chiara Buss, ed., *Silk, Gold, Crimson: Secrets and Technology at the Visconti and Sforza Courts*, exhibition catalogue, Milan, Museo Poldi Pezzoli (Milan: Silvana, 2009), 77, cat. nos. 6 and 7 (Buss and Marie-Hélène Guelton), and "Weaving Techniques" (Guelton), 165–66, figs. cat. 6 and 7.
40 Length of velvet, Italy, ca. 1480–90, in Prato, Museo del Tessuto, inv. no. 75.01.30; see Rosalia Bonito Fanelli, *Il museo del tessuto a Prato: La donazione Bertini* (Florence: Centro Di, 1975), 65, cat. no. 8; *Lo Stile dello Zar*, 165, cat. no. 56.
41 Guelton, "Weaving Techniques," 166; Peter, *Samte vor 1500*, 2: 321–63, cat. nos. 65–69.
42 On this topic, see Peter, *Samte vor 1500*, 1:15–18; Peter, "Velvets of the Fifteenth Century," 13–15.
43 Riggisberg, Abegg-Stiftung, inv. no. 1976; see Peter, *Samte vor 1500*, 1:97–103, cat. no. 15.
44 Boston, Museum of Fine Arts, inv. no. 31.140; see Peter, *Samte vor 1500*, 1:270–75 cat. no. 53, at 273.

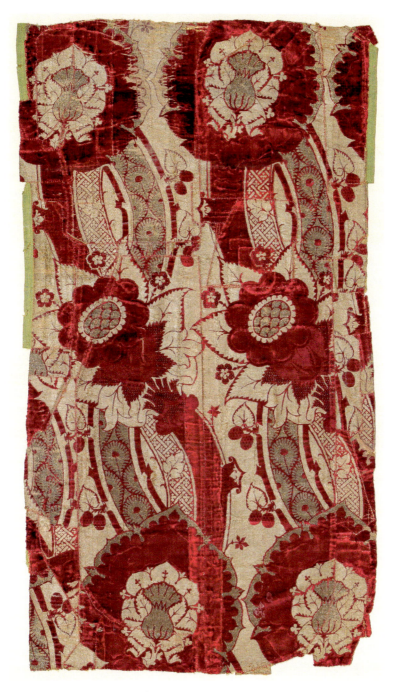

Fig. 2.7: Panel of cloth-of-gold velvet with wavy-vine design, Italy, ca. 1430–40. Riggisberg, Abegg-Stiftung, inv. no. 1976. Photo: Abegg-Stiftung, Riggisberg, 2015 (Christoph von Viràg).

Fig. 2.8: Pattern reconstruction of the velvet panel in fig. 2.7. Drawing: Abegg-Stiftung, Riggisberg, 2019 (Corinna Kienzler).

Serial Production in Silk Weaving

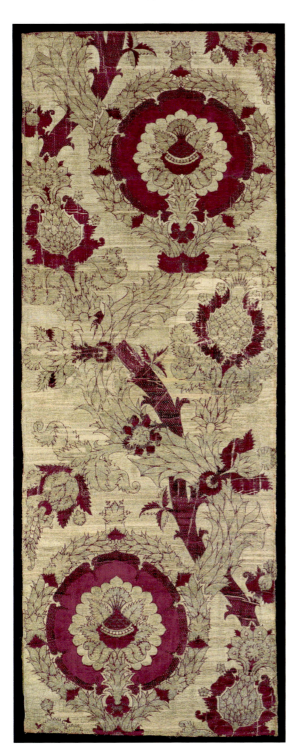

Fig. 2.9: Length of cloth-of-gold velvet with wavy-vine design, Italy, ca. 1470. Boston, Museum of Fine Arts, inv. no. 31.140. Photo: Museum of Fine Arts, Boston.

Michael Peter

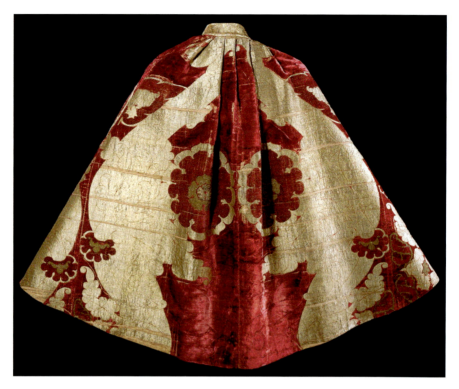

Fig. 2.10: Shoulder cape, brocaded velvet, Italy, ca. 1430–40. Bern, Bernisches Historisches Museum, inv. no. H/23. Photo: Bernisches Historisches Museum, Bern (Stefan Rebsamen).

in Bern (figs. 2.10 and 2.11),[45] which originally served as a cope for liturgical use. Its pattern repeat even reaches 280 centimetres (over 3 yards) in height.[46]

The ever-longer repeat of the pattern designs had far-reaching consequences for luxury dress in the late Middle Ages. It opened up completely new possibilities for meeting the urban and courtly elite's desire for luxury. The very fact that the fabrics could be used without their pattern being repeated on the garment lent these vestments the character of customised wares that were extraordinarily precious and exclusive.

45 Bern, Bernisches Historisches Museum, inv. no. H/23; see Mechthild Flury-Lemberg, *Textile Conservation and Research: A Documentation of the Textile Department on the Occasion of the Twentieth Anniversary of the Abegg Foundation* (Bern, Switzerland: Abegg-Stiftung, 1988), 442–45, figs. 922–30, and 462, cat. no. 8; Gabriele Keck, Susan Marti, and Till-Holger Borchert, eds., *The Splendours of the Burgundian Court: Charles the Bold (1433–1477)*, exhibition catalogue, Bern, Bernisches Historisches Museum, and Bruges, Bruggemuseum (Antwerp: Mercatorfonds, 2008), 272–73, cat. no. 86 (Annemarie Stauffer), plates 30–31.

46 Flury-Lemberg, *Textile Conservation*, 462, cat. no. 8.

Serial Production in Silk Weaving

The tall repeats, which often exceeded the height of the body, also made it possible to select parts of a pattern and to combine them in a completely new way—recumbent or upright, symmetrical, asymmetrical, or in staggered rows—so that the original structure of the ornament, as well as the serially produced nature of the fabric, could no longer be recognised.

How the appearance of the pattern could be altered by the cutting of the fabric can be seen, for example, in a chasuble and a cope (figs. 2.12 and 2.13) that David of Burgundy, Bishop of Utrecht from 1456 to 1496, donated to the Church of St. John in Utrecht.[47] The front and back of the vestments, when worn, each display a different decoration created from the same pattern design. The individual components of the ornament are detached from their position in the continuous course of the pattern design to form new and independent compositions, in which the original pattern no longer played a role. The undulating tendrils and palmettes (radiating petaled leaves) are arranged opposite to and mirroring each other, both on the front and on the back, while they follow one another in sequence along the length of velvet. This also applies to the aforementioned shoulder cape in Bern,[48] where the pattern sections were once again selected in such a way that a symmetrical arrangement of the originally asymmetrical pattern resulted on the back side. Another possible variation is shown by two copes,

Fig. 2.11: Pattern reconstruction of the velvet in fig. 2.10. Photo montage: Abegg-Stiftung, Riggisberg, 1962 (Mechthild Flury-Lemberg).

47 Liege, Belgium, Sint-Pauluskathedraal (chasuble), and Utrecht, Museum Catharijneconvent, inv. no. OKM t89 (cope); see *Schilderen met gouddraad en zijde*, exhibition catalogue (Utrecht, Netherlands: Rijksmuseum Het Catharijneconvent, 1987), 112–13, cat. nos. 22 and 24 (Tuuk Stam), plates 152, 154–55; Leeflang and van Schooten, *Middeleeuwse Borduurkunst*, 194–99, cat. no. 48 (Richard de Beer).

48 For the reconstruction of the pattern repeat, see Flury-Lemberg, *Textile Conservation*, 445, fig. 927.

Michael Peter

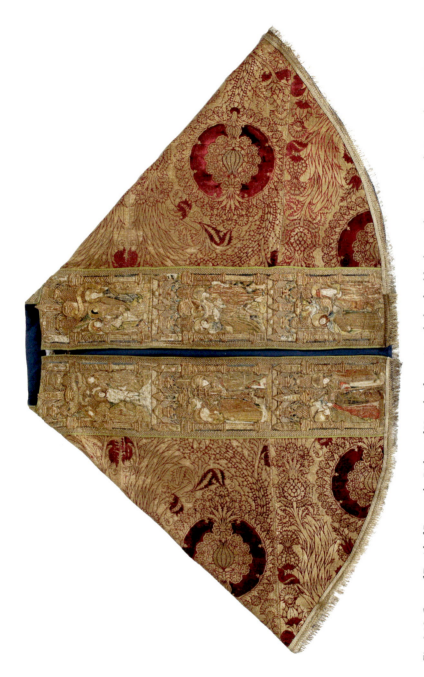

Fig. 2.12: Cope of David of Burgundy, Bishop of Utrecht, front view, cloth-of-gold velvet with wavy-vine design, Italy, ca. 1470–80. Utrecht, Museum Catharijneconvent, inv. no. OKM t89. Photo: Museum Catharijneconvent, Utrecht (Ruben de Heer).

Serial Production in Silk Weaving

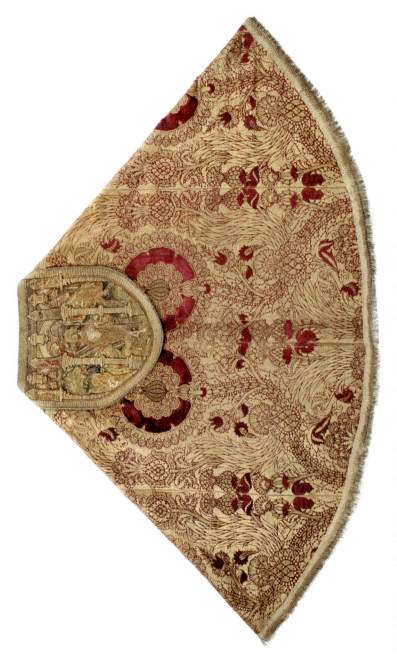

Fig. 2.13: Cope of David of Burgundy; Bishop of Utrecht, back view; cloth-of-gold velvet with wavy-vine design, Italy, ca. 1470–80. Utrecht, Museum Catharijneconvent, inv. no. OKM t89. Photo: Museum Catharijneconvent, Utrecht (Ruben de Heer).

Michael Peter

one in Utrecht[49] and one in Västerås,[50] which display the same vertically ascending wavy-vine design once in an oppositely symmetrical and once in an asymmetrically offset arrangement.

Serially produced fabrics were thus transformed into one-of-a-kind garments whose prestigious effect was created less by the pattern designer or weaver than by the tailor, who stepped between the manufacturer and the buyer to give his client back something of the latter's former role as patron, something which had been lost in serial production.

WOVEN-TO-SHAPE VESTMENTS

The growing uniformity and dissemination of velvet production also generated, conversely, new high-priced product lines and luxury business models. The increasing use of standard patterns gave rise to a new desire for individualised designs that were woven as special commissions. This new demand found its finest outlet in cloth-of-gold velvets that were woven to shape.[51] These velvets probably represent the clearest reaction of the social elites to the growth of serial production, which captured ever-broader customer strata. The few surviving works are attested exclusively for patrons of the highest rank: in the fifteenth century, only kings and popes are recorded as donors. Their heraldic devices, coats of arms, or portraits always form the centre of the composition.

First and foremost among these is the altar frontal of Sixtus IV (1414–84) in Assisi (fig. 2.14),[52] which contains a full-length portrait of the pope venerating St. Francis in the centre and the coat of arms of the della Rovere family with the pope's name and title on the sides. The composition and structure of the design point to the loom having a complicated technical construction. Its setup required a figure harness with four alternating drawing systems using four different sets of lashes. With two pile warp systems for the colours red and green and an original length of more than four metres, a drawloom with more than 1,300 tail cords and almost 2,800 lashes was necessary,

49 Utrecht, Museum Catharijneconvent, inv. no. BMH t5788 b; see *Schilderen met gouddraad en zijde*, 114–15, cat. no. 35 (Tuuk Stam), plate 168; Leeflang and van Schooten, *Middeleeuwse Borduurkunst*, 228–31, cat. no. 70 (Micha Leeflang).

50 Västerås, Sweden, Dom, Skattkammaren [Cathedral Treasury]; see Agnes Branting and Andreas Lindblom, *Medeltida vävnader och broderier i Sverige,* vol. 1: *Svenska arbeten,* vol. 2: *Utländska arbeten* (Uppsala: Almquist & Wiksell, 1928–29), 1:116, plate 96.

51 Lisa Monnas, "The Vestments of Henry VII at Stonyhurst College: Cloth of Gold Woven to Shape," *Bulletin du Centre International d'Étude des Textiles Anciens (CIETA)* 65 (1987): 69–79, at 74.

52 Assisi, Italy, Basilica di San Francesco, Museo del Tesoro, Italy, ca. 1470–80; see Rosalia Varoli-Piazza, ed., *Il Paliotto di Sisto IV ad Assisi: Indagini e intervento conservativo* (Assisi, Italy: Casa Editrice Francescana, 1991), 3–7, figs. 1–3; and 97–114, figs. 1–12; Marta Cuoghi Costantini and Jolanda Silvestri, eds., *Capolavori restaurati dell'arte tessile,* exhibition catalogue, Ferrara, Casa Romei (Bologna, Italy: Nuova Alfa, 1991), 103–5, cat. no. 17 (Rosalia Varoli-Piazza); Monnas, *Merchants, Princes, and Painters,* 58, figs. 50 and 51a–c.

Serial Production in Silk Weaving

Fig. 2.14: Altar frontal of Pope Sixtus IV, polychrome cloth-of-gold velvet woven to shape, Italy, ca. 1470–80. Assisi, S. Francesco, Museo del Tesoro. Photo: Archivio fotografico del Sacro Convento di San Francesco in Assisi.

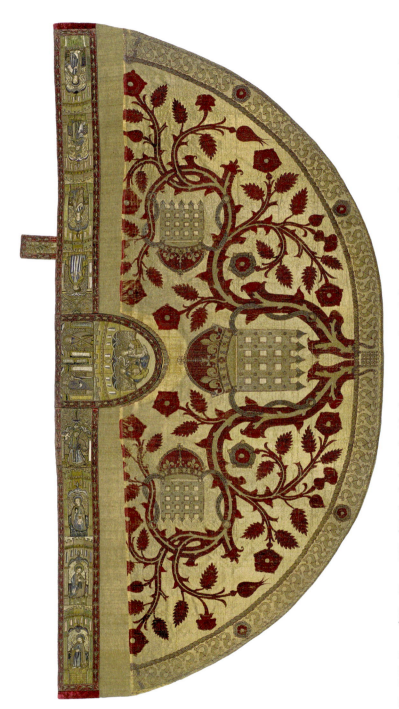

Fig. 2.15: Cope of King Henry VII of England, cloth-of-gold velvet woven to shape, Italy, 1498–1502. Lancashire, Stonyhurst College. Photo: Trustees of the British Jesuit Province, Jesuits in Britain.

Serial Production in Silk Weaving

which amounts to three to five times the number of tail cords and lashes of a regular cloth-of-gold velvet of the time.[53]

A similarly elaborate loom setup was installed for the cope of King Henry VII of England (1457–1509) at Stonyhurst College (fig. 2.15).[54] Its decoration shows the crown of England set above a portcullis, the heraldic badge of the house of Beaufort, with the red rose of Lancaster and the Tudor rose set amidst scrolling rose stems, with the curving hem bordered by the Lancastrian collar of SS. With a length of 314 centimetres (almost 3½ yards) and a width of 140 centimetres (about 1½ yards), it required a figure harness with 2,240 tail cords and 1,400 lashes.[55] Two throne dorsers for King Matthias Corvinus of Hungary (1458–90)—one of which was later altered into a chasuble—represent further examples of this type of cloth-of-gold velvet woven to shape.[56]

The expense and intricacy of these vestments went beyond that of any other textile of the period. The effort involved in their execution was not only due to the preciousness of the material and the tedious and complicated setup of the extensive figure harnesses. The unusual dimensions and outline forms of the velvets also required the construction of particularly broad looms, as the irregular shape and size of the fabrics far exceeded the measurements of an ordinary velvet loom.[57] Such looms could only be used for rare special commissions—the rest of the time they represented dead capital.

Thus, the looms alone constituted an enormous investment for the merchant or workshop entrepreneur, the costs of which—unlike in the case of serial fabrics produced for the market—could not be compensated by the serial repetition of the pattern. The costs of the loom, the setup of the figure harness, the raw materials, and indeed the entire supply chain were therefore likely to have been borne by the client.

TECHNICAL INNOVATIONS

Taking into account the enormous costs involved in the production of such individual pieces and the very impressive effect of their personalised designs, it is hardly surprising that mixed forms of serial and individually commissioned production soon emerged

53 See Michael Peter, "Samte mit gewebten Inschriften," in *Über Stoff und Stein: Knotenpunkte von Textilkunst und Epigraphik*, ed. Tanja Kohwagner-Nicolai, Bernd Päffgen, and Christine Steininger (Wiesbaden, Germany: Harrassowitz, 2021), 121–40, at 130–31, figs. 6–7.

54 Stonyhurst College, Lancashire, England: Italy, dated 1498–1502; see Monnas, "Vestments of Henry VII," 69–79, figs. 1–7; Monnas, *Merchants, Princes, and Painters*, 60, fig. 52; Lisa Monnas, *Renaissance Velvets* (London: V&A Publications, 2012), 27–28, plates 26–27.

55 Monnas, "Vestments of Henry VII," 78; Peter, "Samte mit gewebten Inschriften," 131.

56 Budapest, Magyar Nemzeti Múzeum, inv. nos. 1960.190 and T.1981.197, Italy, ca. 1470; see *Hungaria Regia 1000–1800: Fastes et défis*, exhibition catalogue, Brussels, Palais des Beaux-Arts, Europalia 1999 (Turnhout, Belgium: Brepols, 1999), 135–36, cat. no. 57 (Lilla Tompos); *Matthias Corvinus the King: Tradition and Renewal in the Hungarian Royal Court*, exhibition catalogue (Budapest: Történeti Múzeum, 2008), 196, cat. no. 2.1 (Lilla Tompos).

57 Monnas, "Vestments of Henry VII," 78.

Michael Peter

for a broader clientele, in which coats of arms, personal badges, or the inscriptions of individual clients were combined with an existing design.

Examples of the latter include a velvet fragment with undulating vines and palmettes in New York (fig. 2.16),[58] which was given an individualised form by woven-in coats of arms with a motto, while the serial version of the design, which survives in a chasuble in Kielce,[59] shows the wavy-vine design without a coat of arms, in a different colour scheme and with the usual fruit-and-flower fillings in the centre of the palmette. A number of variants on the design, including a chasuble in Leipzig,[60] as well as three chasuble offcuts in London[61] and a fragment in Vienna,[62] offer further evidence that the velvet with coat of arms in New York was spun off from an already existing series production.

The same probably holds true of another cope belonging to Bishop David of Burgundy in Utrecht (figs. 2.17 and 2.18).[63] Its wavy-vine and palmette design features the bishop's device—flame, chip, and flint—while the other parts of the set of vestments show the serial execution of the pattern (fig. 2.19).[64] The cope is composed exclusively

58 New York, Metropolitan Museum of Art, inv. no. 46.156.141, Italy, ca. 1480–90; see Luigi Serra, ed., *L'antico tessuto d'arte italiana nella mostra del tessile nazionale*, exhibition catalogue, Rome, Circo Massimo (Rome: Libreria dello stato, 1937), 31, cat. no. 88, fig. 71; Adele Coulin Weibel, *Two Thousand Years of Textiles: The Figured Textiles of Europe and the Near East* (New York: Pantheon Books, 1952), 143–44, fig. 235.

59 Kielce, Poland, Bazylika katedralna, Scarbiec katedralny [Cathedral Treasury], Italy, ca. 1480–90; see Marta Michałowska, *Zabytkoe tekstylia Kieleckie: Katalog* [Historic textiles from Kielce: catalogue] (Warsaw: Ośrodek Dokumentacji Zabytków, 1989), 37, cat. no. 1, fig. 1.

60 Leipzig, Stadtgeschichtliches Museum, inv. no. KK 49, Italy, ca. 1480–90; see Hartmut Kühne, Enno Bünz, and Thomas T. Müller, eds., *Alltag und Frömmigkeit am Vorabend der Reformation in Mitteldeutschland: Katalog zur Ausstellung "Umsonst ist der Tod,"* exhibition catalogue, Mühlhausen, Museum am Lindenbühl; Leipzig, Stadtgeschichtliches Museum; and Magdeburg, Kulturhistorisches Museum (Petersberg, Germany: Michael Imhof Verlag, 2013), 118–20, cat. no. 2.3.4 (Christa Jeitner).

61 London, Victoria and Albert Museum, inv. nos. 8680-1863, 8680A-1863, 8680B-1863; Italy, ca. 1480–90; see Monnas, *Renaissance Velvets*, 102–3, cat. no. 26.

62 Vienna, Museum für angewandte Kunst, inv. no. T 00926-1865.

63 Utrecht, Museum Catharijneconvent, inv. no. ABM t2003, Italy, 1470–80; see Henri L. M. Defoer and Wilhelmina C. M. Wüstefeld, eds., *L'art en Hollande au temps de David et Philippe de Bourgogne: Trésors du musée Het Catharijneconvent à Utrecht*, exhibition catalogue, Paris, Institut Néerlandais, and Dijon, Musée des Beaux-Arts (Zwolle, Netherlands: Waanders Editeurs, 1993), 100–1, cat. no. 39; Leeflang and van Schooten, *Middeleeuwse Borduurkunst*, 200–1, cat. no. 49 (Micha Leeflang), fig. 6.11.

64 Utrecht, Museum Catharijneconvent, inv. no. OKM t90a-d, Italy, ca. 1470–80; see Monnas, *Merchants, Princes, and Painters*, 264, fig. 295; Leeflang and van Schooten, *Middeleeuwse Borduurkunst*, 194–99, cat. no. 48 (Micha Leeflang). Velvets with the serial version of the pattern design have also been preserved in a number of other collections: Bergen, Norway, Universitätsmuseet, inv. no. MA 51; Dresden, Germany, Kunstgewerbemuseum, inv. no. 28262; Kansas City, MO, Nelson-Atkins Museum of Art, inv. no. 31-113; Krefeld, Germany, Deutsches Textilmuseum, inv. no. 00129; Trent, Italy, Castello del Buonconsiglio, Monumenti e collezioni provinciali (two dalmatics). For the chasuble in

Serial Production in Silk Weaving

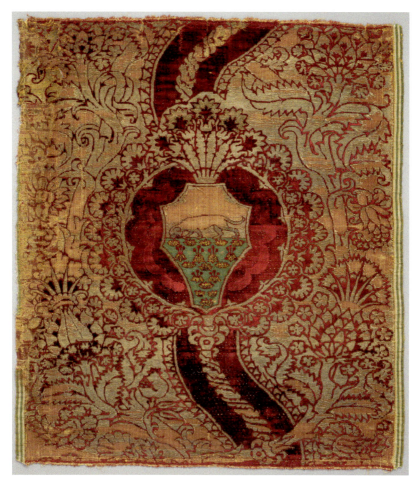

Fig. 2.16: Panel of cloth-of-gold velvet with armorial design, Italy, ca. 1480–90. New York, Metropolitan Museum of Art, inv. no. 46.156.141. Photo: Metropolitan Museum of Art, New York, Fletcher Fund, 1946.

of those short sections of the design that show the device, whereas the other vestments of the set use the entire pattern of vine scrolls and palmettes. Another example of such an individualised serial production has been preserved in an altar tablecloth made

Bergen that was donated by the local shoemaker's guild, see Justin Kroesen and Stephan Kuhn, *Middelalderens Kirkekunst: Universitetsmuseet i Bergen* (Regensburg, Germany: Schnell & Steiner, 2022), 199 cat. no. 94. For the two dalmatics in Trent, see Laura del Prà, Maria Carmignani, and Paolo Peri, eds., *Fili d'oro e dipinti di seta: Velluti e ricami tra Gotico e Rinascimento*, exhibition catalogue (Trent, Italy: Castello del Buonconsiglio, 2019), 356–59, cat. no. 78a–b (Laura del Prà and Paolo Peri).

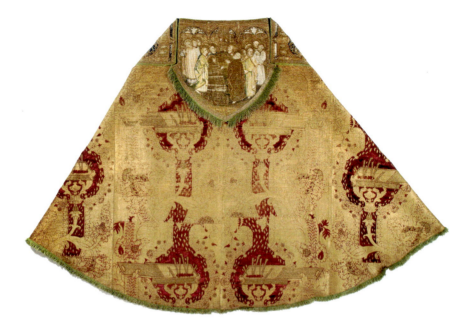

Fig. 2.17: Cope of David of Burgundy, Bishop of Utrecht, back view, cloth-of-gold velvet, Italy, ca. 1470–80. Utrecht, Museum Catharijneconvent, inv. no. ABM t2003. Photo: Museum Catharijneconvent, Utrecht (Ruben de Heer).

from the fragments of two copes belonging to Bishop Richard Foxe in Oxford,[65] in which the pomegranate motif at the centre of the symmetrical vine-scroll design is replaced at regular intervals by the bishop's motto and device.

In technical and economic terms, such modifications of an established pattern offered considerable advantages over a completely new design woven by special commission. They conferred on the fabrics an aura of the highest exclusivity while avoiding the enormous costs associated with an entirely new setup of the loom for only a limited production.

The insertion of a coat of arms or heraldic device also required the adaptation of the figure harness, but the changes were limited to those parts that had to be replaced

65 Oxford, Corpus Christi College, Italy, ca. 1500; see Cinzia Maria Sicca, "Fashioning the Tudor Court," in *Textiles and Text: Re-establishing the Links Between Archival and Object-based Research: Postprints*, ed. Maria Hayward and Elizabeth Kramer (London: Archetype, 2007), 93–104, at 94, fig. 4, colour plate 45; Florence Maskell, "The Investigation and Documentation of a Communion Table Carpet in Corpus Christi College, Oxford," in the same volume, 225–36, figs. 1–6; Lisa Monnas, "'Plentie and abundaunce': Henry VIII's Valuable Store of Textiles," in *The Inventory of King Henry VIII*, vol. 2, *Textiles and Dress*, ed. Maria Hayward and Philip Ward (London: Harvey Miller, 2012), 235–94, at 274, fig. 144.

Serial Production in Silk Weaving

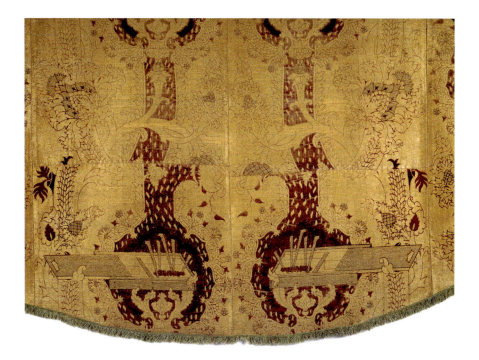

Fig. 2.18: Cope of David of Burgundy, Bishop of Utrecht, detail of fig. 2.17. Photo: Museum Catharijneconvent, Utrecht (Ruben de Heer).

by the new motif. The disadvantage of this method was that the changes had to be undone in order to resume serial production and parts of the harness had to be read in again. Another (better) possibility was the introduction of a supplemental figure harness by means of a movable comber board, which overrode the corresponding part of the original figure harness.[66] It could be exchanged for another supplemental figure harness or abandoned after the special order was completed.

The technique is one of the most groundbreaking inventions of late medieval silk weaving, the use of which can first be reliably proven in the linen-damask production of the late fifteenth century.[67] However, it seems probable that the method was originally invented for the highly developed velvet weaving of the time. A set of

66 Daniël De Jonghe, "Sur la technologie de la nappe aus armories, datée 1625, de Philip Lanchals, Seigneur de Dentergem," in *Leinendamaste: Produktionszentren und Sammlungen*, ed. Regula Schorta (Riggisberg, Switzerland: Abegg-Stiftung, 1999), 141–57, at 144–45 and 156–57, figs. 93 and 102.

67 De Jonghe, "Sur la technologie," 154–55; see also Anna Jolly and Agnieszka Woś-Jucker, "Zur Herstellungsmethode der Leinendamaste von 1527," in *Die Tafelwäsche des Ordens vom Goldenen Vlies*, ed. Mario Döberl (Riggisberg, Switzerland: Abegg-Stiftung, 2018), 71–75.

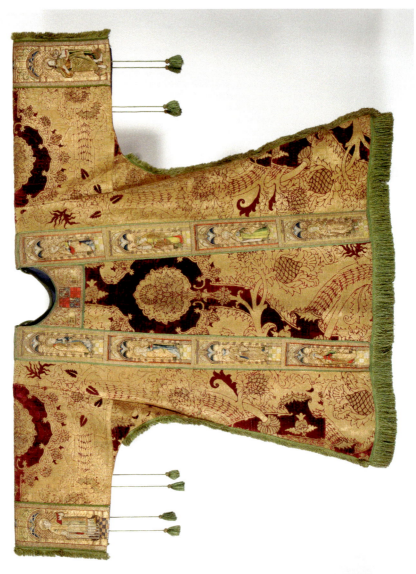

Fig. 2.19: Dalmatic of David of Burgundy, Bishop of Utrecht, back view, cloth-of-gold velvet, Italy, ca. 1470–80. Utrecht, Museum Catharijneconvent, inv. no. OKM t90b. Photo: Museum Catharijneconvent, Utrecht (Ruben de Heer).

Serial Production in Silk Weaving

vestments believed to have been made for Pope Nicholas V for the canonisation of St. Bernardino of Siena in the year 1450, in which specially commissioned figurative scenes are set into a conventional design, could be an early testimony to the introduction of this technique.[68]

The question of whether it was the ever-increasing desire for exclusivity and individual self-representation that led to the emergence of the new technique, or whether, conversely, it was progress in weaving technique and loom construction that allowed for these individualised serial products, should be left open. So too should the question of whether the new type of velvet woven to shape that arose in the fifteenth century should be seen as a trigger of this development or a reaction to it.

Nonetheless, that even such limited interventions in serial production were associated with considerable expense for the client can be illustrated by one of the few velvets for clients north of the Alps woven with an individualised serial design: the rood screen hanging of Albrecht of Brandenburg (1490–1545) in Halberstadt Cathedral (fig. 2.20).[69] The hanging is identified as a donation from Albrecht not only by large embroidered coats of arms, but also by a woven symbol of his power: the six-spoked wheel as the emblem of the Archbishopric of Mayence, which is chosen here as the highest-ranking of Albrecht's bishoprics in lieu of a personal motto or device. The wheel replaces the classical pomegranate motif in the centre of the palmette, as it survives on numerous velvets of the fifteenth and early sixteenth centuries. Works such as a velvet panel in Florence[70] or a small velvet fragment in Berlin[71] show versions of the pattern in serial production that are closely related in style and motif. The fact that even one of the greatest and most spendthrift patrons of the late Middle Ages was unable to change more than the simple pomegranate motif in the design sheds a telling light on the technical and organisational demands

68 Florence, Museo Nazionale del Bargello, inv. no. 72 V-83 V, Italy (Florence), ca. 1450; see Beatrice Paolozzi Strozzi, *Il parato di Niccolò V per il Giubileo del 1450* (Florence: Museo nazionale del Bargello, 2000); Monnas, *Merchants, Princes, and Painters*, 9, figs. 7 and 8; del Prà, Carmignani, and Peri, *Fili d'oro*, 174–84, cat. no. 1 (Marina Carmignani and Paolo Peri).

69 Halberstadt, Germany, Domschatzkammer, inv. no. 601, Italy, ca. 1510–20; see Barbara Pregla, "Die Paramente Albrechts aus den Domschätzen von Merseburg und Halberstadt," in *Der Kardinal Albrecht von Brandenburg: Renaissancefürst und Mäzen,* vol. 1: *Katalog,* vol. 2: *Essays,* ed. Thomas Schauerte and Andreas Tacke, exhibition catalogue, Halle an der Saale, Neue Residenz (Regensburg, Germany: Schnell & Steiner, 2006), 349–63, at 360, cat. no. 8, fig. 7; Harald Meller, Ingo Mundt, and Boje E. Schmuhl, eds., *Der heilige Schatz im Dom zu Halberstadt* (Regensburg, Germany: Schnell & Steiner, 2008), 300, cat. no. 87 (Michael Peter).

70 Florence, Museo nazionale del Bargello, inv. no. 59 F; see Rosanna De Gennaro, *Velluti operati del XV secolo,* vol. 2: *Col motivo de' "camini"* (Florence: Museo nazionale del Bargello, 1987), 30, cat. no. 7, fig. 10; Giovanni Curatola, ed., *Islam e Firenze: Arte e collezionismo dai Medici al Novecento*, exhibition catalogue, Florence, Gallerie degli Uffizi and Museo nazionale del Bargello (Florence: Giunti Editore, 2018), 200, cat. no. 16 (Elisa Gagliardi Mangilli).

71 Berlin, Kunstgewerbemuseum, inv. no. 62.130.

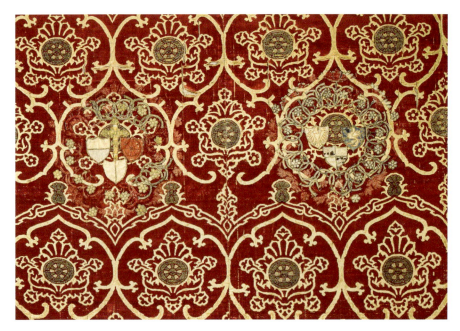

Fig. 2.20: Rood screen hanging of Albrecht of Brandenburg, detail, voided and brocaded velvet, Italy, ca. 1510–20. Halberstadt, Cathedral Treasury, inv. no. 601. Photo: Landesamt für Denkmalpflege und Archäologie Sachsen-Anhalt, Halle (Juraj Lipták).

that such alterations entailed for the work processes of the workshops, as well as on the costs they incurred for those who ordered them.

All the more evident here is once again the outstanding position occupied by the donation of Bishop Heinrich von Rotteneck, which, from the outset, was worked as an individual commission for Regensburg. In both its material and technical elaboration and its expense, it can only be compared to the woven-to-shape velvets of the late fifteenth century, but as a weaving with a figure subject, which lacks a mirror axis or repeat, it goes beyond even these. However, like all individually commissioned and designed works of silk weaving, it remained an exceptional case within the broader landscape of textile arts in the Middle Ages.

The Trousseau of Isabella Bruce, Queen of Norway (The National Archives, Kew, DL 25/83)

Valeria Di Clemente

The inventory of the bridal goods of Isabella Bruce, Queen of Norway, drawn up on 25 September 1293 in Bergen, is considered an important document concerning Scottish-Norwegian relationships at the end of the thirteenth century and has been studied and cited mainly by historians. On closer examination of the text, however, a number of interesting remarks can also be made on the diverse items that made up the trousseau of the Scottish-born queen, their manufacture, quality, fabric, material, colours, and purpose. The colours and decorations of the bedding sets and soft furnishings in particular seem to be linked to significant heraldic figures.

For this article, a palaeographic and linguistic analysis was carried out on a digital copy of the document. The findings contribute to an explanation for some problematic loci, which have led to a new identification of the author/scribe of the inventory and their origins.

The text shows a number of the linguistic features that have been identified in medieval British business documents. Additionally, the analysis sheds light on a couple of technical words found in the inventory whose interpretation is not clear (*banker²* was perhaps used as an adjective meaning "for the seats" and *palees* was perhaps a noun meaning "two-coloured vertical striped cloth"). The document also contains the Medieval Latin hapax *phalereteca* which might mean "a metal ornament similar to a *phalera*" or perhaps "a sort of lock similar to a *phalera*."

HISTORICAL CONTEXT

After the loss of part of their overseas empire in the 1260s, the Norwegian kings sought to re-establish ties with the Scottish crown. This was accomplished in August 1281 through the wedding of Margaret, daughter of Alexander III of Scotland, and the young king, Eiríkr II of Norway. Margaret was about six years older than her husband, who was about thirteen years old at that time. The marriage lasted less than two years:

I thank the reviewers for their comments and suggestions and Ms. Claire Owen for the linguistic revision of the text.

Margaret died giving birth to her only daughter, Margaret of Norway, probably on 9 April 1283. The Norwegian princess became the heir apparent to the Scottish throne after Alexander III's death, but she died on her way to Orkney in late September or early October 1290. As the heir of his late daughter, Eiríkr took part, albeit without success, in the Great Cause that took place between 1290 and 1292 in order to choose a new king of Scots.[1] In 1292–93, aged around twenty-four or twenty-five, he married for the second time: his choice fell upon another Scottish noblewoman, Isabella, probably the eldest daughter of Robert Bruce VI, *iure uxoris* earl of Carrick (and, as of 1292, also lord of Annandale), and Countess Marjorie of Carrick.[2] According to Barbara E. Crawford, Eiríkr "made a marriage alliance with the other failed claimant [to the Scottish throne in the Great Cause]."[3] The reasons why Eiríkr looked for a Scottish bride for the second time are significant: Norway still held feudal sovereignty on the Northern Isles (whose earls owed allegiance both to the king of Norway and to the king of Scots), Eiríkr had inherited his daughter's properties in Scotland, and the Scottish crown owed the king of Norway an annual payment of 100 merk for the Western Isles.[4]

A passport for travel from Britain to Norway was issued in favour of Robert Bruce of Carrick and his daughter Isabella on 28 September [1292?] in Skipton, Craven

1 The so-called "Great Cause" took place in 1291–92 to decide on the legitimate successor to the Scottish throne after the death of Alexander III (1286) and of his only granddaughter and heir, Margaret of Norway, in 1290. The danger of civil war led to an appeal for help to Edward I, King of England. Edward agreed to act as judge, but took advantage of the situation to claim suzerainty over Scotland. Among the thirteen claimants, those who had the best chances were John Balliol, as the grandson of the eldest daughter of David of Huntingdon (d. 1219), youngest brother of King William I; and Robert Bruce V of Annandale, son of David of Huntingdon's second daughter. Balliol's reasons prevailed, and he was named king in November 1292. See G. W. S. Barrow, "Competitors for the Throne of Scotland (*act. 1291–1292*)," in *Oxford Dictionary of National Biography*, online ed. (Oxford: Oxford University Press, 2004–; henceforth abbreviated as *ODNB*), https://www.oxforddnb.com (accessed Sept. 23, 2023).

2 Narve Bjørgo, "Eirik 2 Magnusson," in *Norsk Biografisk Leksikon* (online version, 2009), https://nbl.snl.no/Eirik_2_Magnusson (accessed April 24, 2021); A. A. M. Duncan, "Brus [Bruce], Robert de, earl of Carrick and lord of Annandale (1243–1304)," in *ODNB* (accessed May 28, 2022). We can hypothesise that Isabella was her parents' firstborn child or firstborn daughter because she bore the name of her paternal aunt, grandmother, and great-grandmother. According to a social trend that became customary in Scotland in the Early Modern era, eldest sons took the name of their paternal grandfather, and eldest daughters took the name of their paternal grandmothers; see Donald Whyte, *The Forenames of Scotland* (Edinburgh: Birlinn, 2005), xi. Isabella's birth year is not known, but she was born probably around 1272 or shortly after.

3 Barbara Crawford, "North Sea Kingdoms, North Sea Bureaucrat: A Royal Official Who Transcended National Boundaries," *Scottish Historical Review* 69, no. 188, *Studies Commemorative of the Anniversary of the Death of the Maid of Norway* (1990): 175–84, at 179.

4 The payment happened quite irregularly after the period from 1286 to 1290, to the extent that the Norwegians were forced to protest and repeatedly insist, not only to the Scots but also to Edward I of England, that the arrears be paid. See Ranald Nicholson, "The Franco-Scottish and Franco-Norwegian Treaties of 1295," *Scottish Historical Review* 38, no. 126, pt. 2 (1959): 114–32.

The Trousseau of Isabella Bruce

(Yorkshire) by King Edward I.[5] The passport was valid from the end of September to Christmas day of the same year. We can therefore hypothesise that the journey was undertaken by Lord Bruce to accompany his daughter to her betrothed. The crossing from Britain to Norway could last up to two weeks, and following the arrival, the welcome and wedding ceremonies may have required several days or weeks of preparation. The Icelandic annals record that the wedding of Eiríkr II and Isabella took place in 1293 (two versions of the annals record the year as 1294).[6]

THE DOCUMENT

The document recording Isabella's bridal goods was compiled on the Friday immediately before Michaelmas, i.e. on 25 September 1293, in Bergen, then the capital city of the Norwegian kingdom. Two Norwegian officials, Sir Auðun Hugleiksson and the English-born Master Weland of Stiklaw, received the trousseau from the hands of four envoys of the Earl of Carrick: Sir Ralph of Arden, Master Niall Campbell, Luke of Tany, and Henry of Stiklaw, Master Weland's brother. If the wedding had not already occurred by that time, it would have been imminent, and it is highly likely that Isabella was about to be crowned queen of Norway.

The original document is preserved in the National Archives, Kew, under the shelfmark DL [Documents of the Duchy of Lancaster, Deeds Series L] 25/83. It is a single parchment piece, where a bottom fold hosted the tags to which the signatories' seals were appended. The document was part of an indenture: the wavy upper margin signals that the piece has been detached from a larger folium. The document still shows two parchment tags. On one of these tags a fragment of green wax is still extant, the verso of which shows a legend where some letters are visible: ":….AVDO….SECRE….." This is likely to be the remains of Auðun Hugleiksson's seal.[7] It seems safe to assume that the document is the copy belonging to the Earl of Carrick, carried from Norway to the British Isles by Bruce's envoys; we can hypothesise that in the upper part of the original folium, the copy belonging to the Norwegian archives must have been transcribed, carrying the seals of Bruce's ambassadors. Confusion, nonetheless, arises around the description found on the National Archives website. Here, it is stated that the document is a "memorandum of the delivery to Sir Ralph of Arden and others, messengers from Sir Robert de Brus, Earl of Carrick, of robes, two small crowns, etc.,

5 Christian C. A. Lange et al., eds, *Diplomatarium Norvegicum*, 23 vols. (Christiania [Oslo]: Mallingske Boktrykkeri et al., 1847–; henceforth abbreviated as *DN*), 19:408, no. 379. A searchable electronic version of the *DN* is available at https://www.dokpro.uio.no/engelsk/index.html.

6 Gustav Storm, *Islandske Annaler* (Christiania [Oslo]: Grøndahl, 1888; repr., Oslo: Norsk Historisk Kjeldeskrift Institutt, 1977), 30, 51, 71, 144, 338, 357.

7 Examination of the digitised document, as well as Joseph Bain, ed., *Calendar of Documents Relating to Scotland*, vol. 2: *1272–1307* (Edinburgh: Her Majesty's Stationery Office, 1884), 158–59, no. 675, in an English translation; and *DN* 19:425–27, no. 390.

for the use of Isabel de Brus, Queen of Norway."[8] Yet, evidence from the text clearly tells us that Isabella's goods were not delivered *to* Ralph of Arden and his colleagues, but *by* them, to the Norwegian officials.[9] The writing, a minuscule, shows Gothic features (e.g. the <or>-ligature) and several letters with eyelets. The scribe makes extensive use of phonetic and morphological abbreviations and suspensions, and logograms such as the Tironian note <7>. Some writing errors have been detected, such as diplographies (<*Isasabel<le>>* instead of *Isabel<le>*, line 2) and perhaps visual mistakes (*de carde* instead of *de carda*, but see discussion under "Linguistic Aspects," page 87). The text occupies nineteen written lines. The parchment was folded in eight parts.

The document belongs to the text type called *liberatio* in British Medieval Latin, probably through Anglo-Norman *liveresun* ("delivery"). This document type was one through which a secretary or clerk from the royal (or a noble or high-standing) household recorded and inventoried portable goods including garments, furnishings, jewels, and silverware. Such goods could officially come into the possession of the household in the form of inherited goods, bridal goods, gifts, and so on. In the case of bridal trousseaus, the *liberatio* highlighted the social status of the person who brought these items into her new family.[10]

While the inventory of Isabella's bridal goods is widely quoted for its historical value, its form and content have not, as yet, been satisfactorily studied. Joseph Bain published a (rough) modern English translation of it in his *Calendar of Documents Relating to Scotland* (1884). A critical edition, not free from errors and misreadings, is found in the *Diplomatarium Norvegicum*.[11] A 1990 study by Barbara E. Crawford includes an interesting explanation of some items in the trousseau.[12] Finally, the Norwegian historian Randi Wærdahl has also used the text in order to reconstruct significant information about Isabella's tenure and role as queen of Norway.[13]

8 London, National Archives, document DL 25/83, https://discovery.nationalarchives.gov. uk/details/r/C5685171 (accessed Aug. 12, 2023).

9 In the *Thirty-Fifth Annual Report of the Deputy Keeper of the Public Records* (London: G. E. Eyre and W. Spottiswode, 1874), 32, no. 124, the role of the Anglo-Scottish envoys and the Norwegian officials is correctly reported.

10 Frédérique Lachaud, "Liveries of Robes in England, c. 1200–1330," *English Historical Review* 111, no. 441 (1996): 279–98, passim. See R. E. Latham et al., eds., *Dictionary of Medieval Latin from British Sources* (Oxford: Oxford University Press, 1975–2013; henceforth abbreviated as *DMLBS*), s.v. *liberatio* 1; William Rothwell et al., eds., *Anglo-Norman Dictionary*, online (2nd) ed. (London: Modern Humanities Research Association in conjunction with the Anglo-Norman Text Society, 2006–; henceforth abbreviated as *AND*), http://www.anglo-norman.net, s.v. *liveresun*.

11 Full citations at note 7.

12 Crawford, "North Sea Kingdoms," 183–84.

13 Randi Bjørshol Wærdahl, "Dronning Isabella Bruce," in *Eufemia: Oslos middelalderdronning*, ed. Bjørn Bandlien (Oslo: Dreyers Forlag, 2012), 98–108, at 103.

The Trousseau of Isabella Bruce

THE NORWEGIAN OFFICIALS AND THE ENVOYS OF THE EARL OF CARRICK

Sir Auðun Hugleiksson

The two officials acting on behalf of the Norwegian crown were important men in international politics and diplomacy at the end of the thirteenth century. The first one was Auðun Hugleiksson "Hestakorn." Auðun was born around the middle of the thirteenth century into a family of lesser nobility and received an excellent education, first at the Bergen cathedral school, then at the universities of Paris and Bologna. It seems that he contributed to the improvement of the Norwegian laws undertaken by King Magnús VI Hákonarson Lagabœtir. In the fragmentary *Saga of Magnús Lagabœtir*, composed by the Icelandic historian and poet Sturla Þórðarson at the end of the thirteenth century, Auðun is mentioned as having the title of *stallari* (marshall) around 1276.[14] During the reign of Eiríkr II Magnússon he held other diplomatic roles, such as a plenipotentiary envoy of the king of Norway in the British Isles and in France, and the administrative position of royal treasurer. However, he was disgraced after Eiríkr's death in July 1299, imprisoned by Hákon V Magnússon, then executed in 1302 at Nordnes after some years of incarceration. Auðun has been linked, although without firm evidence, to the so-called "false Margaret," a woman who around 1300 in Bergen claimed to be the late Princess Margaret Eiríksdóttir; this woman was tried and sentenced to the stake in 1302 on King Hákon V's orders.[15]

Master Weland of Stiklaw

Weland of Stiklaw is an interesting historical figure.[16] The first mentions of a Weland of Stiklaw appear in the documents from the 1280s onwards: he was a canon at Dunkeld and in 1283 was assigned the task of choosing the new bishop, alongside the dean, the chancellor, and other canons. In the following years he appears in charge of the royal chamber: it would be reasonable to hypothesise that he was Alexander III's chamberlain. Then, from the 1290s onwards he was in the service of the king of Norway. A document issued by English administrators of Scotland in 1297 testifies that he had been banished from the country.[17]

14 Gudbrand Vigfusson, ed., *Hakonar saga, and a Fragment of Magnus Saga, with an Appendix* (Edinburgh: Eyre and Spottiswode, 1887), 367.

15 Knut Helle, "Audun Hugleiksson," in *Norsk Biografisk Leksikon*, https://snl.no/Audun_Hugleiksson (accessed July 4, 2022); Storm, *Islandske Annaler*.

16 In the *Scalacronica* by Sir Thomas Gray of Heton (ca. 1356) it is reported that a "meistre Weland un clerc d'Escoce" had been sent by Edward I of England to Bergen in the summer of 1290 to be a member of Margaret of Norway's escort during her journey to Scotland and that he perished with her; see Sir Thomas Gray of Heton, *Scalacronica*, ed. Joseph Stevenson (Edinburgh: Maitland Club, 1836), 110. According to Barbara Crawford ("North Sea Kingdoms," 176–77), this report might represent a confusion between Margaret's voyage to Scotland and Isabella's voyage to Norway; both journeys seem to have taken place in the month of September, but in different years.

17 Crawford, "North Sea Kingdoms," 177.

On 1 April 1297 the English treasurer for Scotland, Hugh of Cressingham, signed a passage of safe conduct in his favour. In July 1297 Weland took part in the mission sent by Eiríkr II to Edward I, having a safe conduct which was valid for a year. English documents attest that Weland was reconciled with Edward I in 1302–3 and obtained the guardianship of Magnús, heir of the Orkney earldom. In that capacity he may have promoted the interests of Isabella Bruce, who was queen dowager of Norway from July 1299. Icelandic annals report that Isabella had arranged a marriage alliance between her daughter and Jón Magnússon in the first years of the fourteenth century, but Jón died in 1303. It seems that Weland became a lay official during his stay in Norway. In a document written on 10 December 1305 in Bergen, a "Velent af Stikl[an]" appears among the secular members of the king's council, even preceding the royal chancellor, Áke.[18] That Master Weland could attain this prestigious position may be explained by the strong support received from Isabella. He was among the few Norwegian officials who maintained their rank under Hákon V.[19] We have no further sources about Weland's life, but there is an indication that he was still alive and active in Orkney around 1306–7.[20]

The Anglo-Scottish envoys

Less is known about the Anglo-Scottish envoys. Ralph of Arden seems to have been the leader and the highest-ranking man in the Anglo-Scottish embassy: he is mentioned before his colleagues both in the initial and the final part of the document, and his name is always preceded by the honorific *dominus*. It is possible that he was a member of the powerful Arden family whose descendants held estates in the North and the South of England and in the Midlands.

Master Niall Campbell, as evidenced by his title, must have had a superior academic education. He was a member of the Campbell family, based in Western Scotland and traditionally allied to the Bruce family. A Master Niall Campbell was involved in the 1290–92 Great Cause on the side of Bruce. He appears twice in the 1296 *Ragman Roll* among the aristocrats of Western Scotland who pledged homage and fealty to Edward I after the 1296 invasion of Scotland (where he is mentioned as *Mestre Neel*

18 Crawford, "North Sea Kingdoms," 178; *DN* 3, no. 61.
19 Crawford, "North Sea Kingdoms," 181–82.
20 Crawford, "North Sea Kingdoms," 182. On Master Weland, see also Barbara E. Crawford, "The Earls of Orkney-Caithness and Their Relations with Norway and Scotland: 1158–1470" (Ph.D. diss., University of St. Andrews, 1971), 209–16; Barbara E. Crawford, "Weland of Stiklaw: A Scottish Royal Servant at the Norwegian Court," *Historisk Tidsskrift (Norsk)* 52, no. 4 (1973): 329–39; Ian Peter Grohse, "From Asset in War to Asset in Diplomacy: Orkney in the Medieval Realm of Norway," *Island Studies Journal* 8, no. 2 (2013): 255–68.

Cambel).[21] He has been identified by some scholars with Sir Niall Campbell of Loch Awe (d. ca. 1316), who later married Mary Bruce, one of Isabella's younger sisters.[22]

Luke of Tany was probably a relative (a son?) of Luke of Tany, a Yorkshire nobleman who had served as seneschal of Gascony and then *iustitiarius* of the royal forests south of the river Trent in Edward I's first regnal years and was killed at the beginning of November 1282 during an expedition in Wales.[23] A document preserved in the National Archives, which was written in French at Writtle (Essex) on 9 September (of an uncertain year but after 1292), contains a credence for a Luke of Tany from Robert Bruce, Earl of Carrick and Lord of Annandale, and is addressed to John of Langton, bishop of Chichester and chancellor of the English kingdom.[24]

Henry of Stiklaw, Master Weland's younger brother, was involved in international diplomacy and often travelled between the British Isles and Norway in the 1290s. In July 1297, when Weland took part in the mission sent by Eiríkr II to Edward I, Henry obtained a safe conduct in order to travel from the British Isles to Norway alongside the Norwegian envoy Þóre.[25]

The scribe

According to Knut Helle, the inventory of Isabella's bridal goods was drawn up by Auðun Hugleiksson in his function as royal *féhirdir* (treasurer).[26] However, a series of linguistic features found in the document suggests that the list had a more plausible British origin (see "Linguistic Aspects," page 87): the trousseau, after all, had been prepared in the household of a prominent Anglo-Scottish aristocrat. The Norwegian treasurer may have transcribed the inventory from a previous document, perhaps initially compiled in the British Isles by someone else, a secretary or clerk of the Earl

21 "Niall Campbell, Magister," People of Medieval Scotland 1093–1371 [database], https://www.poms.ac.uk/record/person/18970 (accessed July 31, 2021); and Thomas Thomson, ed., *Instrumenta publica sive processus super fidelitatibus et homagiis Scotorum domino regi Anglie factis, A.D. MDCCXCI–MDXCVI* (Edinburgh: Bannatyne Club, 1834), 126, 148.

22 Stephen Boardman, *The Campbells (1250–1513)* (Edinburgh: John Donald, 2006), 21–27.

23 Luke was appointed seneschal of Gascony by Henry III months before the king's death (1272) and held this office until July 1278; he was *iustitiarius* between 1281 and 1282. Michael Prestwich, "Tany, Sir Luke de (d. 1282)," in *ODNB* (accessed Dec. 26, 2021).

24 The National Archives, document SC 1/26/135, https://discovery.nationalarchives.gov.uk/details/r/C12217167 (accessed Aug. 9, 2021), and examination of a digital reproduction of the document. John of Langton was appointed chancellor in December 1292, after Robert Burnell's death, as shown by a congratulatory letter his brother Ivo sent to him between December 1292 and December 1293. M. C. Buck, "Langton, John (d. 1337)," in *ODNB* (accessed July 20, 2022); National Archives, document SC 1/27/76, https://discovery.nationalarchives.gov.uk/details/r/C12217314 (accessed July 20, 2022).

25 *DN* 19, 452–53, no. 410.

26 Helle, "Audun Hugleiksson": "betegnende nok var det Audun som i Bergen kvitterte for hennes brudeutstyr, trolig i egenskap av kongens fehirde" ("it is also significant that it was Audun who wrote the quittance for her [scil. Isabella's] trousseau in Bergen, surely in his capacity of treasurer of the king").

of Carrick, but some typical "English" features are also found in the initial and final part of the text, occurring for instance in the personal name *Weylando, Weylandus*.[27]

The author of this paper therefore considers it possible that the actual scribe may have been not Auðun Hugleiksson, but Master Weland, who came from North West England and had worked for the Scottish royal household, perhaps as Alexander III's chamberlain. Weland might have been the author of the whole document, or he might have personally composed only the initial and the final parts of it, while transcribing the central section from a previous text provided by the Anglo-Scottish envoys.

CONTENT

Isabella's garments

Isabella's outfits consist of four coordinated sets of garments (*robae*):[28] one *de scarleto*[29] *bruneto*,[30] one *de scarleto murreto*,[31] one of *camelinum, -us* (luxury fabric, resembling the colour of camel hair),[32] one of *bluetum, -us* (blue fabric),[33] each in a different colour (*burnetus* or dark brown;[34] *murretus* or murrey, mulberry colour;[35] white; blue). Each outfit consists of a *tunica* (tunic),[36] *suptunicale aptum, clausum, sine manicis* (surcoat; open, closed, or sleeveless;[37] in two cases the set includes both an open and a closed

27 The original stressed vowel of the name is /e:/, although it sometimes appears as /ai, æi/, perhaps due to folk etymology, which has caused a blend with *wei, wai* 'way, road' (see for instance the modern family name *Wayland*). In a Norwegian document dating from 10 December 1305, Weland's name has been adapted to the Norwegian spelling and pronunciation, *Velent*; *DN 3*, 69–70, no. 61.

28 *DMLBS*, s.v. *roba*; The Lexis of Cloth and Clothing Project database (henceforth abbreviated as LexP), http://lexissearch.arts.manchester.ac.uk, s.v. *robe* 1 (accessed July 2, 2022).

29 *Scarlet* was a luxurious fine woollen cloth. LexP, s.v. *scarlet*; John Munro, "Scarlet," in *Encyclopedia of Dress and Textiles in the British Isles c. 450–1450*, ed. Gale R. Owen-Crocker, Elizabeth Coatsworth, and Maria Hayward, online ed. (Leiden: Brill; 2016–). All articles cited to this reference can be found at https://referenceworks.brillonline.com/browse/encyclopedia-of-medieval-dress-and-textiles and were accessed Jan. 24, 2021, unless otherwise noted.

30 See note 34.

31 See note 35.

32 LexP, s.v. *cameline*; M. S. Giuseppi, "The Wardrobe and Household Accounts of Bogo de Clare, a.d. 1284–86," *Archaeologia* 70 (1920): 1–56, at 9, 30.

33 LexP, s.v. *bluet*; Wendy R. Childs, "Bluet (blewet)," in Owen-Crocker, Coatsworth, and Hayward, *Encyclopedia*.

34 LexP, s.v. *burnet*; Elizabeth Coatsworth and Mark Chambers, "Burnet," in Owen-Crocker, Coatsworth, and Hayward, *Encyclopedia*.

35 LexP, s.v. *murrey*. The murrey hue suggests the use of kermes as dyeing substance; see Wendy R. Childs, "Murrey," in Owen-Crocker, Coatsworth, and Hayward, *Encyclopedia* (accessed Aug. 12, 2023).

36 LexP, s.v. *tunica*.

37 Mark Chambers, "Surcote/surcoat," in Owen-Crocker, Coatsworth, and Hayward, *Encyclopedia*: "It is frequently described as being worn tight around the chest and stomach, buttoned, laced or otherwise fastened around the body or else slipped over the head. It

The Trousseau of Isabella Bruce

surcoat); *mantellū, clausum, aptū* (mantle, closed or open);[38] *caputī, caputiū* (hood: a hood-shaped head covering?);[39] *capa* (cape; the *robae* of murrey scarlet and white cameline include a lined cape, *capa furrat²*).[40] All sets are lined *de minuto vario* (with miniver),[41] except for the *bluet* mantle, which is lined *de grosso vario* (with *grosvair, grover*),[42] and the cameline outfit, which is lined *sindone forti* (with robust *sindon*).[43]

Bedding sets and other bedroom furnishings
The trousseau includes three bedding sets metonymically called *lectus* ("bed"),[44] which are respectively made of:

1. canvas of *carde (caneu(ac)² de carda/carde)*,[45] a red quilted mattress (*culte puncta rubea*),[46] two bed sheets (*duo linteamina*),[47] a blood-red scarlet cover lined with miniver

could be worn with or without sleeves, but is normally described as being sleeveless;" LexP, s.v. *supertunic, supertunica aperta, supertunica clausa.*

38 Maria Hayward, "Mantle," in Owen-Crocker, Coatsworth, and Hayward, *Encyclopedia* (accessed Aug. 19, 2022); LexP, s.v. *cloak, mantle; AND*, s.v. *mantel* (accessed July 4, 2022); *Middle English Dictionary*, online ed. (Ann Arbor, MI: University of Michigan Press, 2001–; henceforth abbreviated as *MED*), https://quod.lib.umich.edu/m/med, s.v. *mantel* (accessed July 4, 2022); W. A. Craigie et al., *Dictionary of the Older Scottish Tongue*, 12 vols. (Oxford: Oxford University Press, 1931–2002; henceforth abbreviated as *DOST*), electronic version at Dictionaries of the Scots Languages / Dictionars o the Scots Leid, https://dsl.ac.uk, s.v. *mantil*. A *mantellum* was a sleeveless overgarment to be worn over a tunic or similar item. A *mantellum apertum* was probably fastened at the neck or shoulder by ties or a brooch, while a *mantellum clausum* was to be put on over the head.

39 LexP, s.v. *caputium.*

40 LexP, s.v. *cap, cape*; Kirstie Buckland, "Caps," and Maria Hayward, "Cloak: post-1100," (accessed Aug. 19, 2022), both in Owen-Crocker, Coatsworth, and Hayward, *Encyclopedia.*

41 LexP, s.v. *miniver. Menuvair, minever, minutus varius*: furs made exclusively from the fur from the belly of the animal. It is predominantly white, with grey edging surrounding it; Maria Hayward, "Fur" and "Miniver," both in Owen-Crocker, Coatsworth, and Hayward, *Encyclopedia*; Elspeth M. Veale, *The English Fur Trade in the Later Middle Ages* (London: London Record Society, 2003), electronic version at British History Online, https://www.british-history.ac.uk/london-record-soc/vol38 (accessed July 4, 2022), 215–29.

42 LexP, s.v. *grover. Grosvair, grover*: used, in contrast to *menuvair*, of the whole squirrel skin and therefore in effect equivalent to *vair* and *bis* (Veale, *English Fur Trade*, 215–29).

43 *Sindon* (linen cloth) often used interchangeably with *cendal* (lightweight silk cloth); LexP, s.v. *sindon.*

44 See *DMLBS*, s.v. *lectus* 3.

45 LexP, s.v. *canvas, carde*; Wendy R. Childs, "Canvas," in Owen-Crocker, Coatsworth, and Hayward, *Encyclopedia; AND*, s.v. *canevas, carde* 1; *DOST*, s.v. *card* (variants *karde, caryd*); *MED*, s.v. *canevas, carde* 3, Walther von Wartburg et al., eds., *Französisches Etymologisches Wörterbuch* (Basel: R. G. Zbinden, 1922–67; Nancy: ATILF-CNRS & Université de Lorraine, 1993–; henceforth abbreviated as *FEW*), digitised version at https://lecteur-few.atilf.fr, s.v. *carduus* (accessed Nov. 5, 2022). *Carde* is a kind of fabric, possibly linen, used for curtains and linings.

46 *AND*, s.v. *coulte, culte; FEW*, s.v. *culcita*; LexP, s.v. *quiltpoint; MED*, s.v. *quilt(e.*

47 *DMLBS* and LexP, s.v. *linteamen.*

Valeria Di Clemente

(*vnū cooptoriū*[48] *de scarleto sanguineo furrat² de minuto vario*),[49] a coverlet of cloth of gold with the French coat of arms (*vnū couˢletʸ*[50] *de panno aureo*[51] *de armis Francie*)

2. canvas of *carde*, a saffron-yellow quilted mattress (*cult¹punta crocei coloris*), a cushion (*vñ cussiñ*),[52] two bed sheets (*duo linteamina*), a green cover lined with miniver (*cooptoriū viride furrat̄ de minuto vario*), a golden-red coverlet of cloth of gold printed with "golden talents" (*vñ couˢlettʸ*[53] *de pano aureo rubeo inpˢssū talentis aureis*)

3. canvas of *carde*, a green quilted mattress (*vnū cultepuncta virđ*), two bed sheets, a cover of *pers* (perse [dark blue] cloth) lined with grey squirrel fur (*cooptoriū de psico*[54] *furratˢ de grīˢ*[55]).

In addition, there was a bed curtain of *carde* (*vnū curtinv̄*[56] *de carda circa lectū*), four saffron-yellow hangings (*quatuor tapet²*[57] *crocei coloris*), and three *banker² palees* (interpreted as "[two-coloured] striped seat coverings," see "Linguistic Aspects," page 87).[58]

The regalia

The regalia, i.e. "items pertaining to the sovereign's person," were those garments and items for official use that the sovereigns and their consorts wore or had with them during their coronation and in the exercise of their functions.[59] They were particularly important on occasions such as coronations or investitures.[60] Medieval archaeological finds and extant figurative art of the period make it possible to know that a sovereign often had a crown for the coronation ceremony and a personal crown. In the case of queen or empress consorts, precious items such as crowns might be

48 Charles du Fresne du Cange et al, eds., *Glossarium mediae et infimae latinitatis* (Niort, France: Favre, 1883–87), electronic version at http://ducange.enc.sorbonne.fr; and *DMLBS*, s.v. *coopertorium*.
49 *DMLBS*, s.v. *varius 2*.
50 *AND*, s.v. *coverlit*; *MED* and LexP, s.v. *coverlet*; in Older Scots, *DOST*, s.v. *coverlat*.
51 Lisa Monnas, "Cloth of Gold," in Owen-Crocker, Coatsworth, and Hayward, *Encyclopedia*; LexP, s.v. *cloth of gold*.
52 Du Cange, *Glossarium*; and *DMLBS*, s.v. *cussinus*.
53 *DMLBS*, s.v. *coverletum, -s*.
54 Mark Chambers, "Pers," in Owen-Crocker, Coatsworth, and Hayward, *Encyclopedia*; LexP, s.v. *perse, persicum*.
55 LexP, s.v. *gris*; Veale, *English Fur Trade*; Maria Hayward, "Squirrel Fur," in Owen-Crocker, Coatsworth, and Hayward, *Encyclopedia*.
56 *DMLBS*, s.v. *curtina, -um*.
57 *DMLBS*, s.v. *tapes*; Du Cange, *Glossarium*, s.v. *tapetum*; but see also *DOST*, s.v. *tapet*; and *MED*, s.v. *tapete*.
58 Elizabeth Coatsworth, "Soft Furnishings and Textiles: Post-1100," in Owen-Crocker, Coatsworth, and Hayward, *Encyclopedia*.
59 *AND*, s.v. *regalie*; *DMLBS*, s.v. *regalia*; *MED*, s.v. *regali(e*.
60 Maria Hayward, "Royal Regalia: Post-1100," in Owen-Crocker, Coatsworth, and Hayward, *Encyclopedia*.

The Trousseau of Isabella Bruce

part of their nuptial goods or were presents by their husbands on the occasion of the wedding or coronation ceremony.[61]

Isabella's regalia are two pieces of red samite, two pieces of cloth of gold, four different pieces of cloth "for the queen," and a piece of silk cloth to make a cushion (*duo samits[62] ruþ, duo panni aurei quatuor pecie*[63] *de pannis diuerse -p regina. et vnus pannus de serico*[64] *ad faciend$^-$ cussiñ*).[65] According to Wærdahl, the pieces of cloth would have been used to make Isabella's coronation garments and overgarments. The piece of silk cloth was explicitly destined to make a cushion, where perhaps the crown would have been laid during the coronation ceremony,[66] or which may have been put on the throne where Isabella would sit.[67]

Silver tableware and other utensils

The trousseau also includes tableware and other utensils with their respective weight, which expresses their economic value: twenty-four silver vessels for food (*scutelle*)[68] with a weight corresponding to 30 marks 5 shillings, twenty-four salt cellars (*salsar$^?$*)[69] with a weight corresponding to 9 marks 10 shillings, twelve cups (*ciphi*)[70] with a weight corresponding to 12 marks, four wine pitchers (*pitalchi*)[71] with a weight corresponding to 16 [?][72] marks 5 shillings, four basins (*pelu$^-$*)[73] with a weight corresponding to 11 marks, and a censer (*turribil*) with a weight corresponding to 40 shillings (for the interpretation of the latter, see "Linguistic Aspects," page 87).

61 Hayward, "Royal Regalia: Post-1100."
62 Elizabeth Coatsworth, "Samite," in Owen-Crocker, Coatsworth, and Hayward, *Encyclopedia*; *AND*, s.v. *samit*; *DMLBS*, s.v. *samitum*; *DOST*, s.v. *samit*; *FEW*, s.v. *hexámitos*; LexP, s.v. *samite*; *MED*, s.v. *samit(e*.
63 The *pecia* was a unit of measurement typically used for cloth, whose value varied due to different customs and laws. It was measured by the yard or ell in length and by the quarter of a yard (about nine inches) in width. LexP, s.v. *piece* 1.
64 Rebecca Woodward Wendelken, "Silk: Cultivation of Silk," "Silk: Silk in the British Isles," and "Silk: Silk Road," all in Owen-Crocker, Coatsworth, and Hayward, *Encyclopedia*.
65 Although the trousseau includes two crowns, they are not listed with the regalia, but are mentioned at the bottom of the list, with other items such as chests, leather sacks, etc.
66 See Wærdahl, "Dronning Isabella Bruce," 98–108; "Isabella Bruce," in *Norsk Biografisk Leksikon*, https://nbl.snl.no/Isabella_Bruce (accessed April 24, 2021); Randi Wærdahl, "Bruce [Brus], Isabella (*d.* 1358)," in *ODNB* (accessed Dec. 26, 2021).
67 Crawford, "North Sea Kingdoms," 184.
68 *DMLBS*; Du Cange, *Glossarium*; and Jan Frederik Niermeyer and C. van de Kieft, eds., *Mediae Latinitatis Lexicon Minus: Medieval Latin Dictionary* (Leiden: Brill, 1976), s.v. *scutella*, which could indicate a sort of soup plate or bowl.
69 Du Cange, *Glossarium*, s.v. *salsarium*.
70 Charlton T. Lewis and Charles Short, *A Latin Dictionary* (Oxford: Clarendon Press, 1879), online version at https://www.perseus.tufts.edu/hopper (accessed April 4, 2022); and *DMLBS*, s.v. *scyphus*.
71 Du Cange, *Glossarium*, s.v. *pitallus*; *DMLBS*, s.v. *phitalphis, pitallus*.
72 The numeral is not clear, as there are two illegible spots in the text.
73 Du Cange, *Glossarium*; *DMLBS*; and Lewis and Short, *A Latin Dictionary*, s.v. *pelvis*.

Other items

The Earl of Carrick had provided three pairs of chests (*tria pia de cophinis*)[74] in which to store Isabella's garments and a pair (*vnū par*) of chests in which to store candles; three leather sacks with round, metal decorations (*tres sacc̓*[75] *de coreo cū tribȝ falereticis*[76]) for the wardrobe; two leather-covered baskets in which to store silverware (*duo panerī́*[77] *coopti de coreo -p vtensiliȝ argenteis*); and two small crowns, one larger than the other (*duo pue corone quarȝ vna maior 7 alia minor*), perhaps one for ceremonial and the other for personal use (see under "Regalia," above).

ISABELLA'S TROUSSEAU: SOME CONSIDERATIONS

The information given about the queen's garments and bedding sets is mainly about fabric, dye, and whether the single items are fur-lined or not (three details that indirectly suggest the expensiveness of the item).[78]

The garments are made from precious, luxurious, and/or exotic fabrics (*bluet*, cameline, scarlet). The colours of the queen's outfits are generally dark or cold (blue, dark brown, murrey); three of them are fur-lined. The *roba* of cameline was probably intended as a warm-weather outfit, as suggested by its white colour and the fact that it was lined with *sindon* cloth; it was to be worn with a sleeveless surcoat.

In contrast to the queen's garments, the bedding sets and soft furnishings are generally in brighter colours (various hues of red, saffron yellow, green, perse, two-coloured striped cloth). Each set includes canvas of *carde*, a quilted mattress, two bed sheets, and a cover (all covers are fur-lined with miniver or *gris*), to which two coverlets are added. The canvases were probably put on the (wooden?) bed frame, under the quilted mattress; if the *quatuor tapet̓ crocei coloris* referred to in the document are bed hangings,[79] we could think of Isabella's as a canopy bed, perhaps a four-poster one.[80] Precious fabrics are used for the bedding sets, especially for covers and coverlets (cloth of gold, *pers*, scarlet), and the bed furnishings are equipped for all seasons, as the fur-lined covers show. It should be noticed that the single items are listed from the bottom (the canvases of *carde*) to the top layer (the coverlets).

The two coverlets show decorative elements inspired by heraldry. The first one bears the *arma Francie* (fleurs-de-lis), probably embroidered or woven in the cloth of gold. The other is "a red coverlet of cloth of gold printed with golden talents" (*vn̄*

74 *DMLBS*, s.v. *cophinus*.

75 Du Cange, *Glossarium*; *DMLBS*; and Lewis and Short, *A Latin Dictionary*, s.v. *saccus*.

76 *DMLBS*, s.v. *phaleretica*.

77 Niermeyer, *Mediae Latinitatis*, s.v. *panerius, panarius*.

78 The cloth colour implicitly indicated the substances used in the dyeing process, their cost, and the difficulty of the dyers' job.

79 *AND*, s.v. *tappitt, tapitz*; *DMLBS*, s.v. *tapes, -eta, ete, etum*; *MED*, s.v. *tapet(e* n. They might have been wall hangings, used to cover the four walls of Isabella's room.

80 See for instance Penelope Eames, "Furniture in England, France and the Netherlands from the Twelfth to the Fifteenth Century," *Furniture History* 13 (1977): 1–303, at 73ff.

The Trousseau of Isabella Bruce

couslett2 de pano aureo rubeo inpsssū talentis aureis), i.e. round decorative motifs similar to the heraldic figure of the bezant. The bezant, as a heraldic figure, was inspired by the Byzantine *solidus* and imported to Europe by the Crusaders; in Early Modern English, it represented a gold coin or roundel (apparently originally a sign of pilgrimage to the Holy Land).[81] As a part of the clothing lexis, a *bezant* generally indicated a "gold or silver ornament made in a variety of shapes and patterns. Bezants could be stitched loosely to cloaks or hats [...] or they could be integral to embroidered ornaments."[82] The verb *inprimere*, however, suggests that the coverlet was a piece of printed cloth and that the round ornaments were printed on the cloth.

Far from being casual, the presence of bezants and fleurs-de-lis in Isabella's trousseau might well have had a symbolical or political meaning. The fleurs-de-lis embroidered or woven into cloth of gold might suggest a connection with France. It is not clear where the piece came from, although it is possible that it was a present given by a member of the French royal family who had significant links to Isabella's maternal or paternal relatives or ancestors.[83]

The coverlet printed with bezants, due to the technique by which it was made,[84] as well as by the motifs represented, may have been brought from the Middle East, perhaps directly by members of the Bruce family. Isabella's paternal grandfather, Robert Bruce V of Annandale, had participated in the so-called "Lord Edward's crusade" (the Ninth Crusade) alongside the future King Edward I. It is not certain if Isabella's father also participated in the Eighth and Ninth Crusades: a letter of protection was issued by Henry III in his favour on 10 July 1270, but we have no sure indications about his travel back to the British Isles.[85]

The colours of bedding sets and soft furnishings suggest that some expensive dyeing substances were used. The reference to *croceus color* possibly indicates that the

81 See James Parker, *A Glossary of Terms Used in Heraldry* (1894), searchable online version at The Heralds Network, https://www.heraldsnet.org/saitou/parker/index.htm; LexP; and *Oxford English Dictionary*, online ed., http://www.oed.com, all s.v. *bezant*.

82 LexP, s.v. *bezant*; *MED*, s.v. *besaunt*.

83 A few hypotheses can be formulated on this matter, but none of them can be fully assessed. Matthew Hammond (e-mail communication) pointed out that there might be a connection between the Bruces and Marie of Coucy, Queen of Scots, great-great-granddaughter of King Louis VI; Isabella's paternal grandfather had been a member of the regency council during Alexander III's minority, alongside Marie, Alexander's mother. Adam of Kilconquhar, the first husband of Isabella's mother, had participated in the Eighth Crusade and in the siege of Tunis of 1270; see Alan MacQuarrie, *Scotland and the Crusades, 1095–1560* (Edinburgh: John Donald, 1997), 25, 125. Adam may have met King Louis IX of France during the siege.

84 The production of printed cloth did not begin in the British Isles before the fourteenth or more likely the fifteenth century (Tonia Brown, e-mail communication).

85 A. A. M. Duncan, "Brus [Bruce], Robert de [*called* Robert the Noble], lord of Annandale (*c.* 1220–1295)," in *ODNB*; MacQuarrie, *Scotland and the Crusades*, 59; Henry Summerson, "Lord Edward's Crusade (*act.* 1270–1274)," in *ODNB* (accessed June 8, 2022).

dye extracted from the *Crocus sativus L.* may have been used for the saffron-yellow quilted mattress and the *tapet*.[86]

Isabella's chamber furnishings also had an official function: the red, gold, and saffron yellow possibly referred to the colours of the Bruce family's coat of arms,[87] as well as to those of the Norwegian kingdom.[88] Gold and red also occur in the regalia, especially the two pieces of red samite and the two *panni* of cloth of gold. Coverlets and regalia cloths thus displayed not only Isabella's social status as a wealthy bride, but also her political relationships and allegiances: a choice that was consistent with her family's royal ambitions.

Most garments are lined with miniver, except for a mantle lined with *grosvair* and a *pers* bedcover lined with grey squirrel fur. As pointed out by Elspeth Veale, *vair* and *gris* were both precious and fashionable lining materials in the thirteenth and fourteenth centuries.[89]

The value of the silver utensils is indicated by the counting units *marca* and *solidus*, which were used both in the British Isles and in other Western European countries. They indicated quite precisely the value of goods in transactions between areas and regions where different currencies were in use. A *marca* corresponded to the value of two-thirds of a silver pound,[90] whereas the *solidus* had the value of 1/72 of a silver

86 Emil Ernst Ploss, *Ein Buch von alten Farben: Technologie der Textilfarben im Mittelalter mit einem Ausblick auf die festen Farben* (Munich: Heinz Ploss Verlag, 1977), 40, 54, 62–63.

87 Gules (red) and or (gold) were the Bruce heraldic colours. As shown by the Balliol Roll (London, British Library, Add. Roll 77242), dating from ca. 1340, the figures and colours of the earl of Carrick's coat of arms were "or, a saltire Gules and on a chief Gules a Lion passant guardant Or"; http://searcharchives.bl.uk/permalink/f/79qrt5/IAMS032-002170207 (accessed Aug. 7, 2023) and "The Balliol Roll," The Douglas Archives, https://douglashistory.co.uk/history/heraldry/balliol_roll.html (accessed June 5, 2022). The Gelre armorial, dating back to the second half of the fourteenth century, displays the colours and figures of the Annandale coat of arms: or, saltire gules, chief gules; Brussels, Royal Library of Belgium, MS 15652-5, https://uurl.kbr.be/1733715, picture no. 133 (accessed June 8, 2022).

88 The coat of arms of the Norwegian kingdom in Eiríkr's time was gules, a lion rampant or, crowned or, holding an axe or with a blade argent; the colours are shown for instance in the more recent testimony of the Gelre armorial, in the depiction of the coat of arms of King Hákon VI (ruled 1343–80): quartered shield, two quarters Norway's coat of arms and two quarters the coat of arms of the Swedish royal house; Brussels, Royal Library of Belgium, MS 15652-5, https://uurl.kbr.be/1733715, picture no. 138 (accessed June 8, 2022).

89 "In the thirteenth and fourteenth centuries, those with any pretensions to elegance wore *minever* and *gris*, the fine squirrel skins from the North. Wills, inventories, and accounts of the period reflect the popularity of these delicate furs, and it was usual for nearly all the fur-lined robes belonging to a wealthy man or woman to be lined with them." Veale, *English Fur Trade*, 133–55.

90 *DMLBS*, s.v. *marca*; *MED*, s.v. *mark(e* n. 2; *DOST*, s.v. *merk*.

The Trousseau of Isabella Bruce

pound.[91] Crawford calculates that all the silver utensils weighed ca. 58 and 1/3 pounds, that is, they corresponded to the value of ca. 78 marks and 60 shillings.[92]

The tableware set, with its twenty-four vessels for food, twenty-four salt cellars, twelve cups, four wine pitchers, and four basins, was probably intended for a table company of twenty-four. The plates and the salt cellars were intended for individual use, whereas the cups were used by two table companions at a time and wine pitchers and basins were service tableware, containing wine and water for around six people each.

The scribe also lists decorations and materials of which chests, sacks, and baskets are made (*coopti de coreo/corio, cū tribʒ faleretecis*). We can only roughly guess the dimensions of the two small crowns provided by the Earl of Carrick, but we can suppose that they were made from some precious material. However, their value must have been essentially symbolic.

LINGUISTIC ASPECTS

The text is notable also for its linguistic aspects, especially in the part of the document containing the list of Isabella's bridal goods.[93] *Couˢletˀ, couˢlettˀ* derives from the Middle English term *coverlet* < Anglo-Norman *covrelit*, Old French *cuevrelit*.[94] *Culte puncta* represents a morphological Latinisation of Middle English *culte (pointe)*, itself deriving from Anglo-Norman *cu(i)lte/coilte (pointe(e))* < Latin *culcita puncta(ta)* (quiltpoint), here specifically a quilted mattress.[95] [*Duo*] *samitˢ* (two cloths of samite) is to be interpreted as the Middle English, Anglo-Norman, or Pre-Literary Scots plural of *samit(e* (samite cloth). In the syntagm *de carde, carde* might represent a writing error influenced by the preceding preposition *de*, instead of *carda*, but also a vernacular form (Anglo-Norman, Middle English/Pre-Literary Scots[?] *carde*).[96]

Some lexemes are Latinisations of Middle English/Pre-Literary Scots words deriving from French and especially Anglo-Norman, or directly of Anglo-Norman terms, as suggested by their phonetic-graphematic features, that is: the suffix *-ar-ius, -a, -um > -ier > -er: paneríí* (baskets) instead of *pan(n)arii*;[97] palatalisation of stressed /a(:)/: *murretus, -a, -um* (murrey) instead of **moratus, -a, -um, scarletum,*

91 Du Cange, *Glossarium*, s.v. *solidus*; *DMLBS*, s.v. *solidus* 3.

92 Crawford, "North Sea Kingdoms," 184.

93 Mark Chambers and Louise Sylvester, "Multilingualism," in Owen-Crocker, Coatsworth, and Hayward, *Encyclopedia* (accessed Aug. 18, 2023).

94 *AND*, s.v. *coverlit* (*coverlet, coverlete, coverlite, couvrelit, covrelite*, etc.); Old French *cuevrelit*.

95 LexP, s.v. *quiltpoint*.

96 AND, s.v. *carde* 1 and 2; *DMLBS*, s.v. *carda*; *DOST*, s.v. *card* n. 1 (variants *karde, caryd*); LexP, s.v. *carde*; *MED*, s.v. *carde* n. (3).

97 Niermeyer, *Mediae Latinitatis*, s.v. *panarium*; Aurelio Roncaglia, *La lingua d'oïl: Avviamento allo studio del francese antico* (Rome: Edizioni dell'Ateneo, 1960), 90, 174; *MED*, s.v. *pan(i)er*, variant *paner(e*.

-us (scarlet) instead of *scarlatus*;[98] maintaining of /k/ before /a/: *caneu(ac)ʒ* ((hemp) cloth(s)) from Latin **cannabaceus*, Medieval Latin *canabacius* (Old French *chanevas*);[99] raising of Medieval Latin /o(:)/ > /u/(:)/: *murretus, -a, -um* (murrey) instead of **moratus, -a, -um*.[100]

Ciphi perhaps represents a rendering of *scyphi*, a word of Greek origin,[101] while *pitalchi* (plural of *pitalchus*, recte *pitalphus* < Greek *pitalphis*) might result from a phonetic misunderstanding of /f/ as /x/.[102]

Two possible *hapax legomena* appear in the document: *bankerʒ* is widely attested as a substantive with the meaning "covering for benches and seats."[103] It is perhaps used here as an adjective in connection with *palees* (see below). The derivative word is built on the Germanic **bankō-*, strong feminine (wooden balk, wooden seat, bench), plus the Latin suffix *-ārium* (pertaining to) > Anglo-Norman *banker* > Middle English *banker*.[104]

The Medieval Latin word *falereteca* (feminine?)[105] seems to represent a derivative form of the Classical Latin *phalera* (round metal boss, round metal decoration),[106] perhaps with the meaning of "ornament similar to a *phalera*" or "sort of lock shaped like a *phalera*." The word occurs in the dative plural (*cū tribʒ faleretecis*). According to the *Dictionary of Medieval Latin from British Sources*, s.v. *phaleretica*, the word may have been formed by the influence of Latin words such as *lectica*, but it is more plausible that the suffix of Greek origin *-etik-* has been added to *phalera*, as happens in Greek adjectives and substantivised adjectives such as **hairetikós, -é, -on*, built on the feminine substantive *haíresis* (choice), Latin *haereticus, -a, -um*.

Palees could be a fully vernacular word. *Palees* (vertically striped cloths),[107] shows the morphological mark of Anglo-Norman or Middle English/Pre-Literary Scots plural nouns. It plausibly represents the substantivisation of the Old French/Anglo-Norman adjective *palé*, Middle English *pale, pali*, "striped," that is, "piece of [two-coloured] striped cloth" < originally the past participle of the Old French verb *paler* meaning "to

98 Niermeyer, *Mediae Latinitatis*, s.v. *moratum 2, scarlata*; DMLBS, s.v. *scarlatus*; Roncaglia, *La lingua d'oïl*, 174.

99 Frédéric Godefroy, *Dictionnaire de l'ancienne langue français et de tous ses dialectes du IXe au XVe siècle*, 9 vols. (Paris: Vieweg, 1881–1902), 2:53, electronic version at http://micmap.org/dicfro/search/dictionnaire-godefroy, s.v. *chanevas* (accessed Jan. 16, 2021); Roncaglia, *La lingua d'oïl*, 174.

100 Niermeyer, *Mediae Latinitatis*, s.v. *moratum 2*; Roncaglia, *La lingua d'oïl*, 174.

101 <sc> of Latin-Romance origin is often represented by <c> (and plausibly pronounced as a voiceless alveolar sibilant) in Anglo-Latin, through French influence (see for instance *scissor* 'one who cuts' = *cissor*, DMLBS, s.v. *scissor*).

102 DMLBS, s.v. *pitalphis*; Du Cange, *Glossarium*, and DMLBS, s.v. *scyphus*.

103 See e.g. DMLBS, s.v. *bancarius* (forms attested: *bancor-, banquer-, banker-*), Niermeyer, *Mediae Latinitatis*, s.v. *bancarium*.

104 AND, s.v. *banker*, MED, s.v. *bankēr* n.; Niermeyer, *Mediae Latinitatis*, and DMLBS, s.v. *bancarium, bancarius, bankerium*.

105 Lemmatised as *phaleretica* in DMLBS.

106 Lewis and Short, *A Latin Dictionary*, s.v. *phalera*.

107 The DN edition and Crawford, "North Sea Kingdoms," 184, read *palces*; Bain, *Documents*, 159, *palees*. My reading, based on a digital reproduction of the document, also *palees*.

The Trousseau of Isabella Bruce

provide with stakes, to make a palisade," Anglo-Norman meaning "to affix stakes in a riverbed to form an obstruction or the foundation of a bridge," ultimately deriving from the (Medieval) Latin *palus* meaning "pale, stake, paling, palisade, fence, stockade" but also "vertical stripe" in heraldry.[108] It seems that the word *palees* for the two-coloured striped seat coverings also represents a meaning transfer from the heraldic vocabulary, where the adjective indicated the figure of vertical stripes showing two alternating colours. We should not rule out, however, that *palees* could be an Anglo-Norman plural form of the adjective *palé*, if we interpret *banker²* as a noun.

The censer that was part of the silver utensils is called *turribił < t(h)uribulum*, in a form in which the word is reinterpreted by the Latin word *turris* (Crawford suggests that it could have been a vessel shaped as a tower),[109] perhaps additionally blended with the Latin adjective *terribilis, -e*.

As far as the morphological aspect is involved, some words are inflected as neuter nouns, probably due to the influence of the Middle English/Pre-Literary Scots vernacular (e.g. *curtinum*, more often *curtina*, feminine noun, in Medieval Latin). One element that particularly stands out on the list is a multipurpose *de* plus ablative that indicates origin, provenance, material, instrument, way, topic, and partitive meaning, probably due to the influence of Anglo-Norman or French *de*, and, from a semantic point of view, also of English *of*.

The list shows a number of the linguistic features individuated by Laura Wright in medieval business writing, which can be described as mixed-language: the presence of multilingual function words (e.g. *de*, Medieval Latin or Anglo-Norman/French); bound morphemes, such as the noun plural marker *–is* (Medieval Latin, Anglo-Norman, Middle English/Pre-Literary Scots, but also dative and ablative plural in Latin); words which had been transposed from one language to another, especially from Anglo-Norman to Middle English/Pre-Literary Scots; roots made visually bare by use of the medieval abbreviation and suspension system; bound morphemes partially suppressed by the medieval abbreviation and suspension system.[110] *Banker*, for instance, could represent an Anglo-Norman, Middle English/[Pre-Literary Scots?] or even a Latinised term: it is visualised in the document as a "bare root" and the final suspending abbreviation makes it impossible to detect a language-specific morphological inflection. In the case of *couˢlett²* and *tapet²*, a vernacular word shows a final suspension, which does not allow for an understanding as to whether and how the word was morphologically Latinised or not. Other terms can follow in either of the languages, e.g. *carda* (feminine

108 *AND*, s.v. *palé¹, paler¹*; *DMLBS*, s.v. *pālus, -um* 1, Godefroy, *Dictionnaire*, 5:705, http://micmap.org/dicfro/search/dictionnaire-godefroy, s.v. 1 *paler* (accessed Nov. 5, 2022), *MED*, s.v. *palē*.

109 Crawford, "North Sea Kingdoms," 184; *DMLBS*, s.v. *turibulum*.

110 Laura Wright, "On Variation in Medieval Mixed-Language Business Writing," in *Code-Switching in Early English*, ed. Laura Wright and Herbert Schendl (Berlin: De Gruyter/Mouton, 2011), 191–218, at 194–95. On the lexical overlapping of Medieval Latin, Anglo-Norman, and Middle English in medieval British documents, see also David Trotter, "*Deinz certeins boundes*: Where Does Anglo-Norman Begin and End?" *Romance Philology* 67, no. 1 (2013): 139–77.

ablative singular) or *carde* (Anglo-Norman or Middle English/Pre-Literary Scots). As the lexis becomes more specific, vernacular words can be partially, i.e. phonetically and/or morphologically and/or lexically Latinised (e.g. *garderoba, vna cultepuncta*) or neutralised (*banker², tapet²*) or appear in their vernacular form (e.g. *palees*).[111]

The initial and final part of the *liberatio* are written in technical, notarial Latin, showing some examples of hypotaxis, while the list of Isabella's bridal goods is rich in nominal syntagms.

111 Louise Sylvester, "Technical Vocabulary and Medieval Text Types: A Semantic Field Approach," *Neuphilologische Mitteilungen* 117, no. 1 (2016): 155–76, at 167.

Appendix 3.1

Transcription and Translation of the Latin Document

Author's note: I did not reproduce diacritics and letter variants such as long and round *s*, round *r*, and the dot that appears above *y*. The symbols used are < > integration; << >> expunction; [] lacuna/damage. I use *-p* to render a small *p* with a flourish. Superscripted characters and punctuation marks (as in *banker²* or *tᵠcio*) are meant to visually represent abbreviation marks from the original manuscript.

Valeria Di Clemente

[1] Memoranda qd . anno . d⁻ Mᵒ ccᵒ. nonaḡ tᵃcio . res subscripte deliberate fuerūt dño
Odoeno Vglacíí⁷ 7 maḡr̄o¹ Weylando de Stiklawe . ad op�q

[2] serenissime dñe dñe Isa<<sa>>bel<le> d<e> Brus regīe Norwagie . die venˢis prxᵒ
ante festū Sī Mich Arch p dm̄ū² Radulp̄ de Ardena Maḡr̄m̄³ Nigellū Cam

[3] bel . Lucam de Tany 7 H<enricum de Stik>lawe / nūcios nobilis viri dñi Robti de
Brus cōītis de Carrik videlicet una roba de scarleto bruneto tu

[4] nica . suptunicale sine <manic>is <mant>ellū caputiū . 7 capa . Īt alia roba de
blueto . tunica . duo suptunicalia / scilȝ vnū clausum / aliud aptū .

[5] mantellū clausū 7 caputi<ū> [] Īt alia roba de scarleto murreto . tunica . duo
suptunicalia vnū clausum aliud aptū . caput̄ 7 ca

[6] pa furrat⁷ . Īt alia r<ob>a de albo camelino . tunica . suptunicale sine manicis
caputiū . 7 capa furrat⁷ . 7 mantellū / et est ista roba

[7] furrata sindone forti / Et omēs alie robe supᵃdc̄e⁴ de minuto vario . excepto mantello
de blueto qd est furrat̄ de grosso vario . Itm̄

[8] vnū�q lectu�q . scilȝ caneuac⁷ de carda 7 vna cultepuncta rubea . duo linteamina 7 vnū
cooptoriū de scarleto sanguineo furrat⁷ de

[9] minuto vario 7 vnū couˢlet⁷ <de p>anno aureo de armis francie . Īt alius lect�q scilȝ
caneuac⁷ de carde 7 vna cult¹punta crocei coloris

[10] 7 vñ cussiñ duo linteam<ina e>t cooptoriū viride furrat̄ de minuto vario / 7 vñ
couˢlett⁷ de pano aureo rubeo inpˢssū talentis

[11] aureis . Īt alius lectus scił vnūm⁵ caneuˢ de carda 7 vnū cultepuncta vird . duo
linteamina . cooptoriū de psico furratˢ de griş. vnū

[12] curtinv̄ de carda circa lectū . quatuor tapet⁷ crocei coloris tria banker⁷ palees . Īt -p
regalibus regine duo samitˢ rub . duo panni aurei

[13] quatuor pecie de pan<n>is diuerse -p regina . 7 vnus pannus de serico ad faciend⁻
cussiñ . Itm̄ viginti quatuor scutele argenti pondis

[14] triginta marca₂ 7 quīque solid⁷ . viginti qᵃtuor⁶ salsar⁷ pondis nouē marcarū 7 decē
soł duodecim ciphi pondis duodecim marc̄ . quatuor

[15] pitalchi pondis decem [] 7 [] marcar⁷ 7 q̄nque soł . quatuor pelu⁻ pondis vndecim
marcar⁷ 7 turribił pondis qᵃdraginta soł . Itm̄

[16] tria pia de cophinis -p gar<deroba> vnū par -p candelis / Īt tres sacc⁷ de coreo -p
garderoba cū tribȝ faleretecis 7 duo paneríí coop

[17] ti de cori<<e>>o -p vtensilibȝ ar<gente>is . Īt due pue corone quarȝ vna maior 7
alia minor . In cuiˢ rei testimoniū pˢentibȝ scriptis ad modum

1 A single stroke over both <g> and <r>.
2 A single stroke over <m> and <u>.
3 A single stroke over <r> and <m>.
4 As <c> and <t> are often identical, it is also possible to read <f>.
5 Not clearly legible.
6 The *Diplomatarium Norvegicum* edition erroneously reads *quatuor*.

The Trousseau of Isabella Bruce

[1] Let it be recorded that in the year of the Lord 1293 the following items have been delivered to Sir Auðun Hugleiksson and to Master Weland of Stiklaw, for the use

[2] of the most serene lady, Lady Isabella Bruce, queen of Norway, on the Friday before Michaelmas, by Sir Ralph of Arden, Master Niall Campbell,

[3] Luke of Tany and Henry of Stiklaw, envoys of the noble Lord, Robert Bruce, Earl of Carrick, that is: outfit of dark brown scarlet:

[4] tunic, a sleeveless surcoat, mantle, *caputium*, cape; then, another outfit of *bluet*: tunic, two surcoats, one closed and the other open,

[5] closed mantle, *caputium* []; then another outfit of murrey scarlet: tunic, two surcoats, one closed and the other open, *caputium* and a

[6] lined cape. Then another outfit of white cameline: tunic, sleeveless surcoat, *caputium*, lined cape, mantle; this outfit is

[7] lined with robust *sindon*. And all the other outfits are lined with miniver, except for a mantle of *bluet* which is lined with *grosvair*. Then

[8] a bedding set, that is: canvas of *carde* and a red quilted mattress. Two bed sheets and a cover of blood-red scarlet

[9] lined with miniver and a coverlet of cloth of gold with the arms of France. Then another bedding set, that is canvas of *carde* and a saffron-yellow quilted mattress,

[10] a pillow, two bed sheets, a green cover lined with miniver and a coverlet of red cloth of gold printed with golden

[11] bezants. Then another [bedding set], that is a canvas of *carde* and a [?] red quilted mattress, two bed sheets, a *pers* cover lined with grey squirrel fur. A

[12] curtain of *carde* [to be hung?] around the bed, four saffron-yellow hangings, three [two-coloured striped] seat coverings. Furthermore, as regalia for the queen: two pieces of red samite, two pieces of cloth of gold,

[13] four different pieces of cloth for the queen, a silk cloth to make a cushion. Then, twenty-four silver bowls (with a weight corresponding

[14] to 30 marks 5 shillings), twenty-four salt cellars (with a weight corresponding to 9 marks 10 shillings), twelve cups (with a weight corresponding to 12 marks),

[15] four wine pitchers (with a weight corresponding to 16 [?][7] marks 5 shillings), four basins (with a weight corresponding to 11 marks), and a censer (with a weight corresponding to 40 shillings).

[16] Three pairs of chests for use as a wardrobe and one where to store candles, three leather sacks with three round metal decorations/locks for the wardrobe, two

[17] leather-covered baskets where to store the silver utensils. Finally, two small crowns, the one bigger, the other smaller. As a testimony of this act, this document has been drawn up in the form of

7 *decem et sex* according to the *Diplomatarium Norvegicum* edition; Bain, *Calendar*, with a question mark. Presently there are two damaged spots after *decem*.

Valeria Di Clemente

[18] cirographi 9fectis p^sdēi⁸ dn̄s Odoen^q 7 Magr̄⁹ Weylandus recipientes / et p^sdēi¹⁰ dn̄s Raḋs . Magr[?] Nigellus . Lucas . 7 henric^q tradentes sigilla

[19] sua alt^snatī apposuerūt . Datū apud ciuitatē Berḡ die 7 anno sup^adēis¹¹ . ·· ———— ·· ———— ·· ———— ·· ———— ··

[Dorse]

[1] Indent^ea de rebȝ liḃatis Isabelle de Bruys

[2] Regine Norwegie.

8 It is also possible to read <f>.
9 A single stroke over both <g> and <r>.
10 It is also possible to read <f̄>.
11 It is also possible to read <f̄>.

The Trousseau of Isabella Bruce

[18] a chirograph; the aforementioned Sir Auðun and Master Weland, recipients, and Sir Ralph, Master Niall, Luke and Henry, in charge of the delivery, have appended their

[19] seals alternately. Given at the city of Bergen, in the said day and year.

[Dorse]

[1] Indenture containing the items delivered, belonging to Isabella Bruce,

[2] Queen of Norway.

Appendix 3.2

Isabella Bruce's Trousseau: Glossary

f. = feminine
m. = masculine
n. = noun
nt. = neuter
pl. = plural
prep. = preposition
vb. = verb
p. pt. = past participle

Albus, -a, -um adj. white.
Apertus, -a, -um p. pt./adj. open.
Argenteus, -a, -um adj. silver -.
Argentum nt. n. silver.
Arma (Francie) pl. n. (coat of) arms of France.
Aureus, -a, -um adj. gold, golden.
Banker? n. seat covering or adj. seat -. See *palees*.
Bluetum, -us m./nt. n. blue cloth.
Brunetus, -a, -um adj. dark brown colour.
Camelinum, -us m./nt. n. light, precious cloth, similar to camel hair.
Caneuac? m.? nt.? n. canvas.
Capa f. n. cape.
Capa furrata f. n. lined cape.
Caputium nt. n. hood (hood-shaped head covering?).
Carda f. n. *carde*; cloth used for curtains and linings.
Carde f./nt. n. (Anglo-Norman, Middle English/Pre-Literary Scots?) See *carda*.
Ciphus m. n. cup, goblet.
Clausus, -a, -um p. pt./adj. closed.
Coopertorium nt. n. bedcover.
Cophinus m. n. chest.
Coreum, corium, -us m./nt. n. leather.
Couerle(t)tum, -us? m.? nt.? n. coverlet.
Croceus, -a, -um adj. saffron yellow.
Cultepuncta f. n. quilted mattress.
Cum prep. with.
Curtinum nt. n. curtain.

Valeria Di Clemente

Cussinus m. n. pillow.
De prep. (+ ablative) about, from, of, with.
Falereteca f.? n. metal ornament / sort of metal lock? similar to a *phalera*.
Fortis, -e adj. robust.
Furratus, -a, -um p. pt./adj. lined (with cloth, fur).
Garderoba f. n. wardrobe.
Grisum, -us m.? nt.? n. grey squirrel (fur).
Inpressus, -a, -um p. pt. of *inprimere* vb. to print, stamp.
Lectus m. n. bedding set; bed.
Linteamen nt. n. bed sheet.
Manica f. n. sleeve.
Mantellum nt. n. mantle.
Marca f. n. mark.
Murretus, -a, -um adj. murrey, mulberry colour.
Palees pl. adj.?/n.? [Anglo-Norman, Middle English/(Pre-Literary Scots?)] (pieces of) [two-coloured] striped cloth.
Panerius m. n. basket.
Pannus m. n. (piece of) cloth.
Pannus aureus m. n. cloth of gold.
Par nt. n. couple.
Pecia f. n. cloth piece.
Peluis f. n. basin.
Persicum, -us? m./nt.? n. cloth of perse, dark blue.
Pitalchus (*recte pitalphus*) m. n. wine pitcher.
Pro prep. (+ ablative) for, in favour of.
Regalia nt. n. pl. items pertaining to the sovereign.
Roba f. n. complete garment, outfit, robe.
Rubeus, -a, -um adj. red.
Saccus m. n. sack.
Salsar? nt.? n. salt cellar.
*Samit*ˢ pl. n. [Anglo-Norman, Middle English/Pre-Literary Scots?] (pieces of) samite.
Sanguineus, -a, -um adj. blood-red.
Scarletum, -us m./nt.? n. fine, luxurious woollen cloth.
Scutella f. n. vessel for food, plate.
Sericum nt. n. silk cloth.
Sindon f. n. linen cloth.
Sine prep. (+ ablative) without.
Solidus m. n. 1/72 of a silver pound, shilling.
Supertunicale nt. n. surcoat.
Talentum nt. n. (in this document) printed round decoration similar to a bezant.
Tapet? pl. (nt.?) n. [Medieval Latin? Middle English/Pre-Literary Scots?] hangings.
Tunica f. n. [female] tunic.
Turribił m.? n. censer.
Utensile, -is nt. n. utensil.
Varium grossum or *varius grossus* m./nt. n. *grosvair*.
Varium minutum or *varius minutus* m./nt. n. miniver.
Viridis, -e adj. green.

Make and Create: The Craftswomen in the Salone Frescoes of the Palazzo della Ragione, Padua

Darrelyn Gunzburg

The first-floor Salone of Padua's first civic public building, the Palazzo della Ragione (fig. 4.1), the Palace of Reason, contains a medieval fresco scheme full of complex imagery: trades and skills exemplified by the medieval Paduan workforce, sky constellations, images of the zodiac signs and the planets, a rich assembly of labours associated with each month and season in the tradition of the Labours of the Months, as well as theological and liturgical themes. The scheme is located at the top of the wall where it meets the great wooden whaleback roof and forms a continuous clockwise seasonal narrative painted across three registers and across all four walls (fig. 4.2). While women are represented gathering flowers, accepting marriage proposals, playing musical instruments, or in religious roles, when it comes to trades and labour men take precedence. They harvest wheat, bake bread, and gather grapes. The apothecary, physician, barber-surgeon, and medical astrologer heal the ill when summer heat brings fevers. The skinners and tanners, boatbuilders and stonemasons, knife grinders, boat repairers, and carpenters maintain the material infrastructure of medieval life. Yet winning their place in a scheme where every image was important are seven women busily engaged in crafts which are rarely, if at all, depicted in medieval mural decorations—spinning, sewing, knitting, and making cord. This article focuses on the crafts of these women and their importance in late medieval Padua.

The Palazzo della Ragione, situated in the main square of Padua, has survived for over eight hundred years. However, the building has been altered and the fresco scheme has twice suffered damage. Hence I begin this paper by examining the genesis of the building, the painter and workshop that created the fresco scheme, and the restoration history of the images in order to gain a better understanding of their original appearance. I then focus on the fresco scheme images themselves and the

The publication of images in colour for this article was generously supported by the Association for Art History's grants programme. I would like to thank Bernadette Brady for reading and commenting on earlier drafts of this article. I am indebted to Cordelia Warr, Robin Netherton, and the anonymous reader for *Medieval Clothing and Textiles* for their invaluable readings of and assistance with the text. This article emerged from my Ph.D. research and forms part of a longer manuscript currently in preparation.

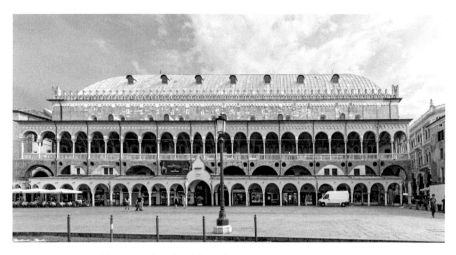

Fig. 4.1: Exterior of the north facade of the Palazzo della Ragione and the Piazza dei Frutti, Padua, Italy. Photo: © 2017 Didier Descouens, Creative Commons license CC BY-SA 4.0, https://commons.wikimedia.org/wiki/File:Exterior_of_Palazzo_della_Ragione_(Padua).jpg.

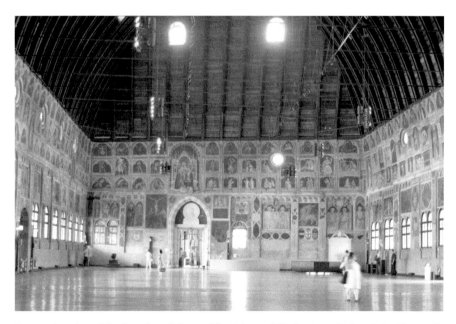

Fig. 4.2: Interior of the first-floor Salone of the Palazzo della Ragione, Padua, Italy. The north wall is to the viewer's left, the east wall directly ahead, and the south wall to the viewer's right. The top three registers of the fresco scheme begin at the juncture beneath the wooden ceiling. Photo: Darrelyn Gunzburg.

Craftswomen in the Palazzo della Ragione Frescoes

crafts depicted within the frescoes, both functionally and metaphorically. I take into account the position of the craftswomen in the scheme, their clothing, and the work that they undertake. In examining these issues and the role of women and work in late medieval northern Italy, the question that arises is whether it was the crafts and skills of these women that were being recognized in the period in which these images were being painted onto the Salone walls, or whether by omission, other areas of women's work were being suppressed.

BUILDING THE PALAZZO DELLA RAGIONE

The economic revival that began in the tenth century and encouraged the proliferation of towns in the Italian peninsula saw an increasing dominance of merchants and bankers and a flourishing industrial and commercial middle class with growing political importance.[1] The political independence of the Italian communes that emerged in the late eleventh century was in part forged from the struggle that occurred between the Holy Roman Empire and the Papacy and the subsequent political deterioration of both powers. The communes established themselves as municipal bodies with limited sovereignty engaged in the business of local government, yet still dependent upon external seigneurial or monarchical authority for economic, military, and trade relations, and crimes where the death penalty was incurred.[2] Communes that were able to turn their partial sovereignty into full independence became known as city-states. In Padua, in 1138, a college of consuls elected by the city joined with individuals of the old establishment and demanded wide decision-making in matters of taxation, the use of public resources, legislation, and the administration of justice.[3] From this civic governance a new style of building emerged, the municipal town hall, or communal palace (*communi palacio*), the word "palace" taking its name from late antiquity and the early Middle Ages where it denoted a building that was the seat of public power.[4]

The first reliable reference to the *communi palacio* of the newly developing consular republic of Padua was documented in two acts of 1166, which described Judge Mainardino and his consuls "engaged in their ordinary activity while sitting *in communi palacio*."[5] This municipal seat was also referred to as the *solarium communis*, with a "chamber of procurators" (referring to the newly established officials with represent-

1 J. K. Hyde, *Padua in the Age of Dante* (Manchester: Manchester University Press, 1966), 13.

2 S. R. Epstein, "The Rise and Decline of Italian City States (Working Paper No. 51/99)," (London: London School of Economics, 1999), 1.

3 Andrea Gloria, *Codice diplomatico padovano: Dall'anno 1101 alla pace di Costanza (25 Giugno 1183)*, vol. 1 (Venice: Regia Deputazione Veneta di Storia Patria, 1879–81), 261.

4 Sante Bortolami, "'Spaciosum, immo speciosum palacium': Alle origini del Palazzo della Ragione di Padova," in *Il Palazzo della Ragione di Padova: La storia, l'architettura, il restauro*, ed. Ettore Vio (Padua: Signum Padova Editrice, 2008), 39–74, at 39, 41.

5 Bortolami, "Spaciosum," 42.

Darrelyn Gunzburg

ative duties of the municipal body) as well as the *palatium communis Padue,* the large hall or the chamber inside it, and was documented consistently throughout the rest of the twelfth century as a place that was routinely used by the *podestà* (the elected head of the municipality) and his councillors in carrying out the functions of government and important political events.[6] After the second Treaty of Constance in 1183, when Frederick I Barbarossa recognised the rights to self-government for Italian cities of the Lombard League, there was great motivation among the emerging city-states along the Po Valley to construct new civic buildings disconnected from the old consular energy, ones that embedded the ideology of the commune as an independent city-state.[7] The Po Valley in northern Italy is the area of land that follows the Po River and which extends 650 kilometres (about 400 miles) in an east-west direction from the western Alps to the Adriatic Sea and, along with Padua, includes, amongst others, the cities of Turin, Pavia, Milan, Cremona, Parma, Mantua, Modena, Bologna, and Ferrara. According to Sante Bortolami, a testimony from 1192 indicated plans for Padua to build a "nova domus Comunis Padue que est in capita fori" (a new house/municipal building of the commune of Padua, located at the head of the market), suggesting that the people of Padua were in the process of replacing an older municipal building.[8] Whether this was to be a completely new building or a renovation of what was there earlier is, however, uncertain and, as Bortolami noted, represents an unresolved issue in studies on the Palazzo della Ragione. What is clear, as Bortolami has pointed out, is that on 16 December 1214 there were prosecutors and evaluators of the municipality acting "in ecclesia Sancti Martini" (in the chapel of San Martino), which is in close proximity to the current Palazzo della Ragione. Therefore, given the evidence or lack thereof, all that can reasonably be suggested is that a single municipal palazzo existed in this location until 1218, and that there was a continuity of headquarters between this and the current Palazzo della Ragione.[9]

The decision to build these palazzi was part of a shared practice with other young city-states across Italy, all of which had struggled to gain autonomy and had emerged victorious.[10] Padua was one of the earliest of the north Italian towns to build such a municipal town hall. Constructed within two years, 1218–19, it was predated by only two other town halls: Bergamo raised its town hall in 1199, and Como in 1215. Designed to house municipal committees responsible for the control and organisation of the daily lives of the urban population, as inner-city constructions these palazzi were carefully located, situated within piazzas or newly cleared areas, and dominating the surrounding buildings. The architectural and decorative language of the palazzo in Padua became the material evidence of a political manifesto of independence and a sign

6 Bortolami, "Spaciosum," 42.
7 Bortolami, "Spaciosum," 44.
8 Bortolami, "Spaciosum," 43.
9 Bortolami, "Spaciosum," 44.
10 Bortolami, "Spaciosum," 45.

Craftswomen in the Palazzo della Ragione Frescoes

of civic pride, the visible expression of the new productive classes that took charge of the municipality between 1200 and 1205, replacing the old consular aristocratic class.[11]

Such a building, however, did not emerge in isolation. Padua was also in the midst of defending itself and its territory from neighbouring cities and consolidating control of the countryside through the construction of large public works. The Battaglia Canal, an important waterway for the transport of building materials from the Euganean Hills, was excavated and revitalized between 1189 and 1201. A great amalgamation of masons, carpenters, wagons, and workshops assembled to create canals, roads, embankments, fortified garrisons, mills, and sometimes whole villages, such as Civè (1189), Villafranca Padovana (1190), Canfriolo near Grantorto (1191), and Terranova (1217).[12] Within the city of Padua, the building programme included new city walls and gates, stone bridges, foundries and shops, churches, monasteries, private houses, and hospitals.

As noted above, by 1192 there is evidence that the Paduans had also begun to rebuild an older municipal structure.[13] In order to construct such a palace, large enough to contain meetings of the *Consiglio Maggior* (Great Council)—whose membership was identified by J. K. Hyde as being 400 in 1242 and then capped at 1,000 by 1277—along with legal committees, and urban necessities such as the prison, the commune took property from the old magnate Manfredi family and bought the tower that guarded the adjacent Palazzo del Consiglio from the aristocratic Camposampiero family.[14] They also appropriated property to the north and south of the Palazzo della Ragione to create the market stall spaces of the Piazza dei Frutti and the Piazza del'Erbe. Such work prepared the way for laying the building's foundations.

Chronicles, annals, and statutes record that the building referred to as the Palazzo Comunale was initially constructed during the communal *podestà* government of Giovanni Rusconi (1218)—"In quel anno fo comenzà el palazzo del chomun de Padoa"—and completed under the communal *podestà* government of Malpilio da San Miniato (1219)—"In quel anno fo compio el palazzo del comun de Padoa."[15] More correctly, the work took place in the two years between 29 June 1218 and 29 June 1220, as the two *podestàs* who oversaw the start and the completion of the building site took office, as was the custom, on 29 June, the feast of St. Peter.[16] In medieval documents the building was known as *palatium ubi ius redditur* ("the palace where justice is rendered"). The Palazzo della Ragione was the geographical centre of Padua, for, as Hyde observed, boundary stones placed at a radius of two miles from the

11 Bortolami, "Spaciosum," 47.
12 Bortolami, "Spaciosum," 47.
13 Bortolami, "Spaciosum," 43.
14 Hyde, *Padua in the Age of Dante*, 93, 220. Tim Benton, "The Three Cities Compared: Urbanism," in *Siena, Florence and Padua: Art, Society and Religion 1280–1400*, ed. Diana Norman, 2 vols. (New Haven, CT: Yale University Press, 1995), 2:7–28, at 19–20.
15 Giovanni Fabris, *Cronache e Cronisti Padovani* (Cittadella, Italy: Rebellato Editore, 1977), 369.
16 Bortolami, "Spaciosum," 40.

Darrelyn Gunzburg

building determined the start of the *contado* (countryside) which was also under its administration.[17] The building was Padua's symbolic heart. It was represented on the seal of the commune, even though the city in its representation was highly stylised, as Hyde pointed out, in being "walled, moated and four-square."[18] Furthermore, judicial proceedings were a public event, and a clause ensuring that the four doors which gave access to the Salone from the market squares to the north and south via four exterior staircases remained open was enshrined in the Paduan statues of 1277.[19]

The original top floor hall existed as three separate rooms where the judges held court. A century later, to provide more room for council meetings and accommodate the growing number of council members, the Paduan Commune commissioned friar-architect Fra Giovanni degli Eremitani (active in Padua from 1289 to 1318) to convert the top floor into one large Salone and, at the same time, to design and implement an architectonic wooden whaleback vault that resembled the keel of an upturned ship. This great maritime roof was said to reflect the marshland that once occupied the site where the Palazzo now stood and where a small canal flowed from Concariola.[20] To support this great roof, it was necessary for Fra Giovanni to increase the height of the outer walls from sixteen to twenty-four metres, thus raising it eight metres (about twenty-six feet). Once this was done, the final act was to cover the roof of the Palazzo della Ragione in lead. Work on the roof began in 1306, in the first week of Lent, and was completed in September 1307.[21]

It is not possible to say when decisions were made regarding the implementation of the painting scheme on the wall that abutted the roof. With a Great Council of 1,000 people, much debate and consideration must have taken place regarding the subject matter of the scheme. All that can be said with certainty is that in the first

17 Hyde, *Padua in the Age of Dante*, 47.

18 Hyde, *Padua in the Age of Dante*, 32. For an image of the seal, see Plate 1.

19 "Hostia vero domus potestatis pateant et stent aperta omni tempore videlicet a campana preconum in mane usque ad terciam et a campana preconum post nonam usque ad vesperas omnibus intrare volentibus. Excepto quando congregatum foret aliquod consilium vel quando congregata foret curia officialium donec duraret ipsum consilium vel curia supradicta." ("Let the doors of the Palazzo be open and stand open at all times, namely from the prayer bell in the morning until terce [the third canonical hour of the day after dawn, around 9 a.m.] and from the prayer bell after none [the ninth canonical hour of the day after dawn, mid-afternoon, around 3 p.m.] until the evening, for all who wish to enter. Except when a council is assembled, or when a court of officials is assembled, for the duration of the aforementioned council or court." My thanks to Frances Pickworth for corroborating and fine-tuning my translation.) A. Gloria, *Statuti del Comune di Padova dal Secolo XII all'anno 1285*, vol. 1 (Padua: F. Sacchetto, 1873), 27.

20 "[H]edificari facient Patavi suum Commune palacium in uno palude in qo (sic) piscatores multos pisces piscabantur et in contrata Conchariole, per quam transibit flumen parvum." ("The Paduans will build their communal palace in a marsh, in which fisherman used to catch many fish and [which is/will be situated] in the locale of Conchariole, through which will flow a small canal." My thanks to Frances Pickworth for this translation.) Fabris, *Cronache e Cronisti Padovani*, 150.

21 Fabris, *Cronache e Cronisti Padovani*, 389.

Craftswomen in the Palazzo della Ragione Frescoes

decade of the trecento, the Paduan Commune commissioned Giotto di Bondone (ca. 1267–1337) to paint a three-tiered fresco scheme at the top of the newly heightened bare walls of the Palazzo della Ragione.[22] This was an age where bare walls were prized surfaces for paintings, and Giotto, who was living in Padua at the time, had recently completed the private fresco scheme in the nearby Scrovegni Chapel (ca. 1303–5). For the commune to be able to commission a fresco scheme from the hand of Giotto added to the prestige of this glorious civic judicial building. Tradition points to the influence of Pietro d'Abano (1250–1318) who was teaching medicine, philosophy, and astrology at Padua University at the time and could advise on the astronomical and astrological imagery.[23]

THE FIRE OF 1420—*UT PRIUS ERAT*

The governance of Padua by the free commune changed with the election of Jacopo da Carrara as the first *signore* (lord) of Padua in 1318, and the da Carrara family governed Padua and its territories until it succumbed to Venice in 1405. Thus, when the roof of the Salone was destroyed by fire on 2 February 1420, and much of the scheme was badly damaged, it was the Venetian Senate who unanimously agreed that the restoration of the building, including a new roof and the Salone fresco scheme, was to take

22 Colin Cunningham, "For the Honour and Beauty of the City: The Design of Town Halls," in Norman, *Siena, Florence and Padua*, 2:29–53, at 51. Pier Luigi Fantelli and Franca Pellegrini, eds., *Il Palazzo della Ragione in Padova* (Verona: Cierre Edizioni, 2000), 7.

23 Giovanni Michele Savonarola, "Libellus De Magnificis Ornamentis Regie Civitatis Padue Michaelis Savonarole," ed. Arnaldo Segarizzi in *Rerum Italicarum Scriptores,* series. ed. L. A. Muratori (Città di Castello: Coi Tipi dell'editore S. Lapi, 1902 [1446]), vol. 24, pt. 15, 47–48. Michele Savonarola wrote in his *Libellus* dated 1445 that "Amplector deinde illud splendidum inter pretoria, superbissimum atque excellentissimum in toto orbe, unicum nostre urbis Pretorium, in quo ad hominum dirimendas lites, ut in unum pacifice vivant, leges disputantur […] Est itaque ut eversa navis, cuius fundum tectum est, lariceis arcubus confabricatum, quaque ex sui parte plumbo coopertum, ad intra vero auro et azurro deauratis magnis cum stellis ornatum […]. Nam ea in parte quedam singulares et egregie picture illud' circuunt, quibus corpora planetarum, et ad que opera peragenda magis homines ab eis inclinantur, mirum in modum etiam per figuras demonstrantur. Huius autem ordinis institutor noster gloriosus *Conciliator* exstitit." ("Then I cherish that splendid praetorium, the proudest and most excellent in the whole world, the only praetorium of our city, in which laws are debated to resolve the disputes of men, so that they may live together peacefully […]. So it is like a capsized ship, the bottom of which is the roof, constructed of arches of larch, covered on each side with lead, and on the inside with real gold and lapis lazuli, decorated with large gilded stars […]. For in that part certain singular and excellent pictures surround it, in which the planetary bodies, and the works to which men are most inclined by them, are depicted wonderfully through figures. And the founder of this order was our glorious Conciliator." My thanks to Frances Pickworth for corroborating and fine-tuning my translation.) The reference to the "Conciliator" points to Pietro d'Abano: Pietro d'Abano, *Conciliator: Conciliator Differentiarum Philosophorum [et] Medicorum in Primus Doctoris* (Venice: Lucantanio Giunta, 1519).

place. The directive, according to the minutes of the meeting held on 6 February 1420, was framed with the vague criterion of returning the Salone to *ut prius erat* ("how it was before").[24] A letter dated 14 February from Tommaso Mocenigo (1343–1423), the Doge of Venice, stipulated that the roof was to be reconstructed by Bartolomeo Rizzo, together with Pizino, the latter of whom was known to the Paduan rectors.[25]

To restore *ut prius erat*, however, one has to know what was there previously. In the fire of 1420, municipal records were almost annihilated, including information on the building of the roof of the Palazzo della Ragione, along with any documents that may have outlined the details for the paintings of the internal fresco scheme of ca. 1306–9.[26] The only contemporary description of the scheme to date appears to be that in a work written by Giovanni da Nono (ca. 1275–1346), the *Visio Egidij Regis Patavie*, which offered a literary description of the city.[27] Hyde has dated the work "with reasonable certainty" to the years 1314–18.[28] Da Nono worked as a judge at the Palazzo della Ragione, and his acceptance into the College of Judges in 1306 was fortunate for, as Eva Frojmovič has pointed out, it was "the very year in which the rebuilding and subsequent redecoration of the palace began."[29] Da Nono continued to work at the Palazzo della Ragione through all the subsequent upheavals and changes of Paduan government until his death in 1346. The *Visio* was the introduction to a larger work, *De Generatione aliquorun Civium Urbis Padue, tam nobilium quam ignobilium*, in which medieval Padua was seen as "a corpus of families" organized by their social position, and which drew on da Nono's personal connections through his experience as a judge.[30] Da Nono's description of the fresco is contained in thirty words:

> Duodecim celestia signa et septem planete cum suis proprietatibus in hac cohopertura, a Zotho summo pictorum mirifice laborata, et alia sidera aurea cum speculis et alie figurationes similiter fulgebunt interius.

24 Adriano Verdi, "Il Monumento attraverso Documenti e Disegni Storici," in Vio, *Il Palazzo della Ragione di Padova*, 75.

25 Verdi, "Il Monumento," 75.

26 Giorgetta Bonfiglio-Dosio, "Padua Municipal Archives from the 13th to the 20th Centuries: A Case of a Record-Keeping System in Italy," *Archivaria* 60 (2006): 91–104, at 93 and n. 94.

27 Published in Giovanni Fabris, "La Cronaca di Giovanni da Nono: Visio Egidij Regis Patavie," *Bollettino del Museo Civico di Padova*, n.s. 10–11 [o.s. 27–28] (1934–39), 1–30.

28 Hyde, *Padua in the Age of Dante*, 29.

29 Eva Frojmovič, "Giotto's Allegories of Justice and the Commune in the Palazzo Della Ragione in Padua: A Reconstruction," *Journal of the Warburg and Courtauld Institutes* 59 (1996): 24–47, at 27.

30 Giovanni da Nono, *De Generatione aliquorun Civium Urbis Padue, tam nobilium quam ignobilium*. The work is unedited. The basic manuscript cited by Hyde, *Padua in the Age of Dante*, 57–58, 324, is Padua, Biblioteca del Seminario, MS Cod. n. 11, fols. 15–53. For a list of other manuscript sources, see Fabris, "La Cronaca di Giovanni da Nono," 21–25.

Craftswomen in the Palazzo della Ragione Frescoes

[The twelve heavenly signs and seven planets with their respective properties/qualities will shine in this complete covering, wonderfully worked by the topmost painter Giotto, and further inside with mirrors will shine other golden constellations and other forms.][31]

These words achieved two things: they placed Giotto ("Zotho") as the original painter of the Salone fresco scheme; and they highlighted the scheme's underlying philosophy as that of medieval astrological cosmology, suggesting that the original scheme formed a continuous clockwise seasonal narrative disposed according to planetary rulership. This statement also suggests that the original ceiling may have included small concave mirrors against a blue background similar to those still extant in the ceiling of the nave of the Lower Church of the Basilica of San Francesco in Assisi. While there is no way of knowing the exact location of the scheme painted by Giotto, it is reasonable to suggest that the "complete covering" also included the top of the raised wall which curved in towards the roofline. What is certain is that the scheme that was repainted and restored in the quattrocento continued to be astrologically underpinned. Additionally, Guglielmo Ongarello noted in his 1441 chronicle that the keel arch ceiling was rebuilt in its original form.[32] Therefore, not only were the images being reproduced in content, if not in form, but also the distinct architecture of the roof was being reconstructed.[33]

According to Francesa Flores d'Arcais, the extensive repainting of the fresco scheme exemplifies two different styles attributable to two different masters and their workshops. The first style encompasses the sequence of 244 images from halfway along the south wall to the end of the north wall, the areas defined by Mercury in its rulership of Gemini (late May to late June) through to Saturn in its rulership of Capricorn (late December to late January). The style and setting of these images follow those of Jacopo da Verona (1355–ca. 1443) and the Maestri della Bibbia istoriata Padovana (Masters of the Paduan Historiated Bible), a workshop associated with Francesco Novello and the Carrara court in Padua and creators of the Paduan Historiated Bible of ca. 1400 (London, British Library, Add. MS 15277).[34] They were most likely painted by Giovanni Nicolò Miretto (ca. 1375–ca. 1450), active in Padua from 1412, and for whom few works are still attributable.[35] The second master and his workshop painted the images that begin after the Coronation of the Virgin Mary and which move clockwise towards the southeast corner and the beginning of the south wall, the months

31 Fabris, "La Cronaca di Giovanni da Nono," 20; my translation. Thanks to Genevieve Liveley for corroborating this translation.

32 Guglielmo Ognarello, *Chronica di Padova*, 1441, Padua, Bibiloteca Civica di Padova, segnato BP 396. Cited in Herbert Dellwing, "Zur Wölbung Des Paduaner 'Salone,'" *Mitteilungen des Kunsthistorischen Institutes in Florenz* 14, no. 2 (1969): 145–60, at 146 n. 7. I am indebted to Amy Kilby for her translation of this article from German into English.

33 Vio, *Il Palazzo della Ragione di Padova*, 75.

34 Manuscript available at https://www.bl.uk/manuscripts/Viewer.aspx?ref=add_ms_15277_f071v [bl.uk] (accessed Sept. 4, 2023).

35 Francesca Flores d'Arcais, "Note sulla decorazione a fresco del Palazzo della Ragione di Padova," in *Il Palazzo della Ragione di Padova*, ed. Anna Maria Spiazzi (Treviso, Italy: Canova, 1998), 11–22, at 18.

defined by Saturn in its rulership of Aquarius (late January to late February), Jupiter in its rulership of Pisces (late February to late March), and Mars in its rulership of Aries (late March to late April). These images, according to Flores d'Arcais, were painted in the International Gothic style. The term International Gothic was introduced by nineteenth-century French art historian Louis Courajod to mean a style of art which began in Burgundy, France, and northern Italy in the late fourteenth and early fifteenth centuries and which then spread widely across Western Europe. The style offered a more contemporary artistic vocabulary. Not only was it livelier and more elegant than that of Nicolò Miretto, it introduced stylistic inventions that were new to Padua in the 1440s. These images have been attributed to a man from Ferrara identified by Carlo Ludovico Ragghianti as "Stefano" (act. fifteenth century).[36] Furthermore, from observing the style and quality of this set of images, Flores d'Arcais argued that this master must have trained in the San Petronio building site in Bologna at the time when Giovanni da Modena (ca. 1379–1454/55) was decorating the Bolognini chapel.[37]

The worldview of Padua in 1420 continued to be underpinned by medieval astrological cosmology.[38] It is possible that the commune, painters, and restorers required access to an authority who could contribute the necessary knowledge of the constellations visible at the various times of the year for the upper register, as well as information about the doctrine of planetary rulerships. This was an integrated system whereby each planet and luminary was understood to rule a particular sign, which meant that it governed or was connected to the characteristics of that sign. Those responsible for the restorations of the frescoes could have turned to Prosdocimo de' Beldomandi (ca. 1370–1428), professor of astrology at the University of Padua, a position Pietro d'Abano had filled in the early fourteenth century.[39]

Further damage occurred to the scheme when, on 17 August 1756, a hurricane tore off the vault and once more, in 1759, the roof was reconstructed. The fresco scheme was overpainted by Francesco Zannoni da Cittadella (1720–92) in the period 27 July

36 Carlo Ludovico Ragghianti, *Stefano da Ferrara: Problemi Critici tra Giotto a Padova, l'Espansione di Altichiero e il Primo Quattrocento a Ferrara* (Florence: Critica d'Arte, 1972), 93, 131–37.

37 Flores d'Arcais, "Note sulla decorazione," 18.

38 Darrelyn Gunzburg, "Medieval European Astrology," in *Astrology through History: Interpreting the Stars from Ancient Mesopotamia to the Present*, ed. William E. Burns (Santa Barbara, CA: ABC-CLIO, 2018), 218–22.

39 Paul F. Grendler, *The Universities of the Italian Renaissance* (Baltimore: Johns Hopkins University Press, 2002), 24. The first surviving Roll from the University of Padua, dated 1422–23, lists Prosdocimo de' Beldomandi as Professor of Astrology, a position he was to keep until his death. He published works on three of the four subjects of the quadrivium—arithmetic, astrology, and music—including tables necessary for computing the position of the Sun, Moon, and planets, and, as José Chabás identified, his catalogue of 1,022 fixed stars became the basis for the star catalogues published in the incunabula editions of the Parisian Alfonsine Tables. His influence spread well into the sixteenth century. See José Chabás, "From Toledo to Venice: The Alfonsine Tables of Prosdocimo de' Beldomandi of Padua (1424)," *Journal for the History of Astronomy* (2007): 269–81.

Craftswomen in the Palazzo della Ragione Frescoes

1762–27 September 1770, although Zannoni did not repaint the stars on the ceiling.[40] During this long work, Zannoni was assisted by Abbot Antonio Rocchi (1724–80).[41] It was Rocchi who helped Zannoni in the interpretation of the more damaged astrological configurations on the basis of an extremely rare copy of Pietro d'Abano's *Astrolabium Planum* specifically purchased by the Consiglio for this purpose.[42]

Finally, in the 1950s, Alessandro Prosdocimi, director of the Museo Civico, instigated the conservation of some of the frescoes on the east and west walls and half of the southern wall, and restorers Giovanni Pedrocca and his son Botter were employed to carry out the work after 1963.[43] Nearly all of Zannoni's eighteenth-century overpaintings were removed, and only when no other paint layer beneath them could be detected were Zannoni's left in place.[44]

Scholars in the twentieth and early twenty-first centuries have continued to puzzle over the meaning of the scheme and have concluded, as William Burges had done in 1858–59, that Giotto had made errors in the order of the images and that some images had been changed, moved, or simply missed out.[45] The underlying assumption has always been that since the fresco scheme is made up of single separate images, they should therefore correlate to a linear, unswerving pattern that could be unlocked through a textual equivalence, and that the three registers of the scheme all expressed the same intent. This approach ignored the understanding of the medieval concept

40 Giulio Bresciani Alvarez, "Il Palazzo Della Ragione: La Storia di una Fabbrica Civile," in *Il Palazzo Della Ragione in Padova*, ed. Pier Luigi Fantalli and Franca Pellegrini (Verona: Cierre Edizioni, 2000), 16.

41 Andrea Moschetti, "Gli Antichi Restauri e il Ritrovamento degli Affreschi Originali nella Sala della Ragione di Padova," *Bollettino del Museo Civico di Padova* 13 (1911): 3–20, at 9.

42 Alvarez, "Il Palazzo della Ragione," 16. The waters of scholarship have been muddied by claims which appear to have originated from Bernardino Scardeone (1478–1574) in the mid-sixteenth century, when he connected the images in the scheme with a work titled *Astrolabium Planum*, which equated the individual images with the theory of degree symbolism, suggesting that the scheme represented an individual horoscope. The argument for the scheme being a reflection of the *Astrolabium Planum* has continued to be advanced by some, although not all, scholars into the twentieth and twenty-first centuries. The argument against the *Astrolabium Planum* being the driver of the scheme goes well beyond the confines of this article but is one that I have covered elsewhere. See Darrelyn Gunzburg, "Giotto's Salone: An Astrological Investigation into the Fresco Paintings of the First Floor Salone of the Palazzo Della Ragione, Padua, Italy" (Ph.D. diss., University of Bristol, 2014); Darrelyn Gunzburg, "Giotto's Sky: The Fresco Paintings of the First Floor Salone of the Palazzo Della Ragione, Padua, Italy," *Journal for the Study of Religion, Nature and Culture* 7, no. 4 (2013): 407–33, reprinted in *The Imagined Sky: Cultural Perspectives*, ed. Darrelyn Gunzburg (Sheffield: Equinox Publishing, 2016), 87–113.

43 Alessandro Prosdocimi, *Restauro agli Affreschi del Palazzzo Della Ragione* (Padua: Società cooperativa tipografica, 1963).

44 Alessandro Prosdocimi, "Restauro Agli Affreschi del Palazzzo della Ragione," *Bollettino del Museo Civico di Padova* 50, no. 1 (1962): 7–37.

45 W. Burges, "La Ragione de Padoue," *Annales Archéologiques* 18 (1858): 330–43, at 338. As part of my Ph.D. research, I reviewed the approaches taken by previous scholars and the texts they had used to explain their approaches to the Salone fresco scheme; Gunzburg, "Giotto's Salone," 12–30.

Darrelyn Gunzburg

of order, where interlaced narratives of non-linear images gave greater depth and complexity to the scheme than simple linearity. As Marilyn Aronberg Lavin worded it in her influential work *The Place of Narrative: Mural Decoration in Italian Churches, 431–1600*, "an 'out of order' visual sequence was the rule rather than the exception."[46] The dissonant pattern in the familiar story forced the spectator/worshipper to look for new ways in which the story was being articulated, and the different juxtapositions of scenes allowed for greater insights and imparted new meaning to the traditional story. Medieval visual narrative thus demanded that the spectator become the narrator of fresco schemes by working out connections and relationships implied within the visual narratives. As Jules Lubbock demonstrated, in requiring the viewer to piece together the story from the visual evidence, pictorial logic became far more complex and reflective compared to that of a verbal story.[47] This was also what Donal Cooper and Janet Robson, acknowledging the work of Alastair Smart, found in the nave of the Upper Church of San Francesco at Assisi.[48]

Lavin defined "narrative" as "a story as a total entity"; "cycle" as "a number of scenes representing different moments in a story placed in relation to one another and connected in a common theme that progressed from a beginning to an end, passing through a development"; "individual episodes" as "separate actions in the plot taking place in localized settings"; and "inscenation" as "the full dramatic situation of a given episode."[49] While Lavin, Lubbock, and Smart were dealing with images that told complex biblical stories within each quadrata (frame), nevertheless they all maintained that the full story, the narrative, deepened as the eyes of the spectator joined one quadrata with another in multiple directions, along as well as across the walls of the churches and cathedrals in which they were painted. Although each individual quadrata in the Salone fresco scheme is less complex than those found in biblical stories in churches and cathedrals, nevertheless the contiguous placement of images horizontally, vertically, and sometimes diagonally along and across the walls allows the viewer to join together individual episodes that form a cycle and tell a story in a narrative sequence.[50] This procedure is also similar to that used to read the sculpted figures of saints, angels, and noble men and women that adorn the facades of Gothic cathedrals and whose location and connection with the figures next to them, and sometimes across from them, create a visually dynamic narrative as the spectator engages with them.[51]

46 Marilyn Aronberg Lavin, *The Place of Narrative: Mural Decoration in Italian Churches, 431–1600* (Chicago: University of Chicago Press, 1990), 4, 5.

47 Jules Lubbock, *Storytelling in Christian Art from Giotto to Donatello* (New Haven, CT: Yale University Press, 2006), 47–48, 286–91.

48 Alastair Smart, *The Assisi Problem and the Art of Giotto: A Study of the "Legend of St. Francis" in the Upper Church of San Francesco, Assisi* (Oxford: Clarendon Press, 1971), 15–29. Cited in Donal Cooper and Janet Robson, *The Making of Assisi: The Pope, the Franciscans and the Painting of the Basilica* (New Haven, CT: Yale University Press, 2013), 103–4.

49 Lavin, *The Place of Narrative*, 9.

50 See Gunzburg, "Giotto's Salone," 400, 401.

51 Jacqueline E. Jung, *Eloquent Bodies: Movement, Expression and the Human Figure* (New Haven, CT: Yale University Press, 2020), 26.

Craftswomen in the Palazzo della Ragione Frescoes

What is visible on the walls today is a multifaceted fresco full of interlaced narratives that reflect the ideas of medieval cosmology, where civic governance was in concert with the dictates of the heavens. The scheme is seasonally disposed according to planetary rulerships (Mars in its rulership of Aries, Venus in its rulership of Taurus, Mercury in its rulership of Gemini, and so on, following the zodiac signs that travel along the band of the ecliptic across the year) and moves clockwise, or sunwise, around the four walls. In this way the scheme can be divided into "chapters" of images anchored by the labour of the month, the zodiac sign connected with the month, the planet ruling that zodiac sign, and an apostle. The seven women who form the focus of this article are placed into three "chapters": the areas defined by Mercury in its rulership of Gemini (late May to late June) along the south wall, Mercury in its rulership of Virgo (late August to late September), and Jupiter in its rulership of Sagittarius (late November to late December) along the north wall (fig. 4.3), their location identifying them as coming from the hand of Nicolò Miretto and his workshop, as previously noted. They act as one interlaced narrative and offer insights into women textile workers in this period.

THE CRAFTS OF WOMEN—ICONOGRAPHY

Mercury in medieval astrology was associated with writing, commerce, books, culture, reasoning, thought, common sense, and words.[52] It was also one of the lords of craft and trade, and amongst its many meanings it ruled marketplaces, workshops for all crafts, cotton and flax plants, as well as garments of flax and garments that were embroidered.[53] Under Jupiter's rulership fell elegant garments made of cotton and sheer cloaks.[54]

While it is uncommon to see everyday women handling textiles represented in civic mural decoration, images do survive in Padua in the fresco cycle on the dado in the chancel of the church of the Eremitani (Augustinian hermits), painted by Guariento d'Arpo (documented 1338–70), dated after 1334 and before 1368. The frescoes depict the seven planets, each shown as a human figure, each flanked by a male and

52 See for example, Keiji Yamamoto and Charles Burnett, *The Great Introduction to Astrology by Abū Maʿšar*, 2 vols. (Leiden: Brill, 2019), 1:813–15.

53 Shlomo Sela, *Abraham Ibn Ezra's Introductions to Astrology*, vol. 5, *Abraham Ibn Ezra's Astrological Writings* (Leiden: Brill, 2017), 175, 529, 531.

54 Sela, *Abraham Ibn Ezra's Introductions*, 157. "Sheer cloaks" is Sela's translation of the Hebrew אדרת דקה. *Addereth* (אדרת) is the word for a cloak or mantle, and *dakah* (דקה) translates as "thin." An alternative translation to "sheer cloaks" might therefore read "fine mantle," such as the *mantello* worn by wealthy people. In the eleventh and twelfth centuries, this overgarment was initially fastened at the right shoulder with a clasp or brooch; by the late twelfth century, the *mantello* was typically secured in the centre of the chest by means of a cord or a button and loop.

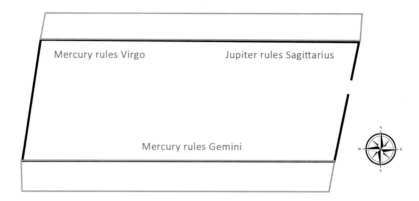

Fig. 4.3: Schematic (not to scale) of the Palazzo della Ragione indicating the placement of the "chapters" in which the images of the women discussed in the article are located. Drawing: Darrelyn Gunzburg.

female figure, and with each frame representing one of the seven ages of man.[55] Due to World War II bombing in 1944, the images on the south side of the chapel (Mars, Jupiter, and Saturn) were completely destroyed and survive only in archive photographs, but those on the north side (Moon, Mercury, Venus, and the Sun) are still in situ. According to Elizabeth Sears, the woman seated to the left of the regal figure of the Sun is engaged with measuring and cutting bands of tape held in an oval tray on her lap.[56] The woman seated to the left of the figure of Mercury, portrayed as a scholar, is being given a spindle from this scholarly figure and holds a distaff in her left hand. The woman seated to the left of the planet Mars, portrayed as a knight, creates a ball of thread in her left hand by drawing it from a skein at her right side; Sears suggested that she is winding wool from a spindle. Guariento was following the Ptolemaic seven ages of man governed by the seven planets in their Chaldean order (observed rate of movement of the planets) of the Moon, Mercury, Venus, Sun, Mars, Jupiter, and Saturn. This iconography has not been followed in the Salone fresco scheme. Nevertheless, the activities of the women in the church of the Eremitani are also some of those that occupied the women in the Salone fresco cycle.

55 Louise Bourdua, "De Origine et Progressu Ordinis Fratrum Heremitarum: Guariento and the Eremitani in Padua," *Papers of the British School at Rome* 66 (1998): 177–92, at 192.
56 Elizabeth Sears, *The Ages of Man: Medieval Interpretations of the Life Cycle* (Princeton, NJ: Princeton University Press, 1986), 110–11. See also 106–13 for further examples of the Ages of Man and the seven planets.

Craftswomen in the Palazzo della Ragione Frescoes

WOMEN SEWING—THE *CAMICIAI*

In detail, then, the first woman working at her craft occurs in the season of late spring along the south wall of the Salone of the Palazzo della Ragione. She appears on the top register in the "chapter" defined by Mercury in its rulership of Gemini (late May to late June), painted by Nicolò Miretto in the years following the fire of 1420. She sits in a high-backed wooden chair, bent attentively over her task. She is holding the neck of a white *camicia* (an undergarment made of a soft washable fabric worn next to the skin) that rests on her knee (fig. 4.4). Damage to the top of the image makes it difficult to ascertain exactly what she wears on her head, but it most resembles a brown *berretta*, the term used to cover any close-fitting cap in the quattrocento. She is dressed in an undyed cotton or linen *gamurra* with a high cinched waist. The *gamurra* was the basic functional, informal gown or dress worn by women of all classes and generally unlined as it was worn over a *camicia*. For wealthier families the *gamurra* could be made of wool or even silk. Since the *gamurra* followed the contour of the body and was unlined, it could be worn at home without an additional layer over it.[57] This woman has been depicted wearing such a close-fitting *gamurra* revealing the shapely form of her breasts, her *camicia* visible only at her wrists. Around her left arm, above the elbow, she wears an armband pincushion made of scraps of fabric, the elbow being a convenient place for pins as it was well away from her working hands and lap. A basket holding her scissors and thread rests on a wooden bench to her left. The image is scant in its representation of location, yet the simplicity of her dress, the ease with which she sits, and her contemplative gaze suggest she is working in her own home or a known, safe, domestic environment.

In Florence, women working in cloth and clothing who were not guild-regulated, yet who created or oversaw the making of these most basic and intimate items of clothing—undergarments and *asciugatoi* (towels), sheets, pillowslips, *cuffia* (caps), and *benducci* (headscarves)—were known as the *camiciai*.[58] The *camiciai* of Florence gained revenue either through working for one family from their own home, employed as a servant within a family, or as young, unmarried women or nuns working from convents.[59] There does not appear to be the same nomenclature for such women in Padua, but it is likely that they worked in a similar way.

Necessary to all levels of society, undergarments were worn directly next to the skin, and were made of a soft washable fabric, such as cotton or linen, or for the wealthy, thin silk or wool. The *camicia*, visible only at the neckline and wrists, became a metaphor for these craftswomen, the visible invisible. Raymond Tallis used this term to define objects "whose surfaces conceal their depths, their interiors, or which are

57 Jacqueline Herald, *Renaissance Dress in Italy 1400–1500* (London: Bell and Hyman, 1981), 217.

58 For a discussion on the *camiciai*, see Carole Collier Frick, *Dressing Renaissance Florence: Families, Fortunes, and Fine Clothing* (Baltimore: Johns Hopkins University Press, 2002), 39–42.

59 Frick, *Dressing Renaissance Florence,* 40.

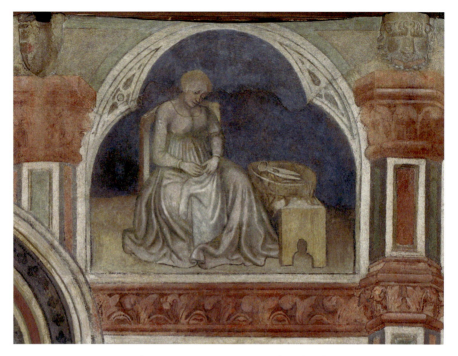

Fig. 4.4: A woman sews a white *camicia*, top register, south wall, Salone. Photo: Courtesy of the Municipality of Padua–Department of Culture. All legal rights are reserved.

folded over themselves."[60] Yet it is a term just as applicable to these women who were as hidden and obscure as the garments they created.[61] Such women stood in contrast to the professional tailors who designed the formal, adorned, and decorated clothing of the elite, but who are not represented in the fresco scheme.

Images of medieval women sewing are more often encapsulated in the figures of St. Anne and the Virgin Mary. For example, in the basilica of Santa Croce in Florence is the image of *St. Anne and the Young Virgin Sewing* (now held in the Museo dell' Opera di Santa Croce) painted by the Master of the Bambino Vispo (act. early fifteenth century), where St. Anne sews a small piece of material with the young Virgin Mary by her side.[62] Another example is *Mary Sewing the Shirt for the Christ Child (Service in the Temple)* painted by Guido Reni (1575–1642) in 1609–11 for the Cappella dell'An-

60 Raymond Tallis, *Of Time and Lamentation: Reflections on Transience* (Newcastle Upon Tyne, UK: Agenda Publishing, 2017), 21.
61 Frick, *Dressing Renaissance Florence,* 40.
62 An image can be seen at https://en.wikipedia.org/wiki/Master_of_the_Bambino_Vispo (accessed Aug. 9, 2023).

Craftswomen in the Palazzo della Ragione Frescoes

nunziata of the Palazzo del Quirinale in Rome.[63] Although this image is later than the period of the Salone fresco cycle quattrocento restoration, it is valuable in that it depicts Mary bending over the garment, her right hand meticulously drawing back the thread, a sewing basket at her feet, as two angels watch attentively.

Such moments, caught in religious visual narrative, can be read on the surface as a mother teaching her daughter a skill that will serve her in her married life to come. Kathryn M. Rudy described this as the "gendered nature of sewing."[64] Rudy was referring to a story found in collections of Marian legends regarding the help given by the Virgin Mary to Thomas of Canterbury following his expulsion from England. According to the story, Thomas was domiciled for a time in the confines of a French monastery. Unskilled in the use of needle and thread, he hid himself away, embarrassed and frustrated at his inability to repair his hair shirt. Then the glorious Virgin Mary appeared in a vision and mended Thomas's garment for him. The message, as Rudy noted, was clear: young women received training in sewing, young monks did not. Mary's sewing in the Temple was specifically paired with prayer, where these two acts, the rhythmic act of hands stitching and shaping cloth, and the rhythmic act of words in the mouth shaping prayer, produced a meditative result and turned labour into a devotional exercise, as Hanneke van Asperen has aptly described it in her research into objects sewn into fifteenth-century books.[65] Such actions were as true of nuns in a convent producing sewn-in prints in a prayer book as it was for Mary in the Temple, and so time spent in repetitive tasks passed honourably.

Although undergarments were necessary items of clothing, understandably the value assigned to them varied according to the occasion. The inventory of clothing belonging to the nobleman Angelo da Uzzano's widow, following his death in 1424 in Florence, for example, included "7 camicie usate" (used undergarments).[66] However, when Piero Guicciardini gave a dowry of money and clothing to Francesco de' Medici on his marriage to Piero's daughter Costanza Guicciardini in 1433, the inventory also contained uncosted items including "17 chamicie" which, as Jacqueline Herald observed, "being of less value, they were not counted officially as part of the agreed

63 An image can be seen at https://archivio.quirinale.it/aspr/mostre-digitali/PHOTO-002-013315/palazzo-del-quirinale/cappella-annunziata#n (accessed Aug. 9, 2023), third photo.

64 Kathryn M. Rudy, "Introduction: Miraculous Textiles in Exempla and Images from the Low Countries," in *Weaving, Veiling, and Dressing: Textiles and their Metaphors in the Late Middle Ages*, ed. Kathryn M. Rudy and Barbara Baert (Turnhout, Belgium: Brepols, 2007), 1–38, at 16–17; Cornelis Gerrit Nicolaas de Vooys, ed., *Middelnederlandse Marialegenden*, vol. 1 (Leiden: Brill, 2018), 144–47, miracle no. 77.

65 Hanneke van Asperen, "Praying, Threading, and Adorning: Sewn-in Prints in a Rosary Prayer Book (London, British Library, Add. MS 14042)," in Rudy and Baert, *Weaving, Veiling, and Dressing*, 96–97.

66 Walter Bombe, *Nachlass-Inventare Des Angelo Da Uzzano Und Des Lodovico Di Gino Capponi* (Leipzig and Berlin: B. G. Teubner, 1928). Cited in Herald, *Renaissance Dress*, 242.

dowry."[67] A Milanese example from later in the century is contained in the letters written by Galeazzo Maria Sforza to Gotardo Panigarole in 1475 which document the day-to-day clothing purchases required for the duke's household. These included nightshirts (*guardacori*) for his own use, but as the duke also supplied clothing to members of his court, we gain further insights into these intimate clothing requirements from a man named Turcheto who worked for the duke and who required "six *camise* with several pairs of underpants (*mutande*), two pairs of hose (*calze*), and a cap (*bareta*)."[68]

The sewing woman has been placed in the top register of the Salone fresco scheme, the register given over primarily to images of the constellations, the eighth sphere of medieval cosmology. This suggests a placement closer to heaven, with the other two registers displaying images more aligned with life on earth. The woman's focused attention and devotion to her work, the inclined head and downward gaze, conforms remarkably with the code and conduct books written by men in the quattrocento that postulated a tradition of ideal conduct for women.[69] Through these books, pressure was continuously exerted on women to be modest and obedient, and they were reflected visually, for example, in the changing role of the Virgin Mary and the prophetess Anna in altarpieces depicting the Presentation in the Temple.[70] In these altarpieces, Mary is depicted as becoming humbler and more subservient as the fifteenth century progresses, whilst Simeon and Joseph take on roles of greater assertion, participation, and presence. Amongst the advice given in these code and conduct books was that regarding what a women could do with her eyes and thus what constituted the social safety of a woman's gaze.[71] The virtue of humility, a religious ethic, became woven into the social fabric for women, defined by the act of lowered or averted eyes.[72] Taking into consideration the fact that undergarments had to be sewn, the location of the

67 Dante Castellacci, *Ricordanze delle Nozze di Francesco De' Medici con la Tessa Guicciardini* (1433) (Florence: M. Ricci, 1880). Cited in Herald, *Renaissance Dress*, 243.

68 Herald, *Renaissance Dress,* 152–55.

69 For example, Paolo da Certaldo, "Libro di Buoni Costumi (Book of Good Customs)," in *Mercanti Scrittori*, ed. Vittore Branca (Milan: Rusconi, 1986); Francesco da Barbaro, "De Re Uxoria (on Wifely Duties, 1416)," in *The Earthly Republics: Italian Humanists on Government and Society*, ed. Benjamin G. Kohl and Ronald G. Witt (Manchester: Manchester University Press, 1978); Vespasiano da Bisticci, *Renaissance Princes, Popes and Prelates: The Vespasiano Memoirs: Lives of Illustrious Men of the XVth Century*, trans. William George and Emily Waters (New York: Harper and Rowe, 1963); Leon Battista Alberti, *I Libri Della Famiglia (The Family in Renaissance Florence)*, trans. Renée Neu Watkins, 4 vols. (Columbia: University of South Carolina Press, 1969).

70 Penny Howell Jolly, "Learned Reading, Vernacular Seeing: Jacques Daret's Presentation in the Temple," *Art Bulletin* 82, no. 3 (2000): 428–52, at 447.

71 Catherine King, *Renaissance Women Patrons: Wives and Widows in Italy c.1300–1550* (Manchester: Manchester University Press, 1998), 20. See also Darrelyn Gunzburg, "Looking Back: The Transgression of Social Codes Explored through the Direct Gaze in Fra Angelico's San Marco Altarpiece when Compared with Madonna and Child with Eight Saints," *St Andrews Journal of Art History and Museum Studies* 14 (2010): 31–44.

72 Marina Warner, *Alone of All Her Sex: The Myth and the Cult of the Virgin Mary* (New York: Knopf, 1976), 184. Gunzburg, "Looking Back," 37.

Craftswomen in the Palazzo della Ragione Frescoes

image along the top register, metaphorically closest to heaven and evoking the idea of Mary sewing and praying, and the introverted, yet focused, nature of the image with a natural downward gaze, it does not stretch the imagination to suggest that this was an image that modelled a way for women to behave in society, full of humility and engaged in worthy work, attentive, focused, and in a state of virtue.

There is a second image of a woman sewing, again placed in the top register, but this time in the season of early autumn along the north wall in the "chapter" defined by Mercury in its rulership of Virgo (late August to late September). This was also painted in the years following the fire of 1420 but clearly in a different hand, perhaps someone within Nicolò Miretto's workshop. The woman is seated on a simple bench and her gaze is concentrated on the white garment in her lap as she draws back her needle and thread (fig. 4.5). While her eyes are also lowered and focused on her task at hand, her posture is more upright than the first woman. The shape of the garment is not helpful in distinguishing its nature, but it may be an *asciugatoio*, a term applied equally to a hand towel, a covering for a chest, a pillow slip, or the type of linen head veil secured with hairpins and ribbons and worn over the head and onto the shoulder by older women and widows.[73] No sewing basket is visible in this image, and the woman is also dressed in different attire to the first woman: she wears a *ghirlanda* (headdress) braided with ribbon on her head and is dressed in a brown *gamurra* with turned-down collar and a short V opening at the front, fastened by lacing and caught at the waist with a cord *cintura* (belt), her white *camicia* visible at her neck. The *ghirlanda* was a feature of high fashion and, when combined with this woman's posture and demeanour, which are a visible contrast to the first sewer, it suggests that, rather than being a craft worker, the woman may instead come from a wealthy family.[74] Even in wealthy families, while it was the wives and mothers who oversaw their servants, the evidence of letters written by three wealthy Florentine wives indicated that, while their role was first and foremost to manage household servants and seamstresses for the family's domestic sewing requirements, nevertheless they were capable of and engaged in stitching garments with needle and thread.[75]

WOMEN SPINNING

Adjacent to this woman sewing in the "chapter" defined by Mercury in its rulership of Virgo is the figure of a woman spinning, painted in the same style and hand as the woman in figure 4.5. Seated on a wooden chair with a wicker seat, her drop spindle by her side, she is depicted in the act of spinning (fig. 4.6). She wears a white turban-style *cappuccio* (cap) on her head, a pleated grey *giornea* (a sleeveless overdress open down the front and at the sides) with a V opening caught at the waist with a cord *cintura*, a rose-coloured *gamurra* with wide red cuffs above the elbow, and a long-sleeved

73 Herald, *Renaissance Dress*, 227.
74 Herald, *Renaissance Dress*, 50.
75 Frick, *Dressing Renaissance Florence*, 40–42.

Darrelyn Gunzburg

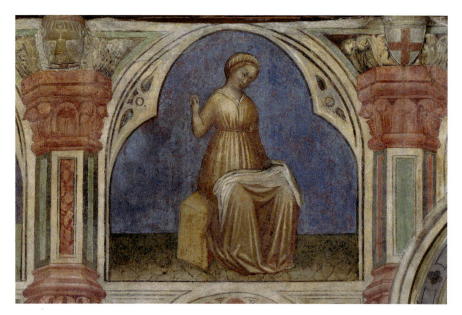

Fig. 4.5: A woman sits on a bench sewing a white garment on her lap, top register, north wall, Salone. Photo: Courtesy of the Municipality of Padua–Department of Culture. All legal rights are reserved.

camicia. The more rustic clothing and *cappuccio* point to the possibility of her being an employee of the woman beside her.

Before it could be sewn, thread first needed to be spun and woven into cloth, and the production of thread using drop spindle and distaff has been well rehearsed in medieval manuscripts. It is humbling to recognise that, as Gale R. Owen-Crocker pointed out, right up until the Industrial Revolution every thread that created a garment that was worn, whether the person was of high rank or a peasant, contained the dynamic imprint of some woman's finger and thumb.[76] The labour-intensive skills of spinning, weaving, and embroidering cloth were learnt as household tasks in the home. Spinning was particularly favoured since it could be performed anywhere and, until recently, remained the domain of women.[77] Such was the volume of thread required to clothe a household that numerous women, whether rich or poor, spun. Illuminated manuscripts, such as the Luttrell Psalter, an English manuscript produced 1325–40,

76 Gale R. Owen-Crocker, "Introduction," in *Encyclopedia of Dress and Textiles in the British Isles c. 450–1450*, ed. Gale R. Owen-Crocker, Elizabeth Coatsworth, and Maria Hayward (Leiden: Brill, 2012), 3–5, at 3.

77 Gale R. Owen-Crocker, "Clothwork, Domestic," in *Women and Gender in Medieval Europe: An Encyclopedia*, ed. Margaret Schaus (London: Routledge, 2006), 150–52, at 150.

Craftswomen in the Palazzo della Ragione Frescoes

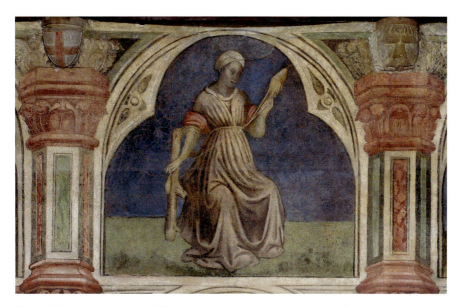

Fig. 4.6: A woman holds a distaff and a drop spindle in the act of spinning, top register, north wall, Salone. Photo: Courtesy of the Municipality of Padua–Department of Culture. All legal rights are reserved.

show women feeding chickens or casting grain and spinning at the same time.[78] Although the spinning wheel reached Europe in the twelfth century, it is not figured in the Salone fresco scheme.[79]

Like the two women sewing, the spinner's counterpart can be found on the south wall in the "chapter" defined by Mercury in its rulership of Gemini. This spinner sits on a wooden chest on a plinth, holding aloft the tools of spinning and gazing intently at the viewer (fig. 4.7). She wears a white *cuffia* (coif) on her head and is dressed in a simple square-necked white *gonnella* (a simple shift garment for women) with *pullite* sleeves (smooth, close-fitting, and neat) and a high waist. Her clothing mirrors almost exactly that of the maid spinning outside the door where St. Anne prays in *The Apparition to St. Anne* in the Arena Chapel, Padua, suggesting the Salone spinner is also a maid. Yet she holds the distaff and drop spindle awkwardly, showing rather than using. The woman in red in the quadrata next to her mirrors her actions without the implements (fig. 4.8). The slightly wider seat and better-quality clothes—the brown *ghirlanda* braided with ribbon on her head, the red *gamurra* with a square neck cinched high with a cloth *cintola* (belt) of the same material as her dress, and her *a gozzi* sleeves

78 London, British Library, Add. MS 42130, 166v (Psalm 91), https://www.bl.uk/online gallery/ttp/luttrell/accessible/images/page19full.jpg (accessed Aug. 9, 2023).
79 Elizabeth Coatsworth and Gale R. Owen-Crocker, "Textiles," in *A Cultural History of Dress and Fashion in the Medieval Age*, ed. Sarah-Grace Heller (London: Bloomsbury Academic, 2017), 11–28, at 16.

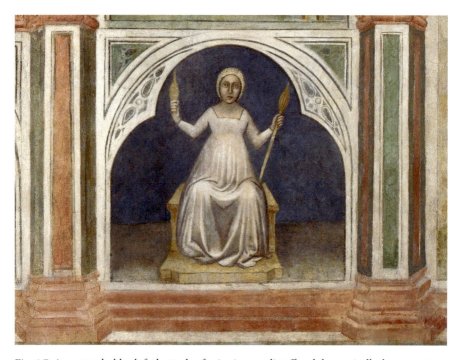

Fig. 4.7: A woman holds aloft the tools of spinning—a distaff and drop spindle, lower register, south wall, Salone. Photo: Courtesy of the Municipality of Padua–Department of Culture. All legal rights are reserved.

(full sleeves attached to a tight band at the wrist)—mark her as being in authority. It is highly possible that spinning or sewing implements may have been lost as a result of restoration. Nevertheless the two images being adjacent to each other suggest the woman in red is the head of the household overseeing a maidservant.

WOMEN KNITTING

Two more images of women textile workers are portrayed in the Palazzo della Ragione scheme. The first is placed along the south wall in the "chapter" defined by Mercury in its rulership of Gemini and is adjacent to the first woman sewing in figure 4.4 in the season of late spring. Unlike the other women, this woman is seated on the ground, wearing a brown *berretta* on her head and a yellow *giornea* over a cream *camicia* (fig. 4.9). She holds an oblong implement, substantial enough to be gripped in both hands and from which a white strip of material with distinctive black stripes falls. Whilst the nature of the implement is unclear from the image, it is entirely possible that she is knitting. Knitting was prevalent across Europe from the late Middle Ages, although

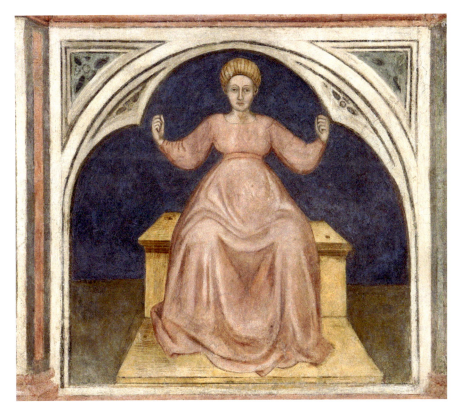

Fig. 4.8: A seated woman holds her arms wide, lower register, south wall, Salone. Photo: Courtesy of the Municipality of Padua–Department of Culture. All legal rights are reserved.

knitting as a wholesale craft production was restricted to men.[80] Knitting was known in Italy and Germany before the Black Death, as evidenced by fourteenth-century altarpieces.[81] For example, Ambrogio Lorenzetti painted Mary knitting the seamless garment for the Christ Child at her side in *The Holy Family* (ca. 1345), now in the Abegg-Stiftung Collection, Riggisberg, Switzerland.[82] In this image Mary knits with four needles and purple yarn, with thread of varying colours in a set of spools or

80 Ruth Mazo Karras, "'This Skill in a Woman Is by No Means to Be Despised': Weaving and the Gender Division of Labor in the Middle Ages," in *Medieval Fabrications: Dress, Textiles, Clothwork, and Other Cultural Imaginings*, ed. E. Jane Burns (London: Palgrave, 2004), 89–104, at 101.
81 Richard Rutt, *A History of Hand Knitting* (London: Batsford, 1987), 44–50.
82 For an image, see Ann Kingstone, "Knitting Madonnas," Dec. 13, 2021, https://annkingstone.com/knitting-madonnas (accessed Dec. 9, 2023), fourth image, and Rutt, *History of Hand Knitting*, 45.

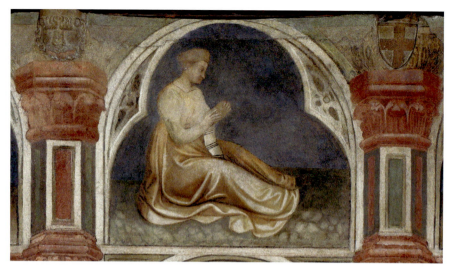

Fig. 4.9: A woman knits in the round, top register, south wall, Salone. Photo: Courtesy of the Municipality of Padua–Department of Culture. All legal rights are reserved.

bobbins in a circular board at her feet. Tommaso da Modena presented Mary knitting the seamless tunic of Christ in the round in his *Altarolo*, painted before 1349, now in the Pinacoteca Nazionale, Bologna, as part of a polyptych.[83] In 1400, Master Bertram of Minden painted Mary knitting the seamless garment on four needles in the round in a detail from the right wing of a double-winged altar retable, called the Buxtehuder Altar (ca. 1390/1415), now in the Kunsthalle Collection, Hamburg, Germany.[84] Mary holds the nearly completed garment in both hands. The garment's thread comes from the balls of wool in the basket beside her. No needles or balls of yarn are visible for the woman in the Salone fresco and yet the placement of her hands and the fall of material suggest she, too, is knitting in the round.

WOMEN MAKING CORD

The final image of a woman textile worker occurs in the late autumn–early winter section of the fresco along the north wall in the "chapter" defined by Jupiter in its rul-

83 An image can be seen at https://pinacotecabologna.beniculturali.it/it/sala-1-dal-duecento-al-gotico/item/366-altarolo-366 (accessed Aug. 9, 2023); a detail showing the portion with the virgin is at Kingstone, "Knitting Madonnas," third image.
84 See https://www.hamburger-kunsthalle.de/en/online-collection. Type "Buxtehuder Altar" in the search box, then click on the thumbnail to enlarge. An image of Mary knitting can be seen in the lower register, second from right. See also a detail at Kingstone, "Knitting Madonnas," first image.

Craftswomen in the Palazzo della Ragione Frescoes

ership of Sagittarius. The woman wears a yellow *berretta* on her head and is dressed in a green square-necked *gamurra* cinched high, with prominent red-and-white-striped short sleeves from which the long grey sleeves of her *camicia* emerge (fig. 4.10). She is seated next to a brown wooden bucket from which she draws unspun carded fibre and from which she then cuts what appears to be spun thread using a pair of long-nosed shears. The spun thread drops into a coil in her lap. Since neither a distaff nor a spindle are visible in this image, the focus is on the spun fibre itself. Such fibre was used to create the cords, laces, and braids that were so essential in lacing bodices, fastening sleeves into armholes, closing sleeves at the wrist, and holding up hose. They were used as drawstrings for purses and to hang items from belts.

There were several means of creating cord or braid for lacing in the medieval period. One possible way was by using an instrument made of bone or wood, now usually referred to as a lucet. Examples date back to the Vikings, but their use is disputed.[85] It has been suggested that linen thread was wrapped around the prongs in a figure-eight and then twisted over itself, repeatedly, to create a cord that was square, strong, and slightly springy. Another method was by fingerloop braiding, for which only hands were necessary. Uneven numbers of thread were folded in half to create loops. The open ends were tied together in a knot and then attached to a fixed point. An even number of loops were held in the outer creases of the fingers of one hand and an odd number in the other. The weaver's fingers then manipulated the loops to create either a flat or a tubular braid.[86] Another technique which required only hands was plaiting three or more threads together to form a braid. To close a gap in clothing, a lace or cord was knotted at either the top or bottom of the opening and then passed back and forth (usually through holes or eyelets) in a continuous line from one end of the gap to the other, often leaving a length of cord dangling where the lacing ended.[87] The front lacing of the hunter's tunic in this same section of the fresco (fig. 4.11) is an example of clothing fastened with a single continuous cord.

The woman's red-and-white striped sleeves add further information as to how this image can be read. From the mid-fourteenth century onwards, smaller, detachable sleeves in a contrasting fabric became fashionable for both men and women. Known as *spagnolesco* sleeves, (or sleeves in the Spanish style, as they were thought to have originated from Spain), they were tied to the bodice with laces through eyelets along the armholes. Such sleeves became popular around 1450.[88] Whether these sleeves were

85 James Graham-Campbell and Dafydd Kidd, *The Vikings* (London: British Museum Publications, 1980), 193. The word "lucet" in English, as an instrument used to make cord, probably dates back only to the nineteenth century. There is a useful of overview of discussions about the history and form of the implement by an archaeologist and craftsperson using the name Rici86, "Brief History of the Lucet Braiding Tool," #LRCrafts, Aug. 28, 2022, https://www.lrcrafts.it/lucet-cordmaking-history [lrcrafts.it] (accessed Feb. 14, 2024).

86 Elisabeth Crowfoot, Frances Pritchard, and Kay Staniland, *Textiles and Clothing c.1150–c.1450*, 2nd ed. (Woodbridge, UK: Boydell, 2001), 138.

87 Elizabeth Birbari, *Dress in Italian Painting 1460–1500* (London: J. Murray, 1975), 74.

88 Frick, *Dressing Renaissance Florence*, 312.

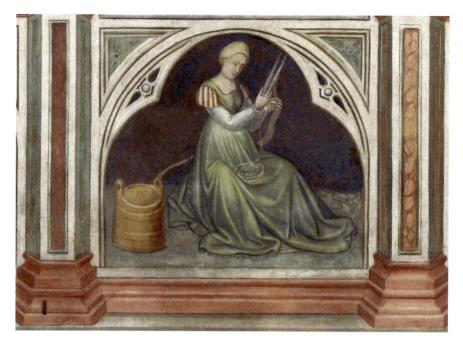

Fig. 4.10: A woman creates cord, lower register, north wall, Salone. Photo: Courtesy of the Municipality of Padua–Department of Culture. All legal rights are reserved.

short or long, sumptuary laws legislated that the arm had to be covered to the wrists, an inviolable ruling even for women labouring in the field.[89] The variations of style of a woman's sleeve were vast and offered an array of possibilities. Stripes added an exotic or foreign element, and striped textiles were used by painters creating biblical settings to convey the exoticism of the Middle East.[90] My reading of this image favours a hypothesis that the women is displaying this new look of exotic detachable sleeves that were tied to the bodice through eyelets with cord similar to the one she is creating, offering another use of cord for this new fashion. The placement of this activity in late autumn–early winter emphasises how cordmaking, an activity necessary to fasten clothes, hose, shoes, and items attached to belts in preparation for the cold months that lay ahead, was a valued and necessary craft. The use of cords to fasten elegant *mantelli*—which also fell under this area of Jupiter's rulership—might offer another connection between cordmakers and this season.

89 Herald, *Renaissance Dress*, 222.
90 Frick, *Dressing Renaissance Florence*, 284; Lisa Monnas, *Merchants, Princes and Painters: Silk Fabrics in Italian and Northern Paintings, 1300–1550* (New Haven, CT: Yale University Press, 2008), 226–27.

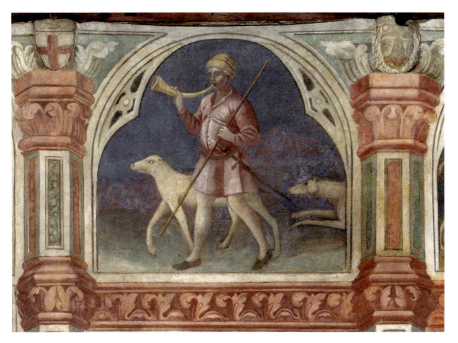

Fig. 4.11: A hunter blows his horn while his two white dogs run alongside, top register, north wall, Salone. The front lacing of his tunic illustrates the use of cord to lace the garment closed. Photo: Courtesy of the Municipality of Padua–Department of Culture. All legal rights are reserved.

CONCLUSION

Medieval women have always worked, and not just in the predictable areas of spinning and sewing, a situation first brought to light in the literature of the 1970s and 1980s.[91] By the early trecento, well before the quattrocento restoration of the Salone fresco scheme, women dominated trades such as ale brewing, tavern keeping, silk spinning, and haberdashery and were qualified members of many guilds.[92] Both the Paduan statutes of 1287 (MS *Statuti Carraresi*, fol. 47r) and the Paduan statutes of 1420 (*Codice Riformato*, fol. 31r) listed woollen workers (*lanarii*), linen workers (*linarolli*), and cloth

91 See Maria Giuseppina Muzzarelli, "Sul Lavoro delle Donne nel Medioevo: Letture Recenti e meno Recenti," in *Il Tarlo dello Storico: Studi di Allievi e Amici per Gabriella Piccinni*, ed. Roberta Mucciarelli and Michele Pellegrini, 2 vols. (Arcidosso, Italy: Effigi, 2021), 2:1051–62, at 1051–52. See in particular 1051 n. 1053 for the authors of these early works.

92 In Venice and Padua, the guilds gave members social connectivity through a religious and philanthropic focus, along with a voice on the governing councils of the Commune. Hyde, *Padua in the Age of Dante*, 243–45.

weavers (*tellarolles*).[93] While David Herlihy found that no Italian guilds in late medieval society were exclusively female, it is likely that some of the members of these Paduan guilds were women.[94] Authors such as Mary Rogers and Paola Tinagli have pointed out that, when women were admitted to guilds, it was often under different conditions to men, and their levels of wages suggested they were unskilled.[95]

Women's roles in commercial life increased after the Black Death, and they continued to excel in cloth production and brewing. By 1400, however, textile guild regulations meant that women were confined to carding and spinning, while men took on the more accomplished and profitable occupations of weaving, knitting, and dying. Women could not legally set up in business by themselves, but they ran businesses and shops when required and could inherit businesses from fathers or husbands who died, indicating that they were prepared, informed, capable, and more than equal to the task.[96] Research since 1990, according to Julius Kirshner, has shown that, rather than simply playing submissive and docile roles within the family, women in late medieval Italy were "active artisans, sellers, consumers, investors, creditors, actresses and witnesses in court proceedings, female advocates, executors of wills, guardians of orphaned children and property managers," clearly pointing to the will and desire on the part of women to learn and engage with the economy.[97]

Furthermore, women did not necessarily wish to join guilds, seeing them as restrictive and limiting, forming instead, as Maria Paola Zanoboni argued, "a dense network of informal relationships and ties external to the corporate world, onto which both hiring and apprenticeships were generally grafted."[98] The phrase used by Maria Giuseppina Muzzarelli was "il basso ostinato," which she defined as the many voices of women engaged in constant and pervasive work, often unskilled, little recognized, paid less than men, frequently tiring, working in the gaps and cracks around work carried out by men and yet providing useful and often essential work without any possibility of gain or social status.[99] For example, between 1347 and 1349 detailed records for the construction site at Orvieto Cathedral documented over 260 workers divided and organized according to profession and rank, including masons, sculptors, carpenters, glassmakers, and blacksmiths. By far the largest category, however, were those linked to

93 Hyde, *Padua in the Age of Dante*, 311. See also Melchiorre Roberti, *Le Corporazioni Padovane d'Arti e Mestieri* (Venice: Istituto Veneto di Scienze Lettere ed Arti, 1902), 122, 136.

94 David Herlihy, *Opera Muliebra: Women and Work in Medieval Europe* (New York: McGraw-Hill, 1990), 162.

95 Mary Rogers and Paola Tinagli, *Women in Italy, 1350–1650: Ideals and Realities: A Sourcebook* (Manchester: Manchester University Press, 2005), 259.

96 Muzzarelli, "Sul Lavoro delle Donne," 1059. Rogers and Tinagli, *Women in Italy*, 258.

97 Julius Kirshner, "Nascoste in Bella Vista: Donne Cittadine nell'Italia Tardo-Medievale," in *Cittadinanze Medievali: Dinamiche di Appartenenza a un Corpo Comunitario*, ed. Sara Menzinger (Rome: Viella, 2017), 195–228, at 205 and n. 234 for scholars who carried out this research.

98 Maria Paola Zanoboni, *Donne al Lavoro nell'Italia e nell'Europa Medievali (Secc. XIII–XV)* (Milan: Jouvence, Mimesis Edizioni, 2016), 40.

99 Muzzarelli, "Sul Lavoro delle Donne," 1053.

Craftswomen in the Palazzo della Ragione Frescoes

the building trades, bricklayers and unskilled workers. Women also formed part of this work force, and between April 1347 and July 1348 sixty-six women were documented as manual labourers removing stone and earth, with a salary of two denarii a day, equal to half that of the lowest-paid male worker. As Lucio Riccetti observed, only ten of the women's names were recorded; the rest were known simply as "mulieres" (women).[100] In 1282, according to Maria Paola Zanoboni, women labourers helped to build the city walls of Messina, on the northeast coast of Sicily. In Tuscany, between 1340 and 1341 fifty-three women helped in the excavation of the Fontebecci aqueduct in Siena; and in the first part of the century, women who worked on the construction site of Siena Cathedral were documented as "chalcinaiuole" (unskilled women who carried mortar), or "che rechano rena" (who brought sand).[101] By contrast, in French, Swiss, Flemish, and Spanish cities between the fourteenth and the seventeenth centuries, women were much more pervasive as masons' assistants and in transporting materials in public and private constructions.[102]

Although focused purely on textile crafts, the seven women in the Salone fresco scheme are, I argue, a part of the Paduan "basso ostinato." Stitches and cords bind clothing together, as essential as the women carrying out these crafts in maintaining the basic bonds of society. Both women and garments were vital to the flow and stability of society, yet in a very real way they remained the visible invisible. The question posed at the beginning of this article as to whether the crafts and skills of these women were being recognized by being painted onto the Salone walls, or whether by omission, other areas of women's work were being suppressed cannot be answered clearly. All that can be said with certainty is that these images, located in a building that was of central importance to Padua's judicial system from the duecento up until the late settecento, highlight key crafts by women rarely seen in the late medieval fresco schemes. Although the women were bound into place by paint and by society's codes, by being given their own interlaced narrative, their own power and purpose made them visible.

100 Lucio Riccetti, "Il Cantiere Edile negli anni delle Peste Nera," in *Il Duomo Di Orvieto*, ed. Lucio Riccetti (Rome: Laterza, 1988), 139–215, at 170–71.

101 Maria Paola Zanoboni, "Donne al Lavoro nell'Edilizia Medievale," *Archivio Storico Italiano* 172, no. 1 (639) (2014): 109–32, at 113. Female workers, on the other hand, were rare in documents connected with the construction site of the Milan Cathedral, and completely absent in those connected with Florence Cathedral.

102 Zanoboni, "Donne al Lavoro nell'Edilizia Medievale," 109–12. Although work in these countries was more prevalent than in Tuscany, as Zanoboni observed, the salaries of these women were far less than those of their more robust male counterparts and more on the level of those of the younger unskilled workers.

Combs, Mirrors, and Other Female Beauty Bling in the Later Middle Ages

John Block Friedman

Late medieval depictions of romance heroines, noble women, and female saints generally focus on their subjects' beauty. Guinevere, Helen, Criseyde, the Virgin Mary, St. Margaret, and even Eve are shown as exceptionally beautiful by medieval standards,[1] while in reaction, a number of clerical misogynistic moralists, such as William Peraldus and Berthold of Regensburg, looked on female beauty as Satan's chief device to entrap men.

Yet if such beauty, good and bad, is everywhere in the Middle Ages, theoretical discussion of its material culture, what makes it up and how it can be achieved, is less common and not particularly innovative. For the extant medieval discourses on beauty show a remarkable reliance on ancient authorities, satiric or not, such as Ovid, suggesting both the historical continuity of such writing and also how little the female desire for beauty changed from Roman antiquity through the Early Modern period.

The present paper attempts to identify specific components of ideal female beauty in the Middle Ages. I shall consider its chief utensils, the comb and the mirror; examine the processes of cosmetically "improving" the skin and lips, and decorating and covering the hair; and finally treat in some detail moralist responses to these practices, which are, incidentally, often good sources of information on beauty and fashion.[2] In addition to classical and medieval written sources, much can also be learned on this topic from manuscript miniatures and other graphic media showing women before

I am grateful to Susanna Morton Braund, Montserrat Cabré, Kristen Figg, Penny Jolly, Jacqueline Leclercq-Marx, Richard Newhauser, and Sherry C. M. Lindquist for advice and information in the preparation of this article.

1 Three particularly useful overviews are Montserrat Cabré, "Beautiful Bodies," in *A Cultural History of the Human Body in the Middle Ages*, ed. Linda Kalof (Oxford: Berg, 2010), 127–47; "La bellesa del cos i els seus secrets: Una arqueologia textual (segles XV–XVII)," *Afers: Fulls de recerca i pensament* 77 (2014): 53–71; Claudio da Soller, "The Beautiful Woman in Medieval Iberia: Rhetoric, Cosmetics, and Evolution" (Ph.D. diss., University of Missouri, 2005).

2 See Katharina M. Wilson and Elizabeth M. Makowski, eds., *Wykked Wyves and the Woes of Marriage: Misogamous Literature from Juvenal to Chaucer* (Albany, NY: State University of New York Press, 1990).

John Block Friedman

mirrors grooming themselves by combing their hair, applying cosmetics to the face, and the like. Moreover, Renaissance dialogues on the individual components of female beauty, such as that offered in a *Decameron*-like Neo-Platonic dialogue by the Italian poet Agnolo Firenzuola (1493–1543) speaking in the guise of Celso Selvaggio with four ladies of Prato, are also excellent sources of information.[3]

These beauty aids feature in a number of medieval and Early Modern discourses on fashion, medicine,[4] beauty workers as a class ("artisans of the body," to use Sandra Cavallo's term),[5] the economics of the comb and the mirror trades, the mercantile distribution of cosmetics,[6] the *toilette* as a subject for art, and the cosmetic recipe collection as a genre.[7] Other beauty aids were fabric wimples and kerchiefs, signifying religious, social, and marital status;[8] floral garlands; and, among wealthy women, metallic thread, jewels, and even flowers such as violets woven into or placed atop the hair, a sign, often, of the husband's civic *virtù* or ability to command respect.[9]

3 See Agnolo Firenzuola, *On the Beauty of Women*, trans. Konrad Eisenbichler and Jacqueline Murray (Philadelphia: University of Pennsylvania Press, 1992).

4 Monica Green, trans., *The Trotula: An English Translation of the Medieval Compendium of Women's Medicine* (Philadelphia: University of Pennsylvania Press, 2002). See more recently on later medieval Iberian uses of the *Trotula*, Montserrat Cabré, "Trota, Tròtula i Tròtula: Autoria i autoritat femenina en la medicina en català," in *Els manuscrits, el saber i les lletres a la Corona d'Aragó, 1250–1500*, ed. Lola Badia, Lluís Cifuentes, Sadurni Martí, and Josep Pujol (Barcelona: Publicaciones de l'Abadia de Montserrat, 2016), 77–102.

5 Sandra Cavallo, *Artisans of the Body in Early Modern Italy: Identities, Families and Masculinities* (Manchester: Manchester University Press, 2007), 1.

6 See Michel Balard, "Importation des épices et fonctions cosmétiques des drogues," in *Les soins de beauté: Moyen Âge, début des temps modernes: Actes du IIIe Colloque international, Grasse (26–28 avril 1985)*, ed. Denis Menjot (Nice: Faculté des Lettres et Sciences Humaines, Université de Nice, 1987), 125–33; Montserrat Cabré, "Cosmetics," in *Women and Gender in Medieval Europe: An Encyclopedia*, ed. Margaret Schaus (New York: Routledge, 2006), 173–74; Jean-Louis Flandrin, "Soins de beauté et recueils de secrets," in Menjot, *Les soins de beauté*, 3–29; Laurence Moulinier-Brogi, "Esthétique et soins du corps dans les traités médicaux latins à la fin du Moyen Âge," *Médiévales* 46 (2004): 55–72, https://journals.openedition.org/medievales/869 (accessed July 22, 2023); and Geneviève Dumas, "Le soin des cheveux et des poils: Quelques pratiques cosmétiques (XIII–XVI siècles)," in *La chevelure dans la littérature et l'art du Moyen Âge*, ed. Chantal Connochie-Bourgne (Aix-en-Provence, France: Presses Universitaires de Provence, 2014), 129–41.

7 See María de los Ángeles Pérez Samper, "Los recetarios de mujeres y para mujeres: Sobre la conservación y transmisión de los saberes domésticos en la poca moderna," *Cuadernos de Historia Moderna* 19 (1997): 121–54; Montserrat Cabré, "La Cura del cos femení i la medicina medieval de tradició llatina: Els tractats 'De Ornatu' i 'De decorationibus mulierum' atribuïts a Arnau de Vilanova, 'Tròtula' de mestre Joan, i 'Flos del tresor de beutat,' atribuït a Manuel Díeç de Calatayud" (Ph.D. diss., University of Barcelona, 1996); Montserrat Cabré, "From a Master to a Laywoman: A Feminine Manual of Self-Help," *Dynamis* 20 (2000): 371–93.

8 See Alison G. Stewart, *Unequal Lovers: The Study of Unequal Couples in Northern Art* (New York: Abaris, 1978), 94–97.

9 See for example, Patricia Simons, "Women in Frames: The Gaze, the Eye, the Profile in Renaissance Portraiture," *History Workshop* 25 (Spring 1988): 4–30, especially the anon-

Female Beauty Bling

As noted, the pervasiveness and breadth of such discourses from the twelfth century on quickly produced a contrary reaction to both male and female adornment (though far more of the latter) as signs of social breakdown, leading to legislation.[10] For the topic of female beauty, especially as pertaining to rich and colorful fabrics and precious metals and gems for decoration of the body and hair, was inseparable from the sumptuary laws, common in the Middle Ages and Early Modern period, intended to control the sort of clothing and ornament appropriate to different social classes. (It is uncertain how often and how rigidly they were enforced.)[11] These laws closely regulated how persons identified by rank and income, and even practitioners of specific trades, should look and dress with regard to color, cut, fabric, and hairstyles, so that a woman's rank in medieval society could be immediately determined at a distance, and she could not be confused with someone of higher or lower status. It goes without saying that the majority of these laws pertained to female dress and accessories.[12]

Many of the items described or depicted in these verbal and visual sources were commodities. For example, with the advent of West African ivory to Europe, there was a burgeoning luxury comb and mirror-frame trade appealing to aristocrats and urban elites,[13] while mercer-peddlers roamed the countryside selling less costly beauty products to villagers;[14] there were also urban dealers in such wares. As well, beauty

ymous portrait in Melbourne, National Gallery, where the sitter, her hair in cornettes, bears a complex jewel on the crown of her head, to match a brooch on her shoulder, plate 1. See note 100 below on Agnolo Firenzuola.

10 Francisco Javier Pérez Carrasco, "Afeites y cosméticos en la edad media, una creación del Diablo," *Historia* 16 (1995): 85–93; José Sánchez Herrero, "Los cuidados de la belleza corporal femenina en los confesionales y tratados de doctrina cristiana de los siglos XIII al XVI," in Menjot, *Les soins de beauté,* 275–96; and Frédérique Lachaud, "La critique du vêtement et du soin des apparances dans quelques oeuvres religieuses, morales et politiques XIIe–XIVe siècles," in *Le corps et sa parure / The Body and Its Adornment,* ed. Jean Wirth (Florence: SISMEL, Edizioni Galluzzo, 2007), 329–51.

11 Good overviews are those of Alan Hunt, *Governance of the Consuming Passions: A History of Sumptuary Laws* (Basingstoke, UK: Macmillan, 1996); Diane Owen Hughes, "Regulating Women's Fashion," in *A History of Women in the West: Silences of the Middle Ages,* 2 vols., ed. C. Klapisch-Zuber (Cambridge, MA: Belknap, 1992), 2:136–58; and Catherine Kovesi Killerby, *Sumptuary Law in Italy, 1200–1500* (Oxford: Oxford University Press, 2002), especially chap. 6. See Sarah-Grace Heller, "Anxiety, Hierarchy, and Appearance in the Thirteenth-Century Sumptuary Laws and the *Roman de la Rose*," *French Historical Studies* 27, no. 2 (2004): 311–48; Maria G. Muzzarelli, "Reconciling the Privilege of a Few with the Common Good: Sumptuary Laws in Medieval and Early Modern Europe," *Journal of Medieval and Early Modern Studies* 39 (2009): 597–617; and Ilaria Taddei, "S'habiller selon l'âge: Les lois somptuaires Florentines à la fin du Moyen Age," in Wirth, *Le corps et sa parure,* 329–51.

12 Killerby, *Sumptuary Law in Italy,* 38.

13 For an overview, see Martha Chaiklin, "Ivory in World History: Early Modern Trade in Context," *History Compass* 8, no. 6 (2010): 530–42, especially 536–38.

14 See Tessa Storey, "Face Waters, Oils, Love Magic and Poison: Making and Selling Secrets in Early Modern Rome," in *Secrets and Knowledge in Medicine and Science, 1500–1800,* ed. Elaine Leong and Alisha Rankin (Farnham, UK: Ashgate, 2011), 143–66.

was an intensely social phenomenon, for women enhanced their appearance not just for themselves but also for their beholders, no matter their gender.

HAIR AND ITS CARE

The care and arrangement of hair is perhaps the single most important component of medieval beauty discourses. While for men in the Middle Ages long hair was often a sign of aristocratic standing among courtiers and thus came to be prized and displayed, by about 1200, for women, plucking and shaping the eyebrows, raising the hairline at brow and temples, and removing facial and pubic hair were considered common aids to beauty and needed for true aristocratic status.[15]

Yet if female hair on the head remained full in line with St. Paul's statement in 1 Corinthians 11:14 that a woman's glory lay in her long hair, its removal in certain circumstances could also mark a decline in social status. For example, to shame women pregnant out of wedlock and female brothel keepers, their heads were often shaved in the Middle Ages, as depicted in the illustrated German legal work *Heidelberger Sachsenspiegel* of ca. 1300,[16] much as in France at the end of the Occupation during the Second World War, women who had taken German soldiers as lovers had their heads shaved and were paraded through the streets, as shown in Max Ophüls' semi-documentary film "The Sorrow and the Pity."

DOCUMENTING FEMALE BEAUTY

I begin this survey of female beauty aids by presenting several medieval descriptions— verbal and visual—as witnesses which, though they treat a largely idealized beauty, still give certain ideas of what was actually considered beautiful and fashionable in the period under consideration here. In doing so I follow a peculiarly medieval order, the *ordo effictionis*, from the hair to the feet.

Medieval students were taught the arts of rhetoric by manuals containing various figures of speech and model descriptions whose form and contents could be adapted to the student's own poetic compositions. For example, such models for describing a person were supplied by Matthew of Vendôme who, composing his student aid about 1175, among other forms of description, catalogued the attributes of both beautiful and ugly women. These catalogues began at the top of the head and progressed to

15 See John Block Friedman, "Eyebrows, Hairlines, and 'Hairs Less in Sight': Female Depilation in Late Medieval Europe," *Medieval Clothing and Textiles* 14 (2018): 81–111. An excellent general guide to medieval views of female hair is Roberta Milliken, *Ambiguous Locks: An Iconology of Hair in Medieval Art and Literature* (Jefferson, NC: McFarland, 2012).

16 This miniature is published in Roberta Milliken, ed., *A Cultural History of Hair in the Middle Ages* (London: Bloomsbury Academic, 2019), fig. I.8.

the feet, commenting on each part of the anatomy, so that they were quite literally an "order" of description.

Matthew used the example of Helen of Troy, who was considered the known world's most beautiful woman, to portray through words ideal female charms. The description here illustrates how a student should imagine Helen:

> Her golden hair, unfettered by any confining knot,
> Cascades quite freely about her face [...]
> Her brow shows its charms like words on a page.
> Her face has no spot, no blemish, no stain.
> Her dark eyebrows, neatly lined twin arches
> Set off skin that is like the Milky Way [...]
> The line of her nose is not too boldly flat,
> Nor is her nose set at too pert an angle,
> The glory of that countenance is her rosy lips [...] Delicate lips
> [...] Lest ever they protrude in an unpleasant manner,
> These honied lips redeem in laughter most delicate.
> Her teeth are straight and even, and their whiteness
> Like ivory. Her smooth neck and shoulders whiter than
> Snow give way to firm but dainty breasts.

In a second exercise, Matthew continues down the body:

> Her chest and waist are narrow and compact, giving
> Way at last to the swell of her rounded abdomen.
> Next is the area celebrated as the store house
> Of modesty, the mistress of Nature, the delightful
> Dwelling of Venus [...]
> Neither the shapely leg, nor the trim knee, nor
> The small foot, nor the smooth hand hangs with loose
> Skin [...][17]

Matthew established Helen's legendary beauty by first describing her hair and brows, which contrast in light and dark, giving the force and authority of classical antiquity to such features. Key characteristics are the broad forehead, a staple of Gothic female beauty; a pale complexion; slender, plucked, and arched eyebrows; an ample belly swelling from a small waist; and smooth, taut skin all over the body. Of particular importance was blonde hair,[18] about which the French poet Christine de Pisan (1364–1430) notes, "nothing in the world [is] lovelier on a woman's head than beautiful blonde hair," and Firenzuola, a century later, concurred: "You know that the proper and true color of hair should be blonde."[19]

17 *Matthew of Vendôme, The Art of Versification*, trans. Aubrey E. Galyon (Ames, Iowa: Iowa State University Press, 1980), 43, section 56.

18 Myriam Rolland-Perrin, *Blonde comme l'or: La chevelure féminine au Moyen Âge* (Aix-en-Provence, France: Publications de l'Université de Provence, 2010).

19 Sarah Lawson, trans., *Christine de Pisan: The Treasure of the City of the Ladies* (London: Penguin, 1985), 135; Firenzuola, *On the Beauty of Women*, 2nd dialogue, 45.

John Block Friedman

Vernacular poets quickly followed suit in developing these beauty canons. For the Spanish poet Juan Ruiz in the *Book of Good Love* (1330–43), the ideal beautiful woman is clearly one with such shaped eyebrows, lacking in lower-class women. Accordingly, he counsels a man "try not to fall in love with a peasant girl [...] look for a [beautiful] woman with / Eyebrows well apart, long and arched,"[20] specifying their aristocratic shape and thinness. Similarly, the Italian poet Giovanni Boccaccio in his *Teseida* (1340–41) adds an additional cosmetic detail, saying of Emilia, a beautiful noblewoman, "her forehead was ample and wide [...] Two eyebrows, blacker than anything and fine curved beneath it." Later, Firenzuola also treasured the wide, high female forehead, giving precise geometrical calculations and proportions for its ideal height and width.[21]

Even the Virgin Mary received this particular beauty treatment, for in an anonymous thirteenth-century south-German poem on Mary, Jesus, and their deeds, in a description cataloguing the features of Mary's astonishing physical beauty, we find this detail obviously referring to her contemporary depictions in painting and sculpture: "her brows were fittingly raised above her eyes, suitably curved. They were black, not wide nor hairy nor thick, nor were they too much in extent [...] just as they are pictured in beautiful images."[22]

Indeed, that the cosmetic eyebrow treatments just described were actually customary among upper-class European and British women by the later fourteenth century is evident from the fact that Geoffrey Chaucer calls attention to his heroine Criseyde's unusual "natural" eyebrows in *Troilus and Criseyde* (1381–86). This is a significant comment, since it is the main distinguishing feature (besides her small, high, round breasts) of her physical appearance in the poem.[23]

By 1470, many of the features outlined above, and their moral and social significance, come together in a panel painting called *Der Liebeszauber* ("The Love Spell"; fig. 5.1), now at the Museum der Bildenden Künste, Leipzig. An apparent copy was made for Josse de Varsenaere (by 1482 mayor of Bruges, died 1490) as a single-leaf

20 Juan Ruiz, *The Book of Good Love*, trans. Elizabeth O. Macdonald (London: Dent, 1999), 112–13.

21 Giovanni Boccaccio, *The Book of Theseus: Teseida delle nozzi d'Emilia*, trans. Bernadette Marie McCoy (New York: Medieval Text Association, 1974), 323–24; Firenzuola, *On the Beauty of Women*, 2nd dialogue, 49.

22 Adolf Vögtlin, ed., *Vita Beate Virginis Marie et Salvatoris Rhythmica* (London: Forgotten Books, 2018), 30–31, book 1, lines 695–700: "Eius supercilia fuerunt elevate / bene super oculos decenter incurvate / Nigra non pilosa nimis non lata neque densa, / Nec fuerunt nimium ad invicem protensa [...] / Velut in imagine pulchra forent picta." My translation. On this work, see Werner J. Hoffman, "Vita Beatae Virginis Mariae et Salvatoris Rhythmica," in *Dictionnaire de Spiritualité* 16 (1974), 1025–29.

23 Geoffrey Chaucer, *Troilus and Criseyde*, in Larry Benson, *The Riverside Chaucer* (Boston, MA: Houghton Mifflin, 1987), V.813. See Jacqueline Tasioulas, "The Idea of Feminine Beauty in Troilus and Criseyde, or Criseyde's Eyebrows," in *Traditions and Innovations in the Study of Medieval English Literature: The Influence of Derek Brewer*, ed. Charlotte Brewer and Barry Windeatt (Cambridge: D. S. Brewer, 2013), 111–27.

Female Beauty Bling

manuscript miniature inserted into the Schiff Book of Hours (now of unknown where-abouts). It shows certain of the hidden implications of such female beauty (fig. 5.2).[24]

The two versions of the scene revisit a familiar iconographic topos, a naked woman at her toilette being admired by a man (or where the admiring gaze was implicit), com-mon in illustrations of biblical stories such as those of David and Bathsheba (2 Samuel 11:2–27) or Susannah and the elders (Daniel 13). This theme, in fact, remained a pop-ular one for artists down through the French Impressionists and Post-Impressionists.[25]

Such beauty and domestic comfort go together, with beauty even commodified. The "Love Spell" woman stands in an elite Northern European household chamber, with a glowing fireplace and a cabinet whose open door reveals silver dining and drinking utensils. A small Maltese dog on a cushion adds to the feeling of a fashion-able and pleasant interior.[26] In short, the scene associates the material comforts of a fifteenth-century bourgeois household with an ideal female beauty understood as desirable and signaling high social status.

The blonde hair of the woman is unfettered as in Boccaccio's *ordo effictionis* of Emilia; her forehead is high and broad, her hairline has clearly been manipulated, and her eyebrows are thin and arched. Her body proportions have the weight concentrated in the abdomen, a mark of great beauty in the Gothic through the Early Modern pe-riods. Her legs are long and slender, her breasts small, apple-like, and high. Chaucer noted this as a mark of beauty in *Troilus and Criseyde*: "hire brestes rounde and lite" (III, line 1250).[27] Yet, however attractive she appears, she wears morally revealing

24 In 1991, the manuscript was sold by the antiquarian book dealer Heribert Tenschert. It is discussed briefly in Jacques Paviot, "Les tableaux de nus profanes de Jan van Eyck," *Gazette des Beaux-Arts*, 135 (2000): 265–82, at 276–77.

25 The topos is discussed with examples by Diane Wolfthal, "Sin or Sexual Pleasure? A Lit-tle-Known Nude Bather in a Flemish Book of Hours," in *The Meanings of Nudity in Medi-eval Art*, ed. Sherry C. M. Lindquist (Farnham, UK: Ashgate, 2012), 279–97, at 285. See, generally, Monica Ann Walker-Vadillo, *Bathsheba in Late Medieval French Manuscript Illustration: Innocent Object of Desire or Agent of Sin* (Lewiston, NY: Mellen, 2008). On the iconographic type, see Elisabeth Kunoth-Leifels, *Über die darstellung der "Bathseba im Bade": Studien zur Geschichte des Bildthemas 4. bis 17. Jahrhundert* (Essen, Germany: R. Bacht, 1962).

26 On the social significance of household dogs in this era, see John Block Friedman, "Dogs in the Identity Formation and Moral Teaching Offered in Some Fifteenth-Century Flem-ish Manuscript Miniatures," in *Our Dogs, Our Selves: Dogs in Medieval and Early Modern Art, Literature, and Society*, ed. Laura Gelfand (Leiden: Brill, 2016), 325–62; and most recently John Block Friedman and Kristen M. Figg, "Dogs of Lust, Loyalty, and Ingrati-tude in the Early Modern Manuscript Painting of Robinet Testard," *Reinardus* 34 (2023): 94–128.

27 A woman not so formed might try reduction by anointing her breasts with hemlock. See Pliny, *Natural History*, Loeb Classical Library 393, ed. and trans. W. H. S. Jones (Cam-bridge, MA: Harvard University Press, 1956), 244–77 (book 25, section 95). See Kim Phillips, "The Breasts of Virgins: Sexual Reputation and Young Women's Bodies in Medi-eval Culture and Society," *Cultural and Social History* 15, no. 1 (2018): 1–19.

Fig. 5.1: *Der Liebeszauber,* or "The Love Spell," anonymous Rhenish artist, ca. 1470. Leipzig, Museum der Bildenden Künste. Photo: Public domain, via Wikimedia Commons.

cork-soled shoes called pattens, typically a symbol of folly in Northern European art and suggesting that men who too much admired her were foolish.[28]

At the beholder's right are other signs of probable moral danger: an ornate wall-mounted convex mirror (for the mirror was typically associated with the siren of

28 See John Block Friedman and Melanie Bond, "Fashion and Material Culture in the Tabletop of the Seven Deadly Sins Attributed to Hieronymus Bosch," *Medieval Clothing and Textiles* 16 (2020): 123–62, especially 137–40.

Female Beauty Bling

Fig. 5.2: Woman at her toilette, anonymous Flemish artist, ca. 1480–90. Schiff Hours, fol. 2r. Formerly in the possession of [Heribert Tenschert] Antiquariat Biebermühle, Ramsen, Switzerland. Present whereabouts unknown. Photo: Public domain.

antiquity),[29] and a peacock tail. Ovid, for example, talks about this bird's association with female vanity, commenting that "the bird of Juno spreads out the feathers praised by man, and in its own beauty many a bird exults."[30]

In the second picture, sexuality is far more evident; the woman is similarly portrayed, even to the pattens, but there is some slight indication of pubic hair beneath her gauze sash. The room is also similar, but less comfortable, and appears to be a starker one intended for private bathing, a prerogative of only the wealthiest homeowners. Such bathing rooms and bath scenes from medieval manuscript illustrations almost always had a licentious connotation.[31] Though an ornate mirror is mounted on the wall, the presence of a chamber pot just below it on the floor undercuts the elegance of the scene, and the woman's features are coarser than those of the Leipzig model.

The dominant piece of furniture in the room is a wooden bathtub with a reflective water surface somewhat concealed behind a hanging with the possible letters NITA, spelling part of the word VANITAS. At the rear of the room, a partially opened door shows a tester bed, suggesting the combination of bathing followed by drinking wine and sexual activity. The chamber pot, the bathtub and bed, and the woman's visible pubic hair all foreground her physicality and sexuality, while her very large comb indicates that she is the iconographic type of the siren temptress. Thus, the Schiff Hours woman brings out the moral and erotic implications of female beauty and its care in ways only hinted at in the original panel painting.[32]

This miniature also closely ties hair grooming and face coloring to bathing as a beauty process and to sexuality, a very ancient connection where the flush of blood brought on by warm water was also the tint of sexual arousal. For example, an Old French fabliau, the *Trois Chanoinesses de Couloigne* by Watriquet de Couvin, gives a comic take on the subject. Watriquet imagines he has been asked to watch three nude canonesses taking a bath. There is the drinking of wine and an erotic promise. "En secré nous voulons baignier" ("We want to bathe in secret"), they tell him, and he sees them "vermeilles et beles / et esprit de grant chaleur / Qui leur fesoit avoir couleur

29 One late medieval mirror was actually wittily made with the form of a siren for a frame; see note 41, below. Such mirrors "with decorative handles in the shape of sirens" are mentioned by Susan Stewart, *Cosmetics and Perfumes in the Roman World* (London: Tempus, 2007), 81.

30 Ovid, *De medicamine faciei liber*, in *Ovid: The Art of Love and Other Poems*, ed. and trans. J. H. Mozley (Cambridge, MA: Harvard University Press, 1979), 5, lines 34–35. See here Christine E. Jackson, *Peacock* (London: Reaktion, 2006), 86–124.

31 Late medieval manuscripts of Valerius Maximus' *Memorable Deeds and Sayings of Philosophers* had bathing scenes involving blatant sexuality. For examples, see Friedman, "Dogs in the Identity Formation," 348 and 349, fig. 14.6.

32 The Schiff miniature is discussed in detail and published by Diane Wolfthal, "The Sexuality of the Medieval Comb," in *Thresholds of Medieval Visual Culture: Liminal Spaces*, ed. Elina Gertsman and Jill Stevenson (Woodbridge, UK: Boydell, 2012), 176–94, at 280–82 and fig. 10.2; and in yet fuller form: Diane Wolfthal, *In and Out of the Marital Bed: Seeing Sex in Late Medieval and Early Modern Art* (New Haven, CT: Yale University Press, 2010).

Female Beauty Bling

/ Li bains chauz et li bons vins frois" (rosy and beautiful from the water's great heat, which gives them color, a hot bath and cool wine).[33]

TOOLS AND TECHNIQUES

In order to attend to their hair and face, the Leipzig woman and her manuscript copy used combs and mirrors, which have an ancient lineage. Both of these utensils were widely popular in classical antiquity, and some combs, for example, remain intact from the volcanic eruption at Pompei.[34] Though most mirrors were of polished metal, glass examples were mentioned by Pliny the Elder (23–79 CE) in the *Natural History* in a discussion of silver, where he connects mirrors with the idea of visual deception. Pliny explains that reflection comes "from the repercussion of the air which is thrown back into the eyes" and that silvering glass was already widely practiced: "a more reliable reflection is given by applying a layer of gold to the back of glass."[35] Ovid chided women for excessive mirror gazing as they applied cosmetics in *The Art of Love*, suggesting that many Roman women did their own beauty preparation without servants.[36]

Mirrors in the Middle Ages held considerably more cultural significance for female self-consciousness than they do today. Indeed, Isidore of Seville (560–636 CE) in his *Etymologies* defines the *speculum* or mirror as "what women use to look at their faces […] so named […] because women looking in it study the appearance […] of their faces."[37] Mirrors, then, reflected a new form of personal self-consciousness developing from the twelfth century onward. For example, Sabine Melchior-Bonnet speaks of the role of mirrors in "a new geography of the body, which made visible previously unfamiliar images (one's back and profile) and provoked sensations of modesty and self-consciousness."[38]

Real and figurative mirrors frequently appear in late medieval literature and are often depicted in medieval art, though few mirrors made earlier than the sixteenth century survive. Glass mirrors—largely replacing the metal ones of antiquity— seem to have been a novel and extremely fashionable part of elite British domestic

33 See, for the Old French text, Willem Noomen, ed., *Nouveau recueil complet des fabliaux*, 10 vols. (Assen, Netherlands: Van Gorcum, 1983–98), 10:83–96, lines 95, 116–19; my translation. See also Mathilde Grodet, "L'eau et le sang: Bains délicieux, bains périlleux dans quelques récits des XIIe et XIIIe siècles," in *Laver, monder, blanchir: Discours et usages de la toilette dans l'Occident médiéval*, ed. Sophie Albert (Paris: Presses de l'Université Paris-Sorbonne, 2006), 85–113, at 90.

34 Steven P. Ashby, "An Atlas of Medieval Combs from Northern Europe," *Internet Archaeology* 30 (2011).

35 Pliny, *Natural History*, Loeb Classical Library 394, ed. and trans. H. Rackham (Cambridge, MA: Harvard University Press, 1968), 97–99 (book 33, section 45).

36 Stewart, *Cosmetics*, 72, 79–81 and fig. 18; Mozley, *Ovid: The Art of Love,* 2.17, lines 7–10.

37 Stephen Barney et al., trans., *The Etymologies of Isidore of Seville* (Cambridge: Cambridge University Press, 2008), 391 (book 19, section 31).

38 Sabine Melchior-Bonnet, *The Mirror: A History*, trans. Katherine H. Jewett (New York: Routledge, 2001), 1.

interiors as early as 1180,[39] and Ingeborg Krüger has argued for the common use of silvered glass mirrors, both handheld and wall-mounted, much earlier than the later fifteenth century.[40]

Two kinds of mirrors featured in luxury domestic décor: the small cosmetic form in a gilt, wood, horn, or ivory frame, associated with both the male and female toilette, and a wall-mounted version, with an ornate frame of various materials, with a similar use. A variant of the small mirror, the *demoiselle* or footed mirror mounted on a table- or floor-high stand, may have been a typical feature of a private space.[41]

Household contents inventories and legacies in wills often itemize ornate combs and mirrors, with mirrors the most frequently mentioned domestic utensil.[42] Thus, they were a very important part of the material culture of the period, costly, and in the case of mirrors, not in common use below the social level of the aristocracy until the Early Modern period.

As was clear from the Leipzig panel painting example, mirrors could be ornate. Figure 5.3 shows an example of a convex wall mirror—one of very few surviving—in a decorated frame with coats of arms. A North Italian ivory mirror case (1390–1400) to be carried on the person offers a scene on its back of a man presenting a large ivory comb to his lover (fig. 5.4).[43] Such combs and mirrors, especially in France, could be made of ivory or framed with it; small handheld mirrors were luxury objects, frequently given in marriages and engagement ceremonies,[44] and mirrors usually had narrative carvings of erotic scenes on the frames. Yet even the comb, as Wolfthal notes, "was a sign of eroticism, since combs served as love tokens, often had amorous inscriptions, and were carved with erotic or amorous subjects."[45]

39 Alexander Neckam, *De naturis rerum libri duo*, ed. Thomas Wright (Cambridge: Cambridge University Press, 2012), 239 (book 2, chap. 154). See also Ingebord Krüger, "Glasspiegel im Mittelalter: Fakten, Funde und Fragen," *Bonner Jahrbucher* 190 (1990): 233–313.

40 See Herbert Grabes, *The Mutable Glass: Mirror-Imagery in Titles and Texts of the Middle Ages and English Renaissance*, trans. Gordon Collier (Cambridge: Cambridge University Press, 1982); and Nancy M. Frelick, ed., *The Mirror in Medieval and Early Modern Culture* (Turnhout, Belgium: Brepols, 2016).

41 As to mirrors on tall or short stands, Jeanne d'Evreux at her death in 1371 had "une demoiselle, en façon d'une seraine d'argent doré, qui tient un mirouer de cristal en sa main" ("a *demoiselle*, in the fashion of a silver-gilt siren, who holds a crystal mirror in her hand"), while King Charles V of France in 1380 according to his inventory had two such "footed" mirrors in ivory frames, one bigger and one smaller, at the Château of Saint-Germain. See Alfred Franklin, *La vie privée d'autrefois: Arts et métiers, modes, meurs, usages de Parisiens du XIIe au XVIIIe siècle* (Paris: Plon, 1896), 155.

42 See Danièle Alexandre-Bidon and Françoise Piponnier, "Gestes et objets de la toilette aux XIVème et XVème siècles," in Menjot, *Les soins de beauté*, 211–44, at 218.

43 Walters Art Museum, Baltimore, acc. no. 71.269, https://art.thewalters.org/detail/30221/mirror-case-with-the-gift-of-the-comb (accessed July 22, 2023).

44 See Richard H. Randall, Jr., *Masterpieces of Ivory from the Walters Art Gallery* (New York: Hudson Hills Press, 1985), 184, for a mirror case showing a lover's gift of a comb or his heart to a woman.

45 Wolfthal, "Sin or Sexual Pleasure," 289.

Female Beauty Bling

Fig. 5.3: Parabolic mirror, from a public building, with town heraldic shields. Germany, ca. 1490. Vevey, Switzerland, Musée Historique. Photo: Courtesy Musée Historique.

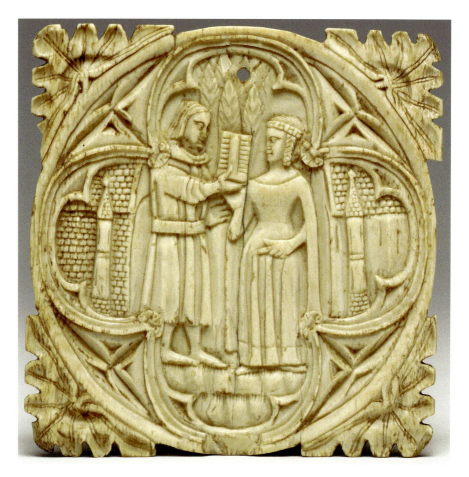

Fig. 5.4: Ivory mirror case showing a lover's gift of a comb. Milan, 1390–1400, Baltimore, Walters Art Museum, acc. no. 71.269. Photo: Courtesy Walters Art Museum.

Though men generally gave such objects to women, the reverse could also be true. In Jean Froissart's *L'Espinette Amoureuse*, the Dreamer-Narrator describes a love gift made by the woman of a small mirror and hints at how the mirror holds reflections from the "species," reflections given off by the beloved still inhering from the time when she last looked into it: "In this glass / Was reflected the one who ensnares / My heart."[46]

46 See Kristen M. Figg and R. Barton Palmer, eds. and trans., *Jean Froissart: An Anthology of Narrative and Lyric Poetry* (New York: Routledge, 2001), 205, lines 2572–93. For the concept of "species," see Carolyn Collette, *Species, Phantasms, and Images: Vision and Medieval Psychology in the Canterbury Tales* (Ann Arbor, MI: University of Michigan Press, 2001), 6.

Female Beauty Bling

What did these mirrors look like? The typical mirror case was a two-piece affair of ivory measuring about two and one-half inches to about six inches in diameter, usually with a gilt metal hinge and, as the inventories note, a silk cord of some type. One section held a mirror, and the other section of the case folded against it for protection, much as with a modern woman's powder compact. For mirrors ornamented with secular subjects, the backs of both sections were generally carved with a central image based on love scenes, as noted earlier, often from romances, and with the figural outlines and poses drawn from model books.

Typically, among the wealthy, these mirrors formed part of complete cosmetic sets: comb (usually of ivory but also of horn, boxwood, or ebony), a cased mirror, and a hair parter or *gravoir*, all in an embossed *cuir bouilli* leather case that closed with an attaching silk lace. A fine example embossed with animals, grotesques, and Gothic foliage is in the Deutsches Ledermuseum, Offenbach.[47] Such kits were expensive. For example, Isabeau of Bavaria, the queen of France, bought in 1386–87 "un petit miroir d'ivoire avec etui pendant a un lacs de soie," (a small ivory-backed mirror with a case, hanging on a silk lace) for ten Paris sous, about the cost of a sheep at that period: 11 sous, 6.5 deniers.[48]

As noted earlier, Gothic ivory mirror cases and ornamented combs were gifts between lovers, part of betrothals and marriage ceremonies. Wolfthal, for example, speaks of such utensils as a "gift to the beloved so that she might use it to beautify herself in a private intimate way." Lovers, then, gave mirrors with their broader surfaces available for ornamentation that could better serve to deliver amorous messages. They sometimes bore inscriptions such as "take this gift of your lover kindly."[49]

For the sources of many staple scenes on these gift mirror cases, carvers turned to courtly romances, for the frames of secular mirror cases typically depicted events ranging from simple meetings between anonymous or legendary lovers (Lancelot and Guinevere) to key elements of entire scenes from Arthurian romances, especially, for France, those of Chrétien de Troyes (such as Guinevere's abduction). These reflexive narrative patterns served to give the love gifts both authority and immediacy, appealing to stories well known to the giver and the recipient.

France, and the area around Paris in particular, seems to have been the point of origin for many such love gifts as well as comb and mirror sets bought for practical reasons. Yet, since these objects were widely traded throughout continental Europe and were carried as far as Scandinavia and the Middle East, it is difficult to know exactly where and when a given carving might have been produced. Most students of

47 Published in Randall, *Masterpieces of Ivory*, 179, fig. 35.

48 See Katherine Elisabeth Staab, "Tactile Pleasures: Secular Gothic Ivory" (Ph.D. diss., University of Pennsylvania, 2012), especially figs. 11, 12, and 13. The dissertation can be found at https://etda.libraries.psu.edu/catalog/23514 (accessed July 22, 2023). For the value of the *sou*, see Jim Chevallier, "Comparing Prices in Medieval France," *Les Leftovers: Sort of a Food History Blog*, August 15, 2014, https://leslefts.blogspot.com/2014/08/comparing-prices-in-medieval-france.html (accessed July 22, 2023).

49 Wolfthal, "Sexuality of the Medieval Comb," 180–81 n. 21.

ivory carving think that the earliest Gothic cases date from the middle to the second half of the thirteenth century, with Raymond Koechlin suggesting the Île-de-France as the focal point of the trade. However, more recent scholarship shows that Italy and Germany were also important centers, and of course examples from their regions could have also come to France.[50]

There is firmer information available about the people who carved these objects and who sold them, as they worked in a well-documented guild system. And a good deal of information on aristocratic buyers comes from expense records for royal or elite households. For example, the *Livre des Métiers* of Etienne Boileau (1260) shows how the different aspects of ivory working in Paris were divided among the guilds.[51] Thus, only the *pigniers* and *lanterniers* made mirror cases, combs, and lanterns, appealing to an aristocratic clientele. The cosmetic items were often sold to the French court in surprisingly large numbers. For example, Marguerite of Flanders, the duchess of Burgundy, in 1405 owned eight large and small mirrors inventoried at three florins, a considerable sum, while her boxwood comb, dated 1400, bore her monogram and coat of arms.[52]

The Parisian ivory workers also distributed combs and mirrors directly to aristocratic women, taking on mercantile as well as manufacturing roles. For example, a Parisian craftsman, Jehan le Seelleur, in a 1322 document, was also called a "mercier," a term which denoted the seller of a wide range of small wares primarily for women, all the way from silk braid to headscarf pins, rouge sticks, and worked ivory and horn products. Jehan first appears in the accounts of Mahaut, Countess of Artois (1266–1329), in 1315 when he sells her two ivory combs and two leather cases to hold combs, a *gravoir*, and a mirror.[53]

For women far below the social station of Mahaut and Marguerite of Flanders there were, of course, much less ornate cased mirrors in widespread use towards the end of the Middle Ages, probably sold at fairs such as those in Champagne in France.

50 Randall, *Masterpieces of Ivory*, 179. For secular mirror cases, see Raymond Koechlin, *Les ivoires gothiques français*, 3 vols. (Paris: Picard, 1924–26), 1:360–411. Since Koechlin's work, the digital cataloguing project for ivories at the Courtauld Institute of Art has made several hundred of these objects easily available for study; see http://www.gothicivories.courtauld.ac.uk (accessed Sept. 3, 2022).

51 René de Lespinasse and François Bonnardot, eds., *Les métiers et corporations de la ville de Paris: XIIIe siècle: Le Livre des métiers d'Étienne Boileau* (Paris: Imprimerie Nationale, 1879).

52 "Huit miroirs grands et petits:" See Koechlin, *Les ivoires gothiques français*, 1:370 n. 6. Marguerite's boxwood comb is in Paris, Musée National du Moyen Age, inv. no. CL22797. See also Susan L. Smith, "The Gothic Mirror and the Female Gaze," in *Saints, Sinners, and Sisters: Gender and Northern Art in Medieval and Early Modern Europe*, ed. Jane L. Carroll and Alison G. Stewart (Aldershot, UK: Ashgate, 2003), 73–93, at 73.

53 Katherine A. Rush, "Lost and Found: Gothic Ivories in Late Medieval French Household Records," in *Lost Artefacts from Medieval England and France: Representation, Reimagination, Recovery*, ed. Kathryn Gerry and Laura Cleaver (Woodbridge, UK: Boydell and Brewer, 2022), 158–78, at 158.

Female Beauty Bling

Some of these had the glass backed with simple lead foil.[54] Martin Biddle, for example, shows such an early-fourteenth-century mirror case of copper alloy with surviving bits of convex mirror and cement. It is quite small, about 30 millimeters (less than 1¼ inch), consisting of hinged covers with a copper rivet through the lugs. Overall, it measures 82 millimeters (3¼ inches) open, and "inside each [section was] cased an irregular piece of apparently once convex glass [...] the convexity of the glass would have allowed the viewer to see a larger area than the mirror, though at a reduced scale."[55] It came from the Winchester Castle Yard *garderobe* or cesspit.

A TRADE POEM ON BEAUTY PRODUCTS

In time, mirrors, as other such utensils relating to female beauty, began a class descent from the court world to elite urban homes and then to fairs and to the packs of rural peddler-mercers. For example, in Britain, John Heywood's *Playe of the Foure PP*, written about 1521, enumerates the contents of a peddler's pack, including a number of items of appeal to women for beautification, such as combs, and pomander, and ribbons with which to decorate the hair and the clothing.[56]

Much more detail about female beautification is offered in the anonymous Old French poem called "Dit du Mercier" ("The Song of the Haberdasher"), ca. 1270–1340.[57] It concerns the stock and sales practices of a traveling salesman or mercer, though the items that he sells are far more various than the modern term mercery covers. As early as 1200, such itinerant peddler-mercers with their packs were a fixture of village life,[58] roaming the French countryside, visiting markets and fairs:

> Hello to this very fine company.
> I am a mercer, and carry mercery,
> Which I would sell willingly,
> For I am in need of pennies.
> Now if it pleases you to listen,

54 See Justine Bayley, Paul Drury, and Brian Spencer, "A Medieval Mirror from Heybridge, Essex," *The Antiquaries Journal* 64 (1984): 399–402, who say thousands of such mirrors had come to London, probably from the Netherlands, by the late fourteenth century.

55 Martin Biddle, *Object and Economy in Medieval Winchester* (Oxford: Clarendon, 1990), 655–59. The mirror is discussed on 655 and 656; fig. 178 shows it as item 2103.

56 Joseph Quincy Adams, ed., *The Playe Called the Foure PPs: Chief Pre-Shakespearian Dramas* (Cambridge, MA: Houghton Mifflin, 1952), 370.

57 The French text of the "Dit du Mercier" is edited by Philippe Ménard, "Le Dit du Mercier," in *Mélanges de langue et de littérature du Moyen Age et de la Renaissance offerts à Jean Frappier*, 2 vols. (Geneva: Slatkine, 1970), 2:797–818. The translation from the "Dit" used here appears in full in John Block Friedman, "Chaucer's Pardoner, Rutebeuf's 'Dit de l'Herberie,' the 'Dit du Mercier,' and Cultural History," *Viator* 38, no. 1 (2007): 288–318, at 315–18.

58 See Arne Zettersten and Bernhard Diensberg, eds., *The English Text of the Ancrene Riwle*, Early English Text Society, o.s. 274 (Oxford: Oxford University Press, 2000), 36, lines 25–27.

John Block Friedman

I can easily describe the goods that I carry
[…] I have wimples saffron tinted and perfumed […]
and for ladies horn clips for your hair […]
I have beautiful silver wimple pins,
As well some of pot metal too,
That I sell to these fine ladies.
I have some pretty headscarves
And lovely coifs with laces
That I can sell to pretty girls,
And a matching silk
For hats with bordered brims,
And I also have some linen hats for young girls
Embroidered with flowers or birds—
Of a smooth and bright warp and woof—
To primp in before their boyfriends
[…]
and combs for the hair—
[…] and napkins
that rich women wear on their heads on holy feast days,
and I have much finery for women:
everything necessary for the toilette:
razors to shave the hairline, tweezers, makeup mirrors
and ear and toothpicks,
hair preeners and curling irons,
[…] combs and mirrors,
and rose water with which to cleanse themselves.
I have cotton with which they rouge,
And whitening with which they blanch themselves.

THE GROOMING OF MEDIEVAL WOMEN

Royal expense records and "trade" poems such as the one just quoted can tell us much about the beauty aids women acquired through urban merchants or bought at fairs and through wandering peddlers. However, there is no comparable corresponding body of information explaining how these products were used—such as, for example, how hair could be arranged—until, perhaps, the more detailed recipe collections of the sixteenth century, such as that of Caterina Sforza (1463–1509) or the commentaries on female beauty such as that of Agnolo Firenzuola, mentioned earlier. Though classical literature had occasionally described women being groomed, such as Juvenal's famous account in the *Sixth Satire* of a woman who beats her "beauty" slave because a curl is out of place during her morning *toilette*, such accounts are literary rather than practical.[59] Medieval cosmetic manuals do, however, in giving recipes for the improvement of the skin and body odor, often provide a certain amount of practical instruction and

59 *Juvenal and Persius*, ed. and trans. Susanna Morton Braund (Cambridge, MA: Harvard University Press, 2004), *Satire* 6, 280–81, lines 492–93.

Female Beauty Bling

identify particular "beauty" spaces such as the public baths mentioned in the *Trotula*, a collection of medical texts attributed to a possibly legendary female physician of that name from Salerno. In royal households, women of the chamber would probably have had a good deal of information on grooming, but middle- and lower-class women may have had to experiment and apply such materials on their own.

Practical beauty instruction in the Middle Ages may have passed orally from mothers to daughters, or for the literate could have been extrapolated from cosmetic manuals, though these largely focused on recipes rather than application. The art of manuscript and panel painting could also have provided models, but again there were relatively few realistic depictions of late medieval women using beauty aids or being groomed, and those that do exist often have a clearly erotic rather than a practical context.

Such artistic representations as have survived can be of two sorts, showing either self- grooming or that done by servants. For example, Wolfthal publishes an example of the first sort, from a manuscript miniature of about 1475, showing a woman in the presence of her lover combing her hair before a wall-mounted mirror. The tester bed dominating the rear of the room indicates that the ultimate purpose of the grooming is sexual congress. The scene's iconography is quite similar to that in figures 5.1 and 5.2, with the implication that beautifully arranged hair would have made the woman immediately desirable to the waiting lover.[60]

The second type might show a woman in a social context of household retainers. One of the most important examples of a woman being so cared for is that occurring in a fifteenth-century manuscript of the popular Arthurian romance *Lancelot du Lac* (Paris, Bibliothèque Nationale de France, MS fr. 112(1), fol. 107, dated 1470), which is roughly of the David and Bathsheba type (fig. 5.5). The text describes Gawain watching a beautiful woman recline on a bed during her *toilette*: "Just behind her a maiden combed her hair with a comb of gilded ivory and another maid held before her a mirror and a chaplet [...]."[61] The ornamental and luxurious character of the implements is obvious. The grooming process may be an accurate representation of such behavior, but the reclining pose seems primarily intended to convey an erotic mood, though the woman is presumably unaware of the presence of an admirer.

MEDIEVAL COSMETICS

Besides the grooming of the hair just shown, the woman could apply (or have applied) cosmetics to enhance her beauty; this was a practice with both a medical and a Christian theological component. For in antiquity, cosmetics rectified "medically"

60 The miniature is published and discussed by Wolfthal, "Sexuality of the Medieval Comb," 182, fig. 7.3, and in greater detail in her "Sin or Sexual Pleasure," 289.

61 See, for the French text, Heinrich Oskar Sommer, ed., *The Vulgate Version of the Arthurian Romances*, 8 vols. (1910; repr., NP: Pranava, 2019), 3:281; my translation. The miniature is published and discussed in Wolfthal, "Sexuality of the Medieval Comb," 183–84, and figure 7.6.

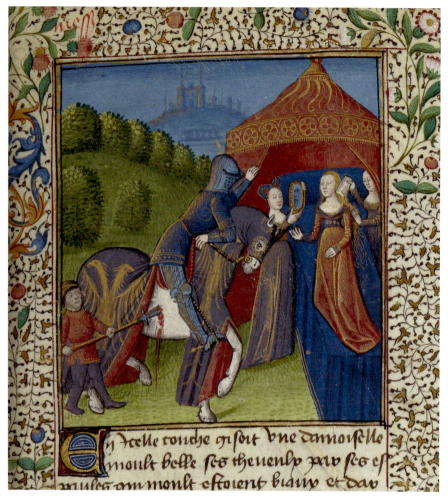

Fig. 5.5: A woman gazes into a handheld mirror while being groomed. Vulgate *Lancelot du Lac*. Paris, Bibliothèque Nationale de France, MS fr. 112(1), fol. 107, 1470. Photo: Courtesy Bibliothèque Nationale de France.

what the woman might perceive as physical anomalies such as wrinkles, blotchiness, hirsuteness, and loss of skin tone, among other defects. Indeed, the wide range of such perceived defects is hinted at in Pliny's *Natural History*. This work has a great many such recipes scattered through the botanical books, primarily reiterating folk knowledge of hair dyes and thickeners, curl inducers,[62] and wrinkle removers, which often involved

62 See Montserrat Cabré, "Women or Healers? Household Practices and the Categories of Health Care in Late Medieval Iberia," *Bulletin of the History of Medicine* 82, no. 1 (2008): 18–51, at 41; and on curling irons and related utensils in antiquity, Elizabeth Bartman,

Female Beauty Bling

decoctions of the fat of swans and lions and crocodile dung, while maidenhair fern removed spots from women's faces as well as dealing with armpit odors. However, these recipes were incidental to the work's larger encyclopedic purpose.[63]

During the Middle Ages the improvement of the female appearance was treated as a topic with little distinction made in both medical treatises and collections of beauty recipes. As Montserrat Cabré has noted:

> Cosmetics—and perfumes—had a visible place within medicine [...]. The sphere of practices understood as *decoratio* and *ornatus* offered techniques for caring and modifying the surfaces of the body: the cleaning and softening of the skin, the hygiene of the mouth, the care and colouring of the hair of the head [...], the depilation of unwanted body hair and the treatment of all kinds of skin imperfections.[64]

In contrast to this "medical" approach, from a theological perspective, with respect to *decoratio* and *ornatus*, loss of facial beauty in women (and the consequent need to rectify it through the application of cosmetic techniques just described) was thought to be a result of the Fall of Man. For example, the anonymous thirteenth-century Anglo-Norman treatise *L'ornament des dames* explains that before the Fall when God made Eve, he endowed her with an ageless beauty. But as a consequence of tasting the apple she lost it. And, accordingly, women since have been bereft of much of their beauty.[65]

Cosmetics, then, are both necessary to improve the female appearance and also by implication to return women to an Edenic state as shining as when they left it. Indeed, the only theoretical statement in Arnold of Villanova's (1240–1311) reworking of Trotula's *De Ornatu Mulierum* concerns just such a brightening of the skin: "whitening [is] vital to women either by necessity or because they consider it suitable to have clear, shining, and beautiful faces,"[66] offering twenty-two recipes to do it. It is likely that with the advent of blonde, fair Northern European Crusaders (and the women who accompanied them), dark Mediterranean women, Christian or Muslim, may have been formulating new codes of beauty, though the blondeness and fairness of subjugated tribes throughout the Roman Empire had also appealed to their conquerors.

Well described in Roman literature, the processes and materials for skin whitening in particular passed with little change down to the Middle Ages and the Early Modern

"Hair and the Artifice of Roman Female Adornment," *American Journal of Archaeology* 105 (2001): 1–25, at 12.

63 Pliny, *Natural History*, Loeb Classical Library 392, ed. and trans. W. H. S. Jones (Cambridge, MA: Harvard University Press, 1951), 337, 353, 355 (book 22, sections 33, 41, 43). See Stewart, *Cosmetics*, 35–36.

64 Montserrat Cabré, "Keeping Beauty Secrets in Early Modern Iberia," in *Secrets and Knowledge in Medicine and Science, 1500–1800*, ed. Elaine Leong and Alisha Rankin (Farnham, UK: Ashgate, 2011), 167–90, at 176.

65 Pierre Ruelle, ed., *L'ornement des Dames* (Brussels: Presses de l'Université de Bruxelles, 1964), 32–35.

66 "[...] clarificatio dominabus multum [...] necessaria et secundum rationem convenit eas tenere faciem claram, fulgentem et pulchram [...]," Cabré, "La Cura," 199; my translation.

period.[67] Examples of these practices are mentioned in Ovid's fragmentary "On Painting the Face," a brief treatise directed to the older woman: "the time will come, when it will vex you to look at a mirror." Ovid advises the woman that she should begin cosmetic application as soon as she awakens, "when sleep has let go your tender limbs," then apply the "clarification." The recipe is complex, involving grinding barley chaff and vetch, and adding macerated narcissus bulbs and honey. "Whoever shall treat her face with such a prescription will shine smoother than her own mirror," but again we are dealing with a literary rather than a primarily practical account.[68] Nonetheless, there is widespread historical evidence for the existence of relatively complex whitening preparations in general use in antiquity and the Middle Ages. For example, during the excavation of a Roman temple in South London in 2003, a tin pot dating from the second century CE was found containing a foundation face cream intended for just such whitening of the skin. Its quite well-preserved and usable contents appear to have been primarily goat fat, starch, and tin oxide.[69]

The very white complexion produced by such cosmetics was highly valued by Roman women,[70] though on the whole Roman poets (with the exception of Ovid) frowned on their use. Juvenal's *Sixth Satire*, for example, contains a tirade against female cosmetics (lines 457–507), imagining cheeks covered with unattractive and thick layers of flour paste. Nonetheless, the classical preoccupation with female facial whitening and feature highlighting was widespread. It was very well developed in the Roman period. Aside from Juvenal's flour paste, other antique pore fillers and whiteners were chalk, pipe-clay, kaolin (a fine textured china clay still in use in modern cosmetics), and *cerussa* or white lead or carbonate of lead, perhaps the substance in the Roman cosmetic box excavated in London;[71] these preparations were intended to focus the gaze on the lips, eyes, and cheeks.

Though some of these antique cosmetic practices—such as the use of charred rose petals, soot, crushed house flies, or galena (lead ore) to darken the eyelashes and brows and outline the eyes—may seem strange today, many of Pliny's plant and chemical recipes were repeated over and over in medieval vernacular cosmetic manuals flourishing from the end of the thirteenth century and reaching a high point in Italian Renaissance beauty collections. Some, often with an amorous emphasis, were even written by women such as Caterina Sforza, who in a work with an alchemical and experimental emphasis offered sixty-six beauty preparations.[72]

67 See generally, Stewart, *Cosmetics*.

68 Mozley, *Ovid: The Art of Love*, 5, lines 47–48.

69 Katharine Mansell, "Recreating a 2,000-Year-Old Cosmetic" [news article], *Nature*, Nov. 3, 2004, https://www.nature.com/news/2004/041101/full/news041101-8.html (accessed July 22, 2023). See also Stewart, *Cosmetics*, 35–36.

70 Kelly Olson, *Dress and the Roman Woman* (New York: Routledge, 2008), 61–70.

71 Stewart, *Cosmetics*, 39, 41.

72 See Elio Caruso, ed., *Ricette d'Amore e di Bellezza di Caterina Sforza, Signora di Imola e di Forlì* (Cesena, Italy: Il Ponte Vecchio, 2009). A selection of twenty-four of Sforza's beauty recipes describing materials and to some degree methods of application appears in Gigi Coulson, ed. and trans., *Caterina Sforza's Gli Experimenti: A Translation* (San Bernardino,

Female Beauty Bling

As mentioned earlier, there was often little distinction between medical and cosmetic works, and beauty preparations and even processes like facial and genital depilation were discussed in standard medical works as a part of the broad subject of female health. For example, the eminent Italian physician Aldobrandino of Siena (d. 1296), writing in French, gives a lengthy recipe in his *Le Régime du Corps*—a work one might think from its title to be purely medical—for "clarification" or whitening of the complexion to achieve a "healthy" skin with white and rose tints:

> This water is better beyond anything […] Make a water of ranunculus [buttercup] flowers and wash the face, for it is perfect for that. And then with ranunculus seeds make a fine powder and put in it alum of lead and one pinch of brazilwood and make a liquid […] when you wish to use it, soak one ounce in rose or in ranunculis water and then apply it to the face to blanch the skin and make it well colored.[73]

Similarly, in the popular *Compendium Medicinae*, by the important English physician Gilbertus Anglicus (1180–1250), book 3, *De Rubricatione Facie*, offers an opening recipe primarily to heighten the red in the cheeks: "If you wish to make the face red, [mix] chips of brazilwood in an eggshell with rose water alum and apply it with a square of silk to the face […]"[74] The medieval collection of medical information called *Trotula* also provides information on lip coloring:

> Women adorn their faces thus, and thus the lips can be adorned. They have skimmed honey, to which they add a little white bryony, red bryony, squirting cucumber, and a little bit of rose water. They boil all these things until it is reduced by half. With this ointment, women anoint their lips.[75]

Another recipe is for a specific dye: "If, however, a woman needs to color herself, let her rub the lips very well with the bark of the root of the nut tree."[76]

With the exception of the *Trotula*, and the *Physica* of the abbess Hildegarde of Bingen (1098–1179), almost all of these high medieval collections were written by men for women, sometimes of important social status. For example, one such Spanish collection is for "muy honorables señores," and a fourteenth-century Catalan beauty

CA: CreateSpace Independent Publishing Platform, 2016). On Sforza's cosmetic interests, see Joyce de Vries, *Caterina Sforza and the Art of Appearances: Gender, Art and Culture in Early Modern Italy* (Farnham, UK: Ashgate, 2010).

73 French text in Louis Landouzy and Roger Pépin, eds., *Le Régime du Corps de Maître Aldebrandin de Sienne* (1911; repr., Geneva: Slatkine, 1978), 99–100; my translation.

74 *Compendium Medicinae Gilberti Anglici*, ed. Michael de Capella (Lyon: J. Saccon, 1510), book 3, fol. 117: "Si autem volueris rubefacere faciem, radas brazilii lignum in testa ovi continente parus aque rosa […] ibi tali inungat bombacem […] imprimat super faciem et reddet eam rubeam." My translation.

75 Green, *Trotula*, 185.

76 Green, *Trotula*, 185.

John Block Friedman

manual is addressed to a queen "flor de Arago."[77] Presumably, such authors were male physicians at royal courts.

One of the most detailed and interesting of these for historians of cosmetics, since it contains an unusual amount of application information, was the *Tresor de Beutat*, attributed to a Manuel Dias Calatayud (d. 1443). Very little is known about this author, but he wrote copiously on cosmetic matters in ninety-three chapters containing 223 recipes involving animal, plant, and mineral products.[78] The audience appears to have been primarily wealthy women, some of whom may have also been successful courtesans and midwives of middle-class status. His beauty aids treated bodily cleanliness and health; the mechanics of cosmetic preparation; troubles with skin, nose, eyes, and teeth; and menstrual irregularities. Each recipe gives the materials involved, quantities, how it should be prepared, and how it should be applied. Deer and goose broth, crabs, and ant, frog, and tortoise eggs served for depilation; goat bile, cuttlefish bone, and ass's milk were used in whitening agents; genets for perfumes; and crow eggs for hair dye. To peel the skin, a drowned rat was applied to the spot. An owl's head could also be used cosmetically. Some of these recipes, such as ass's milk, have a very ancient pedigree, for Cleopatra was believed to have bathed in pure ass's milk.[79]

COLORING AND AUGMENTING HAIR

The care of the hair was of primary concern for women from classical antiquity through the Middle Ages. As noted earlier, blonde hair was highly desirable, and well-off Roman brunettes who wished to have it made use of a trade in blonde hair gathered from Teutonic slaves and made into extensions and wigs (*capillamenta*), partly as a sign of the subjugation of barbarians.[80] Thus, Ovid refers to the hair of captives as spoils of war. In the *Amores*, for example, he imagines a man addressing his lover who, to his chagrin, has capriciously cut her splendid hair:

> Now Germany will send you tresses from captive women; you will be saved by the bounty of the race we lead in triumph. O how oft, when someone looks at your hair, will you

77 See Manuel Díes de Calataiud, *Flores del Tesoro de la Belleza: Tratado de muchas medicinas o curiosidades de las mujeres: Manuscrito no. 68 de la Bib. Un. de Barcelona, Folios 151–170*, ed. and trans. Teresa María Vinyole, Josefina Roma, and Oriol Comas (Palma de Mallorca, Spain: José J. de Olañeta, 2001); Cabré," From a Master to a Laywoman," 375; and Mercè Puig Rodríguez Escalona, "La bellesa femenina a l'edat mitjana segons els tractats de cosmètica," in *Belleza escrita en femenino*, ed. Àngels Carabí and Marta Segarra (Barcelona: University of Barcelona, 1998), 39–48.

78 See Isabel Betlloch-Mas, et al., "The Use of Animals in Medicine of Latin Tradition: Study of the *Tresor de Beutat*, a Medieval Treatise Devoted to Female Cosmetics," *The Journal of Ethnobiology and Traditional Medicine* 121 (2014): 752–60. The work is published in modern form as Díes de Calataiud, *Flores*.

79 Stewart, *Cosmetics*, 39.

80 See Victoria Sherrow, *Encyclopedia of Hair: A Cultural History* (Westport, CT: Greenwood, 2006); and Bartman, "Hair and Artifice," 2, 14.

Female Beauty Bling

redden, and say: "The ware I have bought is what brings me favour now. 'Tis some Syg-ambrian woman that yonder one is praising now, instead of me. Yet I remember when that glory was my own."[81]

Sometimes there was a mixture of this Teutonic light-colored hair braided in with the Roman woman's dark hair as an element of fashion for those who could not afford or did not desire a wig. That the practice of using false blonde hair to augment a woman's own hair for fashion or other reasons continued into medieval England is clear from the recovery of plaits of such hair dating from the second quarter of the fourteenth century during the process of an excavation in London.[82] We have already seen that Christine de Pisan and Agnolo Firenzuola considered blonde hair a glory. To achieve such blondeness for brunettes, a variety of chemical and botanical processes were used. Thus, Pliny's *Natural History* mentions true or false saffron to lighten hair color, as well as vinegar bleaches, recipes that continued in use well into the Middle Ages.[83]

The twelfth-century *Trotula* continues these practices through a number of recipes, some of "Saracen" origin, to achieve lightening effects. Possibly dark-haired Muslim or Mediterranean women may have written these recipes. Saracens—really, any Muslim woman—and Jewish women were believed to have exotic cosmetic and aphrodisiac powers. Though the *Trotula* may simply have meant that the recipe was of Middle Eastern origin, the term "Saracen" connoted what the adjectives "French" or "Parisian" for perfume and "English" for leather may mean today. The *Trotula* counsels lye as a bleach to achieve a degree of blondness:

> After leaving the bath, let her adorn her hair, and first of all let her wash it with a cleanser such as this. Take ashes of burnt vine, the chaff of barley nodes, and licorice wood (so that it may the more brightly shine), and sowbread: boil the chaff and the sowbread in water. With the chaff and the ash and the sowbread, let a pot having at its base two or three small openings be filled. Let the water in which the sowbread and the chaff were previously cooked be poured into the pot, so that it is strained by the small openings. With this cleanser let the woman wash her head. After the washing, let her leave it to dry by itself, and her hair will be golden and shimmering.[84]

The *Trotula* also makes provision for the older woman. In the event that through age or other cause a woman has gone grey, she may remedy this by a "proven Saracen preparation" in order to return to a Mediterranean appearance:

81 Ovid, *Heroides and Amores*, ed. and trans. Grant Showerman (Cambridge, MA: Harvard University Press, 1977), *Amores*, 375 (book 1, sec. 14, par. 31, lines 45–50). See also Mozley, *Ovid: The Art of Love*, 3, lines 165–66, for purchased hair.

82 Maria Hayward, "Hair Accessories, post-1000," in Gale Owen-Crocker, *Encyclopedia of Medieval Dress and Textiles of the British Isles c. 450–1450* (Leiden: Brill, 2012), 261, speaks of these plaits, citing Geoff Egan and Frances Pritchard, *Dress Accessories 1150–1450, Medieval Finds from Excavations in London 3* (Woodbridge, UK: Boydell, 2013), 291–96.

83 Stewart, *Cosmetics*, 44–45.

84 Green, *Trotula*, 169–70.

John Block Friedman

Take the rind of an extremely sweet pomegranate and grind it, and let it boil in vinegar or water, and strain it, to this strained substance let there be added a powder of oak apples and alum in a large quantity, so that it might be thick as a poultice. Wrap the hair in this, as though it were a kind of dough. Afterward, let bran be milled with oil and let it be placed in any kind of vessel upon the fire until the bran is completely ignited. Let her sprinkle this on the head down to the roots [...] afterward, let her hair be washed and it will be completely black.[85]

As late as the sixteenth century this problem of slowing down the graying of the hair for women was still being addressed.[86]

PERFUMES

Perhaps next in importance to hair as a beauty concern from Roman antiquity onward was the woman's scent or lack of it. It appears in the ancient world and in the Middle Ages that perfumes were applied to the body, though written sources are rather general about where exactly they were applied. Pliny's *Natural History* mentions actual fashions in perfumes among Roman women, and devotes much of Book 13 to their history and manufacture; thus, there is a good deal more information about their use and preparation in antiquity than survives from the Middle Ages. Pliny attributes perfumes to the Persians and notes that "the iris perfume of Corinth was extremely popular for a long time, but afterwards [...] the attar of roses [...] and almond-oil suddenly became more popular." Some Roman art even shows such perfumes being used.[87]

Other sources give more detail about the perfuming of the hair, which was usually done by means of pellets or pills to be inserted in the coiffure or applied as a liquid, as when the *Trotula* counsels the woman:

Take some dried roses, clove, nutmeg, watercress, and galangal. Let all these, powdered, be mixed with rose water. With this water let her sprinkle her hair [...] and it will smell marvelously.[88]

Evidence that perfume use for both skin and body was widespread in southern Spain comes as early as the eleventh century.[89] Rose water and oils made from rose

85 See Carmen Caballero-Navas, "The Care of Women's Health and Beauty: An Experience Shared by Medieval Jewish and Christian Women," *Journal of Medieval History* 34 (2008): 146–63.

86 See Alessio Piedmontese, *Dei Secreti di Diversi Eccellentissimi Huomini nuovamente Raccolti: Parte Terza* (Milan: Giovanni Antonio de gli Antonij, 1559), 23.

87 Pliny, *Natural History*, Loeb Classical Library 370, ed. and trans. H. Rackham (Cambridge, MA: Harvard University Press, 1960), 101 (book 13, section 2). See Stewart, *Cosmetics*, 12–13, 33.

88 Green, *Trotula*, 171.

89 Lucie Bolens, "Les parfums et la beauté en Andalousie Médiévale (XIème–XIIème siècles)," in Menjot, *Les soins de beauté*, 145–69; and, generally, Montserrat Cabré, "Cosmética y Perfumería," in *Historia de la Ciencia y de la Téchnica en la Corona de Castilla,*

Female Beauty Bling

petals feature in a great many of the recipes for female perfumes. Other late medieval ingredients for perfume were the iris, sweet flag, lavender, and in warmer climates such as southern Spain and Provence, orange and lemon peel extracts in various vehicles such as gum tragacanth. Some of the more powerful musks such as that of the civet cat were used with ambergris as bases for perfumes.

HAIR COVERINGS

Though the hair could be perfumed to make it attractive, as with other aspects of beauty, its attractiveness had to be limited and controlled, usually with some sort of headgear, tacitly indicating male control and authority.[90] In fact, the idea that women should cover their hair with a coif or veil as a sign of spiritual humility is very ancient and found in several cultures. Outside of Hebrew and later Islamic strictures, the Romans were also very concerned with the veiling of women. As the anthropologist Elizabeth Bartman notes:

> In the Roman world [...] hair's erotic potential made it a lightening rod for anxieties about female sexuality and public behavior. Hence the ancient sources preserve many references to veiling and other strictures regarding female headwear.[91]

Ovid, for example, testifies to the idea that such a covering was vital to a woman's reputation, speaking in *The Art of Love* of "slender fillets, emblems of modesty."[92]

More elaborate fabric head coverings were often colored or ornamented, and they were also frequently associated with various treatments and arrangements for the hair. The simplest style of these coverings was cap or kerchief-like. Married and older women wore linen veils and wimples,[93] often elaborately arranged on wire or willow frameworks, with a focus on modesty. One English sumptuary law of October 1363 pertained to the status of grooms and their families: "their wives, daughters [...] shall [...] not wear any veil worth more than 12d [in value of fabric and ornamentation]." A similar statute passed in Scotland in March 1429 noted "likewise neither that commoners' wives [...] wear [...] costly caps such as lawn or Rheims."[94] The import of such laws was to control and limit sexual attraction and to indicate female unavailability.

ed. Luis Garcia Ballester (León, Spain: Consejería de Educación y Cultura, 2002), 773–79; Isabelle Lévêque-Agret, "Les parfums à la fin du Moyen Âge: Les différentes formes de fabrications et d'utilisation," in Menjot, *Les soins de beauté*, 135–44.

90 J. Stephens, "Ancient Roman Hairdressing: On (Hair)pins and Needles," *Journal of Roman Archaeology* 21 (2008): 111–32.

91 Bartman, "Hair and Artifice," 5.

92 Mozley, *Ovid: The Art of Love*, 15, book 1, line 31.

93 Gabriela Signori, "Veil, Hat, or Hair? Reflections on an Asymmetrical Relationship," *Medieval History Journal* 8, no. 1 (2005): 25–47.

94 Published in Louise M. Sylvester, Mark C. Chambers, and Gale R. Owen-Crocker, eds., *Medieval Dress and Textiles in Britain: A Multilingual Sourcebook* (Woodbridge, UK: Boydell, 2014), 203, 213.

Naturally, such laws soon led to work-arounds of various kinds, and the writing of medieval moralists is much preoccupied with fantastic headdresses and their coloring, where the practice of dyeing the linen of the wimple, veil, or headdress bright yellow with saffron was common. It was felt that this color concealed aging flesh and was also one typically legislated for Jews and prostitutes. Accordingly, the practice of dyeing was widely criticized from several points of view. For example, Heinrich von Langenstein's late-fourteenth-century treatise, *Erkantnus der Sund*, counseled the avoidance of such dyeing for all aspects of the female headdress,[95] and Robert Manning's *Handlyng Synne* criticized more specifically the deceitful nature of "wimples and kerchieves dyed with saffron: they hide yellow under yellow. Then men do not know which is which, the yellow wimple or the leathery skin."[96]

Issues of religion and male control were easily intermixed. For example, in a German sermon, the celebrated Franciscan open-air preacher Berthold of Regensburg or Ratisbon (1210–72) brought criticisms of contemporary extravagant hair arrangements and dyed head coverings together with official anti-Semitism, arguing that women should not dye their wimples or veils with a color legally confined to Jews and prostitutes. He spoke of women "constantly fussing with their hairstyles, their ribbons, and their veils that they dye yellow like the Jews, or those whores who shamefully troll for trade outside the city walls."[97] The practice of wimple dying as an open flouting of male control was castigated in one of the most important medieval manuals of penitence, that of William Peraldus, where women could be asked by a parish priest if they sinned through such dyeing and be given various penances to amend the sin. Peraldus discusses in some detail how divinely decreed veiling indicates female subjection and how saffron tinting plays against this.[98]

Besides serving as an indicator of marital status and, implicitly, of a woman's acceptance of male domination, other types of ornamented hair coverings often signaled the increasing porosity of the boundaries of social positioning in the late Middle

95 Quoted by Signori, "Veil, Hat, or Hair," 30.

96 Sylvester, Chambers, and Owen-Crocker, *Medieval Dress and Textiles,* 151. Yellow was associated with the betrayal of Judas and had a very bad reputation in the Middle Ages. See Katharina Simon-Muscheid, "'Schweizergelb' und 'Judasfarbe': National Ehre, Zeitschelte und Kleidermode um die Wende vom 15. zum 16. Jahrhundert," *Zeitschrift für Historische Forschung* 22, no. 3 (1995): 317–43; and Herman Pleij, *Colors Demonic and Divine: Shades of Meaning in the Middle Ages and After,* trans. Diane Webb (New York: Columbia University Press, 2004), 46. It was not common in the clothing descriptions in medieval wills. See Kristen M. Burkholder, "Dress and Textiles in English Wills," *Medieval Clothing and Textiles* 1 (2005): 133–53, at 140.

97 Claude Lecouteux and Philippe Marcq, eds. and trans., *Péchés et Vertus: Scènes de la vie du XIII siècle* (Paris: Diffusion, PUF, 1991), 125ff; my translation. See Alan Cutler, "Innocent III and the Distinctive Clothing of Jews and Muslims," *Studies in Medieval Culture* 3 (1970): 90–116; and Flora Cassen, *Marking the Jews in Renaissance Italy: Politics, Religion, and the Power of Symbols* (Cambridge: Cambridge University Press, 2017), 126–53.

98 William Peraldus, *Summa on the Vices,* ed. Richard G. Newhauser, Siegfried Wenzel, Bridget K. Ballin, and Edwin Craun, "Superbia," 6b, cap. 14, 1711, https://www.public.asu.edu/~rnewhaus/peraldus (accessed July 22, 2023).

Female Beauty Bling

Ages. Thus, sumptuary laws, especially in Florence, often forbade certain forms of hair ornamentation and covering on the grounds of the wearers' insufficient wealth and status, although there could be exceptions. For example, wives within a certain social niche could wear ornamental headdresses, but they had to pay a substantial tax for doing so. An ordinance of 1373 required that

> all women and girls, whether married or not, whether betrothed or not, of whatever age, rank and condition [...] who wear—or who wear in the future—any gold, silver, pearls, precious stones, bells, ribbons of gold or of silver, or cloth of silk brocade on their [...] heads [...] will be required to pay each year [...] the sum of 50 florins.[99]

This ordinance seems to have been directed especially at women just below the level of the Florentine elite, and may have been a means of bringing in revenue as much as anything else. But it seems to have had a puzzling social *fortuna*.

By the end of the fifteenth century, the largely Italian practice of decorating the hair with gems mentioned in the statute was being replaced by one using a variety of woven-in flowers. It appears that wealthy women may have been imitating upper-middle-class fashion in this, if we can trust the Italian theoretician of beauty Agnolo Firenzuola, who quotes the opinion of one of the imagined debaters on beauty, Mona Lampiada, in his Second Dialogue:

> I think even gentlewomen started to wear flowers in their hair around the house, instead of pearls or gold, since not all our peers had the means to adorn themselves with stones from the Orient or sand from the Tagus.[100]

The change could also be an acknowledgement of the heavy fines in the sumptuary laws just mentioned and it suggests that flowers were a way around these legal and cultural restrictions for certain groups of Italian women.

While ornamental hair treatments in Italy, as we just saw, were a matter for social regulation and class identification by the state, elsewhere they were of universal moral concern, largely to mendicants but to parish preachers as well.[101] In England, for example, the Dominican moralist John Bromyard (d. 1362) put together a manual for the use of preachers so that they could find helpful commonplaces for their own sermons. It contains unfavorable reference to the practice of weaving such decorative garlands of real or artificial flowers into the hair. Bromyard mentioned them as a sign of the destructiveness to men of vain and fashionable females: "in the woman wantonly adorned to capture souls, the garland upon her head is as a single coal [of fire]."[102]

99 Cited in Gene Brucker, *The Society of Renaissance Florence: A Documentary Study* (New York: Harper and Rowe, 1971), 180. See generally Killerby, *Sumptuary Law in Italy*.

100 Firenzuola, *On the Beauty of Women*, 2nd dialogue, 54.

101 Thomas S. Izbicki, "Pyres of Vanities: Mendicant Preaching on the Vanity of Women and Its Lay Audience," in *De Ore Domini: Preacher and Word in the Middle Ages*, ed. Thomas L. Amos et al. (Kalamazoo, MI: Medieval Institute Publications, 1989), 211–34.

102 John Bromyard, *Summa Praedicantium*, chap. 7, "Pride," in Sylvester, Chambers, and Owen-Crocker, *Medieval Dress and Textiles*, 155.

So, too, the Augustinian friar John Waldeby (1315–72) took aim at both contemporary extravagant female headdress and hair decoration. He compared the height of the English version of the French female *hennin* to a chimney pot and criticized the floral garlands and jewels women wove into the hair below as inducements to male lechery.[103] Bromyard and Waldeby are hardly alone in such comments in England, for decoration is the subject of many of the sections on pride in Chaucer's *Parson's Tale*.

An Italian hair arrangement variant of the sort criticized by Waldeby combined both extravagant positioning and ornamentation by jewels or other materials foreign to the hair. It was the "ram's-horn" style, popular in the third decade of the fifteenth century, where the braids spiraling like the horns of a ram were often interwoven with ribbons, silk lace or net, or sometimes jewelry. This style became popular in Italy, in the later fifteenth century with the addition of silks, ribbons, and veils interwoven into the side horns, often with a large jeweled brooch as some part of the hair decoration (fig. 5.6).[104] These jewels could also be simply woven into the hair. A portrait of an anonymous Italian woman by Alessio Baldovinetti of 1465 now in the National Gallery, London (NG 758), shows the sitter's hair gathered at the ears, a piece of cloth going around it from the bottom to the top of the skull surmounted by what looks like a cluster of large pearls at the crown, and a loop or frontlet on the forehead.[105] Portraits of this type, of course, may not be fully accurate representations of the styles of the era, for the sitter may have been shown wearing clothing or hairstyles that would have been forbidden to her by sumptuary legislation, and the painter may have heightened or changed details for a flattering effect.

HORNS AS A HAIRSTYLE

By about 1400 we find numerous representations of an extravagant female hairstyle which became fashionable in Northern Europe during the fifteenth century. Medieval moralists and satirists referred to this style as horns. These essentially were masses of hair in braids that went above the head like small, short animal horns or were thickly gathered in front of the ears in a lateral decorative arrangement. Such hairstyles are relatively common in late medieval funeral monuments and in the representations of fashionable women donors found on brass funeral plaques set into church floors.

103 Quoted in G. W. Owst, *Literature and Pulpit in Medieval England* (Cambridge: Cambridge University Press, 1933), 392.

104 Piero della Francesca, "The Duke and Duchess of Urbino Federico da Montefeltro and Battista Sforza" (Uffizi Gallery, Florence, no. 1890 nn. 1615, 3342) dated by the museum to ca. 1473–75, viewable at https://www.uffizi.it/en/artworks/the-duke-and-duchess-of-urbino-federico-da-montefeltro-and-battista-sforza (accessed July 22, 2023).

105 Published by Marian Campbell, *Medieval Jewellery in Europe: 1100–1500* (London: Victoria and Albert Museum, 2009), 53, fig. 51. See generally for women with some of the hairstyles just described, Patricia Lee Rubin, Beverly Louise Brown, Peter Humfrey, and Rudolf Preimesburger, eds., *The Renaissance Portrait from Donatello to Bellini* (New York: Metropolitan Museum of Art, 2011).

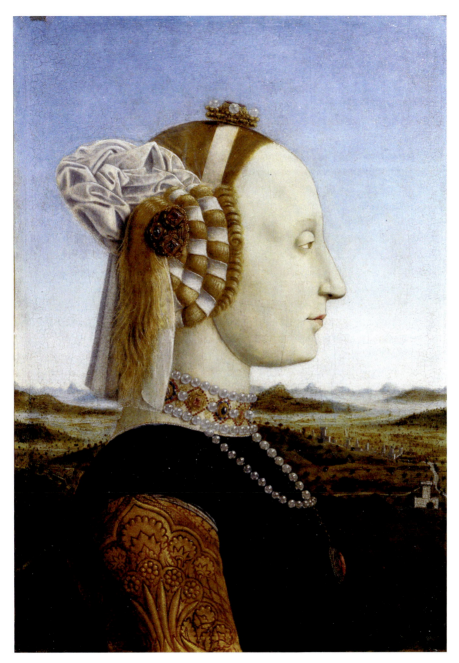

Fig. 5.6: Ram's-horn hairstyle, Piero della Francesca, *Portrait of Battista Sforza*, 1465–66. Florence, Uffizi Gallery. Photo: Public domain, via Wikimedia Commons.

Funerary art, both three- and two-dimensional can, then, be a useful guide to medieval aids to female beauty pertaining to the covering and arrangement of the hair. These sources, of course, as examples of material culture, cannot be taken uncritically as actual representations of contemporary fashions, and may often lag as much as several decades behind the times, and may express elements of fashion fantasy or an artist's conception rather more than an actual garment or accessory. Women were often depicted in funerary art as flatteringly younger than their actual age or more fashionably attired than they were in life. Moreover, clothing and accessories were so highly valued even into the fifteenth and sixteenth centuries that they passed to others as legacies in wills. Thus, a person may have inherited an accessory "older" or "younger" than the age of the legatee. Also, monuments may have been made considerably later than the death date of the subject. Additionally, in the case of monuments that may have been colored or gilded, time may have removed these helpful indicators.

All of this being said, a detailed study of English medieval funeral monuments indicates that many of the female figures from the early thirteenth century onward had elaborate hairstyles.[106] A typical example of the "horn" hairstyle in England appears on a monumental brass made circa 1393–99 in All Saints Church, Little Shelford, Cambridgeshire, representing Lady Claricia de Freville, the wife of Robert de Freville. It suggests that upper-class women of that era in both England and France often had hair plaited and trimmed with ribbons, and worn in bunches coiled in front of the ears on either side of the face to create exactly such horns.[107] The Anglo-Norman confessional manual of William of Wadington, written between about 1220 and 1240, comments sourly on this fashion style: "Of decorated heads the less said the better for each man well knows these come from pride […]. Let pass women who go about with horns."[108]

106 Pamela A. Walker, "Fashioning Death: The Choice and Representation of Female Clothing on English Medieval Funeral Monuments 1250–1450" (Ph.D. diss., University of Manchester, 2012), available at https://research.manchester.ac.uk/en/studentTheses/fashioning-death-the-choice-and-representation-of-female-clothing (accessed July 22, 2023).

107 The rubbing is given in Walker, "Fashioning Death," 339. See also Hayward, "Hair Accessories, post-1000," 261, and, on this brass, Friedman, "Dogs in the Identity Formation," 332 n. 2. For discussion, see Herbert Walker Macklin, *Macklin's Monumental Brasses Including a Bibliography, Rewritten by John Page-Phillips* (London: Allen and Unwin, 1972), no. 95. On "horns" of ornamental headdresses on wire rats, see the lyric "The Pride of Women's Horns," in Rossell Hope Robbins, ed., *Historical Poems of the XIVth and XVth Centuries* (New York: Columbia University Press, 1959), 139, no. 53, and "A Satire of Women's Horned Headdresses," in Frederick Fairholt, ed., *Satirical Songs and Poems on Costume from the 13th to the 19th Centuries* (1849; repr., New York: Johnson, 1965), 29–39; Mireille Madou, "Cornes and Cornettes," in *Flanders in a European Perspective: Manuscript Illumination around 1400 in Flanders and Abroad: Proceedings of the International Colloquium, Leuven, 7–10 September 1993*, ed. Maurits Smeyers and Bert Cardon (Leuven: Uitgerij Peeters, 1995), 417–26; and Cheunsoon Song and Lucy Roy Sibley, "The Vertical Headdress of Fifteenth-Century Northern Europe," *Dress* 16 (1990): 4–15.

108 William of Wadington, "Le Manuel des Pechiez," in Sylvester, Chambers, and Owen-Crocker, *Medieval Dress and Textiles*, 133, 135.

Female Beauty Bling

Soon, the image of horn-like extensions on the female head, either vertical or horizontal, gave rise to a trope where devils were imagined as sitting on the woman's head between the horns. Striking examples appear on roof bosses in St. Peter's Church, Ugborough, and in All Saints Church, Budleigh, Devon (ca. 1450), where grotesque devils squat between the horns of women's headdresses.[109] This was similar in conception to the extended and highly ornamented train of a dress, which was also a subject for moralists' satire: Devils were imagined riding on such trains as vain women were carried off to hell by other monstrous demons.[110]

MORALIZING ON BEAUTY CARE

Many of the cosmetic and style features for women just discussed were considered desirable attributes of beauty in the Middle Ages, yet received the attentions of clerical moralists on the grounds of aesthetic fraud. Thus, as to whitening, Robert Mannynge of Brunne's Middle English *Handlyng Synne*, written in 1303, castigates women "who make themselves more attractive than God made them using cosmetic powder [*oblanchre*] or else flour to make themselves look paler."[111] By the twelfth century, in addition to white skin, rouging the cheeks was also widely criticized. Thus, the *Art of Courtly Love* by Andreas the Chaplain (reworking for a medieval audience Ovid's *Ars Amatoriae*), giving some prescriptions for what to look for in a lover and what to avoid, notes "if you see a woman too heavily rouged you will not be taken in by her beauty [...] since a woman who puts all her reliance on her rouge usually doesn't have any particular gifts of character."[112]

Such whitened and heavily rouged women who falsified their natural appearance also caught the wrath of clerics writing on practical pastoral matters, as is indicated in another penitential manual by William of Wadington, written in the thirteenth century. William speaks scathingly of "one who colours her face differently from the way God made her with powder or rouge, by St. Michael this is pride, it is an immeasurable outrage not to be satisfied with what God had made."[113] As noted earlier, these penitential manuals were designed to identify for parish priests both the sin and the

109 Susan Andrew, "Facing Sin: Late Medieval Roof Bosses in Ugborough Church, Devon," *Ecclesiology Today* 51 (January 2015), available at https://devonassoc.org.uk/devoninfo/facing-sin-late-medieval-roof-bosses-in-ugborough-church-devon-2015 (accessed Aug. 10, 2023), figs. 13, 14.

110 On the moralist response to such trains, see Cordelia Warr, "The Devil on My Tail: Clothing and Visual Culture in the Camposanto *Last Judgment*," *Medieval Clothing and Textiles* 11 (2015): 99–117, especially 115–17.

111 Sylvester, Chambers, and Owen-Crocker, *Medieval Dress and Textiles*, 145. See also Anne-Laure Lallouette, "Bains et soins du corps dans les textes médicaux (XIIe–XIVe siècles)," in Albert, *Laver, monder, blanchir*, 33–49.

112 Andreas Capellanus, *The Art of Courtly Love*, trans. John J. Parry (New York: Columbia University Press, 1960), 34 (book 1, chap. 6).

113 Sylvester, Chambers, and Owen-Crocker, *Medieval Dress and Textiles*, 133.

appropriate penance for it. Many such manuals single out the tools and practices of female beautification, such as tweezers and facial depilation.

As these moralizing comments have already indicated, to some female beauty care generally smacked of temptation, seduction, and diabolical deception symbolizing female vanity, just as we saw in the Leipzig and Schiff paintings. Often such iconography had classical roots, as when Venus, the goddess of love and sexual passion, is pictured holding a mirror, and the siren or mermaid who lured men to their destruction typically holds both a comb and a mirror and is usually shown combing her hair.[114] Indeed, combing hair, especially when done by a siren or mermaid, is a trope for dangerous female vanity everywhere in medieval art, and the image of the comb alone can stand for this.

So too, excessive interest in the beauty utensils discussed above can also be a sign of the gold digger, or more broadly, female graspingness. For example, Eustache Deschamps' *Miroir de Mariage*, in the tradition of Juvenal's misogamous *Sixth Satire*, warns the prospective husband about potentially dangerous female behavior. A newly married *bourgeoise* is satirized for requesting an ivory-framed mirror from her husband on his return from Paris. In fact, she seems to expect an entire cosmetic set:

> You should give me a comb, and similarly a hair parting tool, and a mirror to primp in, all of ivory. And the case ought to be noble and elegant, hung by silver chains.[115]

Just as with the comb, the mirror was also tied to excessive vanity among other human failings, where, as Satan's instrument, it often reflects a monitory image of the user, shown on Satan's buttocks. For example, a well-known medieval proverb—when you look in a mirror, you are looking up the devil's ass—was widely used by medieval painters and woodcut artists, particularly Dürer and Bosch.[116]

While combs were tied to simple vanity, mirrors signified deception and false reflections of a much more complex sort, often linked to demonic agency. For example, some moralists believed mirrors could be manipulated by a magician or *specularius* to change reality altogether,[117] making people see in them what was desired rather than what was actually present. Sometimes they could even be a sign of sorcery;[118]

114 See John Block Friedman, "L'Iconographie de Vénus et de son Miroir à la fin du Moyen Âge," in *L'Erotisme au Moyen Âge*, ed. Bruno Roy (Montréal: Aurore, 1977), 53–82.

115 Queux de Saint-Hilaire, ed., *Œuvres Complètes De Eustache Deschamps: Lettres. Balades. Pièces Diverses* (1893; repr., Gloucester: Nabu, 2013), vol. 10, *Miroir de Mariage*, 45, lines 1306–10; my translation.

116 See Friedman and Bond, "Fashion and Material Culture," 145–48 and figs. 6.11, 6.12.

117 Armand Delatte, *La Catoptromancie grecque et ses dérivés* (Liège, Belgium: Vaillant-Carmanne and E. Droz, 1932); and Crystal Addey, "Mirrors and Divination: Catoptromancy, Oracles and Earth Goddesses in Antiquity," in *The Book of the Mirror: An Interdisciplinary Collection Exploring the Cultural Story of the Mirror*, ed. Miranda Anderson (Newcastle upon Tyne, UK: Cambridge Scholars, 2007), 32–46.

118 John of Salisbury, *Frivolities of Courtiers and Footprints of Philosophers*, trans. Joseph B. Pike (Minneapolis: University of Minnesota Press and Oxford University Press, 1938), 42 (book 1, chap. 12) and 147 (book 2, chap. 28). Some of these deceptive mirrors are dis-

Female Beauty Bling

for example, in 1321, a small mirror was among the personal possessions serving as evidence in an episcopal court used to convict the Cathar Béatrice de Planisoles (1274–ca. 1322) of witchcraft.[119] Thus, as these examples would suggest, misogynistic scenes of women grooming themselves before mirrors often hinted at danger, and typically in medieval art a woman with these utensils would likely carry the subtext of vanity and deception.

From the foregoing passages it can be seen that the sale, distribution, and counsel for aids to female beauty were sufficiently widespread in the later Middle Ages to merit depiction in visual art and receive extensive clerical criticism. Indeed, a consideration of these aids in pictures of the female toilette has shown us a good deal about the canons for female beauty in this period and how such beauty was created and maintained by a well-developed and highly commodified supporting network of beauty workers, comb and mirror makers, and others engaged in helping elite women look as much as possible like their aristocratic counterparts.

cussed by William of Auvergne in *De universo* in *Opera* (1674; repr., Frankfort am Main: Minerva, 1963), 878 (book 2, chap. 35) and 1058 (book 3, chap. 18); and on these alleged ruses of mirror conjurers, see K. Haberland, "Spiegel im Glauben und Brauch der Volker," *Zeitschrift für Volkerpsychologie* 13 (1882): 324–47, and A. G. Molland, "Roger Bacon as Magician," *Traditio* 30 (1974): 445–60.

119 The trial is recorded in Jean Duvernoy, *Le Registre d'Inquisition de Jacques Fournier* (Paris: Mouton, 1978), 283.

The Dividing Lines of Social Status in Sixteenth-Century Scottish Fashion

Melanie Schuessler Bond

The extant accounts of expenditure from the royal treasury in mid-sixteenth-century Scotland represent a gold mine of information on many topics. Purchases of finished clothing items, fabric for clothing, and dress accessories appear mingled among others, although they are usually found in sections with titles such as "The expensis debursit upoun my Lorde Governour, his Ladye, and bairnis awyn personnes" or "The expensis debursit be my lord governoris precept and spetiall commande." The Lord Governor was James Hamilton, Earl of Arran and regent for Mary, Queen of Scots, between 1543 and 1554. This article is based on an analysis of records of clothing, fabric, and accessory purchases extracted from the accounts of royal treasury expenditure during his tenure, collated according to recipients.[1]

Amongst the accounts lies the key to deciphering how certain types of clothing and fabric represented layers of social status and the dividing lines between them. Although the accounts provide fascinating individual wardrobe biographies, which I discuss in *Dressing the Scottish Court, 1543–1553: Clothing in the Accounts of the Lord High Treasurer of Scotland,*[2] broader analysis also yields interesting results, including which groups of people commonly wore certain garments and fabrics and the importance of particular types of cloth and clothing to maintaining social status. This study provides analysis across whole categories of garments and fabric types cross-referenced with the social status of the wearers. The data set is rich enough to support many different types of analysis.

This article was originally presented as a paper at the 2021 International Congress on Medieval Studies at Kalamazoo, Michigan. I appreciate the support and feedback of the Sunday Tea Chat Group and the DISTAFF community.

1 National Records of Scotland (henceforth NRS), E21/39–45. All other quotations from these accounts will be given in modern English translation. For a full transcription and translation of the clothing and accessories in these accounts, see Melanie Schuessler Bond, *Dressing the Scottish Court, 1543–1553: Clothing in the Accounts of the Lord High Treasurer of Scotland* (Woodbridge, UK: Boydell, 2019).

2 See note 1.

Melanie Schuessler Bond

All of the clothing analyzed in the accounts must be viewed through the lens of Arran's patronage because, as regent, he authorized all expenses drawn on the royal treasury, many of which were his own personal expenditures. In addition to a large number of clothes for himself, he supplied garments to servants, familial and personal connections, political allies (or those he wished to become allies), and, in a few cases, to those needing charity.[3] Those on Arran's payroll in these accounts included not only his personal servants but also people serving the government in various capacities. Members of this expanded household received clothing as part of their remuneration, as livery in a general sense, while only Arran's pages and a few others had "display livery"—heraldic livery that they wore to add consequence to the Regent as he went about his business running the country.[4] Most of those serving Arran and the government received clothing comparable to any other items that they would normally wear.[5] Clothing was provided to a wide range of social ranks, from lowly kitchen servants to well-born captains in charge of castles. Arran also supplied clothing to members of his family: both his immediate family, who were of high rank, and his extended family, some of whom were lower on the social scale. His current and potential political allies tended to be in the top tier of society, while the charity cases were, of course, at the bottom.

The social class of most of the people in the accounts is fairly clear, so looking at who wore certain garments and the fabrics and dyes of those garments can reveal prevailing ideas about what constituted high-status clothing. When evaluating the status of a garment or textile, the assumption is generally that greater expense coincided with higher class, and often it did, but the end use sometimes circumvented class. For example, some high-status people had cheap fabrics as linings for garments; and some people not as high on the social scale were granted clothing above their station for weddings or funerals. Anomalies also appear: sometimes high-status individuals received quite inexpensive materials for the main fabric of a garment and low-status individuals received very costly fabrics. Some of these instances can be explained—the latter cases were often due to the fact that the Regent used the clothing of his household members to bolster his own status—but some cannot.

In order to best use the results of this study, it is important to understand its limitations. The first of these is the people included in the study, which does not focus on the population of Scotland or even the population of the Regent's court but, instead, consists of surviving records of people to whom the Regent gave cloth and clothing. The study tends to skew towards men because he had many male servants and because he had more reasons, politically, to give clothing to men than to women. There is a relatively broad range of class represented because the Regent gave clothing to many members of his household, including lower-rank servants, and in a few cases he gave clothing as a form of charity. But the study skews towards the upper classes—especially for women, as the Regent had relatively few female servants. Most of the women in

3 Bond, *Dressing the Scottish Court*, 3–6.
4 For more on display livery, see Bond, *Dressing the Scottish Court*, 138–41.
5 An important exception is mourning clothes; see below.

Social Status in Scottish Fashion

the accounts were members of his family, who tended to be in the upper echelons of society. In addition, many of lower social rank were simply granted sums of money, while those of middle and upper rank were more likely to have particular garments specified, thus making them more useful in this study.

It is also important to keep in mind that the 149 men and fifty-eight women identified who received materials or money for clothing in the accounts had other sources of clothing as well, so this is not a full view of each person's wardrobe but rather what the Regent thought needful or appropriate for those particular individuals. In some places the numbers arrived at during the analysis are a little difficult to pin down because it is sometimes hard to tell whether people listed in different ways are actually the same person (for example, people whose name changed when they married or who assumed a title partway through the period of the regency). Sometimes there is an entry for a group of people (for example, "my lady's gentlewomen") and it is not clear which people are part of that group. In addition, many just received a sum of money for clothing, but the nature of the clothing is not specified, so those recipients are not included in the totals here. While it is important to keep these caveats in mind, there is still much that can be learned from analysis of this data set.

This study discusses in broad terms three main dimensions of clothing status: garments, fabrics, and dyes. These dimensions interlock, as more than one are often employed in a single garment or outfit. First, I consider several types of garments, divided by gender, and compare those garments when made in different fabrics. In some cases, I consider the social position of the recipients. Then I plot the values of various kinds of fabrics and follow this with a discussion of how different dyes changed the price of those fabrics. While a person today can easily imagine looking at others and identifying what types of garments they are wearing, it is important to note that in sixteenth-century Scotland people could also readily estimate the quality of a fabric and expense of a color and use that information to gauge social status as well.[6] Most people today may not have fine-tuned perceptions with regard to fabric quality and color, likely because mechanization and synthetic dyes have made fairly good-quality fabrics and almost any color affordable. In Western Europe in the sixteenth century, however, quality and price varied widely for fabrics and dyes, and they were status markers just as garments were.

GARMENTS

Men's gowns and night gowns
Men's gowns were the most formal and the outermost layer of clothing, but not all men wore them. They were a marker of status and, generally, were made of more expensive

6 Sumptuary laws, which often focused on fabric types and colors, make clear that these were important dimensions of status. See, for example, a summary of the Acts of Apparel passed by King Henry VIII in Maria Hayward, *Rich Apparel: Clothing and the Law in Henry VIII's England* (Farnham, UK: Ashgate, 2009), 29–39.

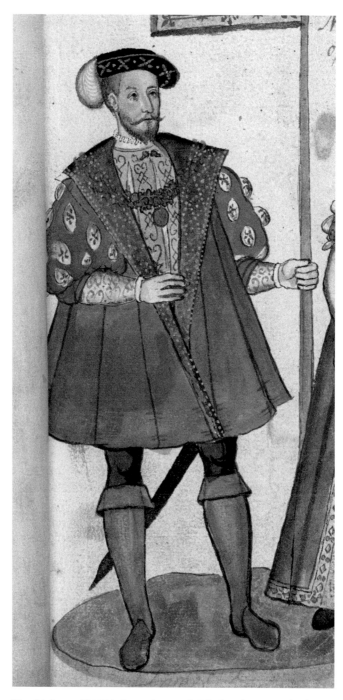

Fig. 6.1: James V, 1591, Seton Armorial, Edinburgh, National Library of Scotland, MS Acc. 9309, detail of fol. 19r. Photo: Reproduced by permission of the National Library of Scotland.

Social Status in Scottish Fashion

fabrics, although gowns for children were sometimes made of cheaper materials. The outer crimson garment of James V of Scotland shown in figure 6.1 is one style of gown from this period. Of the 149 men listed in the accounts, 103 were given money or materials designated for specific garments. Of those, only twenty-two were given gowns. All of them were of noble status or were addressed with the titles Master or Sir, with the exception of three members of the Regent's household who received only mourning gowns, most likely to display the Regent's status rather than their own. Given that the sample of those with clothing granted to them in the accounts (as opposed to just a sum of money) skews towards people with higher rank in comparison with the likely ratios in the population as a whole, it is probable that gowns were fairly rare and marked a visible dividing line between those of high rank who wore gowns and those of lower rank who did not.[7]

Night gowns were not used for sleeping but were worn for comfort when at home. They were loose, of variable length, and sometimes lined with fur.[8] Only four males received night gowns: the Regent himself, two of his sons, and a son-in-law. It is not clear whether this had to do with status or because it was an item that would customarily be given only to family members. Of the nine night gowns given to these four recipients, one was lined with marten (related to the weasel), one with lamb and rabbit, one with rabbit alone, and one with an unspecified fur.

Figure 6.2 shows the prices for men's gown and night-gown fabric in shillings per ell of the gowns and night gowns for which the fabric and its price are both known.[9] The gray bars represent wool gowns, and the black bars represent silk. All but two of the cheapest fabrics (priced below 20 shillings per ell) were for children.[10] Although it may seem strange that the highest-priced fabric in this chart went to the Regent's Master of Household rather than to someone of higher rank, it should be noted that many gown cloths do not appear in this chart because their prices were not given in the accounts. Sometimes this was because the fabric came from the Regent's own personal wardrobe (which also furnished fabrics for other types of garments). At other times, the cost simply does not appear in the accounts for reasons that cannot be ascertained. Those unpriced textiles included some silks that were probably fairly expensive. For example: "Item, for lining of a gown of crimson velvet for my lord Gordon with lynx furs, 24s."[11] Though the price of the lining is given, the cost of the velvet is not. The

7 Of the 103 men who received money or materials for specific garments, twenty-one were of high rank and sixteen of middle rank.

8 Night gowns could be worn when receiving visitors. They were not garments that would be worn only in private (like a modern bathrobe). For an example that is probably a garment of this type, see the outer layer in Hector Boece's portrait (ca. 1530; University of Aberdeen, Marischal Museum, no. ABDUA:31197). See also Bond, *Dressing the Scottish Court*, fig. 5.

9 A Scottish ell at this time was thirty-six inches in length.

10 There is some dispute about the age of the Master of Arran, the Regent's eldest son and heir, but even if his birth date is the earlier of those proposed (1532 rather than 1537), he would have been only sixteen when he received his last gown in these accounts.

11 NRS E21/42/248v. See also Bond, *Dressing the Scottish Court*, 346.

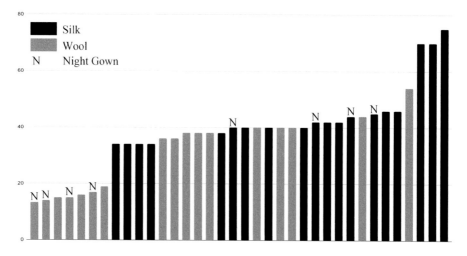

Fig. 6.2: Men's gowns (price per ell in shillings). Figures 6.2–6.16 created by author based on data extracted from the accounts of the royal treasury, 1543–54, National Records of Scotland, E21/39–45.

price range for crimson velvet in the accounts was 80–160 shillings per ell, however, so even the cheaper end of this scale would cost more than the Master of Household's 75 shillings per ell gray velvet.

Men's coats
Coats were worn underneath a gown, with a cloak, or on their own and were owned across the social spectrum. At this period, most had skirts or were otherwise long enough to conceal the tops of the hose.[12] Underneath the coat would have been a doublet, to which the hose were tied with points. Figure 6.3 shows fabric prices for the 147 wool coats that were not mourning coats, which ranged from 6 shillings to 90 shillings per ell. If there were two kinds of fabric used (as in particolored coats for livery), I averaged the prices per ell. The light gray bars represent people of lower social rank: servants, pages, grooms, etc. The dark gray bars are people of middle rank: those with the titles Master or Sir, and higher household servants who were likely to have been of good birth. The black bars are those of high rank: the Regent, his immediate family, and other lords and their heirs.

12 For examples of coats, see Will Somers, from *The Psalter of Henry VIII*, illustrated by Jean Mallard (ca. 1538–47; British Library, MS Royal 2 A XVI, 63v, http://www.bl.uk/manuscripts/Viewer.aspx?ref=royal_ms_2_a_xvi_f063v) and the figures around the fountain in *The Field of the Cloth of Gold*, British School (1545; Royal Collection Trust, RCIN 405794, https://www.rct.uk/collection). See also Bond, *Dressing the Scottish Court*, figs. 6 and 7.

Social Status in Scottish Fashion

Fig. 6.3: Men's non-mourning wool coats (price per ell in shillings).

It is notable that a number of light gray bars appear in the higher price range. Many of these were pages (identified in fig. 6.3 with arrows) and most of their higher-priced coats were part of their display livery to uphold the Regent's rank, not the pages' rank. The most expensive coat fabric granted to a page was a personal grant that is discussed below. The two pages who were granted cheap fabric were not Arran's servants but rather a couple of French pages whom he outfitted before sending them home. He gave them some money and a full set of clothes, some of which were of reasonably high quality, but, for whatever reason, the coats were not very expensive.

The following list shows the top end of the price scale for wool coats and gives the identity of the person with relation to the Regent:

Earl of Arran, Regent	90 shillings per ell
Earl of Arran, Regent	75 shillings per ell
David Hamilton, son	70 shillings per ell
John Hamilton, brother	65 shillings per ell
Claude Stratoun, former page	60 shillings per ell
Earl of Arran, Regent	55 shillings per ell
Earl of Arran, Regent	55 shillings per ell
Earl of Arran, Regent	50 shillings per ell

These names are not surprising except for one: Claude, a former page of the Regent. In fact, he was Arran's first page during his regency. This grant of coat cloth was part of the Regent's final gift to his former page in the accounts and included a matched coat and cloak of very fine wool bordered with satin, a doublet of satin, a pair of hose with taffeta lining, and a velvet bonnet, as follows:

> Item, by my lord governor's precept and special command, delivered to Claude Stratoun, to be a cloak and a coat for him, 4¼ ells of cloth of the seal of Rouen, each ell 3li.; total: 12li. 15s.
>
> Item, 2¾ ells of satin to be a doublet for him, each ell 40s.; total: 5li. 10s.
>
> Item, 1½ ells of satin to border this cloak and coat, each ell 40s.; total: 3li.
>
> Item, an ell of stemming of Milan to be a pair of hose for him, 36s.
>
> Item, an ell of taffeta to line the same, 16s.
>
> Item, an ell of fine canvas to stiffen this doublet, 3s.
>
> Item, 3 ells of fustian to line the same, each ell 4s.; total: 12s.
>
> Item, a velvet bonnet, 36s.[13]

13 NRS E21/45/35v and Bond, *Dressing the Scottish Court*, 534.

Social Status in Scottish Fashion

Fig. 6.4: Men's non-mourning wool coats (price/ell 6s to 22s).

Either Claude was still working for the Regent in some other capacity, or the Regent wished to give him a grand parting gift to start him off in life.

Figure 6.4 shows the recipients of wool coats priced below 23 shillings per ell. The cheapest are for friars and fools, and almost everyone in this section is a servant, lackey, page, or child (even children of high rank sometimes had inexpensive fabrics, presumably for their everyday clothing). A few exceptions appear, identified by the black bars: the Regent's nephew James Hamilton, the Regent's brother James Hamilton, and the Regent himself (also named James Hamilton). All of these generally had more expensive fabrics, but clearly there were instances when they wore cheaper goods as well.

The accounts list forty-seven silk coats for which the price of the fabric is given. All the silk coats went to the Regent, his sons, brothers and brother-in-law, and nephews, except three that went to two highly placed members of his household. A clear division appears between the twenty silks priced 45 shillings per ell and lower (grosgrain taffeta, satin, plain taffeta, and damask) and the twenty-seven silks priced 65 shillings per ell and higher (velvet).

Silk was not automatically more expensive than wool, however. Figure 6.5 shows the prices for wool (in gray) superimposed over the prices for silk (in black). The price range for silk is in the upper half of the overall wool price range, although most of the silks used for coats were more expensive than all but the costliest wools. One wool coat was more expensive than any of the silks used for coats, probably because of the color: violet dyed in grain.[14]

14 "Grain" was a term used in medieval and Early Modern Europe to refer to a variety of very expensive dyes and the insects from which they were made. They yielded a deep red color but could also be used to create many other shades. These dyes are also sometimes referred to as "kermes," though they include not just dyes derived from *Kermococcus vermilio* (living on the kermes oak) but also dyes from several other insects, including those

Fig. 6.5: Men's wool coats *vs.* men's silk coats (price per ell in shillings).

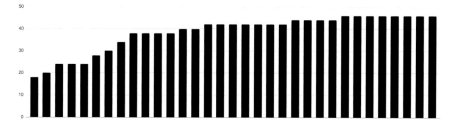

Fig. 6.6: Men's mourning coats (price per ell in shillings).

Mourning coats had a much smaller spread of value than wool coats in general (fig. 6.6). Mourning coats may be considered as something of a special case. The accounts contain a number of them because, as regent, the Earl of Arran provided mourning clothes for many members of his household on the death of Marie de Guise's father in 1550. Marie de Guise was the mother of Mary, Queen of Scots, and Arran's chief rival for the regency during Mary's youth. With the backing of Henri II of France, she eventually took the regency from him on her daughter's behalf.[15] The Guise family was also very powerful in France, and France was Scotland's most important ally. Given the circumstances, Arran's outlay on mourning clothes for his household after the death of a Frenchman who had never visited Scotland was almost certainly for political reasons.[16] Although the clothing of the Regent's household always reflected upon him to a certain extent, because this particular provision was made with an eye towards a political goal, it is interesting to compare the prices of the wool cloths he provided for mourning coats as opposed to non-mourning coats.

Figure 6.7 compares prices for wool mourning coats (dark bars) with wool non-mourning coats (light bars) for individuals who received both. If someone had more than one of either type of wool coat, the price per ell in shillings of each type was averaged. In every case, the price per ell for mourning coats was higher. Although, using all relevant purchases in the accounts, the average price per ell of black coat fabrics was much higher (38.9 shillings) than that of coat fabrics in other colors (25.7

now known as Polish and Mexican cochineal. See John H. Munro, "The Medieval Scarlet and the Economics of Sartorial Splendor," in *Cloth and Clothing in Medieval Europe: Essays in Memory of Professor E. M. Carus-Wilson*, ed. N. B. Harte and K. G. Ponting (London: Heinemann Educational Books, 1983), 15–18; Munro, "Scarlet," in *Encyclopedia of Dress and Textiles of the British Isles c. 450–1450*, ed. Gale R. Owen-Crocker, Elizabeth Coatsworth, and Maria Hayward (Leiden: Brill, 2012), 479–80.

15 Pamela E. Ritchie, *Mary of Guise in Scotland, 1548–1560: A Political Career* (East Lothian, Scotland: Tuckwell Press, 2002), 18, 37, 61–64, 87–88, 91–95. Ritchie usefully complicates the narrative of how Marie de Guise came to the regency of Scotland, outlining the myriad political and dynastic considerations.

16 For more on mourning clothing in Scotland at this time and about Arran's purchase of it for his household, see Bond, *Dressing the Scottish Court*, 131–36.

Melanie Schuessler Bond

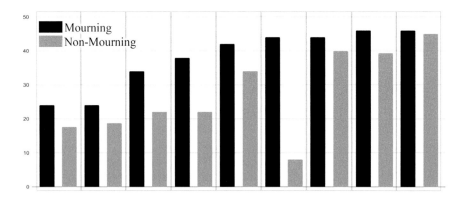

Fig. 6.7: Men's wool mourning coats vs. men's wool non-mourning coats (price per ell in shillings).

shillings), there were certainly cheaper options in black that the Regent could have chosen, including some of the non-mourning coats in figure 6.7 and many of those granted overall. Instead of economizing, given the sudden large expense of dressing his household in mourning clothes, he supplied each of his servants with fabric more expensive than that he would usually have granted them. This was true even for Arthur Hamilton, his page, whose other coats were part of his display livery. It seems clear that the Regent was more concerned with the status statement he was making via his household with their mourning clothes than he was at other times because of the political capital he was hoping to gain.

Although the clothing in these accounts is primarily of wool and silk, a few garments made of leather do appear. The leather clothing was exclusively reserved for men and, despite the expectations of modern popular culture, included not one doublet. Leather coats, however, do appear and were generally cheaper than wool ones. Their quality apparently varied widely, with prices for materials from 9 shillings all the way up to £8 16s 8d (almost 177 shillings), nearly twenty times more expensive than the cheapest example. Some of these coats went to people of middle and lower ranking on the social scale:

John Hamilton of Orbiston, Master of the Stables[17]

John Mont, Master Cook[18]

Archibald Hamilton of Raploch, Master of the Pantry (two leather coats)[19]

17 NRS E21/42/155r and Bond, *Dressing the Scottish Court*, 576.
18 NRS E21/41/113r and Bond, *Dressing the Scottish Court*, 565.
19 NRS E21/41/191r, E21/42/156v and Bond, *Dressing the Scottish Court*, 559, 560.

Social Status in Scottish Fashion

James Hamilton of Orbiston, Groom of the Chamber[20]

Robert Gourlay, Groom of the Chamber[21]

Thomas Hamilton, page[22]

Gilbert Ruthven, servant to Anne Hamilton[23]

Robert Denogent, servant to James V[24]

David Hamilton of Orbiston, servant in the stables[25]

But men of high rank also wore them, and some had several:

Earl of Arran, Regent (four leather coats)[26]

Master of Arran, son of the Regent[27]

James Hamilton of Kinneil, brother of the Regent (three leather coats)[28]

James Hamilton of Sprouston, brother of the Regent[29]

James, son of Sir James of Finnart, nephew of the Regent (five leather coats)[30]

James Johnstone, young Lord of Johnstone[31]

One of the Regent's leather coats was a fairly fancy one with velvet trim that was more expensive than the leather:

Item, to the said Archibald for two skins to be a coat for his grace, price of each piece 34s.; total: 3li. 8s.

Item, 1¼ ells of black velvet for it, price of each ell 4li.; total: 5li.

Item, for great Paris silk to stitch [or embroider] it with, 8s.

Item, for two buttons for it, 8d.[32]

20 NRS E21/42/155v and Bond, *Dressing the Scottish Court*, 537.
21 NRS E21/42/73r and Bond, *Dressing the Scottish Court*, 543.
22 NRS E21/44/74r and Bond, *Dressing the Scottish Court*, 546.
23 NRS E21/44/51v and Bond, *Dressing the Scottish Court*, 631.
24 NRS E21/40/26r and Bond, *Dressing the Scottish Court*, 603.
25 NRS E21/42/155v and Bond, *Dressing the Scottish Court*, 572.
26 NRS E21/40/24v, E21/42/81r, E21/42/346r, E21/44/68r and Bond, *Dressing the Scottish Court*, 157, 184, 222, 239.
27 NRS E21/42/81r and Bond, *Dressing the Scottish Court*, 304.
28 NRS E21/41/142v, E21/42/88v, E21/42/156r and Bond, *Dressing the Scottish Court*, 285, 287 (two on this page).
29 NRS E21/41/62v and Bond, *Dressing the Scottish Court*, 282.
30 NRS E21/41/69v, E21/41/139r, E21/41/189v, E21/42/72v, E21/42/78v and Bond, *Dressing the Scottish Court*, 355, 358, 360, 363, 364.
31 NRS E21/42/156r and Bond, *Dressing the Scottish Court*, 377.
32 NRS E21/42/81r and Bond, *Dressing the Scottish Court*, 184.

Melanie Schuessler Bond

Women's clothing

The number of women represented in the accounts is about a quarter of the total, and as mentioned previously, they were mostly from the higher end of the social spectrum, so they are slightly less useful for generalizations than the men. However, a few trends emerge from the data.

The French hood was popular amongst the upper-class women of Scotland.[33] It was most commonly made of black velvet and lined with black taffeta and occasionally had a jeweled edging. Women's hoods were markers of high status and created a visible dividing line between those who wore them and those who did not. Although most of the women in the accounts came from the higher end of society rather than the lower end, only 40 percent of those who received clothing and accessories were given hoods. Everyone who received a hood was of noble status, or a niece of the Regent, or a lady-in-waiting to his wife or daughters.

The gown was the outermost layer of clothing, though as with men's gowns, not all women wore them. It had sleeves of various styles, and during this period, options included the wide turned-back style, commonly worn in England, and the short puffed style, commonly worn in France. Undersleeves would have been worn with both styles and were probably attached to the kirtle underneath. Gowns might also have wrist-length sleeves. Women's gowns were not as much of a status marker as they were for men, but, even so, among this group of mostly high-status women, over a quarter did not receive a gown. The real dividing line in this group was the train, as only 12 percent of women received one or more gowns with a train.

Like those for men, women's night gowns were not for wearing to bed but rather for comfort and warmth when at home. Even fewer females than males received night gowns. The only recipients were the Regent's wife, his eldest daughter, and his youngest daughter. All but one of these night gowns were furred with rabbit or lamb.

FABRICS AND DYES

In addition to types of garments, fabrics and dyes also varied widely in price and thus contributed to status. The chart of wool fabric values in coat cloths (fig. 6.3) shows the wide range of prices, but a comparison of the price ranges of most of the types of wool represented in the accounts overall is also instructive. The wool types in figure 6.8 are arranged generally in ascending order of the bottom end of each price range. The blocks show the range of prices in shillings per ell from lowest to highest for each type. These accounts mention around fifty different types of wool, so any type that

33 For an example of a gown and hood from Scotland, though from a few years later, see the portrait of Agnes Keith, Countess of Moray, by Hans Eworth (1561, Darnaway Castle Collection) in Roy Strong, *The English Icon: Elizabethan and Jacobean Portraiture* (New Haven, CT: Yale University Press, 1969), 94, viewable at https://commons.wikimedia.org/wiki/File:Hans_Eworth_Agnes_Keith_Countess_of_Moray.png.

Social Status in Scottish Fashion

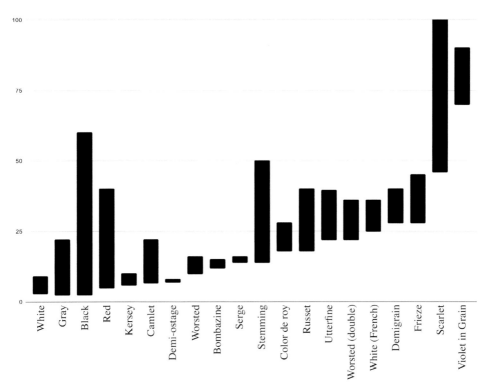

Fig. 6.8: Wool fabrics (price per ell in shillings).

had three or fewer examples was excluded, and variations of certain types have been combined. A few, such as black, red, stemming,[34] and scarlet,[35] had a very wide range of price and probably quality. In some cases this is due to variations within that category, each of which had a smaller range of value. For example, figure 6.9 shows several types of black.[36] Most of the higher-quality types of black worn in Scotland were produced in and imported from France, as is clear from their names.

34 This fabric was called stemming in Scotland, but it was known in other places as stamin or estamin. It was a relatively narrow cloth of worsted wool. See Eric Kerridge, *Textile Manufactures in Early Modern England* (Manchester: Manchester University Press, 1985), 22.
35 Scarlet more often referred to a type of fabric than a color in sixteenth-century Western Europe. This fabric was characterized by a fine, smooth surface resulting from repeated raising and shearing of the nap and also by the dye used on it (grain, or kermes, as discussed in note 14).
36 Although all types of "black" were probably black in color, "black" was also used as a fabric name referring to the many different varieties of black fabric, for example, "Lille black" and "black of the seal of Rouen."

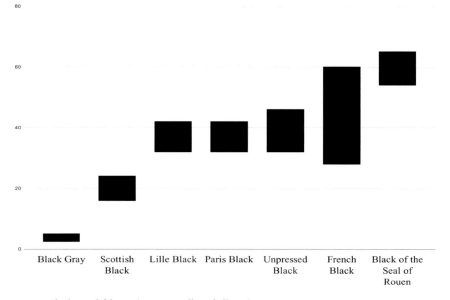

Fig. 6.9: Black wool fabrics (price per ell in shillings).

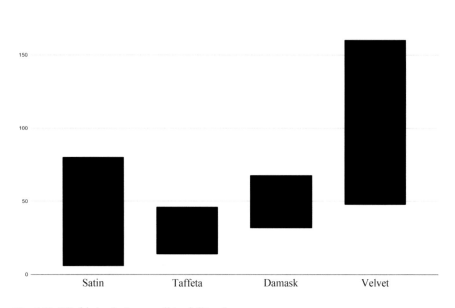

Fig. 6.10: Silk fabrics (price per ell in shillings).

Social Status in Scottish Fashion

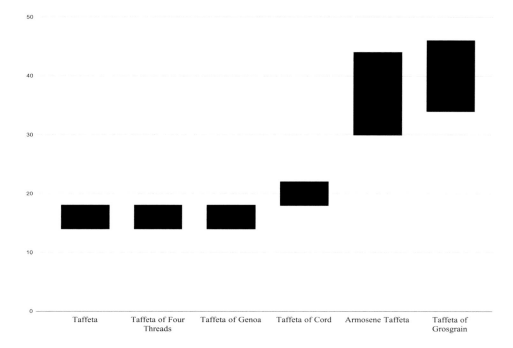

Fig. 6.11: Taffeta fabrics (price per ell in shillings).

Silks were generally at the higher end of the price range. Figure 6.10 shows a chart of the silks most commonly purchased in these accounts, with velvet clearly the most expensive fabric among them.[37] An analysis of the variations within a particular type of fabric reveals finer gradations. Figure 6.11 compares various grades of taffeta. The cheaper ones were probably thinner, as they tended to be used for linings, trim, pullings-out for men's hose,[38] and belts and garters, though in a few cases garments were made from them. Armosene taffeta and taffeta of grosgrain, in contrast, were usually made into garments—men's doublets, coats, and gowns, and women's gowns, kirtles, and cloaks—though armosene was, rarely, also used for lining.

37 All variations have been combined into the main categories, for example, all types of satin.
38 Pullings-out were what the Scots called the fabric that would be drawn through the decorative slashes of a garment from underneath.

Linen fabrics were for the most part not used for outer clothing[39] in the accounts but rather for underclothing (shirts, smocks, and socks),[40] accessories (collars, night caps, head kerchiefs, combing kerchiefs, and handkerchiefs), pullings-out for women's sleeves, and linings and stiffenings. There are a few references to linen sleeves for women, but it is not clear how they were worn. Although some English portraits show sheer linen sleeves worn over embroidered ones (presumably as protection), they tend to be from the 1570s and later. Linen fabrics were also used for purposes such as wrapping clothing for transport, laying in between the folds of precious fabrics to protect them in storage, and creating patterns for making clothing. Figure 6.12 shows the range of values of different types of linen. As with other fabrics, some types of linen came in various grades. These were noted with descriptors such as "fine," "small," and "round."

Figure 6.13 compares silk and wool values. In general, silk was more expensive than wool, but some wools were more expensive than some silks. This is a little easier to see with the more granular set of data in figure 6.14, which combines just the black wools and the taffetas. With the variations separated, it is clear that when wools of low-to-middling price are compared with relatively cheap silks, it is not necessarily predictable which would have been more expensive. Figure 6.15 combines the main types of wool, silk, and linen and shows the complexity of the value scale. While the cheapest fabrics were linens, high-end linen cambric and lawn were more expensive than several types of wool and even the lower grades of silk satins and taffetas due to the labor- and time-intensive processes needed to produce them.[41]

The priciest fabrics of this time period—figured velvet, cloth of gold, and cloth of silver—are mentioned in these accounts, but they were not paid for by the royal treasury, so their prices are not given. The Regent had a personal stock of fabric paid

39 Only a few outer garments were sometimes made from linen. Doublets were occasionally made from canvas. See NRS E21/42/363r, E21/42/368r, E21/45/54r, E21/41/142v, E21/41/168r, E21/42/109r, E21/41/194v, E21/41/149r, E21/42/46r, E21/44/87v and Bond, *Dressing the Scottish Court*, 225, 226, 250, 285, 359, 532, 538, 571, 592, 628. There were safeguards made from buckram as well. These protected a horse rider's clothing from road dust. See NRS E21/45/15v, E21/44/36r, E21/44/60r, E21/45/15v, E21/45/17r, E21/45/65v and Bond, *Dressing the Scottish Court*, 630 (two on this page), 464, 469, 472, 474.

40 There are a few items that were probably worn underneath other garments that do not fit into any of these categories. The Regent had three canvas "false doublets" that were seemingly sleeveless. These may have been intended to control his figure. See NRS E21/42/356v, E21/42/368r, E21/45/67r and Bond, *Dressing the Scottish Court*, 224, 226, 254. He also had a canvas "corselet to bear his grace's points," which may have been an arming doublet—similar to his canvas harness doublet—to which pieces of armor could be tied with points. See NRS E21/44/68r, E21/41/45v and Bond, *Dressing the Scottish Court*, 239, 161, with further discussion on 151. The Regent's daughter, Anne, also had "false bodies" of canvas for one of her gowns. See E21/45/49v and Bond, *Dressing the Scottish Court*, 474.

41 For more information on the processes involved in linen production, see Leslie Clarkson, "The Linen Industry in Early Modern Europe," in *The Cambridge History of Western Textiles*, ed. David Jenkins, 2 vols. (Cambridge: Cambridge University Press, 2003), 1:76–81.

Social Status in Scottish Fashion

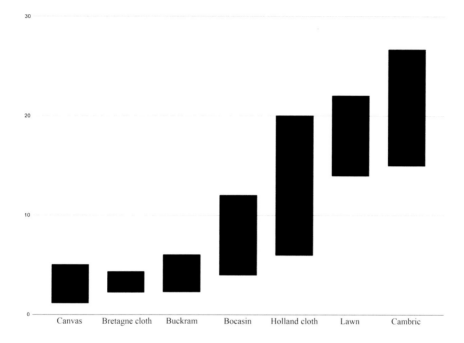

Fig. 6.12: Linen fabrics (price per ell in shillings).

for from his own resources, and he sometimes supplied expensive fabrics for the visible part of a garment and charged the treasury for linings and facings. For example:

> Item, 4 ells of red taffeta of the cord to line the hems of two gowns of crimson velvet and crimson satin, the stuff of my lord governor's own, for his grace's daughter, Lady Barbara, being with the Queen's grace in Stirling, each ell 22s. 6d; total: 4li. 10s.[42]

> Item, to line this gown and a kirtle of patterned velvet gotten out of my lord governor's wardrobe, 7 ells of lining gray, price of each ell 5s.; total: 35s.[43]

The Regent and his immediate family wore this expensive fabric, and it was especially noticeable in the preparations for his eldest daughter Barbara's wedding.[44] The Regent's wife, Margaret Douglas, also had such clothing, as is made clear by a letter that mentions several items from her wardrobe made from cloth of gold, including two gowns, a kirtle, and a night gown:[45]

42 NRS E21/42/230v and Bond, *Dressing the Scottish Court*, 427.
43 NRS E21/43/1r and Bond, *Dressing the Scottish Court*, 393.
44 NRS E21/42/239r and Bond, *Dressing the Scottish Court*, 129–30 and 429–30.
45 One must wonder about having a garment for wearing at home made in such an expensive fabric. It is possible that there was some occasion or situation that made such a garment desirable, or perhaps she simply liked the luxury of it.

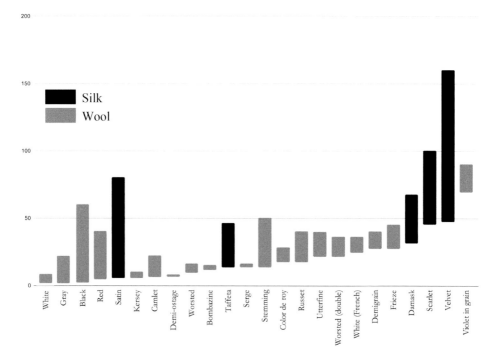

Fig. 6.13: Comparison of silk and wool fabrics (price per ell in shillings).

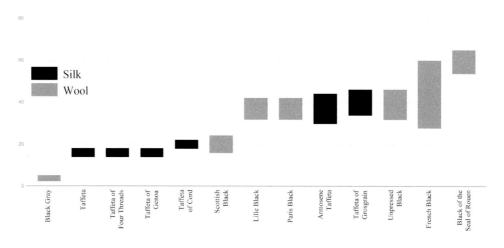

Fig. 6.14: Comparison of black and taffeta fabrics (price per ell in shillings).

Social Status in Scottish Fashion

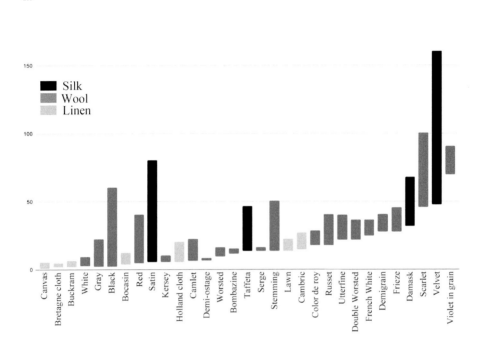

Fig. 6.15: Comparison of silk, wool, and linen fabrics (price per ell in shillings).

 a night gown of cloth of gold lined with white taffeta
 a kirtle of friezed cloth of gold lined with black taffeta
 a gown of cloth of gold lined with white taffeta and the sleeves lined with white ermine
 a gown of black cloth of gold with gold passementerie and lined with black taffeta[46]

Dye also made a difference in price: anything crimson in color was always much pricier than the same fabric in another color and constituted a clear dividing line between those wearing it and others. These fabrics were dyed with one of the more expensive red dyes, known as grain or kermes.[47] Figure 6.16 compares, on the left, crimson satin with satins of two different grades dyed with other colors; in the middle, crimson and non-crimson damask; and on the right, crimson and non-crimson velvet. The bottom of the crimson price range was always at or above the top of the price range of any other color.

46 NRS GD254/625 and Bond, *Dressing the Scottish Court*, 657–58.
47 See note 14.

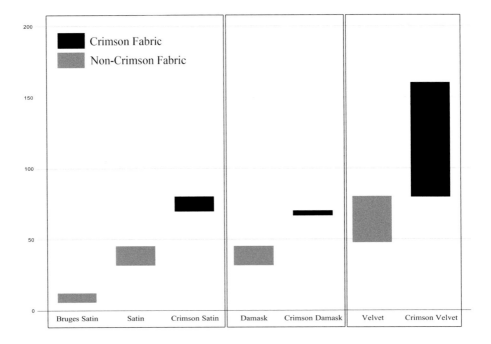

Fig. 6.16: Comparison of crimson and non-crimson fabrics (price per ell in shillings).

The list below contains every instance in the accounts of scarlet wool and wool dyed in grain (again, dyed with one of the more expensive dyes, and most likely also benefiting from labor-intensive processing to create a dense, soft surface). It shows the relationship of each person to the Regent, the color, the price (in shillings per ell), and the garment type.

Margaret Douglas, wife	scarlet	100s/ell	petticoat[48]
Earl of Arran, Regent	violet in grain[49]	90s/ell	riding coat[50]
Margaret Douglas, wife	scarlet	80s/ell	riding cloak[51]
Earl of Arran, Regent	moran? grain	75s/ell	coat[52]

48 NRS E21/41/107r and Bond, *Dressing the Scottish Court*, 389.
49 Although the accounts do not specify that these fabrics dyed in grain are wool rather than silk, the number of ells allotted for the garments in question is too few for the relatively narrow silks of the time, so it is unlikely that they were silk.
50 NRS E21/42/311v and Bond, *Dressing the Scottish Court*, 216.
51 NRS E21/40/19v and Bond, *Dressing the Scottish Court*, 385.
52 NRS E21/41/129r and Bond, *Dressing the Scottish Court*, 165.

Social Status in Scottish Fashion

David Hamilton, son	violet in grain	70s/ell	coat[53]
Margaret Douglas, wife	scarlet	50s/ell	cloak[54]
Claude Hamilton, son	scarlet	50s/ell	legs of breeches[55]
David Hamilton, son	scarlet	50s/ell	legs of breeches[56]
David Hamilton, son	scarlet	50s/ell	legs of hose[57]
David Hamilton, son	scarlet	50 s/ell	legs of hose[58]
Arthur Hamilton, page	scarlet	46 s/ell	coat and cloak[59]

The first example is the most expensive piece of wool in these accounts: a length of scarlet used to make a petticoat for the Regent's wife.[60] The last example is the only instance of scarlet wool or wool dyed with grain used for someone outside the Regent's immediate family. This coat and cloak were part of a display livery for one of Arran's pages.

Few garments of purple appear in these accounts. Purple exists in the modern imagination as the color of royalty, and indeed it was designated as such in the English sumptuary laws at the time.[61] In the sixteenth century in Scotland, purple fabric was not necessarily more expensive than other colors, but it still had a definite relation to status. For one thing, all purple garments in these accounts were made from silks (velvet, satin, and taffeta) except for one instance of camlet, which may have been a silk blend.[62] For another, these garments were given to an exclusive list of people. Of 207 recipients in these accounts, only ten received fabric for garments made primarily of purple:

Earl of Arran, Regent[63]

Margaret Douglas, wife[64]

53 NRS E21/42/326v and Bond, *Dressing the Scottish Court*, 320.
54 NRS E21/42/346v and Bond, *Dressing the Scottish Court*, 392.
55 NRS E21/42/346v and Bond, *Dressing the Scottish Court*, 340. The terms "legs of breeches" and "legs of hose" referred to stockings.
56 NRS E21/42/346v and Bond, *Dressing the Scottish Court*, 340.
57 NRS E21/42/363r and Bond, *Dressing the Scottish Court*, 323.
58 NRS E21/42/368r and Bond, *Dressing the Scottish Court*, 323.
59 NRS E21/43/9r and Bond, *Dressing the Scottish Court*, 526.
60 Petticoats for women in mid-sixteenth-century Scotland seem to have taken various forms. Given the amount of fabric, this one might have been an underskirt or a waistcoat with sleeves. For a fuller discussion of petticoats in these accounts, see Bond, *Dressing the Scottish Court*, 97–99.
61 Hayward, *Rich Apparel*, 29.
62 Camlet was generally a blended fabric composed of wool and silk or wool and linen at this time.
63 NRS E21/41/61r, E21/42/106r and Bond, *Dressing the Scottish Court*, 162, 189.
64 NRS E21/44/78r and Bond, *Dressing the Scottish Court*, 397.

Melanie Schuessler Bond

James Hamilton, eldest son[65]

Barbara, eldest daughter[66] (one instance of which was for a royal robe for her wedding)[67]

Jean, middle daughter[68]

James Hamilton, nephew[69]

Grisel Hamilton, niece[70]

Margaret Hamilton, niece (for her wedding)[71]

Katherine Herries, ward (one of which was for her wedding)[72]

Jane Herries, ward (one of which was for her wedding)[73]

Weddings tended to be occasions for display of as much rank as could be mustered, and often demonstrated more wealth than the bride's family actually possessed. The Regent and two other people had smaller purple items such as sleeves,[74] or purple trim on garments that were mainly of another color.[75] Although it was not necessarily more expensive than other colors, its exclusivity suggests that it represented a dividing line between people's status.

CONCLUSION

To sum up the range of status represented in the accounts, it is helpful to compare the poor boy Pannycuke and the Regent's eldest daughter Barbara. Pannycuke received a single grant of £1 for coat, shirt, and breeches.[76] By contrast, Barbara's royal robe for her wedding cost a total of £60 13s ½d.[77] This total included a piece of lining fabric that was rejected, after it was cut out, by the dowager Queen Marie de Guise, who was apparently consulting on the proceedings.[78] Royal robes have not been a point of

65 NRS E21/40/25r and Bond, *Dressing the Scottish Court*, 293.

66 NRS E21/40/20v, E21/44/68v and Bond, *Dressing the Scottish Court*, 417, 438.

67 NRS E21/42/238v, E21/42/248r and Bond, *Dressing the Scottish Court*, 429, with further discussion on 129–30, 431.

68 E21/41/112v and Bond, *Dressing the Scottish Court*, 455.

69 NRS E21/42/38v, E21/42/72v, E21/42/175r, E21/42/176r and Bond, *Dressing the Scottish Court*, 362, 363, 366 (two on the same page).

70 NRS E21/42/78r and Bond, *Dressing the Scottish Court*, 491.

71 NRS E21/44/63v and Bond, *Dressing the Scottish Court*, 494.

72 NRS E21/43/12r, E21/43/14v, E21/44/64r and Bond, *Dressing the Scottish Court*, 513, 514.

73 NRS E21/43/12r, E21/43/14v, E21/44/64r and Bond, *Dressing the Scottish Court*, 513, 516.

74 NRS E21/40/19r, E21/41/61r and Bond, *Dressing the Scottish Court*, 156, 493.

75 NRS E21/41/129r, E21/41/188v, E21/40/20v, E21/40/31v, and Bond, *Dressing the Scottish Court*, 165, 170, 417, 649.

76 NRS E21/40/17v and Bond, *Dressing the Scottish Court*, 647.

77 NRS E21/42/238v–239r, E21/42/248r, E21/42/248r and Bond, *Dressing the Scottish Court*, 429, 431, with further discussion on 129–30.

78 NRS E21/42/239r. The rejected piece of lining was listed at £9 5s 7½d, though £9 would be correct for the number of ells and price per ell given.

Social Status in Scottish Fashion

discussion in this article because Barbara's is the only example in this set of accounts. Previous and later accounts suggest that Scottish monarchs tended to have royal robes of purple velvet and ermine that they wore to parliament sessions.[79] Barbara and her father were certainly aware of the royal robes in the wardrobes of Marie de Guise and King James V,[80] and since Marie de Guise was apparently involved in the process, the idea of this royal robe must have met with her approval. Probably not coincidentally, Barbara's royal robe was also made of purple velvet. It should be noted that the robe was meant to be worn over something else, so this large sum was not for an outfit but merely for a single garment.

This vast differential and the discerning rejection of a piece of lining fabric exemplify the importance of cloth and clothing to the maintenance of social status in sixteenth-century Scotland and the acute perception that enabled people to judge the sartorial efforts of others. Certain types of garments and accessories, such as men's gowns, women's hoods, and women's gowns with trains, were generally reserved for the social elite.[81] Particular fabrics could also mark high status, especially if they were dyed an expensive color. The combination of all three aspects—an exclusive garment, a high-quality fabric, and an elite color—would signal a very lofty class of person indeed.

It is no accident that King James V was portrayed in a crimson gown (fig. 6.1). He had several gowns in crimson velvet and satin in his wardrobe,[82] and these combinations of garment, fabric, and dye would have clearly proclaimed his rank to all. It is to this that Barbara and her family aspired with her royal robe, trusting the various aspects of clothing status to make it clear on which side of the dividing lines she stood.

79 Sir James Balfour Paul, ed., *Accounts of the Lord High Treasurer of Scotland*, vol. 2 (Edinburgh: H. M. General Register House, 1900), 224; "Elizabeth: June 1563," in *Calendar of State Papers, Scotland*, vol. 2, *1563–69*, ed. Joseph Bain (London, 1900), 9–17, available at British History Online, http://www.british-history.ac.uk/cal-state-papers/scotland/vol2/pp9-17 (accessed June 21, 2021); Thomas Thomson, ed., *A Collection of Inventories and Other Records of the Royal Wardrobe and Jewelhouse; and of the Artillery and Munitioun in Some of the Royal Castles, M.CCCC.LXXXVIII–M.DC.VI* (Edinburgh: privately printed, 1815), 219.

80 Sir James Balfour Paul, ed., *Accounts of the Lord High Treasurer of Scotland*, vol. 7 (Edinburgh: H. M. General Register House, 1907), 277.

81 In some places, hoods devolved to the middle class towards the end of the century, and their fashionable trajectory varied in different locations. See Melanie Schuessler, "French Hoods: Development of a Sixteenth-Century Court Fashion," *Medieval Clothing and Textiles* 5 (2009): 138–39.

82 John Harrison, "The Wardrobe Inventories of James V (Particularly BL Royal 18C XIV F. 184-215)" [research report], Stirling Castle Palace Archaeological and Historical Research 2004–8 (Edinburgh: Historic Scotland, undated), 12–14.

Recent Books of Interest

The Bologna Cope: Patronage, Iconography, History and Conservation, edited by M. A. Michael, translated by Jane Bridgeman (London: Harvey Miller, 2022). ISBN 978-1923554874. 228 pages, 160 color illustrations.

This volume—part of a planned series on significant examples of medieval English embroidery—focuses on the Bologna Cope, a spectacular early-fourteenth-century *opus anglicanum* vestment associated with Pope Benedict XI (r. 1303–4). The book's eight chapters provide an in-depth consideration of the cope's history, iconography, provenance, and conservation.

The first two chapters are particularly strong. Chapter 1 is an extensive look into Benedict XI's donation history, diplomatic career, and relationship with Edward I of England, ending with a short but valuable discussion of English embroideries as diplomatic gifts. Chapter 2, a deeply researched examination of the medieval English embroidery industry, pays particular attention to the role of women in the production and marketing of *opus anglicanum* to the rest of Europe.

Chapters 4 and 5 are similarly excellent. The former, a detailed look at references to the cope in monastic inventories, also recounts anecdotes of how the cope was nearly lost to Napoleonic armies, then to a Victorian theatrical impresario who planned to remake it as a costume. Chapter 5 continues with a fine history of the cope from the 1880s to the present, as well as its photographic and exhibition history.

Arguably the strongest chapter is the seventh, a superb account of the cope's recent conservation to prepare it for a 2016 exhibition. The details of the cope's condition, previous attempts at conservation, and the extensive work needed to clean, repair, and stabilize the fragile silk and metallic threads are fascinating, particularly the efforts needed to correct the distortions caused by storage conditions and the passage of time.

Unfortunately, the three remaining chapters suffer by comparison. Chapter 3, an otherwise excellent description of the cope's iconography, is marred by the consistent misidentification of the fur coverlets and cloak linings depicted in the embroidery as "ermine" (rather than vair), while Chapter 8, a short description and key to the iconography, might have been better at the beginning for the benefit of readers not familiar with the cope. Weakest of all is Chapter 6, purportedly a look at fourteenth-century Italian textiles that is actually a somewhat disjointed discussion of the fabrics in items personally associated with Benedict XI.

Recent Books of Interest

The book is lavishly illustrated with full-color photos of the cope, with particularly fine close-ups taken during the conservation work. The volume is completed by an extensive bibliography, index, and a useful glossary of textile and costume terms. — *Lisa Evans, Easthampton, Massachusetts*

Brilliant Bodies: Fashioning Courtly Men in Early Renaissance Italy, by Timothy McCall (University Park, PA: Pennsylvania State University Press, 2022). ISBN 978-0271090603. 240 pages, 86 illustrations (36 in color).

Timothy McCall's book is a sparkling investigation of the material radiance that surrounded and helped to support the power of Renaissance Italian lords. It is packed with information about the use of clothing, its representations, and the way in which it was perceived within the context of political authority. McCall has an engaging writing style, and this book succeeds in being scholarly and accessible at the same time.

Brilliant Bodies is divided into four main chapters together with an introduction and an epilogue. The introduction sets out the themes to be explored: the importance of the qualities of brilliance and light in the Renaissance court, the need for lords to display their bodies in order to demonstrate power, the materials—cloth, clothing, jewels—required to ensure that lords were shown to their peers and subjects to best advantage. The following chapters focus, in turn, on the armour and types of cloth and clothing that enabled these powerful men to, literally, shine; the jewels and jewellery that also contributed to their refulgent appearance; the ways in which clothing was designed and cut in order to show off the ideal slim male body; and the importance of male physical beauty as evidenced through skin and hair.

The book is packed with information about how contemporaries articulated their awe—both real and politically expedient—of the gleaming ostentation achieved by fifteenth-century Italian lords. McCall succeeds admirably in demonstrating the importance of expensive clothing and its effects on observers, although more discussion of the intent behind the reports of courtiers and ambassadors would be welcome, for these sources were, like the clothes of the lords, carefully crafted. For these lords—the main examples are Milan and Ferrara—power politics, McCall argues, was heavily dependent on shining bodily displays of masculinity removed from later sixteenth-century aspirations towards darker clothes worn with apparent lack of effort, as voiced by Baldassare Castiglione in *The Book of the Courtier*. Yet, as McCall discusses in the epilogue, black did not necessarily equal drab. Lords could use black as a means by which to demonstrate their spending power and as a foil to shining decorative elements in their wardrobes.

The main sources used in *Brilliant Bodies* are chronicles, letters between courtiers or from courtiers to lords and their families, paintings, sculptures, and extant clothing and armour. The high publication standards of the Pennsylvania State University Press allow the reader to follow arguments based on visual material with only a few exceptions: the details of photographs of extant clothing can be difficult to make out.

Brilliant Bodies is not a book that provides detailed information on specific textile designs, on technical aspects of types of weave (although a useful short glossary is provided), or on the relationships between painters and textile design. For that, one must

Recent Books of Interest

turn, for example, to Lisa Monnas's *Merchants, Princes and Painters* (2008). Nor is it a book that looks to archival sources for its discussions about fashion. Rather, through his focus on the importance attached to the dazzling displays of the lords' appearance, McCall succeeds in making an important contribution to the social history of elite male clothing. He highlights the attention-seeking, body-focused, "blingy" aspects of the projection of masculinity and power in fifteenth-century Italian courts, and he does it with brio. — *Cordelia Warr, University of Manchester*

The Valkyries' Loom: The Archaeology of Cloth Production and Female Power in the North Atlantic, by Michèle Hayeur Smith (Gainesville, FL: University Press of Florida). ISBN 978-0813066622 (hardback, 2020), 978-0813080116 (paperback, 2023). 218 pages, 41 black-and-white illustrations.

Michèle Hayeur Smith examines North Atlantic archaeological textiles to explore how the production, use, and economic status of textiles served as an indicator of female social power from the ninth century through the early modern era. She argues that the economy of cloth was explicitly gendered, with cloth production throughout most of this period being the domain of women and avoided by men for fear of association with the feminine. Textile tools and cloth production were closely linked to magic, fate, and the body, especially in relation to birth and death. In a society where the masculine verbal arts were highly valued, the feminine production of a literally material creative art provided women with economic and social power.

Hayeur Smith usefully compares the plentiful extant cloth fragments from Greenland and Iceland as well as the more limited corpus from Scotland and the Faroe Islands to analyze their physical, social, and economic functions. Details of production like spin direction are shown to be heavily culturally influenced and therefore able to reveal how waves of female immigrants contributed to the evolution of textile production. Similarly, her close analysis of the archaeological textiles shows how local innovations met similar demands using different mechanisms, such as maximization of warmth via plied wefts in Iceland but through weft-dominant weaves in Greenland.

Through the archaeological and textual evidence for *vaðmál*, the legally standardized commodity fabric produced on Icelandic farmsteads, Hayeur Smith examines the role of textiles as currency in medieval Iceland. This commodity good, produced by the hands of women, largely in independent settings, was of sufficient quality and consistency to represent a significant contribution to international trade. In contrast, Greenlanders' subsistence production is interpreted as having been focused less on standardization and commoditization and more on the creation of textiles that were warm, long-lasting, and reusable. Despite the availability of many fur-bearing animals, genetic analysis of textiles shows limited local use of fur, because furs and ivory were the cash crops of Greenland, not textiles.

Hayeur Smith tracks how the ascendance of the Danish trade monopoly in the North Atlantic brought changes to the production, export, and import of textiles as an increase in availability of finer, processed, dyed, fulled, and non-wool-fiber imported textiles competed with locally produced goods. This increase in importation of textiles correlated with a shift from female home-based production to centralized industrial

Recent Books of Interest

production and from feminine independence to masculine control. Potentially as a grass-roots resistance to this loss of textile autonomy and power, knitting quickly became more important in Iceland, and limited homespun cloth continued to be produced into the nineteenth century.

The book relies primarily on archaeological data, but the social manifestation of women's textile-based power, especially at local or individual rather than societal levels, could have been bolstered by the inclusion of additional textual sources. Hayeur Smith provides a data-forward analysis of the textiles and trends in production, but provision of additional source data would clarify her arguments. Several of the tables and figures suffer from lack of clarity, poor organization, or simply the challenges of black-and-white reproduction. Additionally, the text is occasionally vague or misleading about the specifics of textile properties and techniques, although not in ways that significantly impair the overall arguments.

The Valkyries' Loom provides an exploration of how cloth shaped the development of North Atlantic identities by acting as an extension of the human body and most importantly as a feminine artistic physical and social performance in a society that often placed higher value on the male voice. It should be of interest and enjoyment to readers interested in the economics, sociology, and archaeology of medieval and early modern textiles. — *Jean Kveberg, Madison, Wisconsin*

The World in Dress: Costume Books Across Italy, Europe, and the East, by Giulia Calvi (Cambridge: Cambridge University Press, 2022). ISBN 978-1108823302. 106 pages, 56 black-and-white illustrations.

This slim volume is part of the series *Elements in the Renaissance*, which the publisher states showcases "cutting-edge scholarship … designed to introduce students, researchers, and general readers to key questions in current research [and] to explore the conceptual, material, and cultural frameworks that structured Renaissance experience." That seems a rather tall order to fill with only 92 pages of text (plus 14 of bibliography).

The opening section, "Staging the Clothing of the Modern World," introduces the reader to the well-studied sixteenth-century costume books and plates of European origin. While this section treads some well-known ground, the book's second and third sections expand to discuss depictions of dress produced in the East, collections which are far less well known or examined. Specifically, section 2, "The Ottoman Empire," presents costume albums produced in the Ottoman Empire in the early seventeenth century. These were often collections of plates commissioned by "diplomats, scholars and travelers," first drawn by European artists who accompanied diplomats and later by their Ottoman counterparts. Section 3, "Italy, Europe and Japan," examines the illustration of Japanese dress facilitated by diplomatic exchanges and gifts and the role of Jesuit missionaries in the so-called Christian century in Japan (1549–1640). The portability of these and the Ottoman albums must have been key to their widespread distribution—whether as objects of scholarly interest, as curiosities representing "exotic" cultures, or simply as gifts.

Recent Books of Interest

Some questions are left unanswered: The author states that Cesare Vecellio "had his own smaller printing business and printed maps" (4, and again at 12) but provides no source for this information, leaving the reader without a trail for further investigation. She indicates that the depictions of Christian minorities in Nicolas de Nicolay's costume books were "particularly meaningful for Venetian artists" (35), but fails to answer the question "How so?"

However, although this is not a comprehensive (or even in-depth) study of the depiction of foreign dress in the sixteenth and seventeenth centuries, the author has clearly mined the depths of her extensive list of sources. She examines these books and albums in a new light, as "a dynamic genre in a changing geopolitical context shaped by Western and non-Western cross-cultural exchanges" (4). From that point of view, *The World in Dress* succeeds in offering a good deal of new information and, as the publisher suggests, in introducing readers to "key questions in current research," perhaps leading them to broader fields of inquiry of their own. — *Tawny Sherrill, California State University, Long Beach*

Woven into the Urban Fabric: Cloth Manufacture and Economic Development in the Flemish West-Quarter (1300–1600), by Jim van der Meulen (Turnhout, Belgium: Brepols, 2022). ISBN 978-2503594552. 251 pages, 16 black-and-white illustrations.
The Fabric of the City: A Social History of Cloth Manufacture in Medieval Ypres, by Peter Stabel (Turnhout, Belgium: Brepols, 2022). ISBN 978-2503600512. 278 pages, 18 black-and-white illustrations.

Do you know Nieuwkerke? No, not surprisingly, this village with just under 2,000 inhabitants in the Belgian province of West Flanders was previously only known to initiated textile researchers. This will change significantly with *Woven into the Urban Fabric* by Jim van der Meulen, based on his 2017 dissertation from the University of Antwerp. The author examines the rise (and fall) of this village (Nieuwkerke never received city privileges), which was one of the most important Flemish textile production centres of the sixteenth century. Inspired by the long Antwerp tradition of economic theorising, the author examines in five chapters: (1) the links between agriculture and industry in the late Middle Ages, (2) "entrepreneurship" and industrial organisation, (3) the commercial aspects of Nieuwkerke's cloth production, (4) the relationship between town and country in West Flanders, and finally (5) aspects of collective action as the basis for commercial success.

The author convincingly demonstrates the coherence between the development of the textile industry in Ypres and other towns and the rural area in the Flemish West Quarter. In this way, he persuasively places Nieuwkerke on the map of research as an outstanding example of late medieval (pre?-)industrial development trends. If you are not familiar with Nieuwkerke, now is the time to add this village to your knowledge.

The same lack of knowledge cannot really be assumed for the cloth trade and production of the city of Ypres, as this name is normally part of the great canon of relevant economic histories and nearly all overviews of cloth trade. And yet the history of the cloth production of this town is surprisingly under-examined. This is

Recent Books of Interest

mainly due to the fact that the Ypres town archive was not accessible when the great Hanseatic diplomataries were published, and then, due to an internal dispute between the Ypres archivists, it was not brought to safety in time before the turmoil of the First World War. The unique collection on Ypres' cloth history fell victim to the first battles of 1914. So it is only to be welcomed that Peter Stabel had to abandon his plans for a synthesis on the urban history of Europe, Byzantium, and the Islamic world due to the COVID epidemic and instead turned his attention to cloth production and its social background in the city of Ypres.

In *The Fabric of the City*, the author attempts in ten chapters to describe the history and development of cloth production in Ypres using the little material still available and a few sources that were edited before the destruction. In the first section, he describes the rise and fall of Ypres' cloth production (and its conversion from light to heavy and expensive cloth), then *in extenso* the individual work steps from the raw wool to the finished cloth and their executors. In the third section, he discusses the question of town and country, or in the case of Ypres, the suburbs in relation to the old town, and from there deals with the merchants' capital and the clothiers. He then turns to the guilds (chapter 6), wages (chapter 7), and gender aspects (chapter 8). Finally, he discusses the role of cloth producers and merchants in the Flemish uprisings and revolts before venturing a broad outlook in the tenth chapter, in which (among other things) he compares Ypres with Florence.

Stabel's work thrives on the author's ability to combine the theoretical insights of modern economic history with the conditions on the ground. It clearly shows his origins in the Antwerp school. However, it also has its weaknesses. In addition to numerous redundancies, the author's statements on the Hanseatic League in particular are poorly substantiated if not unsubstantiated or incorrect (e.g. pp. 26ff). Here, a discussion of German (and older) sources would have helped the work considerably.

It should be noted, however, that both books impressively fill a hitherto painfully felt gap in our knowledge of medieval cloth production as well as the wool and cloth trade. Both are from the same cloth. They impressively demonstrate that it is possible to profitably incorporate regional studies into general considerations of international economic history. Ypres and Nieuwkerke have now (finally) been given their rightful place in research. — *Carsten Jahnke, University of Copenhagen*

ALSO PUBLISHED

The Dutch Hatmakers of Late Medieval and Tudor London, by Shannon McSheffrey and Ad Putter (Woodbridge, UK: Boydell, 2023). ISBN 978-1837650804. 176 pages, 15 black-and-white illustrations.

Textiles of the Viking North Atlantic: Analysis, Interpretation, Re-creation, edited by Alexandra Lester-Makin and Gale R. Owen-Crocker (Woodbridge, UK: Boydell, 2024). ISBN 978-1837650132. 244 pages, 40 illustrations (11 in color).

Author Index, Volumes 1–17

Amati Canta, Antonietta. "Bridal Gifts in Medieval Bari," vol. 9 (2013).

Anderlini, Tina. "The Shirt Attributed to St. Louis," vol. 11 (2015); "Dressing the Sacred: Medallion Silks and Their Use in Western Medieval Europe," vol. 15 (2019).

Anderson, Joanne W. "The Loom, the Lady, and Her Family Chapels: Weaving Identity in Late Medieval Art," vol. 15 (2019).

Andersson, Eva I. "Clothing and Textile Materials in Medieval Sweden and Norway," vol. 9 (2013).

Beer, Michelle L. "'Translating' a Queen: Material Culture and the Creation of Margaret Tudor as Queen of Scots," vol. 10 (2014).

Benns, Elizabeth. "'Set on Yowre Hondys': Fifteenth-Century Instructions for Fingerloop Braiding," vol. 3 (2007).

Bertolet, Anna Riehl. "'Like two artificial gods': Needlework and Female Bonding in *A Midsummer Night's Dream*," vol. 11 (2015).

Besson-Lagier, Catherine. "The Sleeve from Bussy-Saint-Martin: A Rare Example of Medieval Quilted Armor," vol. 17 (2023).

Blatt, Heather. *See* Swales, Lois.

Bond, Melanie Schuessler. *See* Friedman, John Block; Schuessler, Melanie.

Brandenburgh, Chrystel. "Old Finds Rediscovered: Two Early Medieval Headdresses from the National Museum of Antiquities, Leiden, the Netherlands," vol. 8 (2012).

Bridgeman, Jane. "'Bene in ordene et bene ornata': Eleonora d'Aragona's Description of Her Suite of Rooms in a Roman Palace of the Late Fifteenth Century," vol. 13 (2017).

Burkholder, Kristen M. "Threads Bared: Dress and Textiles in Late Medieval English Wills," vol. 1 (2005).

Carns, Paula Mae. "Cutting a Fine Figure: Costume on French Gothic Ivories," vol. 5 (2009).

Carroll-Clark, Susan M. "Bad Habits: Clothing and Textile References in the Register of Eudes Rigaud, Archbishop of Rouen," vol. 1 (2005).

Cavell, Megan. "Sails, Veils, and Tents: The *Segl* and Tabernacle of Old English *Christ III* and *Exodus*," vol. 12 (2016).

Author Index, Volumes 1–17

Chambers, Mark. "'Hys surcote was ouert': The 'Open Surcoat' in Late Medieval British Texts," vol. 7 (2011); "How Long Is a *Launce*? Units of Measure for Cloth in Late Medieval Britain," vol. 13 (2017).

Chambers, Mark, and Gale R. Owen-Crocker. "From Head to Hand to Arm: The Lexicological History of 'Cuff,'" vol. 4 (2008).

Coatsworth, Elizabeth. "Stitches in Time: Establishing a History of Anglo-Saxon Embroidery," vol. 1 (2005); "Cushioning Medieval Life: Domestic Textiles in Anglo-Saxon England," vol. 3 (2007); "'A formidable undertaking': Mrs. A. G. I. Christie and *English Medieval Embroidery*," vol. 10 (2014).

Concha Sahli, Alejandra. "Habit Envy: Extra-Religious Groups, Attire, and the Search for Legitimation Outside the Institutionalised Religious Orders," vol. 15 (2019).

Cooper, Jonathan C. "Academical Dress in Late Medieval and Renaissance Scotland," vol. 12 (2016).

D'Ettore, Kate. "Clothing and Conflict in the Icelandic Family Sagas: Literary Convention and the Discourse of Power," vol. 5 (2009).

Dahl, Camilla Luise. "Dressing the Bourgeoisie: Clothing in Probate Records of Danish Townswomen, ca. 1545–1610," vol. 12 (2016).

Dahl, Camilla Luise, and Isis Sturtewagen. "The Cap of St. Birgitta," vol. 4 (2008).

Davidson, Hilary, and Ieva Pīgozne. "Archaeological Dress and Textiles in Latvia from the Seventh to Thirteenth Centuries: Research, Results, and Reconstructions," vol. 6 (2010).

Evalds, Valija. "Sacred or Profane? The Horned Headdresses of St. Frideswide's Priory," vol. 10 (2014).

Evans, Lisa. "'The Same Counterpoincte Beinge Olde and Worene': The Mystery of Henry VIII's Green Quilt," vol. 4 (2008); "Anomaly or Sole Survivor? The Impruneta Cushion and Early Italian 'Patchwork,'" vol. 8 (2012).

Farmer, Sharon. "*Biffes, Tiretaines*, and *Aumonières*: The Role of Paris in the International Textile Markets of the Thirteenth and Fourteenth Centuries," vol. 2 (2006).

Farris, Charles. "The Administration of Cloth and Clothing in the Great Wardrobe of Edward I," vol. 17 (2023).

Finley, Jessica. "The Lübeck *Wappenröcke*: Distinctive Style in Fifteenth-Century German Fabric Armor," vol. 13 (2017).

Friedman, John Block. "The Art of the Exotic: Robinet Testard's Turbans and Turban-like Coiffure," vol. 4 (2008); "The Iconography of Dagged Clothing and Its Reception by Moralist Writers," vol. 9 (2013); "Coats, Collars, and Capes: Royal Fashions for Animals in the Early Modern Period," vol. 12 (2016); "Eyebrows, Hairlines, and 'Hairs Less in Sight': Female Depilation in Late Medieval Europe," vol. 14 (2018).

Author Index, Volumes 1–17

Friedman, John Block, and Melanie Schuessler Bond. "Fashion and Material Culture in the *Tabletop of the Seven Deadly Sins* Attributed to Hieronymus Bosch," vol. 16 (2020).

Garver, Valerie L. "Weaving Words in Silk: Women and Inscribed Bands in the Carolingian World," vol. 6 (2010).

Grinberg, Ana. "Robes, Turbans, and Beards: 'Ethnic Passing' in *Decameron* 10.9," vol. 13 (2017).

Haas-Gebhard, Brigitte, and Britt Nowak-Böck. "The Unterhaching Grave Finds: Richly Dressed Burials from Sixth-Century Bavaria," vol. 8 (2012).

Hammarlund, Lena, Heini Kirjavainen, Kathrine Vestergård Pedersen, and Marianne Vedeler. "Visual Textiles: A Study of Appearance and Visual Impression in Archaeological Textiles," vol. 4 (2008).

Heller, Sarah-Grace. "Obscure Lands and Obscured Hands: Fairy Embroidery and the Ambiguous Vocabulary of Medieval Textile Decoration," vol. 5 (2009); "Angevin-Sicilian Sumptuary Statutes of the 1290s: Fashion in the Thirteenth-Century Mediterranean," vol. 11 (2015).

Hennequin, M. Wendy. "Anglo-Saxon Banners and *Beowulf*," vol. 16 (2020).

Higley, Sarah L. "Dressing Up the Nuns: The *Lingua Ignota* and Hildegard of Bingen's Clothing," vol. 6 (2010).

Høskuldsson, Karen Margrethe. "Hidden in Plain Black: The Secrets of the French Hood," vol. 14 (2018); "From Hennin to Hood: An Analysis of the Evolution of the English Hood Compared to the Evolution of the French Hood," vol. 17 (2023).

Hyer, Maren Clegg. "Textiles and Textile Imagery in the *Exeter Book*," vol. 1 (2005); "Reduce, Reuse, Recycle: Imagined and Reimagined Textiles in Anglo-Saxon England," vol. 8 (2012); "Text/Textile: 'Wordweaving' in the Literatures of Anglo-Saxon England," vol. 15 (2019).

Izbicki, Thomas M. "Forbidden Colors in the Regulation of Clerical Dress from the Fourth Lateran Council (1215) to the Time of Nicholas of Cusa (d. 1464)," vol. 1 (2005); "Failed Censures: Ecclesiastical Regulation of Women's Clothing in Late Medieval Italy," vol. 5 (2009); "*Linteamenta altaria*: The Care of Altar Linens in the Medieval Church," vol. 12 (2016).

Jack, Kimberly. "What Is the Pearl-Maiden Wearing, and Why?" vol. 7 (2011).

Jackson, Cynthia. "The Broderers' Crown: The Examination and Reconstruction of a Sixteenth-Century City of London Livery Company Election Garland," vol. 16 (2020).

James, Susan E. "Domestic Painted Cloths in Sixteenth-Century England: Imagery, Placement, and Ownership," vol. 9 (2013).

Jaster, Margaret Rose. "'Clothing Themselves in Acres': Apparel and Impoverishment in Medieval and Early Modern England," vol. 2 (2006).

Author Index, Volumes 1–17

Johnston, Mark D. "Sex, Lies, and *Verdugados*: Juana of Portugal and the Invention of Hoopskirts," vol. 16 (2020).

Keefer, Sarah Larratt. "A Matter of Style: Clerical Vestments in the Anglo-Saxon Church," vol. 3 (2007).

Kirjavainen, Heini. *See* Hammarlund, Lena.

Kirkham, Anne. "Hanging Together: Furnishing Textiles in a Fifteenth-Century Book of Hours," vol. 17 (2023).

Kneen, Maggie, and Gale R. Owen-Crocker. "The Use of Curved Templates in the Drawing of the Bayeux Tapestry," vol. 16 (2020).

Krag, Anne Hedeager. "Byzantine and Oriental Silks in Denmark, 800–1200," vol. 14 (2018).

Ladd, Roger A. "The London Mercers' Company, London Textual Culture, and John Gower's *Mirour de l'Omme*," vol. 6 (2010).

Leed, Drea. "'Ye Shall Have It Cleane': Textile Cleaning Techniques in Renaissance Europe," vol. 2 (2006).

Magoula, Olga. "Multicultural Clothing in Sixth-Century Ravenna," vol. 14 (2018).

Meek, Christine. "*Laboreria Sete*: Design and Production of Lucchese Silks in the Late Fourteenth and Early Fifteenth Centuries," vol. 7 (2011); "Clothing Distrained for Debt in the Court of Merchants of Lucca in the Late Fourteenth Century," vol. 10 (2014); "*Calciamentum*: Footwear in Late Medieval Lucca," vol. 13 (2017).

Miller, Maureen C. "The Liturgical Vestments of Castel Sant'Elia: Their Historical Significance and Current Condition," vol. 10 (2014).

Monk, Christopher J. "Behind the Curtains, Under the Covers, Inside the Tent: Textile Items and Narrative Strategies in Anglo-Saxon Old Testament Art," vol. 10 (2014).

Monnas, Lisa. "Some Medieval Colour Terms for Textiles," vol. 10 (2014).

Muendel, John. "The Orientation of Strikers in Medieval Fulling Mills: The Role of the 'French' *Gualchiera*," vol. 1 (2005).

Munro, John H. "The Anti-Red Shift—To the Dark Side: Colour Changes in Flemish Luxury Woollens, 1300–1550," vol. 3 (2007).

Neijman, Maria. *See* Sundström, Amica.

Netherton, Robin. "The Tippet: Accessory after the Fact?" vol. 1 (2005); "The View from Herjolfsnes: Greenland's Translation of the European Fitted Fashion," vol. 4 (2008).

Nicholson, Karen. "The Effect of Spindle Whorl Design on Wool Thread Production: A Practical Experiment Based on Examples from Eighth-Century Denmark," vol. 11 (2015).

Author Index, Volumes 1–17

Nowak-Böck, Britt. *See* Haas-Gebhard, Brigitte.

Nunn-Weinberg, Danielle. "The Matron Goes to the Masque: The Dual Identity of the English Embroidered Jacket," vol. 2 (2006).

Oldland, John. "The Finishing of English Woollens, 1300–1550," vol. 3 (2007); "Cistercian Clothing and Its Production at Beaulieu Abbey, 1269–70," vol. 9 (2013). *See also* Quinton, Eleanor.

Owen-Crocker, Gale R. "Pomp, Piety, and Keeping the Woman in Her Place: The Dress of Cnut and Ælfgifu-Emma," vol. 1 (2005); "The Embroidered Word: Text in the Bayeux Tapestry," vol. 2 (2006); "The Significance of Dress in the Bayeux Tapestry," vol. 13 (2017); "Old Rags, New Responses: Medieval Dress and Textiles," vol. 15 (2019); "Embroidered Beasts: Animals in the Bayeux Tapestry," vol. 17 (2023). *See also* Chambers, Mark; Kneen, Maggie.

Øye, Ingvild. "Production, Quality, and Social Status in Viking Age Dress: Three Cases from Western Norway," vol. 11 (2015).

Pac, Grzegorz. "The Attire of the Virgin Mary and Female Rulers in Iconographical Sources of the Ninth to Eleventh Centuries: Analogues, Interpretations, Misinterpretations," vol. 12 (2016).

Pedersen, Kathrine Vestergård. *See* Hammarlund, Lena.

Pīgozne, Ieva. *See* Davidson, Hilary.

Powell, Susan. "Textiles and Dress in the Household Papers of Lady Margaret Beaufort (1443–1509), Mother of King Henry VII," vol. 11 (2015).

Pritchard, Frances. "A Set of Late-Fifteenth-Century Orphreys Relating to Ludovico Buonvisi, a Lucchese Merchant, and Embroidered in a London Workshop," vol. 12 (2016).

Quinton, Eleanor, and John Oldland. "London Merchants' Cloth Exports, 1350–1500," vol. 7 (2011).

Randles, Sarah. "One Quilt or Two? A Reassessment of the Guicciardini Quilts," vol. 5 (2009).

Rozier, Emily J. "'Transposing þe shapus þat God first mad them of': Manipulated Masculinity in the Galaunt Tradition," vol. 11 (2015).

Sayers, William. "Flax and Linen in Walter of Bibbesworth's Thirteenth-Century French Treatise for English Housewives," vol. 6 (2010).

Schuessler, Melanie. "'She Hath Over Grown All that Ever She Hath': Children's Clothing in the Lisle Letters, 1533–40," vol. 3 (2007); "French Hoods: Development of a Sixteenth-Century Court Fashion," vol. 5 (2009). *See also* Bond, Melanie Schuessler.

Sciacca, Christine. "Stitches, Sutures, and Seams: 'Embroidered' Parchment Repairs in Medieval Manuscripts," vol. 6 (2010).

Author Index, Volumes 1–17

Sherman, Heidi M. "From Flax to Linen in the Medieval Rus Lands," vol. 4 (2008).

Sherrill, Tawny. "Fleas, Fur, and Fashion: *Zibellini* as Luxury Accessories of the Renaissance," vol. 2 (2006); "Who Was Cesare Vecellio? Placing *Habiti Antichi* in Context," vol. 5 (2009).

Sinisi, Lucia. "The Wandering Wimple," vol. 4 (2008); "The Marriage of the Year (1028)," vol. 9 (2013).

Skoglund, Git. "Construction and Reconstruction of the Past: The Medieval Nordic Textile Heritage of Hemp," vol. 16 (2020).

Slefinger, John. "Historicizing the Allegorical Eye: Reading Lady Mede," vol. 16 (2020).

Stanford, Charlotte A. "Donations from the Body for the Soul: Apparel, Devotion, and Status in Late Medieval Strasbourg," vol. 6 (2010).

Staples, Kate Kelsey. "Fripperers and the Used Clothing Trade in Late Medieval London," vol. 6 (2010).

Straubhaar, Sandra Ballif. "Wrapped in a Blue Mantle: Fashions for Icelandic Slayers?" vol. 1 (2005).

Sturtewagen, Isis. "Unveiling Social Fashion Patterns: A Case Study of Frilled Veils in the Low Countries (1200–1500)," vol. 7 (2011). *See also* Dahl, Camilla Luise.

Sundström, Amica, and Maria Neijman. "Gilt-leather Embroideries from Medieval Sweden and Finland," vol. 17 (2023).

Swales, Lois, and Heather Blatt. "Tiny Textiles Hidden In Books: Toward a Categorization of Multiple-Strand Bookmarkers," vol. 3 (2007).

Swedo, Elizabeth M. "Unfolding Identities: The Intertextual Roles of Clothing in the *Nibelungenlied* and *Völsunga Saga*," vol. 15 (2019).

Sylvester, Louise. "Mining for Gold: Investigating a Semantic Classification in the Lexis of Cloth and Clothing Project," vol. 8 (2012).

Talarico, Kathryn Marie. "Dressing for Success: How the Heroine's Clothing (Un)Makes the Man in Jean Renart's *Roman de la Rose*," vol. 8 (2012).

Thomas, Hugh M. "Clothing and Textiles at the Court of King John of England, 1199–1216," vol. 15 (2019).

Tiddeman, Megan. "Lexical Exchange with Italian in the Textile and Wool Trades in the Thirteenth to Fifteenth Centuries," vol. 14 (2018).

Tilghman, Carla. "Giovanna Cenami's Veil: A Neglected Detail," vol. 1 (2005).

Twomey, Lesley K. "Poverty and Richly Decorated Garments: A Re-Evaluation of Their Significance in the *Vita Christi* of Isabel de Villena," vol. 3 (2007).

Vedeler, Marianne. *See* Hammarlund, Lena.

Ward, Susan Leibacher. "Saints in Split Stitch: Representations of Saints in *Opus Anglicanum* Vestments," vol. 3 (2007).

Author Index, Volumes 1–17

Warr, Cordelia. "The Devil on My Tail: Clothing and Visual Culture in the Camposanto *Last Judgment*," vol. 11 (2015).

Wendelken, Rebecca Woodward. "Wefts and Worms: The Spread of Sericulture and Silk Weaving in the West before 1300," vol. 10 (2014).

Whitfield, Niamh. "Dress and Accessories in the Early Irish Tale 'The Wooing Of Becfhola,'" vol. 2 (2006).

Wild, Benjamin L. "The Empress's New Clothes: A *Rotulus Pannorum* of Isabella, Sister of King Henry III, Bride of Emperor Frederick II," vol. 7 (2011).

Williams, Patricia. "Dress and Dignity in the *Mabinogion*," vol. 8 (2012).

Wright, Monica L. "'De Fil d'Or et de Soie': Making Textiles in Twelfth-Century French Romance," vol. 2 (2006); "The *Bliaut*: An Examination of the Evidence in French Literary Sources," vol. 14 (2018).

Zanchi, Anna. "'Melius Abundare Quam Deficere': Scarlet Clothing in *Laxdæla Saga* and *Njáls Saga*," vol. 4 (2008).

Zumbuhl, Mark. "Clothing as Currency in Pre-Norman Ireland?" vol. 9 (2013).